THE INSTANT
IT HAPPENED

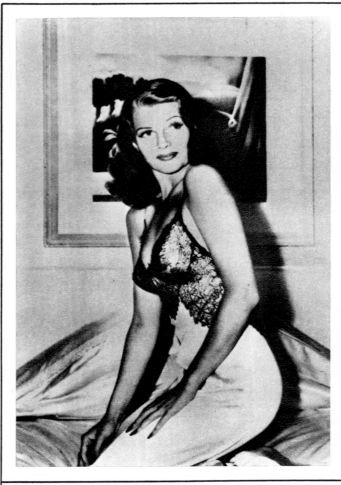

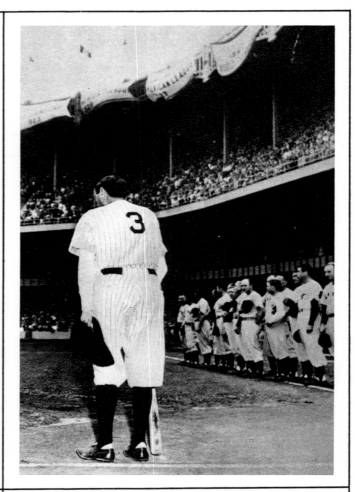

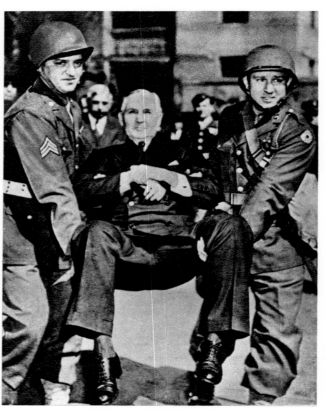

THE
INSTANT
IT
HAPPENED

THE
ASSOCIATED
PRESS

Harry N. Abrams, Inc., Publishers, New York

Project Director	Keith Fuller
Editors	Hal Buell and Saul Pett
Writers	Sidney Moody, John Barbour, Jules Loh, Richard Meyer, Kay Bartlett, Saul Pett
Research	John Faber, historian of the National Press Photographers Association, and from the AP Photo Library, Henry Mecinski, Yvanna Mundell and Robert White.

LIBRARY OF CONGRESS CATALOGING IN PUBLICATION DATA

Associated Press.
 The instant it happened.

 1. Photography, Journalistic. I. Title.
TR820.A78 1976 779 75-42279
ISBN 0-8109-0376-8

Library of Congress Catalogue Card Number: 75-42279
Published in 1976 by Harry N. Abrams, Incorporated, New York

THIS BOOK of great photographs is
dedicated to the men and women who
took them, to those who died or grew
old in the taking, to the professionals
who worked for them and the amateurs
who happened on them, to all those who
have pursued history with a relentless
camera, with devotion, courage and
stamina, in the great and small moments
of revelation.

Wes Gallagher

Wes Gallagher,
President and General Manager,
The Associated Press

Foreword

This book began with a simple idea and grew of its own mysterious force. We had thought we would put between two covers the great news photographs of our time and the thoughts of the photographers who took them. But our time quickly became all time and there we were back on the banks of the Antietam, more than 100 years ago, with Mathew Brady.

Mathew Brady, who said, "A spirit in my feet said go, and I went" off to the Civil War, the same compulsion that sent civilians with cameras off to the Vietnam war more than a century later.

We did not intend history but, in the excitement of the research, history kept intruding, crying to be bridged between peaks, begging to be clothed more fully in the colors and texture of its time.

This, of course, led to furious arguments: What is a great news photograph? Are we including this or that one because it is intrinsically fine or because it tells something of history? What, precisely, do we mean by "the instant it happened"?

We argued and pounded desks and, being civilized, tried to see the other fellow's point of view, usually over a drink he was buying, and we finally concluded that the whole business is subjective; greatness is in the eye of the beholder. If forced to a definition, we might say that a great news photograph is one which says something compelling and intrinsic about an event or a time or a man or a moment.

Thus, the instant a long drought ends with rain splashing on an old farmer's face becomes as irresistible as the instant a war begins. The instant a deaf boy hears his own voice for the first time must share in human experience with the instant a leader is assassinated, and the instant of magic when music lifts a little girl off her chair and sends her pirouetting against the sunlight must be included with the instant the world changed at Hiroshima. One can only look back and wish there were more of the one than the other.

And there are pictures in this book—ordinary pictures, technically—which reach back into a man's memory and bring back more than their own substance. Thus, we aid and abet them with words. The sight of a blindfolded man picking something out of a glass bowl would be meaningless to the young unless they knew this was the start of the chain of events by which the balding man, who now supplies their weekly allowance, once ended up in the uniform of his country. The picture of two men walking up

a flagstone path, their backs to the camera, would mean little unless you knew that one was the new President and the other was the old President and that at this instant, John Kennedy is seeking the advice of Dwight Eisenhower at a moment of national crisis. Thus, other pictures on other levels: a vintage football player running with the ball, pursued by other players, except that they are his own teammates and he is Roy Riegels running the wrong way; young men carrying guns, but they are black and they are college students and they are carrying guns at Cornell; men wading in the sea, not very good quality, but this is Dunkirk and a high moment in the war against Hitler; Rita Hayworth in a silky something, long since outdistanced in the art of cheesecake by girls who wear less, but oh what it did for Old Dad!

A word about the photographers. The reader will note from their own stories that they frequently got a spectacular picture out of "instinct." That does not tell it all. They had to be there in the first place and they had to react within one micro-second of thought and motion.

Thus, as the arm of the Vietnamese police chief goes up with the gun, the arms of Eddie Adams go up with his camera and there, like it or not, is the shocking summary execution of a Viet Cong suspect on film. Thus, the flag goes up on Iwo Jima and little myopic Joe Rosenthal, who almost drowned a few hours before, would have missed the whole dramatic lunge and symbol of costly victory if he hadn't first built a little pile of rocks to stand on and calculated just the right angle. Thus, "something told" Bob Jackson to stay where he was, in the basement of the Dallas jail, against the orders of his superiors, and he had his camera up when Jack Ruby shot Lee Harvey Oswald.

About half of the pictures in this book were taken by Associated Press photographers. Most of the rest were shot by men and women working for member newspapers of the AP, which is a cooperative. Some were taken by photographers working for other organizations and some were taken by raw amateurs who happened on the scene and did very well, even with year-old film in box cameras. We salute them all.

In some cases, their pictures have come down to us in poor quality, suffering the scars, the scratches and the spots of time. A few have come to us already retouched. We ourselves have retouched none of them, even the moving picture of three Queens of England melded together in grief. The original glass plate of that one happened to have been dropped within a few hours of the taking and what remains to history are copies of a handful of originals. The mushroom cloud that billowed up over Nagasaki was better photographed, with more delineation, but we chose to go with the first one, the one over Hiroshima, because that was the first and turned history. That one happened to have been taken by an Air Force sergeant who was handed a camera at the last moment and shot through the streaked plexiglass of his tailgun bubble.

Photographers have been helped immeasurably by technological advances. They are now a long, long way from Mathew Brady who had to paint laboriously the emulsion on his glass plates and lug heavy equipment in his "what-is-it" wagon. They are a generation removed from flash powder and the 30-pound Big Berthas men used to have to shoulder for long shots. They now have faster film, faster, longer lenses that bring them in closer with less burden. They are today much less the slaves of their equipment and more the masters of content.

But they are still, all of them, a special breed of individuals who are constantly imploring history to stop for just one more, at considerable risk to life, limb, pulse rate and psyche. They are not the gentlest of creatures for the simple reason that, even with technological advance, no one has yet figured out how to shoot a picture through the body of the idle spectator or the pompous mayor standing between them and history. They are not the most articulate of men because their poetry is in their eyes and their fingers.

They are brave and they are tough and they are not insensitive. Their pictures do not show the adrenalin flowing in them at the moment of taking. The pictures of the vengeful tortures in East Pakistan do not show the sweat and the shakes and the revulsion felt by the photographers, Horst Faas and Michel Laurent. The Pulitzer prize they won did not erase that feeling. The Pulitzer prize he won did not mitigate the heavy dismay Max Desfor felt on shooting a picture of refugees scrambling like ants over a broken bridge in Korea.

They are brave and they are tough but like Murray Becker after the explosion of the Hindenburg, Eddie Adams after the flag was handed to Jacqueline Kennedy at Arlington, Boris Yaro after Robert Kennedy was shot in Los Angeles, like many others with a job to do in an instant of tragedy or shock, they do it and they cry later.

— Saul Pett

Contents

THE BEGINNING

The Rebels were on the move. After a year and a half of defensive fighting Gen. Robert E. Lee has moved his forces northward in a grand plan to "shift the burden of occupation from Confederate to Federal soil," a plan that ultimately would take him as far north as Gettysburg.

And so in September of 1862 Lee and his generals are confident. On his way to join his commander after another smashing success at Harper's Ferry, Md., Lee's chief subordinate, Stonewall Jackson, pauses to let his men relax near a peaceful white church by a river called the Antietam. He does not expect a counterattack. It comes with withering fury from troops under "Fighting Joe" Hooker who rake Jackson's men with cannister shot.

———————————

As the smoke of battle lifts, temporarily, an ungainly wagon draped in black lumbers onto the blood-drenched field. At the reins is a slight man in a broadcloth suit and linen duster, attire as strange among the blue-clad troops as was the odd vehicle, which Hooker's men have laughingly dubbed the "What-is-it" wagon. The driver is Mathew B. Brady, known among the rich and titled of two continents, whose portraits line his New York galleries, as the foremost practitioner of the infant art of photography.

Quickly now, even as Jackson's men regroup to fight again, even before the Confederate dead are recovered, Brady and his assistants, James and Alexander Gardner, haul out a cumbersome contraption, a camera, along with several delicate glass plates. The plates have been coated, in the field, in total darkness, with a chemical mixture, then fixed, at precisely 60 degrees fahrenheit, "to just the right degree of stickiness" in a bath of nitrate of silver. Brady and his men expose the plates to the sunlit carnage. Before the plates fog over they rush them back to the wagon for developing—and back to an awed civilian populace for viewing.

The world gets a new insight into the horror and numbing fatigue of men in battle. Says Oliver Wendell Holmes: "Let him who wishes to know what war is look at these illustrations."

When the Civil War began, Brady was enjoying a life of elegance, sought out by princes and presidents. But he was more than just a successful maker of studio portraits. He was a photographer. In the truest sense. He felt the same inner tug that would pull at the photographers who followed him through history, and when war came Brady picked up his camera and went to war. "I felt I had to go," he explained. "A spirit in my feet said go, and I went . . ." Not content with going himself, Brady sponsored 22 other teams of photographers and dispatched them to other battlefronts. His commercial business dwindled in his absence and finally failed. He was never able to restore it. On December 16, 1896, Mathew B. Brady, the prince of photographers, died in an alms ward.

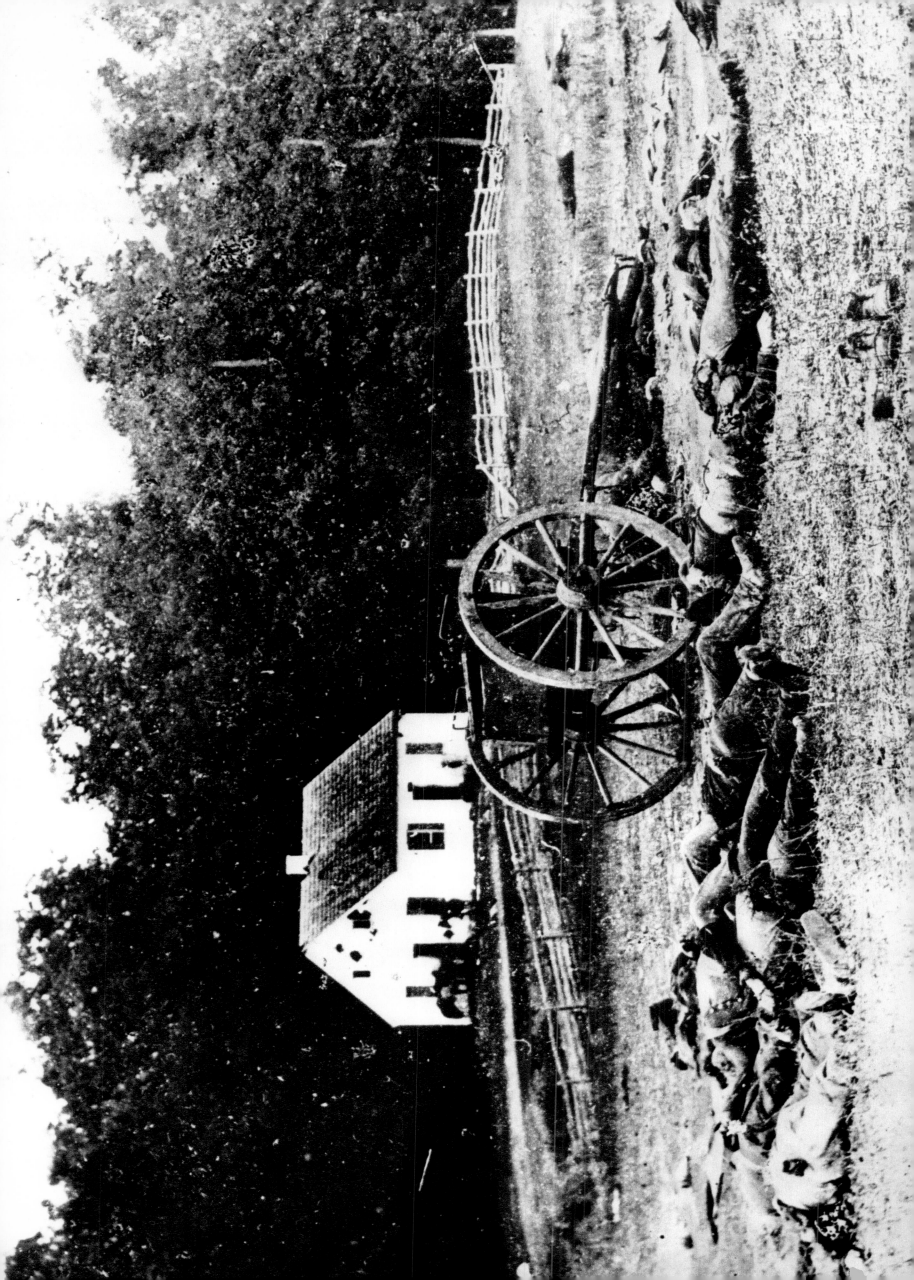

DONE

Who thought of it first is beyond knowing. It had been the dream of so many so long: a railroad stretching across the land from sea to sea; a continent at last united; a nation's destiny made truly manifest with a bond of steel. With the Civil War ended, the dream could become a promise.

Starting from Sacramento, Calif., the Central Pacific, with a labor force of 6,000 Chinese immigrants, pushed eastward through the white-crowned Sierras, the parched desert. Starting from Omaha, Neb., the Union Pacific, with its force of adventurous, brawling Irishmen, pushed westward across the boundless prairies, the torturous Rockies. After five years of great striving, of sweating and cursing and dying, the tracks met. . . .

Monday, May 10, 1869, is bright and chilly at a place in the high wilderness north of Great Salt Lake designated Promontory Point, Utah. A skim of ice covers puddles and a stiff wind tears at a small American flag atop a telegraph pole near a gap in the tracks where the last two rails will be placed. Nearby, 14 tent saloons advertise potables with names as lusty as their kick—Red Cloud, Blue Run, Red Jacket. Business is brisk. A few settlers straggle in on horseback. Three companies of U.S. Infantry, en route to San Francisco, show up with a band. All is ready.

Just before noon, shrill whistles, one from the east, one from the west, announce that the trains are approaching: on the western track, the Central Pacific's locomotive, the Jupiter, with its funnel stack; on the eastern track, the Union Pacific's locomotive No. 119. They stop. A polished laurel tie is put in place with holes pre-drilled to receive two spikes, one of California gold, the other of Nevada silver. The silver spike is fixed so that when it is tapped in place it will close a telegraph circuit and a single word will flash across wires from coast to coast: "Done."

A team of Irish railhands swings one rail across the waiting ties; a team of Chinese, in clean blue jackets, swings the other. They slam iron spikes in place to hold the rails to the ties—all except one, the laurel tie. From the western train, Central Pacific director Leland Stanford strides forward with a silver-plated sledge hammer; from the eastern train steps Union Pacific vice president Thomas C. Durant. Both make brief speeches. A minister offers a prayer. Stanford and Durant stand over the laurel tie, smile, take up their sledges and drive home the silver and the gold spikes. Done.

After the spike driving ceremony, a photographer, Andrew J. Russell, asked the two engineers of the railroads to step out front and shake hands. Samuel S. Montague of the Central Pacific and Grenville M. Dodge of the Union Pacific posed, hands clasped, and a moment in history was frozen on Russell's fragile glass negative. After the photo, champagne flowed, along with the Red Jacket and Blue Run, and, inevitably, souvenir hunters carved up no fewer than six railroad ties for keepsake slivers. The laurel tie, along with the ceremonial spikes, had been safely removed.

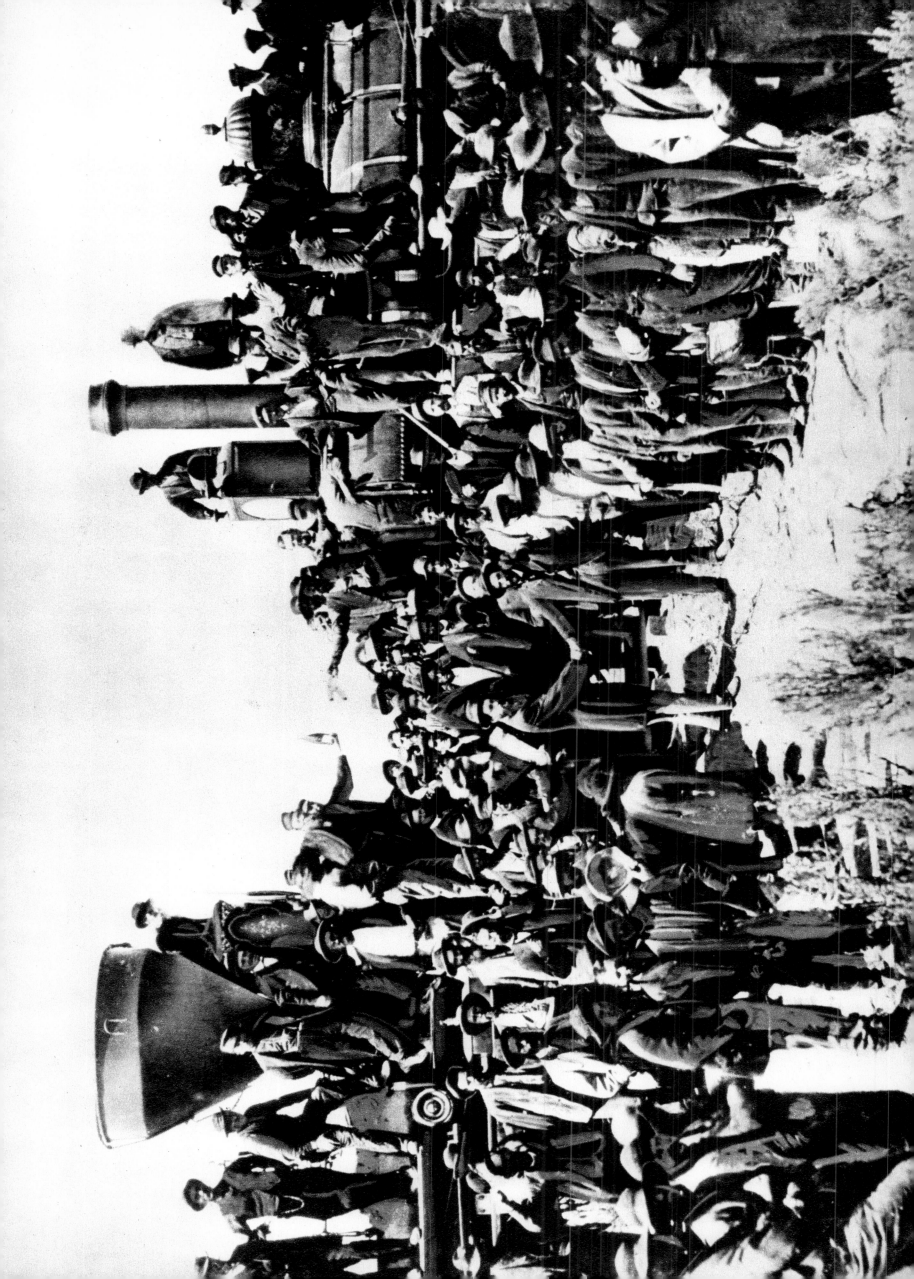

"A LITTLE BIT TECHED"

Icarus tried, but his wings fell off. Da Vinci tried, but his machines wouldn't stay in the air.

In 1871, Alphonse Penaud, a Frenchman, tried, on a tiny scale. He made toy helicopters out of paper, cork, bamboo and rubber bands. And they flew. And some were brought to the United States.

An Iowa churchman bought one for his sons, Orville and Wilbur Wright, aged 7 and 11. In the house, outside in the yard, the boys flew the helicopter and tested it and tried to discover what made it soar, until they had it in pieces. They built helicopters of their own and found the bigger they made them the less they flew.

Through the years, they turned to other things. They made and sold kites. They built a wood lathe and remodeled their parents' house; fashioned a printing press and published a newspaper; bought bicycles and sold them, repaired them and finally made them. Bicycles became their business.

Yet they never forgot the helicopter. The Wrights moved to Ohio in 1884, and Wilbur and Orville read everything they could find in the Dayton library about men who tried to fly, from Da Vinci to a German named Lilienthal who was experimenting with gliders. While the rest of the country watched Teddy Roosevelt bust trusts and start the Panama Canal, the Wright brothers watched birds. They noticed how they twisted their wingtips slightly to keep their balance when they soared. Would it work with gliders?

In 1900, the two brothers went to the beach at Kitty Hawk, N.C., because of its prevailing wind. Over three summers, they flew gliders, with wingspans of 16 feet, 22 feet and 32 feet, by hauling them to a huge sand dune called Kill Devil Hill and pushing them over the side. They controlled the gliders by moving vertical and horizontal vanes on their noses and tails—and by twisting their wingtips with wires.

If they could power a glider, would it climb and fly by itself? . . .

Thursday, December 17, 1903. The Wright brothers haul their largest glider, more than 40 feet from wingtip to wingtip, out of its shed on the sand at Kitty Hawk. They rest its wingtips on two small benches. They place its skids on a small platform running on two wheels, one ahead of the other, along a single wooden rail. Fastened to the bottom wing of the glider is a four-cylinder gasoline engine the Wright brothers built at their bicycle shop in Dayton. It drives two propellers.

Wilbur and Orville warm themselves at a driftwood fire and measure the wind: 27 miles per hour. Orville starts the engine.

Having used his turn in an unsuccessful attempt three days before, Wilbur stays on the ground, standing near the right wing. Orville climbs aboard and settles his 145 pounds, stomach down, on the bottom wing beside the engine. He releases a wire. The "flyer," as the Wright brothers call it, begins to move. Wilbur runs alongside, balancing it as it rolls forward on its trolley and its wingtips slide off their benches. As it reaches the end of the rail, it starts to climb . . . two feet up . . . four . . . eight . . . ten feet . . . until Orville lands it back on the sand. Total distance flown: 100 feet. Total elapsed time: 12 seconds.

John T. Daniels, a lifeguard at the Kill Devil Hill Life Saving Station a quarter mile away, had seen a signal the Wrights raised to beckon anyone within five miles to come and watch. Daniels, two other lifeguards, a man from the nearby town of Manteo and a young boy from Nag's Head joined the two brothers at their camp. As the Wrights directed, Daniels put his head under a black cloth behind a camera they had placed on a tripod and aimed toward the end of the wooden rail. Like many, John Daniels had a private hunch the Wrights were "a little bit teched." Now, as man flew for the first time in a machine that lifted itself by its own power and sailed forward without any reduction of speed, Daniels squeezed a bulb that tripped the shutter. Later, he told his children he had been "astonished" at what he had photographed.

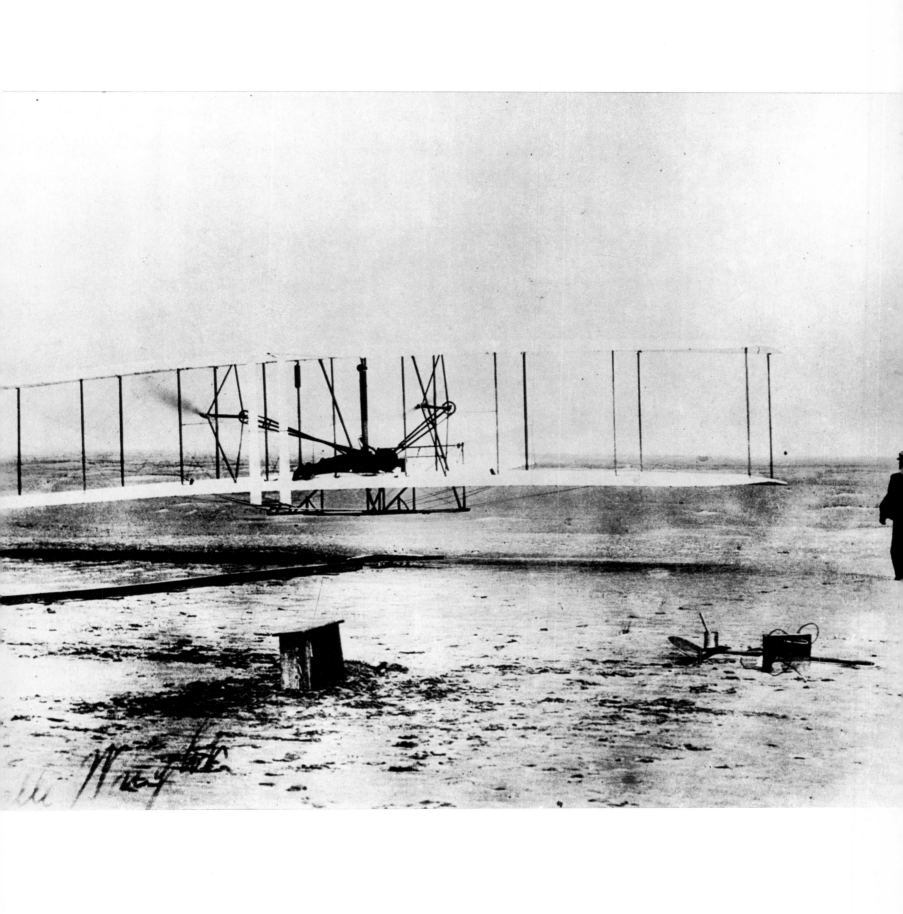

EARTHQUAKE

Patrolman Leonard Ingham had had the dream again Monday night: a recurring nightmare in which he saw the heart of his native San Francisco engulfed in fire.

That did it: he bought a $2,000 insurance policy on his house the very next day. He slept soundly that night only to be awakened about 5 a.m. the next morning —April 18, 1906—by a milk wagon horse prancing nervously.

Across town at the Palace Hotel, touring Metropolitan Opera star Enrico Caruso was sleeping off a night on the town during which he had been entertained at Zinkand's Restaurant by a young pianist named Elsa Maxwell. Nearby at the St. Francis Hotel, actor John Barrymore was also entertaining in his room—a young lady, assisted with several bottles of champagne.

What the horse seemed to sense—dogs, too, often howl in premonition— several people actually witnessed. "I could see it coming up Washington Street," said police sergeant Jesse Cook. "It was as if the waves of the ocean were coming towards us."

Atop Russian Hill, highest point in the city, artist Bailey Millard awaited dawn to begin work on a landscape of San Francisco at sunrise which he had already entitled "When Altruria Awoke." Instead, at about 5:12 a.m., he is flung to the ground and sees the whole city beneath him "rocking and rolling. Each crack would be the signal for more chimneys, more spires, more cornices to be snapped off."

The city was writhing under a force greater than all the explosives used in World War II, a force that overwhelms with instant terror when the very foundation of humankind, the earth, betrays and goes mad with a noise "like thousands of violins, all at a discord."

Church bells clanging wildly. Buildings shaken like a dog's prey before crashing into their own dust. Doomed homes creaking in their agony as though all their nails were being pulled out at once. And then, after earthquake, fire.

For three days San Francisco burned, its water system dropless from main breaks. The Nob Hill mansions of the mighty, the sleazy saloons and whore-houses of the Barbary Coast, Chinatown—all went in the inferno that burned almost five square miles and was only stopped by a dynamited fire break.

Then it began to rain and patrolman Ingham returned home to find his house still standing and his new insurance policy safe in the kitchen.

But as many as 700 had died, 250,000 were homeless and the fatal flaw that underlies the city—the San Andreas fault—remains, leaving the question: not if history would repeat, but when?

By Arnold Genthe, artist and photographer.

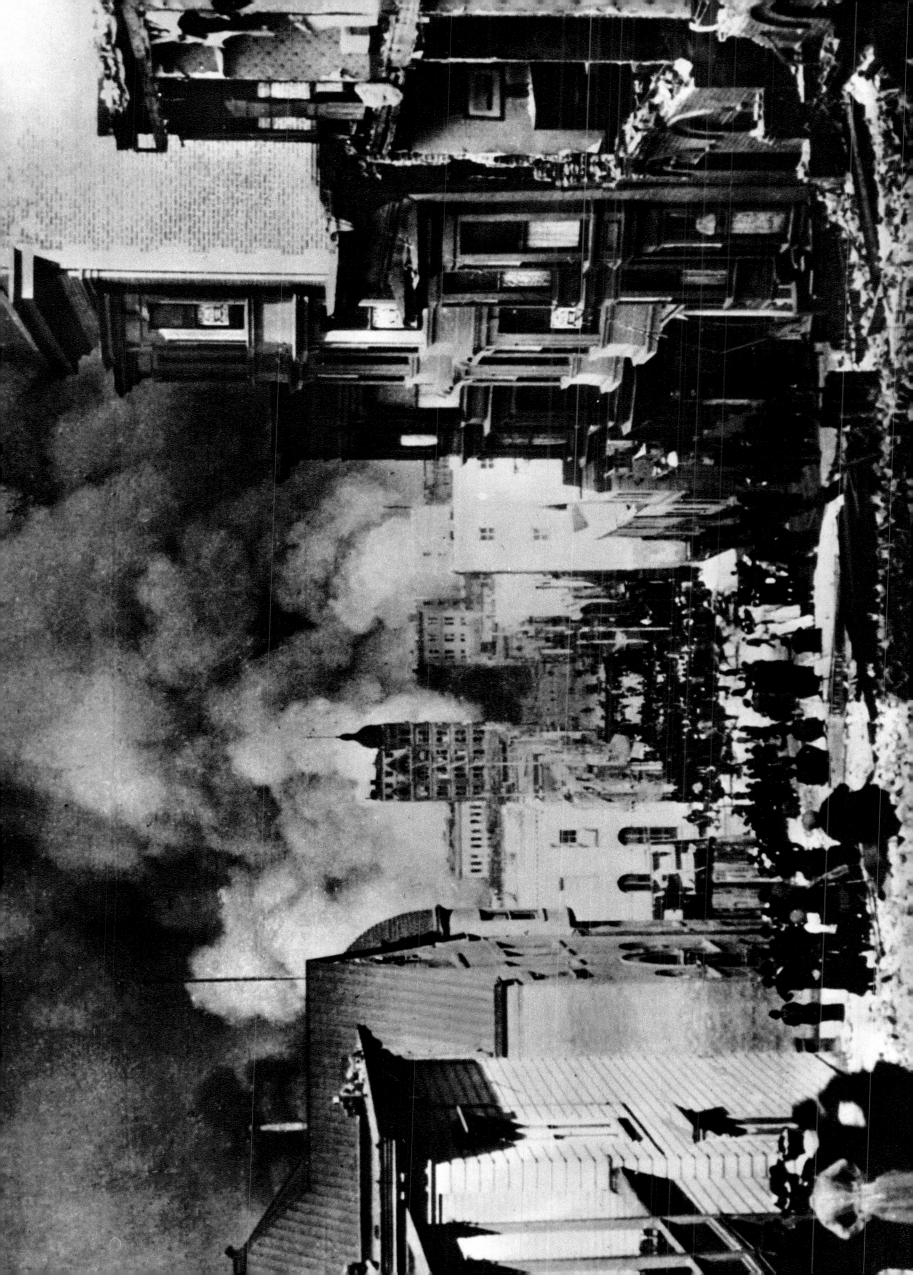

A FIREMAN'S LIFE

Whether the horses got to the fire in time; what started it or even if it was only a false alarm are details left far back in time.

There is but one message, for anyone, anywhere, any time: Fire!

This picture happened to have been made in New Haven, Conn., in 1910. But no more urgency, no more drama could have been caught in a photo of the latest diesel-powered aerial rig furiously wheeling a corner in Los Angeles. Or, if our forefathers had had cameras, in a shot of a leather-bellowed handpumper squirting its meager stream back in colonial days.

Other photos of 1910 would appear dated. Of Glenn H. Curtiss, say, when he set a record by flying nonstop from Albany to New York in one of those dragon-fly-like aircraft. Of Dan Beard in shorts and puttees and campaign hat, having just founded the Boy Scouts of America. We look at them for history, or out of curiosity, like rummaging through ancient hand-me-downs in an attic trunk.

But this picture says all that need be said about a fireman's life. Ever.

———————————

When he made this picture, Delmar Barney Roos was an engineer student at Cornell working summers for a photo service in New York. He had been assigned to photograph the Yale commencement, particularly to get one of Robert A. Taft, son of President William Howard Taft, who was graduating that June. The younger Taft demurred and Roos used 23 of his 24 plates on other things.

Dejectedly walking to a trolley to catch a train home, he heard the fire engine, steam pouring from the boiler, horses charging. He stepped from the curb and exposed his final plate with his Press Graflex. When he developed his 24th plate later, Roos noticed, in the far left corner, in cap and gown and carrying his diploma, sure enough, the President's son, who had happened on the scene.

Roos left photography that summer and eventually became chief engineer for the Studebaker Corporation as well as designer of the World War II jeep. But when asked what in all of his achievements he was proudest of, he thought a moment and replied, "I once made a famous news picture."

20

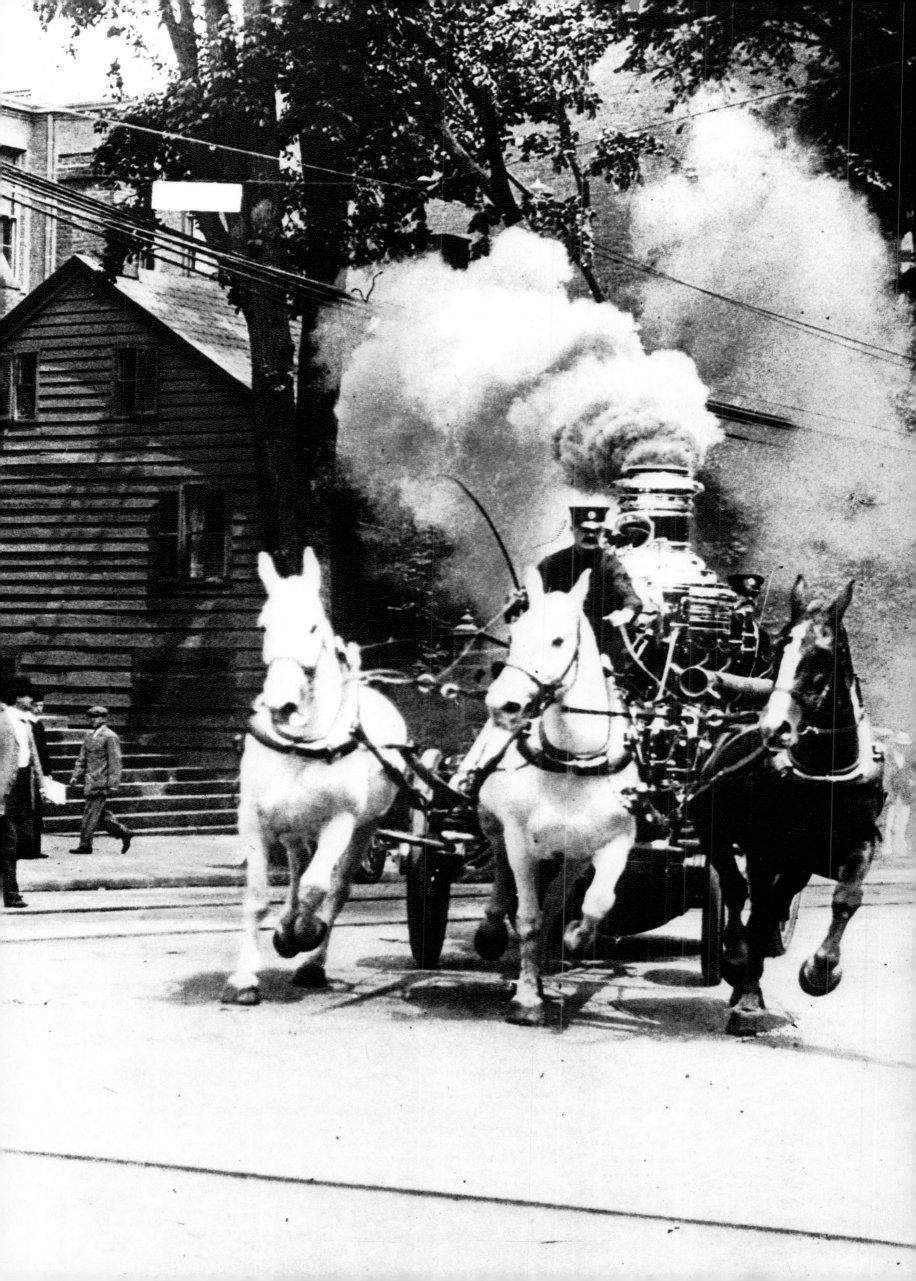

AT THAT MOMENT...

Bill Warneke was late, but that's what you get for being a nice guy.

Warneke had been assigned to cover the departure of New York's Mayor William J. Gaynor from Hoboken to Europe, August 9, 1910. Pretty routine stuff for Joseph Pulitzer's New York World which liked to stress the improbable.

Just as Warneke was leaving, a colleague came in with a problem. The city was replacing its fire horses with motor-driven fire engines and the World city desk wanted a shot of a horse having a last laugh. But how do you get a horse to laugh?

Warneke said he would try something on his way to Hoboken. He stopped off at a fire house and tried all the sure fire things that make horses laugh. None worked. Then an idea: he fed the animal some caramel candy. Trying to get the goo off his teeth, the horse wriggled his lips and Warneke clicked. After all, no one had to HEAR the laugh . . .

So, by the time Warneke boards the SS Kaiser Wilhelm der Grosse, all the other photographers have come and gone. The Mayor is talking to several newsmen so Warneke takes a picture, then changes holders for just one more, your Honor.

At that moment, a man named J. J. Gallagher walks up, pulls a pistol out and jerks the trigger six inches from Gaynor's head. The gun misfires. The man fires twice more, hitting the Mayor both times. He staggers as aides rush up. The would-be assassin is overpowered by 300-pound "Big Bill" Edwards, the Street Cleaning Commissioner. Gaynor, who will survive, is carried off on a stretcher and Warneke has a classic of photo journalism, proving again that it can be better late than never. And who ever heard of a laughing horse, anyway?

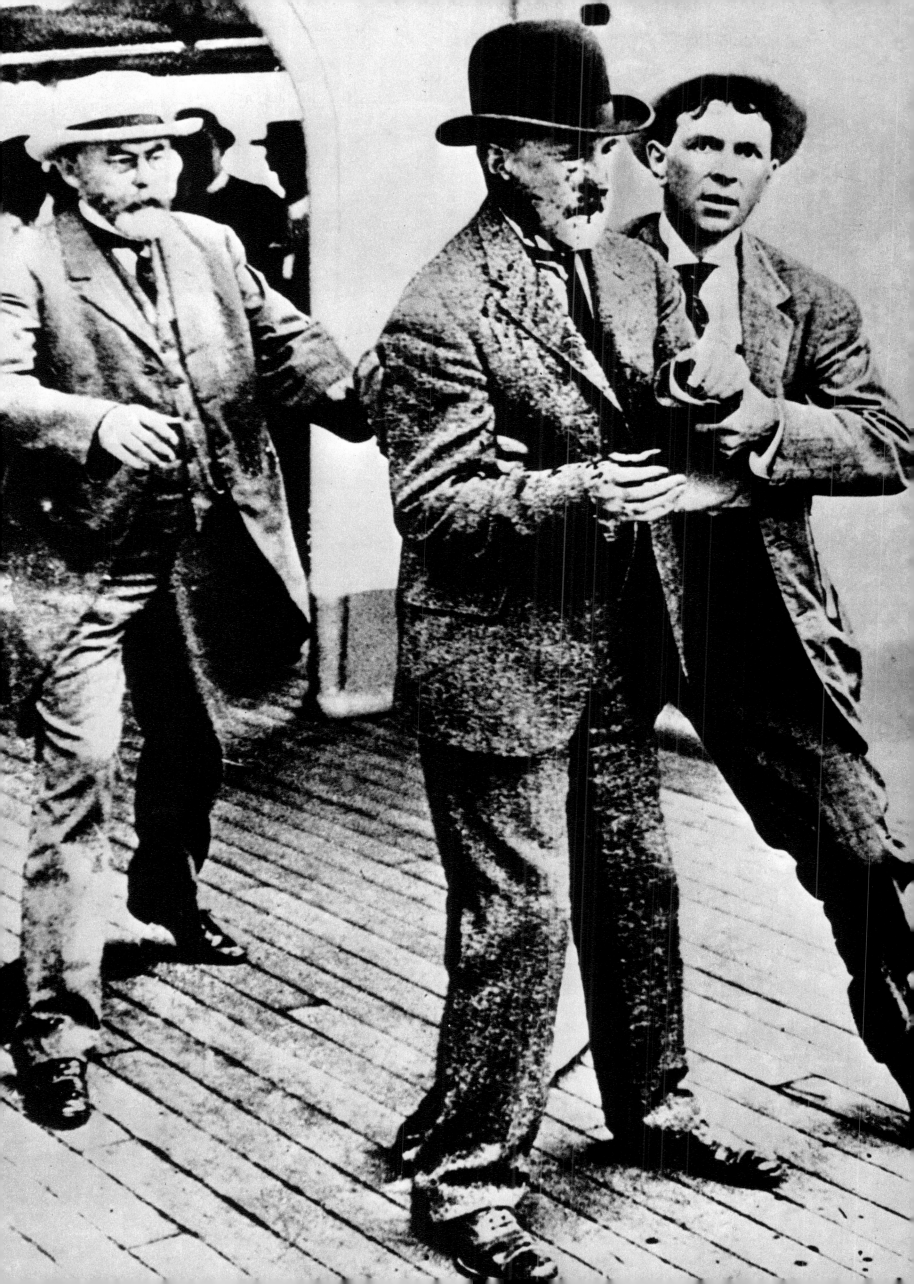

THE OLD DAYS

In the good old summer time. . . .

There was such an era, when summer was a rocker and lemonade on the front porch, the soundless winking of fireflies in the backyard, homemade ice cream for a picnic down at the park and maybe a swim later.

Summer pleasures were softer, slower. No rush to the golf course and then the cocktail party and then the dinner. Camping was a nearby wood, not a race on an Interstate or a fight for a place to plug in a trailer.

Summer travel then might have been a week at a Chautauqua or that old American favorite, a day away from it all on an excursion steamer. Summer, when time seems to go on, unchanging, forever.

Or so it might have seemed in America, in 1915. A nation grown to robust young manhood could relax with its pleasures and small town contentment while an ocean away nations bled themselves white.

The Germans had begun using poison gas at Ypres in France? What did that mean to 7,000 people gathered for a steamer excursion in Chicago? Tens of thousands were dying on an isthmus named Gallipoli somewhere in Turkey? What matter? These people were off to Michigan City, Indiana, U.S.A.

The Western Electric Company's "Hawthorne Club" has chartered five steamers for the trip for its employes and their friends. A crowd of 2,500 shoves its way aboard the first one, the Eastland, because she is the fastest.

They line the rail waving to the shore as the Eastland moves from the pier in the Chicago River at 7:40 a.m. The Eastland is listing with the weight of her human cargo. And listing. And listing. An icebox begins to slide down the deck. . . .

Below decks, in the salons and private cabins, people careen into each other and furniture, stacking themselves in sudden heaps of doomed humanity against walls that have become floors. Fear becomes panic. The Eastland rolls on her side like a vast hippopotamus and settles in the muck.

In Gallipoli, Lt. Gen. Frederick Stopford had spent the day scouting a new landing area for the Allied armies. And in America, more than 800 pleasure seekers had died only a few feet from shore in the Chicago River.
And so the summer day of July 24, 1915.

———————

Fred Eckhardt, a Chicago Daily News photographer, saw the earlybirds boarding the Eastland as he took the El to work. Within an hour, he was back at the scene. "From high up, I made my over-all picture (with a 4x5 Auto Graflex). Completing this, I went down to the river edge and photographed survivors." He took the El home again that night. "I could see lights and people working on the Eastland where she lay in the river."

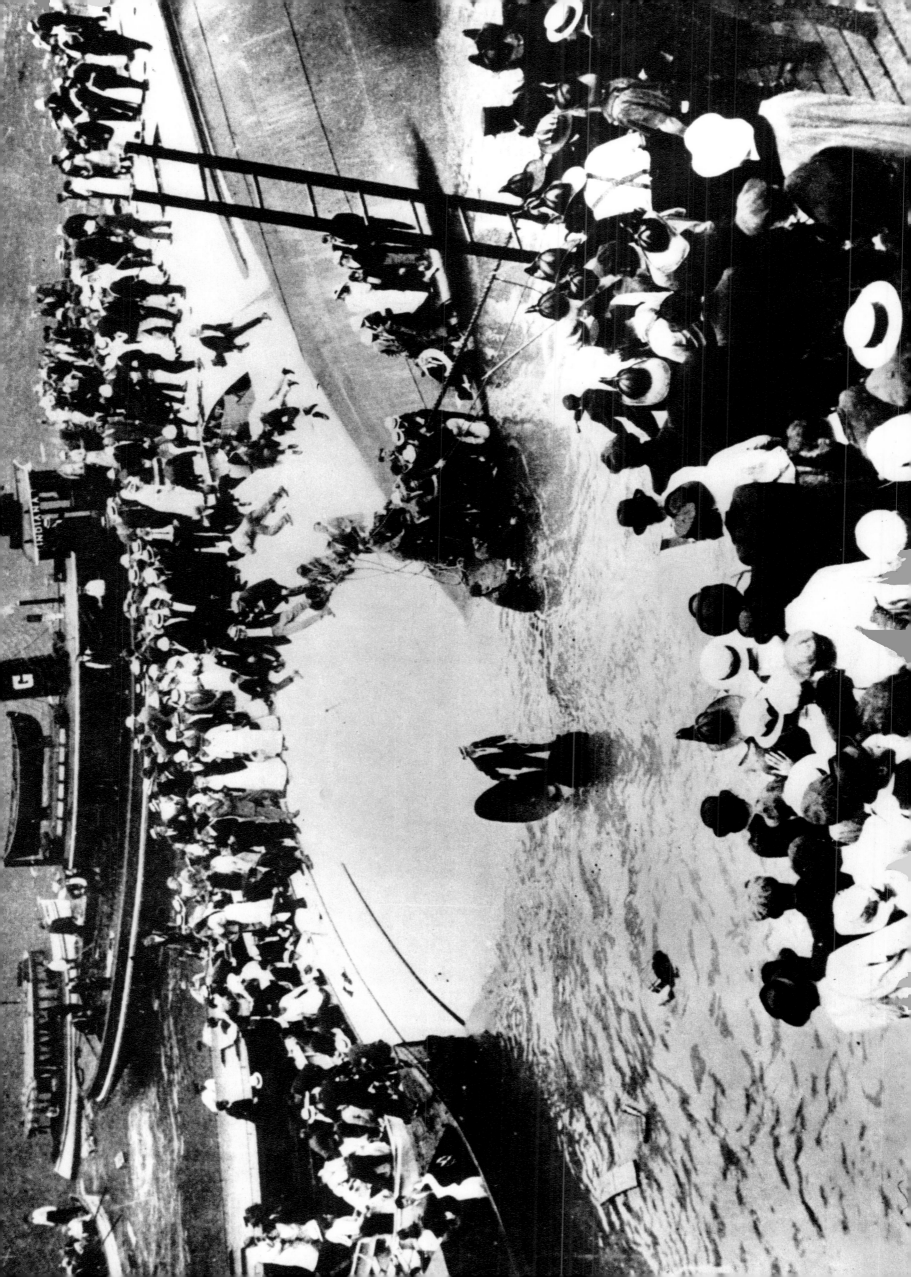

OVER THERE

The Argonne Forest had been twice tortured, by nature and by man.

Created a gullied thicket of dense trees and rocks, it was further ravaged and bloodied by the great World War I battle of Verdun in 1916, when Germany spent 300,000 lives for only 130 square miles of French territory.

It was but one instance of the insanity of trench warfare that pitted charging men in wave after wave against the machine gun. On an average day, both sides suffered 7,000 casualties. In a major battle such as the Somme in 1916, the British lost 60,000 men on the very first day—and the fighting in the bootsucking mud of Flanders raged for months longer.

By 1918, in the fourth year of war, Russia had already dropped out, her armies bled white, her government overthrown by Lenin and his Bolsheviks. After Verdun, a mutiny had swept the French army, involving 100,000 men in 52 divisions. But the Central Powers, Germany and Austria-Hungary, were also feeling the strain. The British blockade brought deep hunger and unrest to the German home front. By September, 1918, Austria was demanding that Germany sue for peace.

A major reason was that the Doughboys were coming. The Yanks, taking their nickname from the adobe dust that caked them during the chase after Pancho Villa on the Mexican border two years before, had landed almost 40 divisions since their commander, Gen. John J. Pershing, stepped ashore in France on June 28, 1917.

His men were strong, fresh, bred to the belief their country could do anything. They had not known the scars of the Somme with its 1,300,000 casualties, nor choked on the rolling clouds of mustard gas, nor seen comrades buried alive under the mud of a shell blast at Ypres.

They strode into battle in July, 1918, to the tune of George M. Cohan's "Over There," to help stop the Germans' last great offensive at Belleau Wood and Chateau Thierry, the Second Battle of the Marne. . . .

Now, on September 26, 1918, they go over the top again, across the moonscape of Verdun and the Argonne—"a blind world of whiteness and noise," one officer called it. The aim is to drive north, to meet eventually with the British driving east from Flanders and trap the German armies in a giant pouch.

It is a time of heroic tableaus: Col. George S. Patton, his primitive tanks shot from under him, leading his men against German machine guns and firing his two ivory-handled pistols as he runs; Alvin York, a corporal then and a dead-eyed Tennesseean, nipping off Germans like squirrels until they surrender en masse. How many had he taken? his commander asks, as the mob passes by.

"Jesus, Lieutenant, I ain't had time to count 'em all yet."

There were, in fact, 132.

There, leading the men of his 42nd Rainbow Division, is Douglas MacArthur in a cloth overseas hat. He didn't like helmets. There is Capt. Harry S Truman, an artillery officer with the 35th Division, and Capt. Eddie Rickenbacker, who became America's leading air ace in an age of trailing silk scarves and cognac glasses smashed in the fireplace. And there is Capt. Nelson Holderman, with five wounds, using two rifles as crutches while firing his .45 at the Germans, Capt. Holderman of the "Lost Battalion" which held out, though surrounded, for six days.

And there are the unnamed, such as this 37-mm gun crew manning their weapon in the never-never-again land of the Argonne Forest.

The Yanks make three miles the first day, then gradually bog down in a tangle of supply lines. At their end of the line, the British also slow down after initial success. But between them, they have written the inevitable on the wall.

On October 4, Kaiser Wilhelm of Germany orders his government to wire President Wilson for peace terms. Five weeks later, the War to End Wars ends. Total cost: 8,500,000 dead, including 53,000 Americans.

————————————

Photographer unknown.

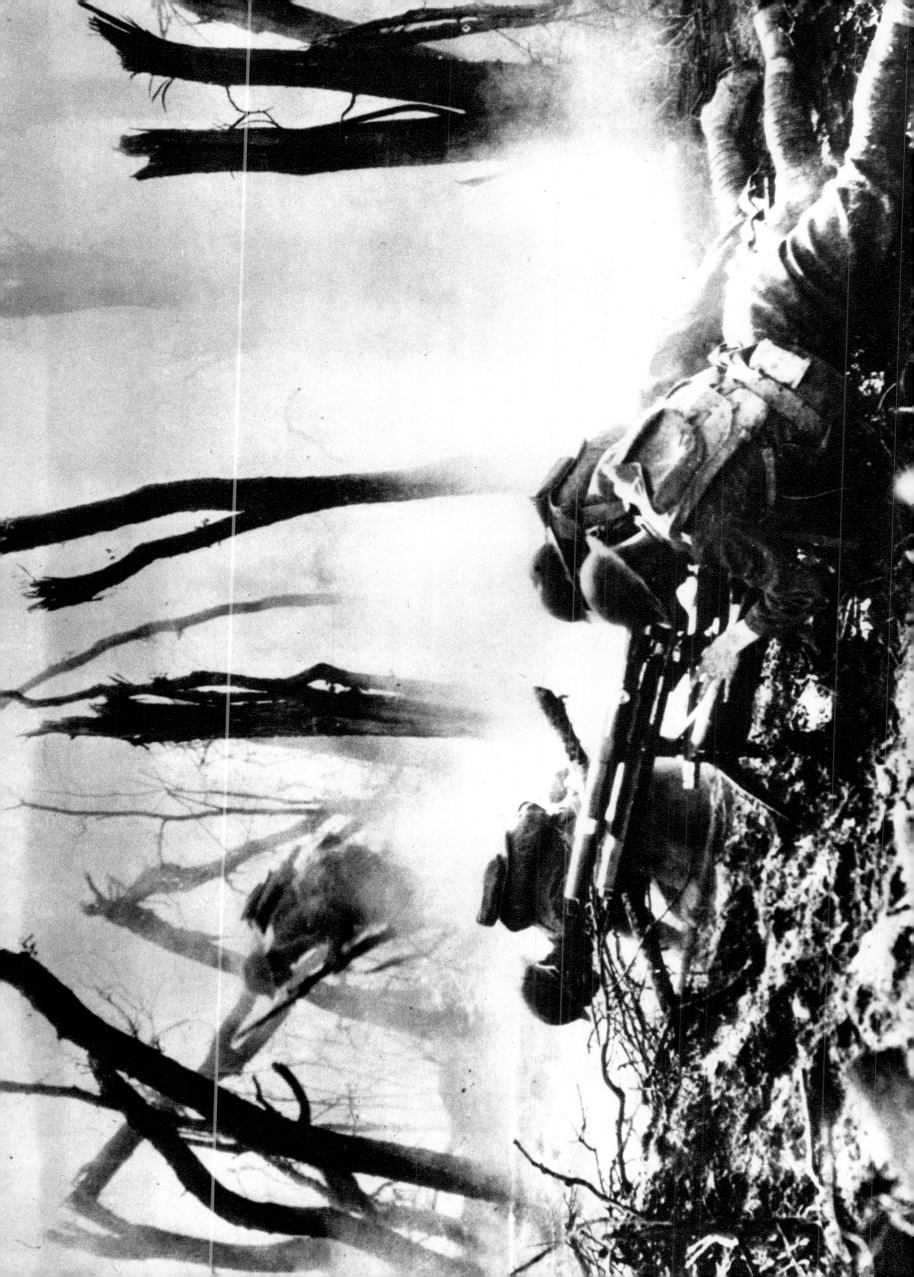

"THE REDS?"

In the gilded vale of Wall Street, it is a lovely day, one that suggests the kings are all safely in their castles and all's well with the world.

To be sure, the king of kings, J. P. Morgan, is on holiday in England, but son Junius is at work at the House of Morgan, 23 Wall, and other barons are securely within their bastions, their names etched boldly and forever on the granite lintels of their massive counting houses.

The drones, the decimals of Big Money—secretaries, young runners, cloth-capped clerks—are flowing out onto the street for lunch. It is clear, a little cool—69 degrees—for September 16, but the Trinity Church bell at the head of Wall bongs noon reassuringly and the New York Stock Exchange confirms the sense of well being. Stocks are up slightly.

It is 1920, a time of recent peace, time to get back to the business of American business. Even the womenfolk should be settling down now that they had got the vote three weeks before. True, the nation has experienced a rash of bombings, invariably blamed on those vaguely identified as "the Reds," who have even badly damaged the home of U.S. Attorney General A. Mitchell Palmer. But this does not seem to worry the crowds today. Nor the armed guards who are moving $900 million in bullion from the Sub-Treasury Building to the Assay Office just across from Morgan's. Business as usual.

Few notice an ancient wagon, drawn by an old bay horse, stopped at the curb of 23 Wall. Suddenly it disappears in an explosion of greenish smoke that flings chunks of cut up window sashes into the crowd. Windows half a mile away are shattered. Awnings 12 stories above the street catch fire. An employe of Morgan's is one of 30 killed outright. Junius himself is cut in the instant shambles of the building. He is one of 300 injured, 10 of whom will die.

But most victims are the pawns, not the princes. Such as a mortally wounded young runner pleading for someone to deliver his bundle of securities so he could die with his duty done. Investigations begin almost immediately, adding fervor to the nation's first "Red Scare." But whoever did it, anarchist or what, has not been identified to this day.

And the House of Morgan still stands, shrapnel pocked, bearing its scars proudly or defiantly.

George Schmidt, a photographer with the new picture tabloid, the New York Daily News, was in the paper's office at Park Place not far from the explosion. Grabbing his 4x6 Ica Trix camera, he ran to the scene to take this memorable shot of the day they bombed Wall Street.

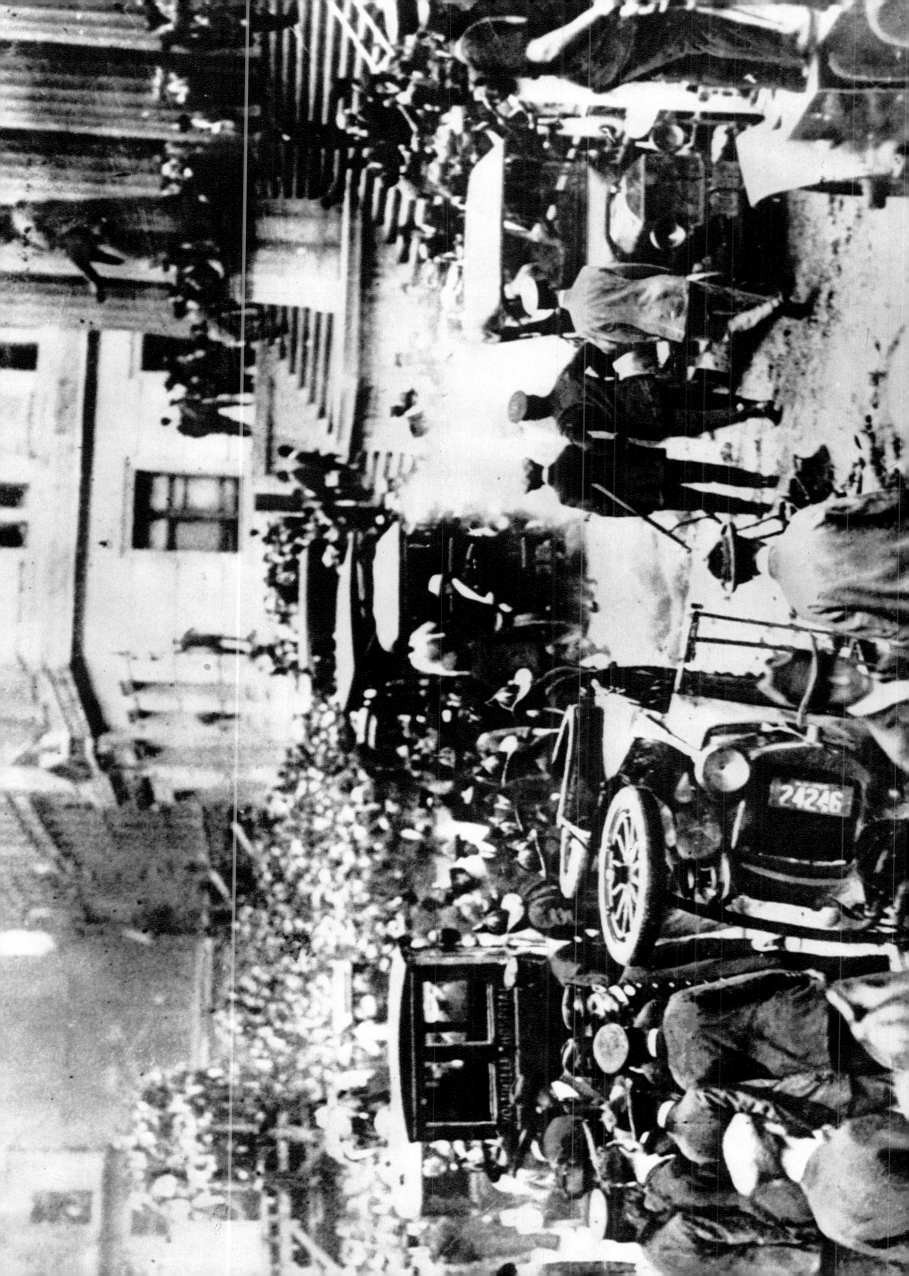

SCOOP

If reporters could describe the execution in words, why couldn't photographers do it with their cameras, the editor reasoned.

Because they couldn't, officials had declared.

Well, this was the heyday of Front Page journalism when reporters really did wear press cards in their hatbands in a constant battle to outwit the unwilling—and the competition. And here was one of the big stories of that Headline Decade, the Twenties: the execution at Sing Sing of Ruth Snyder and her lover, Judd Gray, a corset salesman. They had been convicted the year before, in 1927, for the murder of her husband, Albert. It was a sensational crime, involving poisoned whiskey, binding the victim with picture wire and the wife and lover taking turns bashing his head with a sashweight. The tabloid press had had a field day.

So Harvey Deuell, city editor of the New York Daily News, schemes a scheme to get the drop on his arch rivals, Hearst's Daily Mirror and Bernarr Macfadden's Evening Graphic.

Deuell, Ted Dalton, picture assignment editor, and George Schmidt, his assistant, decide to sneak into the death house a miniature camera strapped to the photographer's ankle. That would probably escape any frisking.

Then they have to predetermine the lens focus which requires in turn knowing distances in the execution room. By reportorial legerdemain, a staffer obtains a blueprint of the room.

They bring in photographer Thomas Howard from a sister paper, the Chicago Tribune, figuring he would be unknown to the competition and prison authorities. He will go to Sing Sing as a reporter. For a month Howard practices making test shots. He will have only one chance, the exposure being made on a single glass plate. He was to aim the camera by pointing his shoe and shoot it with a cable release running up his leg into his pocket.

The night of the execution, January 12, 1928, Howard takes his place in the execution chamber. Ruth Snyder walks in calmly and is strapped to the chair and masked. Howard lifts his pants cuff, shoots at the first jolt and again at the second and later races to New York.

And the Daily News, in an era when papers were not above faking photographs to outdo one another, got a picture scoop of the real thing, a shocker then and now.

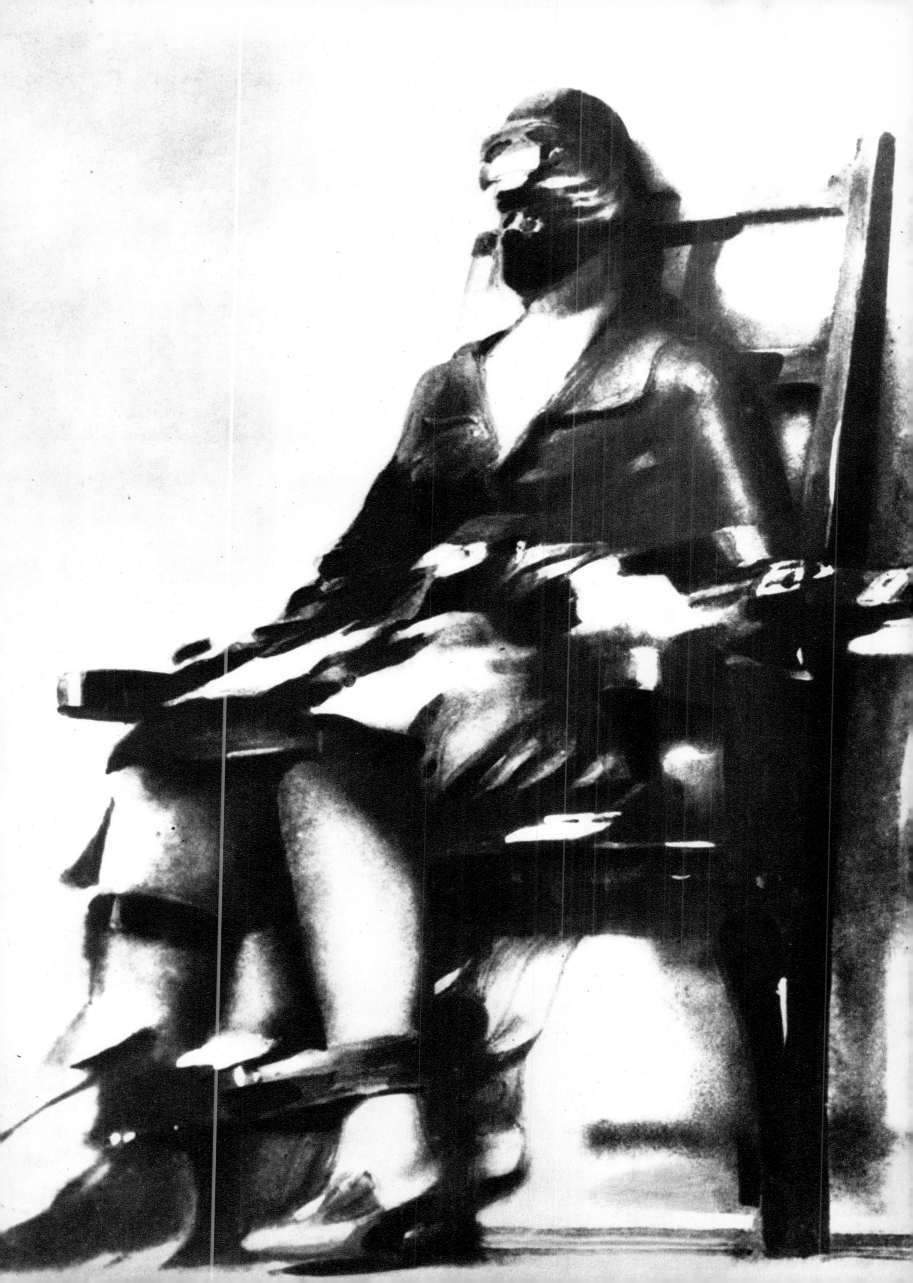

THE SINKING OF THE VESTRIS

The ads had been intriguing: "For the traveler who wishes a change from the conventional . . ." Challenge enough for the Jazz Age fun seeker of 1928.

And so 129 passengers are on the dock at Hoboken, N. J., waiting to board the Lamport & Holt Line's SS Vestris for a Christmas trip to Argentina. A few notice a slight port list, a not unlikely tilt considering the old steamer, built in 1912, is heading south with 6,000 tons of cargo and 3,000 tons of coal and actually is overloaded by 200 tons.

The Vestris puts to sea after a jolly seasonal send-off into a stiff northeaster. Second Steward Alfred Duncan awakes the next morning and can't remember experiencing such a list. Only five passengers make it to breakfast. By now, the old steamer has a permanent five-degree heel.

During dinner that night, the Vestris lurches violently, sending a waiter head first across the room. A passenger wonders: "Is she ever going to stop?" She does.

But the next morning the Vestris has a 32-degree list. Water is up to the portholes. Bedclothes slide to the floor. And deep in the ship, water is rising. The pumps go on but are quickly clogged by soggy coal dust. Capt. William J. Carey orders an SOS sent.

"Oh please come at once. We need immediate attention," comes the message from the roiling seas off the Virginia Capes. Four minutes later, another message: "Rush help we are sinking slowly." Finally: "We are taking to the lifeboats." Then silence.

Crewmen and passengers inch down the slanting deck, their secure shipboard world now reduced to a handhold on a rail, a funnel, a rope. Clinging from his bridge, Capt. Carey cries over the storm to his crew: "Goodbye, boys."

True to tradition, he stays with his ship as she sinks from sight, "silently with just a little puff of steam."

One hundred and ten people die with the Vestris. No child is saved. Only 10 women are. One who is lost is a young bride. A passenger in a lifeboat sees her floating by, "her beautiful golden hair streaming in the water ahead of her."

Later—too late—a report on the disaster finds that the Vestris was a "tender" ship, one inherently unstable beyond a critical point. It concludes: "We must hereafter stress MEN more than THINGS."

———————————

Just before the Vestris sails from Hoboken, crewman Fred Hansen shops around for a camera. He buys an $8.50 Kodak, the kind that folds up like an accordion, and six rolls of film. After the Vestris' cargo shifted, sending the load of farm machinery and cars crashing through wooden bulkheads, Hansen gropes his way on deck. "Everyone was screaming and yelling. I stayed until all boats had been launched except Number One." Then he, too, leaves, taking with him one of the memorable pictures of the terror of the sea.

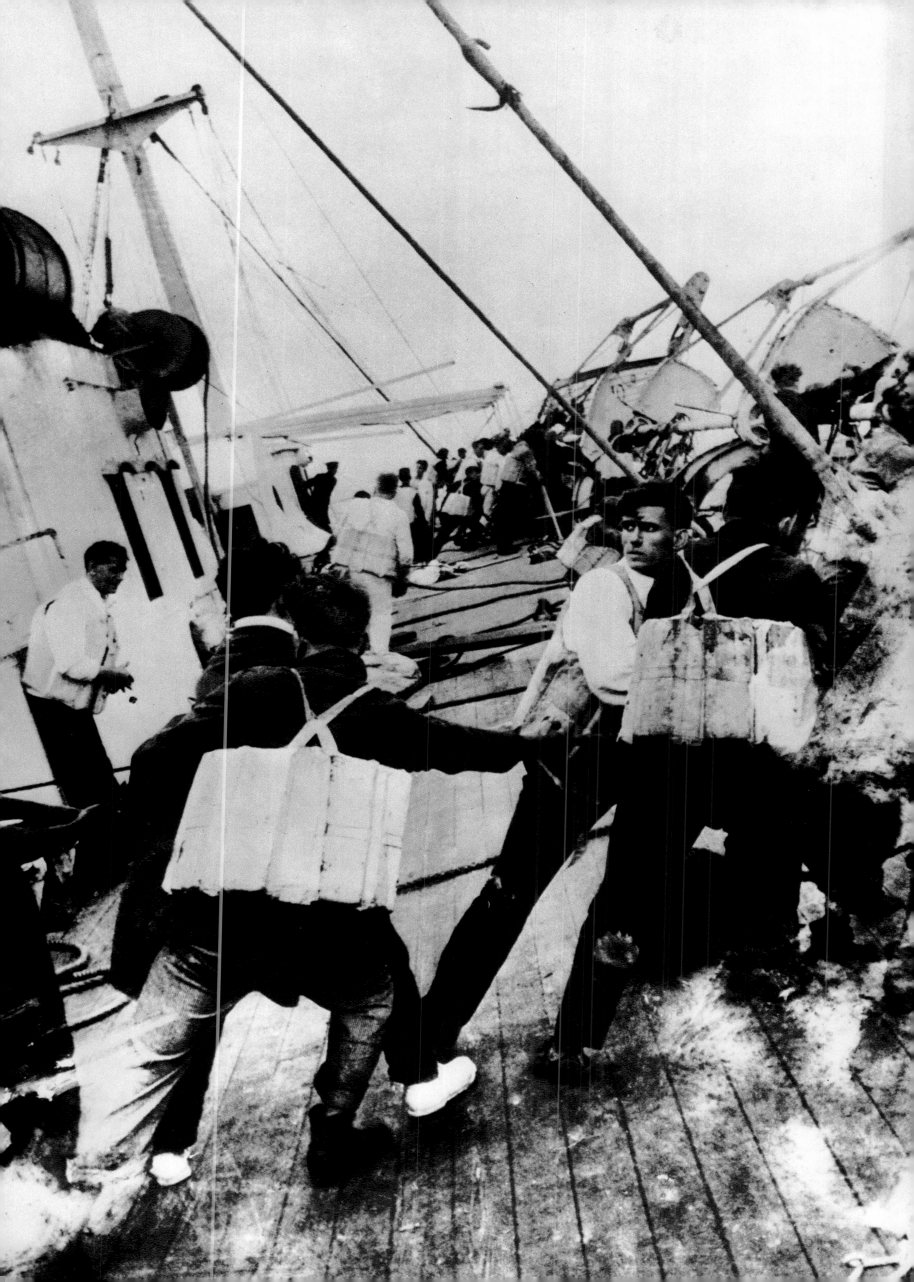

FIFTY . . . FORTY . . . THIRTY . . . TWENTY . . . OHMYGOD!

Like the guy who asks, when the temperature is 108, if its hotenufforya, like the poor and the dead and the taxes, sports cliche photos are always with us.

Who hasn't flipped the local daily to the jock section just in time to see a snap of a sprinter, arms aloft and teeth bared, at the moment his heaving pectorals popped the tape?

Or that guy you never heard of forming a circle with thumb and forefinger to signify to Mom, the photographer and everyone else that he just threw a no-hitter. . . .

So here we have another. Some hero from yesteryear (note the cocker spaniel ear flaps of the helmet) heel and toeing it for Old Siwash toward the goal line with the enemy in grimacing pursuit.

Such seems the case. The ball carrier is one Roy Riegels, center of the Golden Bears of California, who has picked up a fumble and is running to glory in the 1929 Rose Bowl against Georgia Tech.

But hold it. Those aren't Rambling Wrecks trying to catch him. They're fellow Bruins.

For this, folks, is a photo of one of those rare moments when The System breaks down, when everything has left-hand threads, when The Course of Human Events turns about face and drowns you. Like when three Dodger runners found themselves on third base, like when Cornwallis woke up and found he had to surrender to Washington, like when Dewey woke up and found he had to phone Truman.

Yes, this is a confused but eager Roy Riegels sprinting 63 yards the wrong way until a teammate nails him on their own two and Tech's winning score is set up, and you are there on the day a player ran not to daylight but to midnight.

———————

Sam Sansone of the Los Angeles Examiner wasn't feeling much better before he took this picture than Riegels was after. Sansone had a beaut of a hangover from a sleepless night with the boys and had retired to an unpopulated end of the field, away from the action, to contemplate, when he heard the crowd roar. Turning, he saw the ball game coming at him, reflexively made the shot and left for the darkroom to develop what he called an "n. g." (no good) plate. It wasn't until the next day he learned he had caught not a cliche but one of sport's surpassing goofs.

34

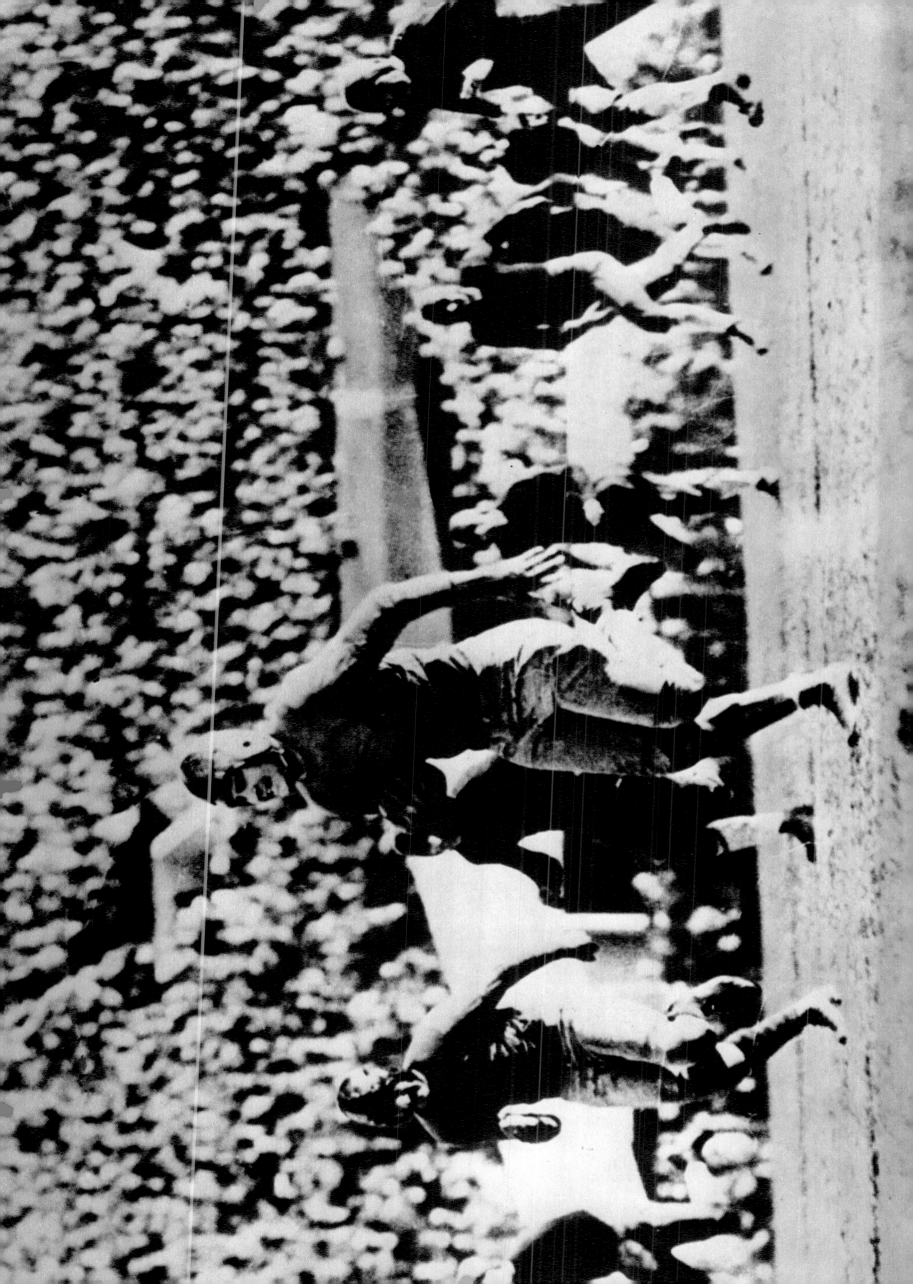

TO BUGS, WITH LOVE

Jazz Age? Maybe to some. But to others it was The Booze Age, and seven hoods of George "Bugs" Moran are sitting around the shop in Chicago waiting to make a dishonest buck.

The date is February 14, 1929, and the place is 2122 North Clark Street, and the sign out front says this is the S. M. C. Cartage Company, which it ain't.

Bugs is out of the office but a load of hijacked hooch is due in, so, Valentine's Day or not, the boys have turned out. Put some coffee on. Wait. Take a sip. Wait. Lot of waiting in that great national thirst called Prohibition.

Whatsis! There's three cops getting out of that car out front. Into Bug's garage they come with two men in civvies carrying machine guns and sawed-off shotguns. This a raid, captain? We ain't done nothin'.

The answer is an outburst of gunfire that sets a record for gang warfare, even in Chicago: six dead and one dying.

The gunmen drive off in a blue sedan, leaving what gangologists think is a crisply packaged Valentine gift from Alphonse Capone to Bugs Moran.

————————————

The dying man refused to tell the real police anything when they arrived. With them came John "Hack" Miller, photographer for the Chicago American, who recorded the pleasantries for history and had an easy time with the captions. A police officer gave him the guided tour:

"This one's Pete Gusenberg, an ex-con and the chief gunner for the Drucci-Moran gang. Here's Al Weinshank, the North Side booze runner, and Artie Davis from the West Side mob. And this was James Clark, Bugs Moran's brother-in-law. Here's what's left of Doc Schwimmer . . ."

Miller left with his pictures and the only survivor of the massacre, a young police dog which had been cowering under a car.

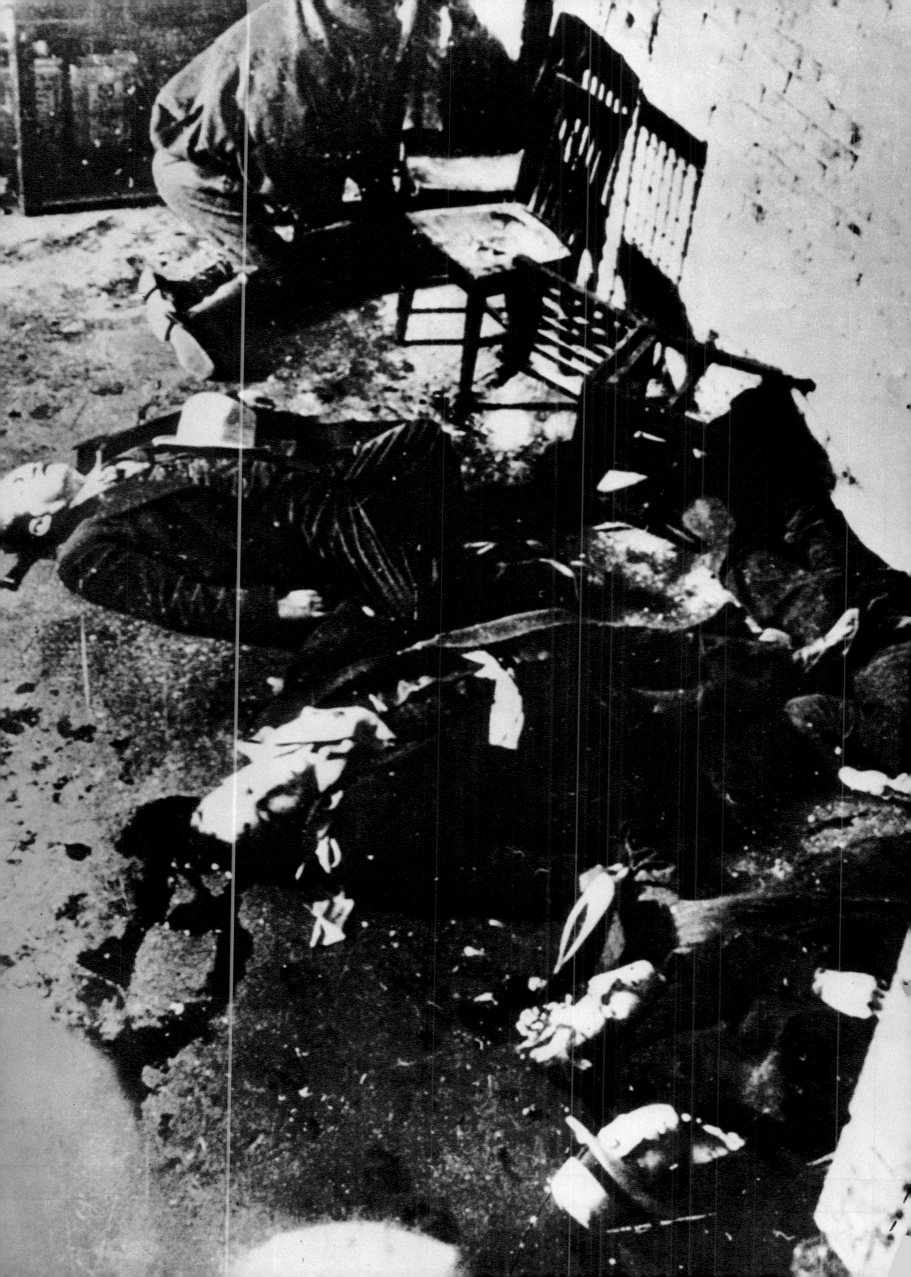

HERE'S HOW, UNCLE SAM

It was called the noble experiment—Prohibition—a period of nearly 14 years beginning January 16, 1920, during which a small, ill-equipped army of agents fought against unquenchable odds to keep a whole nation thirsty.

The agents never numbered more than 3,000 (some of them also on the payroll of a larger, better-equipped army—of bootleggers) and they had 20,000 miles of land and sea borders to protect against those who would break the 18th Amendment. An impossible task. They did, alas, win an occasional battle, smashing a keg here, a jug there, but it has been estimated that for every five gallons of booze that went down the drain 95 gallons went down the hatch. One study showed that per capita consumption actually went up during the "dry" years.

Trucks, wagons, rumble seats, wheelbarrows, any conveyance at all, lugged illegal liquor over backwoods border roads from Canada night after night; some of the stuff even came in by freight cars with phoney labels. Offshore— three miles offshore, to be precise—a fleet of large cargo ships bent to the task of supplying a fleet of swift, unmarked boats bent on supplying parched throats everywhere.

For the do-it-yourself drinker, little stores quaintly called "malt shops" sprang up across the land. They sold malt. They also sold yeast, bottles, bottle caps—a large and varied assortment of items the uses of which were not hard to define. One thriving mail-order house offered a premixed concoction prominently labeled: "Warning. Do not add yeast since this will create alcohol which is illegal."

On December 5, 1933—an anxious nation noted the exact time, 5:32 p.m.—the Utah legislature became the 36th state to ratify the 21st Amendment, repealing the 18th. Prohibition, which never prohibited much, came to an unmourned end.

———————————

Photographer unknown.

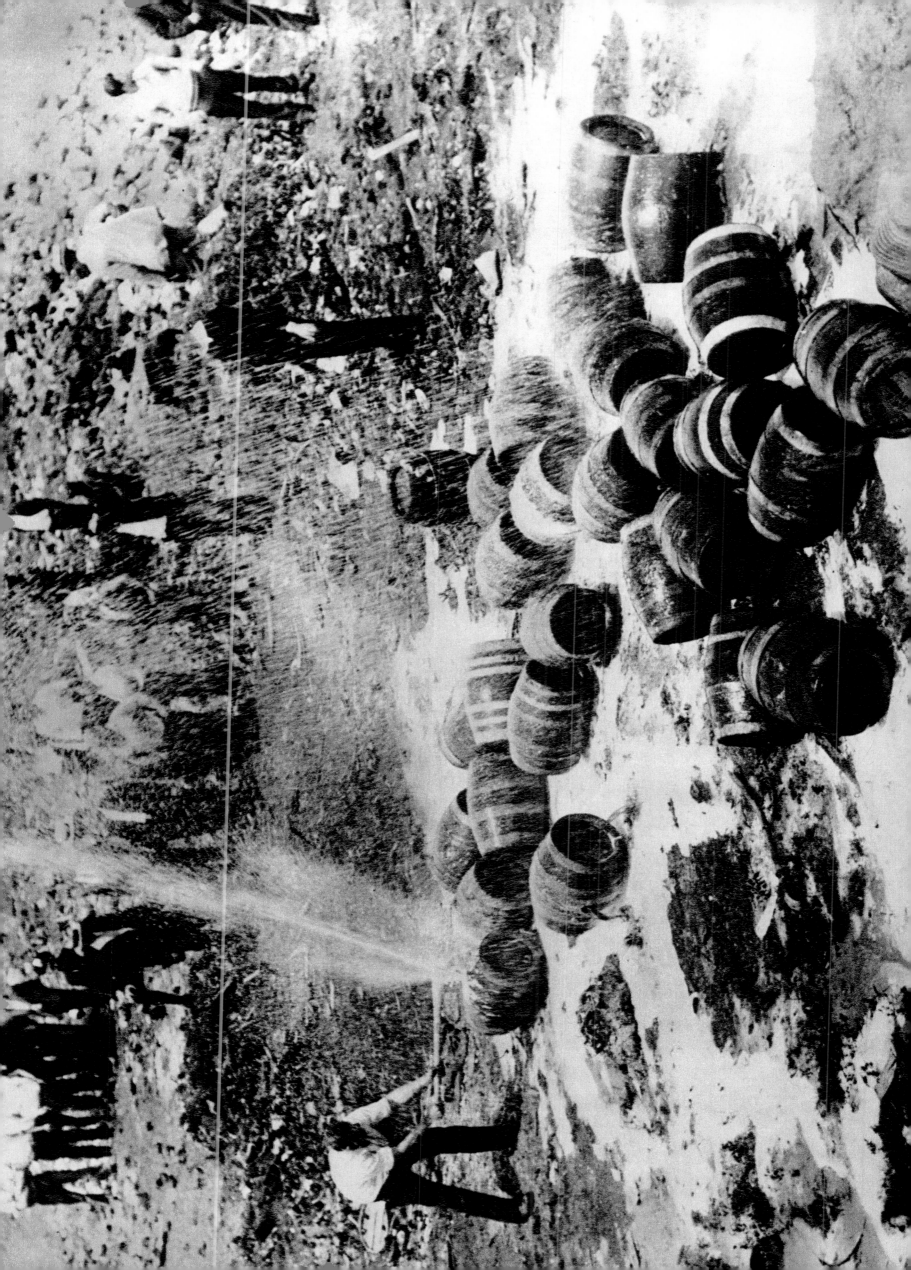

HARD TIMES

It began, on a Thursday, on Wall Street.

Then slowly, as surely as lights flicking off in an apartment house, the nation sank into that hopeless night called The Great Depression.

The collapse of the stock market that started October 24, 1929, was both a cause and a symptom of what was to follow. The market, a barometer of the nation's dreams, exemplified the limitless optimism of the 1920s. You worked hard, you played hard, and there was nowhere to go but up.

But by 1932, not only had $74 billion in stock values simply vanished like summer smoke; not only had 4,835 banks closed; not only were women prowling the docks in New Orleans searching for rotten bananas while shabby men asked waitresses for a cup of hot water to make tomato soup with the ketchup; not only had 86,000 businesses failed and wheat dropped from a postwar high of $2.90 a bushel to a dime; not only were the nation's wages down almost a half; not only were half a million sand-caked refugees coughing on Route 66—"the road of Flight"—in their flivvers away from the new desert of the Dust Bowl; not only were ex-brokers selling apples for a nickel on street corners; not only were 12 million Americans jobless; there was something gone that went deeper into the soul, that ached more than hunger. Hope had died. The system had broken down and there was no one to fix it.

In 1930, Herbert Hoover said: "We have now passed the worst." And that same year, a man saw a crowd outside a Charlie Chaplin movie and asked, "Is that a bread line or a bank closing?" And the worst had not yet come.

There were hunger riots in Oklahoma City and St. Paul. Oregon sheep raisers fed their stock to the buzzards because they didn't have money to ship them to market while in San Francisco starving men picked through garbage cans.

Out of the nation's despair rose Franklin Delano Roosevelt. He would break with tradition. He would try anything if it worked, and he did.

The New Deal ravaged the alphabet in creating a blizzard of new agencies: AAA for farmers, NRA for industry, PWA, CCC, WPA, FCC, SEC, TVA.

There were many who cried socialism and saw the programs as giveaways. There was grist for their mill, especially in the Works Progress Administration.

A whole team of WPA writers in New York was set to work on a history of the safety pin. In Washington, 100 men kept busy trailing balloons on strings to chase away the starlings and keep the Capitol clean.

But WPA also funnelled $8 billion in paychecks into eight million households— a sixth of the population. It repaired 250,000 miles of roads, repaired or built 1,000 airports.

The Supreme Court would overrule many of the innovations. But a corner had been turned even as the economy slowly revived, and the tin and tarpaper shacks of the Hoovervilles were slowly brushed from the landscape.

The people who suffered through it and survived would bear the scars for their lifetime, but they had lived through a pivot of history. From now on, for better or worse, richer or poorer, wiser or more foolish, the course of the nation would be run and regulated from Washington as never before.

The photographer of the apple vendors in New York in 1932 is unknown. The picture of the Oklahoma farmer and his sons was taken in 1936 by Arthur Rothstein.

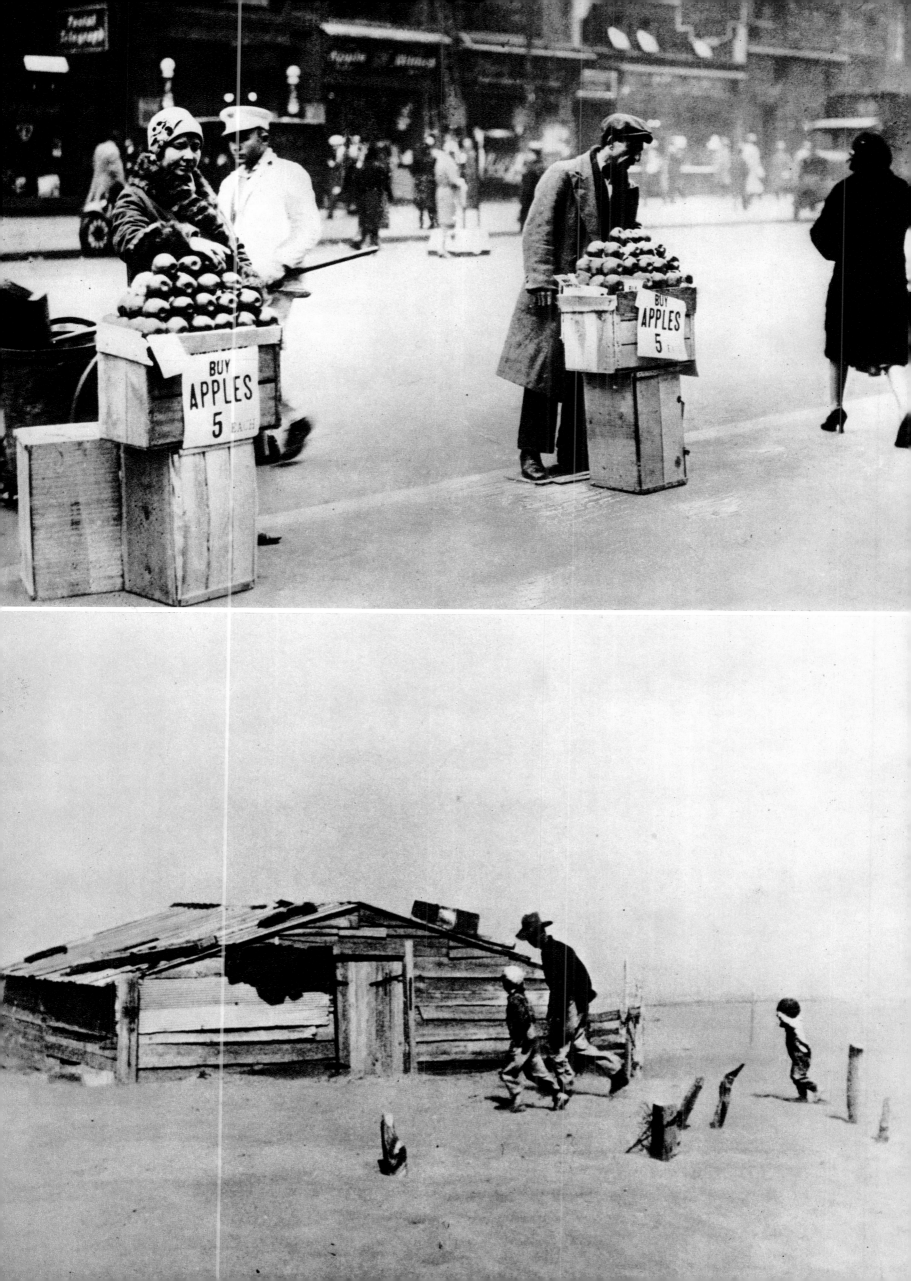

THE FIRST MARCH ON WASHINGTON

The future is a long way off when you are hungry, and in the spring of 1932, the time of the Great Depression, many Americans were hungry.

Some marched on Washington. Jobless veterans of World War I, the pride of the nation in 1918 but now a ragtag army of perhaps 10,000, set up camp on the outskirts of Washington in Anacostia Flats.

They dug latrines and lived off greasy mulligan stew and coffee. They called themselves the B. E. F., the Bonus Expeditionary Force, a bitter play on the once victorious American Expeditionary Force. In 1924, a somewhat grateful and booming nation had voted veterans a bonus averaging $1,000 to be paid, according to the legislation, by 1945. By 1932, that was not soon enough.

The B. E. F. sought to convince Congress by its presence that payment should be immediate. There was the feeling that if the federal government could aid banks and railroads, it couldn't turn its back on veterans. By mid-summer there was also the sure knowledge that the President, Herbert Clark Hoover, had received athletes and essay winners in the White House, but not the bonus marchers.

The House passed a bill to provide immediate payment of the bonus, and the veterans were exuberant. But then the Senate defeated it soundly on the grounds that the national treasury could not take the strain in a time of depression. The dismayed veterans gathered on the Capitol steps and sang, in one rising voice of bitterness, "America." . . .

July 28, 1932. The veterans occupy federal buildings along Pennsylvania Avenue, vowing to stay until 1945 if necessary. By now, in the summer heat and frustration, tempers are short. Federal agents evict them.

Three veterans, carrying a flag and followed by others, try to reenter the building. Police rush to block their way. Someone throws a brick. Then more bricks. "Give the cops hell," someone shouts. Ex-doughboys grab lead pipes, concrete, wooden planks, and police open fire, and two of the bonus marchers die.

Before he was President, Herbert Hoover once said, "Man in the mass does not think but only feels. . . . Popular desires are no criteria to the real need."

Now, he calls out the troops. Gen. Douglas MacArthur, assisted by two young officers named Dwight Eisenhower and George Patton, leads 1,000 cavalrymen and foot soldiers against the veterans. Five tanks and tear gas also are used and by midnight dozens are injured, but the capital is cleared. . . .

Seeking reelection later, Hoover said, "Thank God we still have a government . . . that knows how to deal with a mob." He lost.

Joe Costa, photographer of the New York Daily News, was talking to a police official when the veterans tried to reenter the buildings on Pennsylvania Avenue. He followed the rush of police and took pictures until he was hit by a brick, but already in his camera was a bitter chapter of American history.

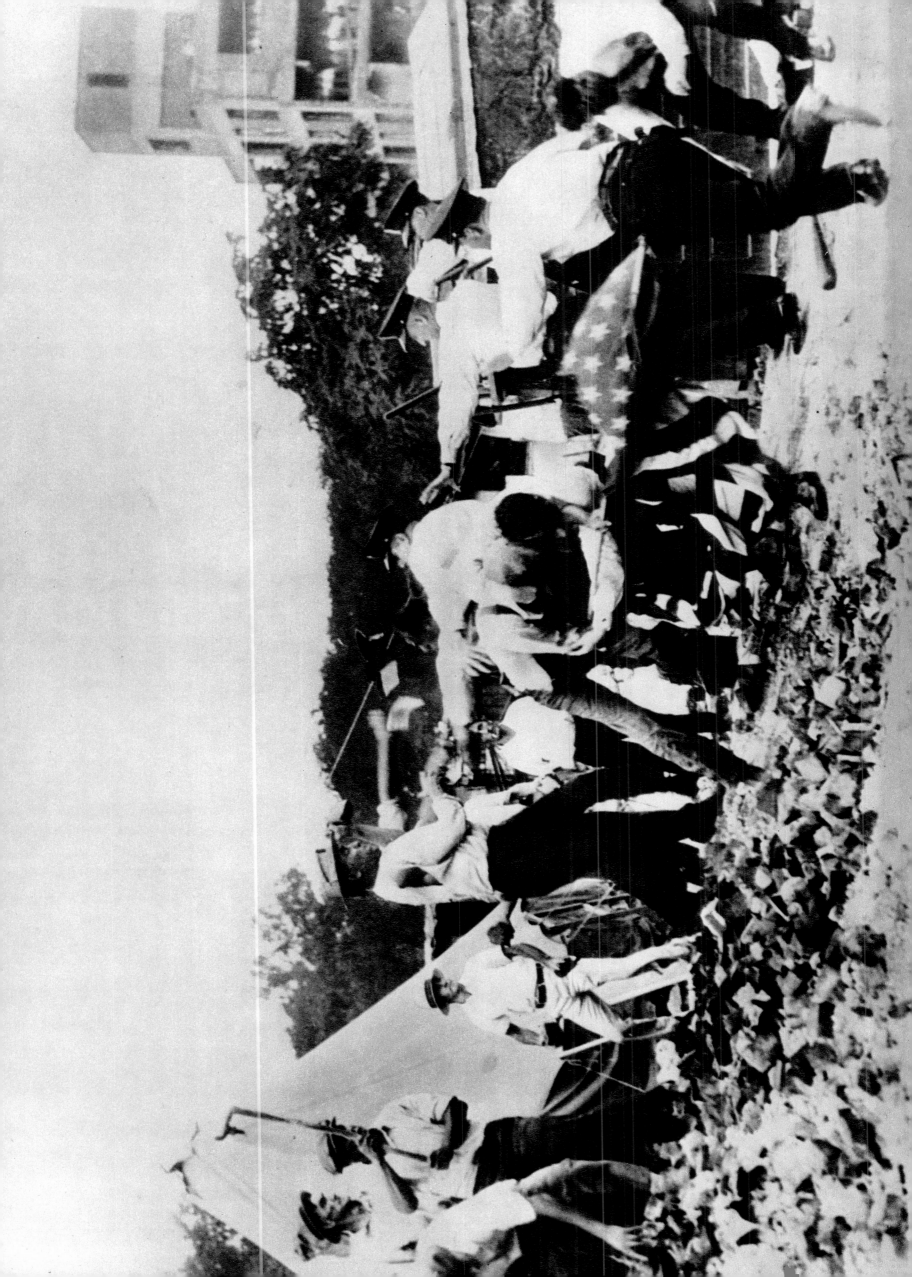

DOWN ON THE LEVEE

The year 1937 began in the rain.

It rained in Wheeling and it rained in Cincinnati and it rained in Louisville and in Washington it rained while the President was telling 3,000 drenched spectators, from his inaugural stand, of his dissatisfaction with "one-third of a nation ill-housed, ill-clad, ill-nourished."

It rained in the bayous of Arkansas and in the hills of Pennsylvania and for a two-day period on the plains of Ohio it rained six inches.

Up and down the Ohio and Mississippi valleys, it rained, 16 inches here, 20 inches there. And rolling tributaries—the White, the Arkansas, the Ouachita, the Monongahela—coursing through 10 sodden states, dumped their foaming waters into the swollen Ohio which in its turn plunged with such might and violence into the Mississippi that, for a stretch, the Father of Waters flowed upstream.

Never in recorded U.S. history has a flood of such proportions visited such a vast section of the country with such fury. By February 1,500,000 are homeless and another 50,000, fleeing the lowlands around Memphis, are streaming into that old steamboat town which itself is imperiled. It is apparent that the system of "flood-proof" levees on the lower Mississippi, recently completed by the Army Corps of Engineers at a cost of $325 million, will not be sufficient: the Mississippi is expected to crest at 53 feet at Memphis, seven and a half feet above the record crest.

The levees must be strengthened—and all must help. From out of their armories come National Guardsmen. From out of their work camps come members of the Civilian Conservation Corps. From out of the Shelby County Penal Farm in Tennessee, leg irons fast to ankles, comes a chain gang.

Chain gang? Most urbanites of 1937 are vaguely aware of this quaint practice in penology, but only through books and movies. Rural southerners could on occasion get an actual look at the forlorn lines of black faces working on road-beds. But photographs of the men are actively discouraged and extremely rare.

For most Americans, then, the picture they see in their morning papers February 2, 1937, four chained men on a Mississippi levee, is an eye-opener in the truest sense.

In the lobby of Memphis's Peabody Hotel, Associated Press photographer John Lindsay hears some talk, hardly more than a rumor, about a chain gang working on the levee nearby. No official will confirm the report. Next morning, early, he rents a car. The going is rough: roads washed out, blocked. Snaking around trees through a patch of soggy woods, he finds his way to the levee and sees the gang at work. To his astonishment, the guard is helpful, cooperative, offering him hot coffee under a canvas tent. Still, Lindsay is appalled, personally hurt, at the sight. He wants to ask the guard, "Why do they need chains while they're working?" But he holds his tongue and shoots several pictures. Driving back, he says to himself, "Maybe the pictures will do some good." Several days later, after his pictures are published, he reads in the paper: "Chairman E. W. Hale of the Shelby County Commission has recommended commutation of sentences for the 500 black prisoners who worked on the levee."

44

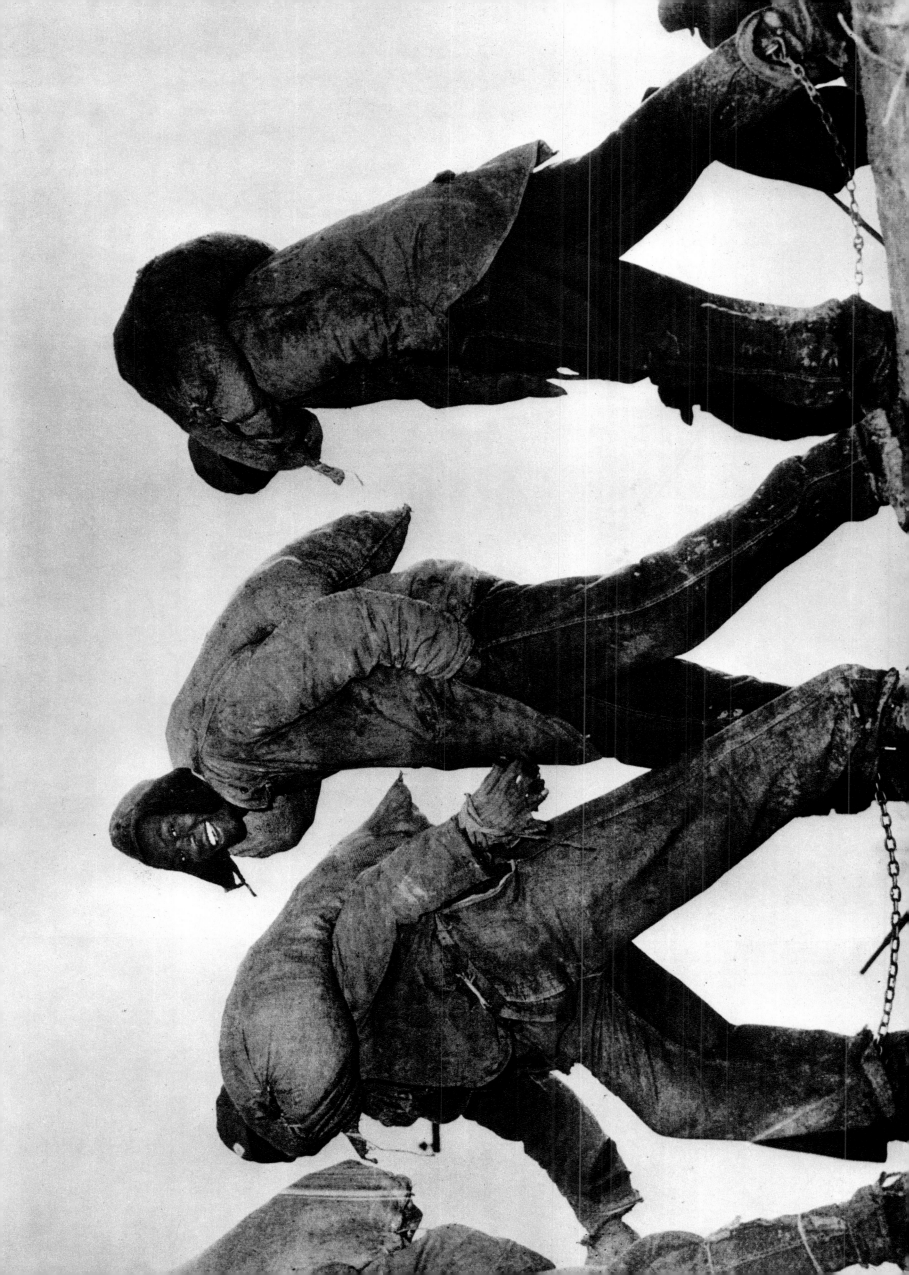

"MY GOD, MY GOD!"

The photographers are grumbling. The big airship is already late; natural light is fading; another big electrical storm is on the way. Will the damn thing never show . . .?

The Hindenburg drifts slowly toward the mooring mast at Lakehurst, N. J., 97 souls safely tucked away in the passenger gondola and crew stations along the 803-foot length of the airborne cigar. The Hindenburg is ending its 37th passage from Nazi Germany, whose resurgence it symbolizes. Top speed: 90 mph. On the ground, another festive group of passengers waits to depart. The age of the big dirigible seems secure.

May 6, 1937. Three months since Adolph Hitler declared Germany will no longer be bound by the Versailles Treaty. Two weeks after Generalissimo Francisco Franco declared a one-party state in Spain.

Time narrows down to an instant: 7:20 p.m., May 6, 1937. The Hindenburg hovers 200 feet up, nose approaching the mooring mast. Landing lines drop to rain-soaked ground. Ground crews reach up.

7:30 p.m. Explosion rips open the tail of the world's largest airship. Flames race forward. The tail section touches ground, forcing hydrogen forward and bursting from the nose. Front section settles toward earth. Passengers and crew, some in flames, leap to the ground. Fire completely devours ship. Thirty-six people die. Total elapsed time of destruction: 47 seconds. The age of the dirigible is over.

Murray Becker, Associated Press, moves instinctively with 4X5 Speed Graphic, fingers faster than brain. Slip in slide, remove holder, turn it over, push back into camera, cock shutter, make second shot. Five seconds gone . . . Seven. Changing holders, make third shot as ship groans to earth. . . .

"My God! My God!" Murray Becker keeps murmuring aloud as he keeps shooting. He photographs the last of the horror, a passenger "with skin hanging from his arms," being led away. He photographs the last of the great airship, a tangle of steaming metal. Now, he leans back against the rear of the hangar. Now, Murray Becker cries, uncontrollably.

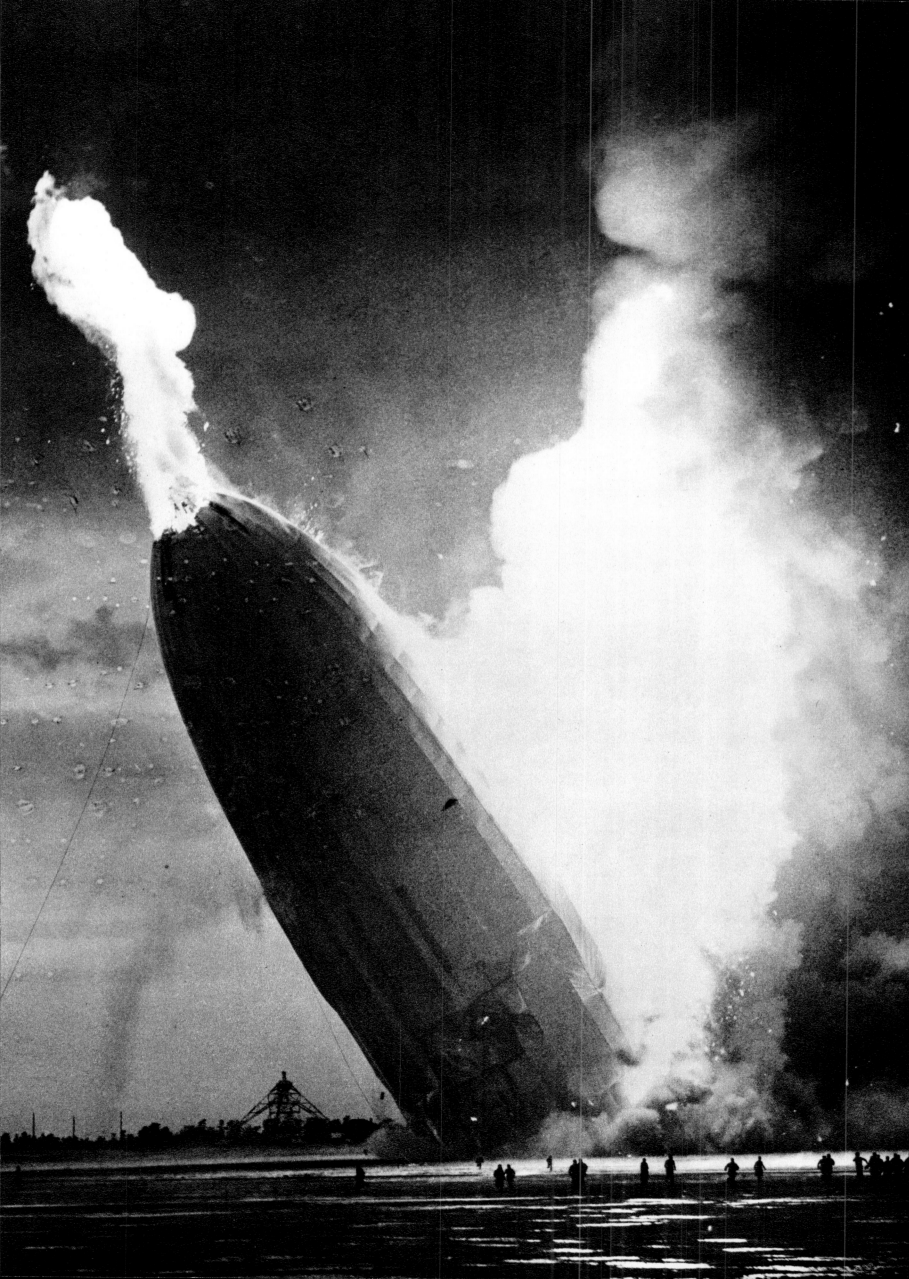

DAWN ... BUT NO DAY

Now the wind grew stronger and hard ... Little by little the sky was darkened by the mixing dust, and the wind felt over the earth, loosened the dust and carried it away. The wind grew stronger. The rain crust broke and the dust lifted up out of the fields and drove gray plumes into the air like sluggish smoke. The corn threshed the wind and made a dry, rushing sound. The finest dust did not settle back to earth now, but disappeared into the darkening sky.

The wind grew stronger, whisked under stones, carried up straws and old leaves and even little clods, marking its course as it sailed across the fields. The air and the sky darkened and through them the sun shone redly, and there was a raw sting in the air. During a night the wind raced faster over the land, dug cunningly among the rootlets of the corn and corn fought the wind with its weakened leaves until the roots were freed by the prying wind and then each stalk settled wearily sideways toward the earth and pointed the direction of the wind.

The dawn came, but no day. In the gray sky a red sun appeared, a dim red circle that gave a little light, like dusk; and as that day advanced, the dusk slipped back toward darkness, and the wind cried and whimpered over the fallen corn ...

When the night came again it was black night, for the stars could not pierce the dust to get down, and the window lights could not even spread beyond their own yards ...

In the middle of that night the wind passed on and left the land quiet ...

—John Steinbeck, The Grapes of Wrath

———————————

May 29, 1937. A dust storm rolls into Clayton, N. M. Photographer unknown.

MEMORIAL DAY AT REPUBLIC

It looked like a Goth-Roman battle scene in an old Latin reader: the police in an orderly row and coming towards them across a field, a ragged crowd of about 1,500 people.

Two are carrying American flags. Another a sign: "Republic vs. the People."

This is the Republic Steel Company plant in South Chicago, Memorial Day, 1937. For two days strikers have been battling police to seize the plant and oust company maintenance men inside. There are 75,000 steel workers on strike across the nation as John L. Lewis and his new Congress of Industrial Organizations (CIO) are trying to gain union recognition. U. S. Steel, the giant of the industry, has already settled, giving a 10 per cent wage increase and establishing a 40-hour week. Now Lewis turns to Little Steel—Republic, Inland, Youngstown.

Six Republic plants are virtually under siege by strikers. The company drops food to its people inside by plane. One plane is fired on.

It is a time of sit-down strikes, beatings by company goons, hardjawed hostility between management and its workers. Union organizers at the Ford Motor Company are bloodily beaten in their effort to win recognition and an $8 day. Henry Ford says with finality he'll only pay $6. And definitely no union.

And at South Chicago they are marching, tattered crusaders, veterans of the hunger-ache of the Depression. Their leader, a hard-muscled young man in shirtsleeves with a CIO button in the ribbon of his felt hat, approaches a police officer.

The officer makes an impatient gesture, as if to say no. The crowd is yelling and throwing rocks and pebbles from slingshots. Suddenly the 300 police draw their guns and fire directly into the mob. The strikers stop, then run, climbing over the fallen in their maddened dash to safety.

A heavy, bareheaded middle-aged man finds himself at the rear of the mob and tries to run a gauntlet of police. They begin clubbing him with their nightsticks as he tries to dodge past them. Then he is trapped and holds his hands up. The clubbing goes on. Slowly, clumsily, he goes down. The clubbing continues. The CIO says later one of the 10 people who died was found with his brains literally beaten out. Six others were shot in the back.

The strikers lose the battle: the strike is settled on Republic's terms. But they win the war: four years later the government invokes the New Deal's Wagner Act to order Republic and other firms of Little Steel to recognize the union, the United Steel Workers of America.

———————

Photograph by Carl Linde, Associated Press.

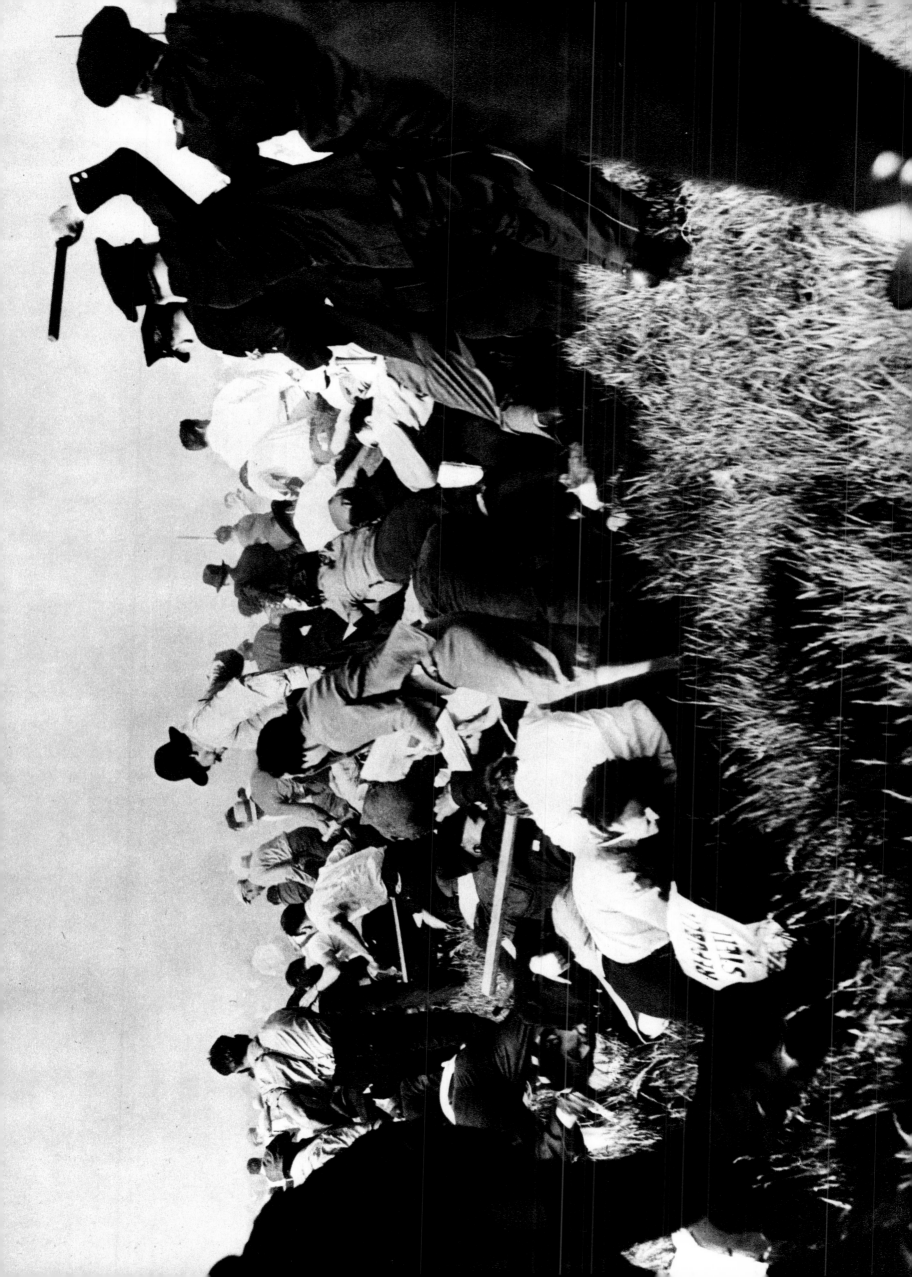

PRELUDE IN ASIA

American eyes turn to Europe by habit. There is even more reason now, 1937. Hitler and Mussolini test their steel in Spain's civil war. Italian armor, air power and poison gas have already crushed Ethiopia. Europe is in trouble and America knows it.

So Americans pay scant attention to the Japanese hordes invading China, to a slant-eyed war and its oriental barbarism. Few note Chiang Kai-shek's troops in their death stand at Shanghai, or the almost daily bombardment by Nippon's planes and ships.

August 28. Shanghai. Newsmen and cameramen wait for the expected attack on the blockaded Whampoo River. It doesn't materialize. By afternoon they leave their vantage point atop an office building. All but one.

Four p.m. The drone of engines. Three Japanese bombers lazily circle the city. Bombs and black smoke from the South Railway station. Of 1,800 people, mostly women and children awaiting evacuation, only 300 survive. The Japanese say their pilots thought it was a troop movement . . .

H. S. Wong, the only cameraman left on the roof of the office building, sees the attack and speeds his car toward the smoke. All he finds are the maimed still trying to rise, the dead, the dying. He turns his camera on the scene, and especially on a father retrieving his children from the railroad tracks, the mother dead over the steel rails. He turns it finally on a crying baby. Only now Wong notices his shoes are soaked with blood.

Two weeks later the pictures fill American movie screens, magazines and newspapers. Suddenly in the image of that tiny crying child the Asian war takes meaning. There is an angry U. S. demand that the Japanese cease bombing cities. There is a furor over the sale of American scrap steel to the Japanese, the raw material of bombs.

The Japanese claim the picture is fake. They put a price on Wong's head and he flees to British protection in Hong Kong. But the picture has already done its work on the conscience of America.

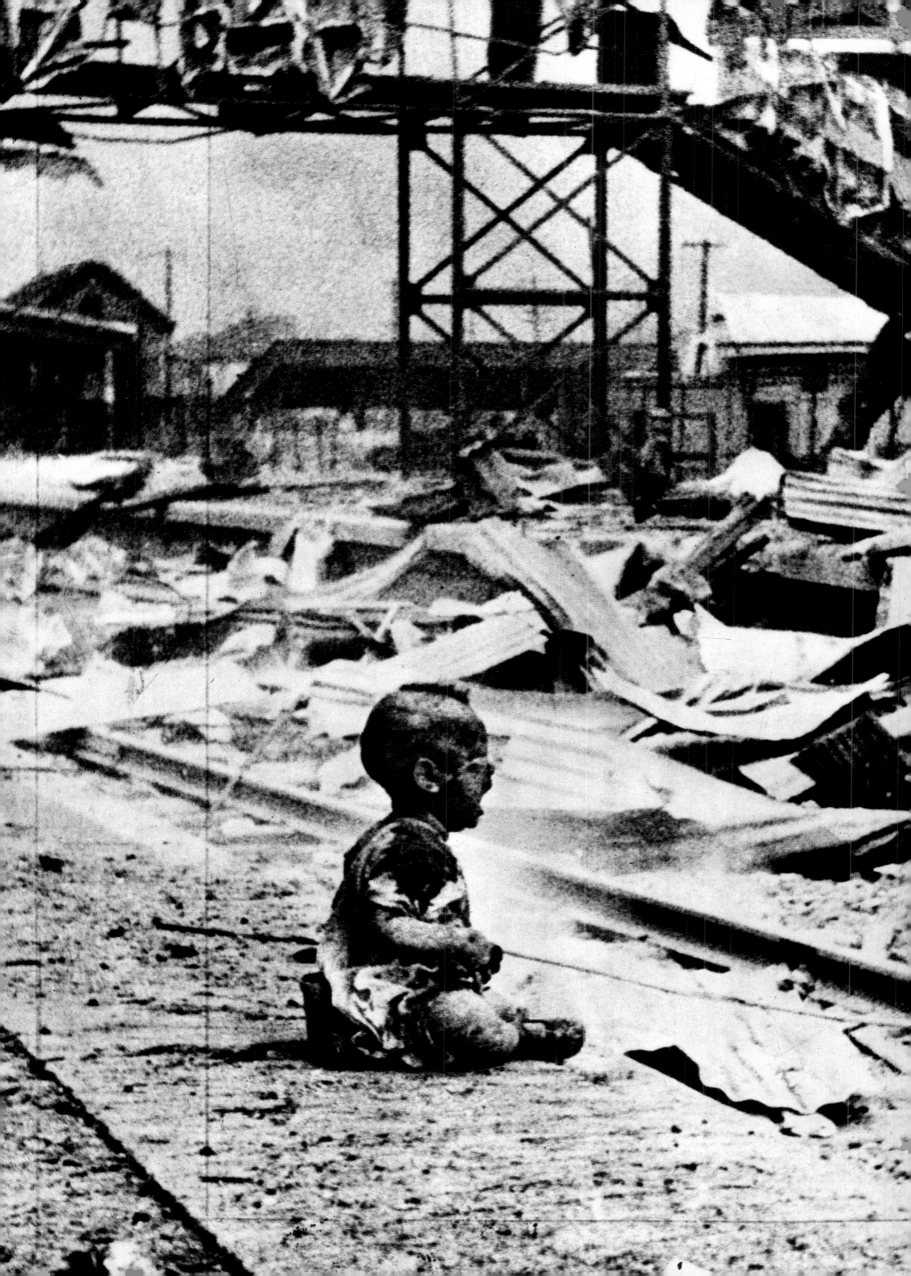

"WE LOVE YOU, LOU"

Is it a tear?

No wind blows dust this day, a sunny Fourth of July in Yankee Stadium, appreciation day for Lou Gehrig, who has played 2,130 straight games for the New York Yankees—a record.

It is 1939. War seems inevitable in Europe, but for the 61,808 fans gathered in the Bronx there is only one purpose: to honor a man who has played brilliantly and steadily in the shadow of Babe Ruth—some think even better than the flamboyant slugger who preceded him in the batting order on "murderers' row."

People first noticed him the day he stepped to the plate at Wrigley Field, slammed a ball over the right field fence and won his high school championship. Then they, and a Yankee scout, noticed when his Columbia University team played Rutgers in the spring of 1923 and he lofted two pitches into the trees and a third onto the Columbia library steps.

They cheered that June when he suited up alongside his idol, the Babe, and hit .313 in his first full season. They cheered as shyly, quietly, he slugged his way into baseball's firmament—always on the fringe of his hero's limelight. The Babe had splash, and they cheered themselves hoarse for Ruth, only to find they didn't have as much voice left when Lou Gehrig hit one just as far. But he didn't really mind. Good naturedly, efficiently, he batted .373 in his second season, then .374, .300, .379, .341, .349, .334, .363, .329, .354 and .351. They called him the "Iron Horse."

Then, on July 13, 1934, they watched him falter. He had picked a single off the Tigers in Detroit, run to first and doubled over—with a rare kind of paralysis called "amytotrophic lateral sclerosis." It would kill him, slowly, over the next seven years.

They are chanting, "We love you, Lou," as Murray Becker of the Associated Press, halfway down the first base line, trains his Graflex on Lou Gehrig's face. Gehrig steps to the home plate mike.

Silence. In a moment, he will manage: "I may have been given a bad break, but I have an awful lot to live for." But at this instant, the words just won't come. Gehrig looks down. He puts his hand to his eyes. Becker presses the shutter, and on his caption card he writes: "Lou Gehrig is crying."

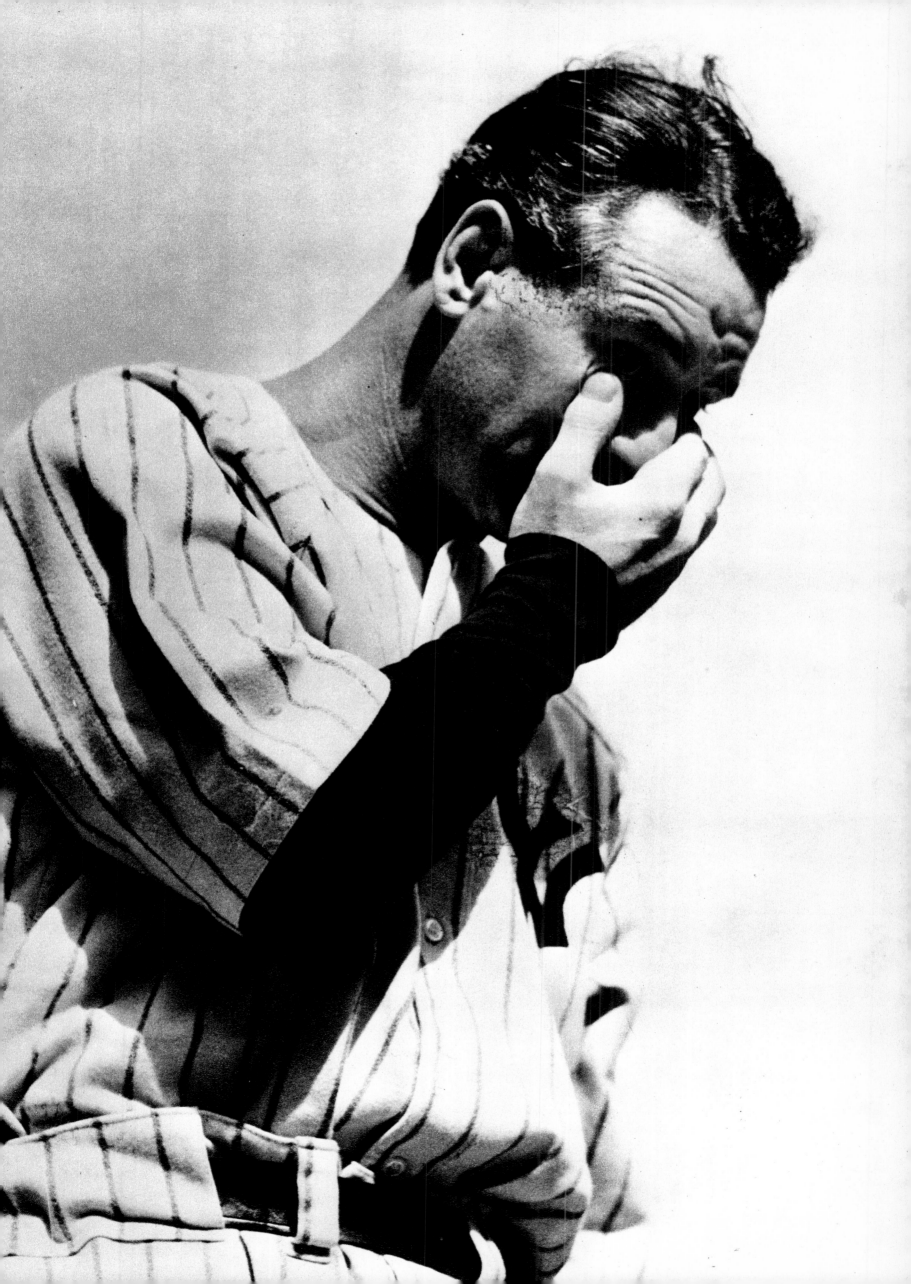

THAT MAN

The picture captures it all.

The patrician pince-nez clipped to his nose. The jaunty tilt of his elegant cigarette holder. The cock-of-the-walk assurance of the smile.

It is Franklin Delano Roosevelt in 1939, at full flower, at mid-passage of an unprecedented 12 years of Presidency; FDR in a flick of a camera lens jutting his jaw with the absolute self-confidence that had led a nation out of hunger and would lead it through the cannon roll of war; FDR grinning with a near arrogance that caused many to hate him with a fervor matched only by the devotion of those who venerated him.

He had only to say the familiar "My friends . . ." to open one of his so-called fireside chats on radio to set the molars of the Old Guard grinding in near apoplexy. To them, this son of Groton and Harvard was a traitor to his class, Big Business, the American Way of Life, and was about to turn the nation socialistic if not worse. "That Man in the White House . . ." they sputtered.

But before he was done, Roosevelt worked a social revolution. He came to office in 1932 at the Depression's depth when there was starvation right here in Golconda, when factories rusted, when abandoned farmhouse doors creaked in the wind, when no one, try as he might, could put Humpty-Dumpty back together again.

"The only thing we have to fear is fear itself," said this silver-spooned blue blood standing in the iron braces that gripped his polio-crippled legs. Then, he launched into a frenzy of makeshift reform called The Hundred Days. Some of it failed outright. Some was outlawed by the Supreme Court. But the abiding legacy of his New Deal would be Social Security for the aged, the right to unionize and bargain for the worker, electricity for the farmer, overseers on Wall Street for the investor, federal savings account guarantees for the depositor, housing for the ghettos—a myriad of change a later generation would take for granted.

A man who became a lifelong friend thought Roosevelt "a spoiled, silk pants sort of a guy" when he first met him. But in a nation's need Roosevelt was the man who held its hand. There were times when he filled it with alphabetic handouts, times when he twisted it with a blithe paternalism, times when he slapped it like a physician giving life. And times when he firmed it, leading as to war.

With guile—for he had more than enough of that—Roosevelt guided a nation basically anti-war towards the conflict he regarded as inevitable. There were destroyers for Britain and a peace time draft and Lend-Lease and then, the day after Pearl Harbor, the ringing, outraged words of the Commander in Chief denouncing "a date that will live in infamy."

He had promised men and promised arms and promised victory and saw that they were delivered. He, along with Winston Churchill, were the foci of national purpose, the prods, the exhorters, the men of words and spirit tough and eloquent enough to lead their people.

He would stumble. At Yalta, when he was dying, Roosevelt would trust too much in the wartime good will of the inscrutable Stalin. History would tax him for it. But he had vision, too. He saw beyond war to peace and laid the foundations of the United Nations. But it was a peace he was not to reach.

On April 12, 1945, as he sat for a portrait in his Harvard tie and familiar cape, he said "I have a terrific headache" and died of a cerebral hemorrhage. Sorrowing, they slowly took Franklin Roosevelt, their leader in peace and war, back up the Hudson from whence he had come and there laid him to rest.

There had been a man in the White House.

———————————

Photographer unknown.

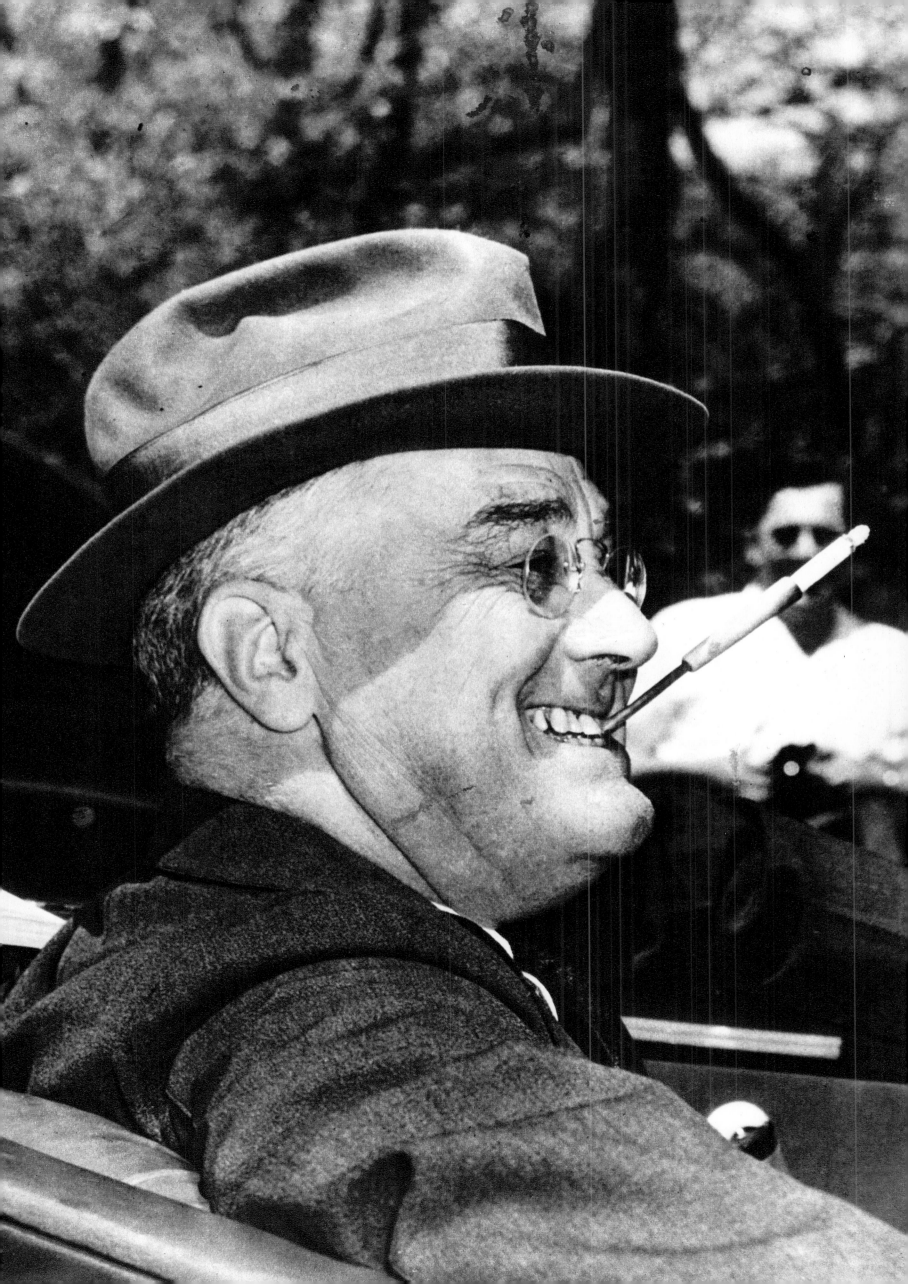

A PLACE CALLED DUNKIRK

In 1938, Austria fell to ultimatum, Czechoslovakia to threat and the promise of peace. In 1939, Poland fell to blitzkrieg in less than four weeks, a demonstration of what lay behind Adolph Hitler's ultimatums, threats and promises. Britain and France declared war on Germany.

On April 9, 1940, Denmark was taken in its sleep, and Norway was invaded with ruse and lightning power. On May 10, 1940, the Nazis invaded the Low Countries. Hours later Prime Minister Neville Chamberlain, who had believed Hitler, yielded the British government to Winston Churchill, who had not. Luxemburg fell in a day; Holland in six. On May 12, the Germans crossed the French frontier and four days later broke the line at Sedan.

Churchill, in his first speech as prime minister, told the Commons, "I have nothing to offer but blood, toil, tears and sweat. We have before us an ordeal of the most grievous kind. But I take up my task with buoyancy and hope. I feel sure that our cause will not be suffered to fail among men."

With more than 200,000 troops on the continent, the British faced a disintegrating Europe. On May 14, the British Broadcasting Corporation announced calmly, "The Admiralty has made an order requesting all owners of self-propelled pleasure craft between 30 and 100 feet in length to send all particulars to the Admiralty within 14 days of today."

There was little time. Shortly after midnight, May 27, King Leopold III urgently messaged the British, "The Belgian army is losing heart . . ." He surrendered the next day. The British, French and Poles were now trapped in a corner of southern Belgium and northern France, their backs to the sea and Germans on all sides.

Leaving small rear guard units, the Allies fell back on the port of Dunkirk. The Germans pressed them relentlessly, on the ground, in the air, smashing the town, destroying the docks and water supply.

The Allied pocket is now a beach. Death or capture seem inevitable. But from England comes a miracle.

Ferry boats, fishing boats, cabin cruisers, slow sail boats under power, paddle wheelers, fire boats, tugs and lifeboats, merchantmen, minesweepers, destroyers and speedboats—887 vessels in all, and some of them barely deserving of the name. They are crewed by a staggering variety of sailors, from regular Navy to taxi drivers, Sea Scouts, longshoremen, butchers, Sunday sailors. They capsize, they collide, they go awash, but still they come.

The beaches are alive with men struggling into shoulder deep water to reach the rescue fleet. The British Navy lays down a stifling barrage to protect the rear, and anti-aircraft shells fill the sky . . .

It went on for nine days, from May 26 to June 3. In the end, 13 British and French destroyers were lost along with 27 other boats. But 338,226 soldiers were rescued from the jaws of the juggernaut. The Germans captured no more than 40,000.

"Wars are not won by evacuations," said Winston Churchill, but the victory in defeat was so stirring he could now soar: "We shall fight on the seas and oceans. We shall fight with growing confidence and growing strength in the air. We shall defend our island, whatever the cost may be. We shall fight on the beaches. We shall fight on the landing grounds. We shall fight in the fields and in the streets. We shall fight in the hills. We shall never surrender."

Photographer unknown.

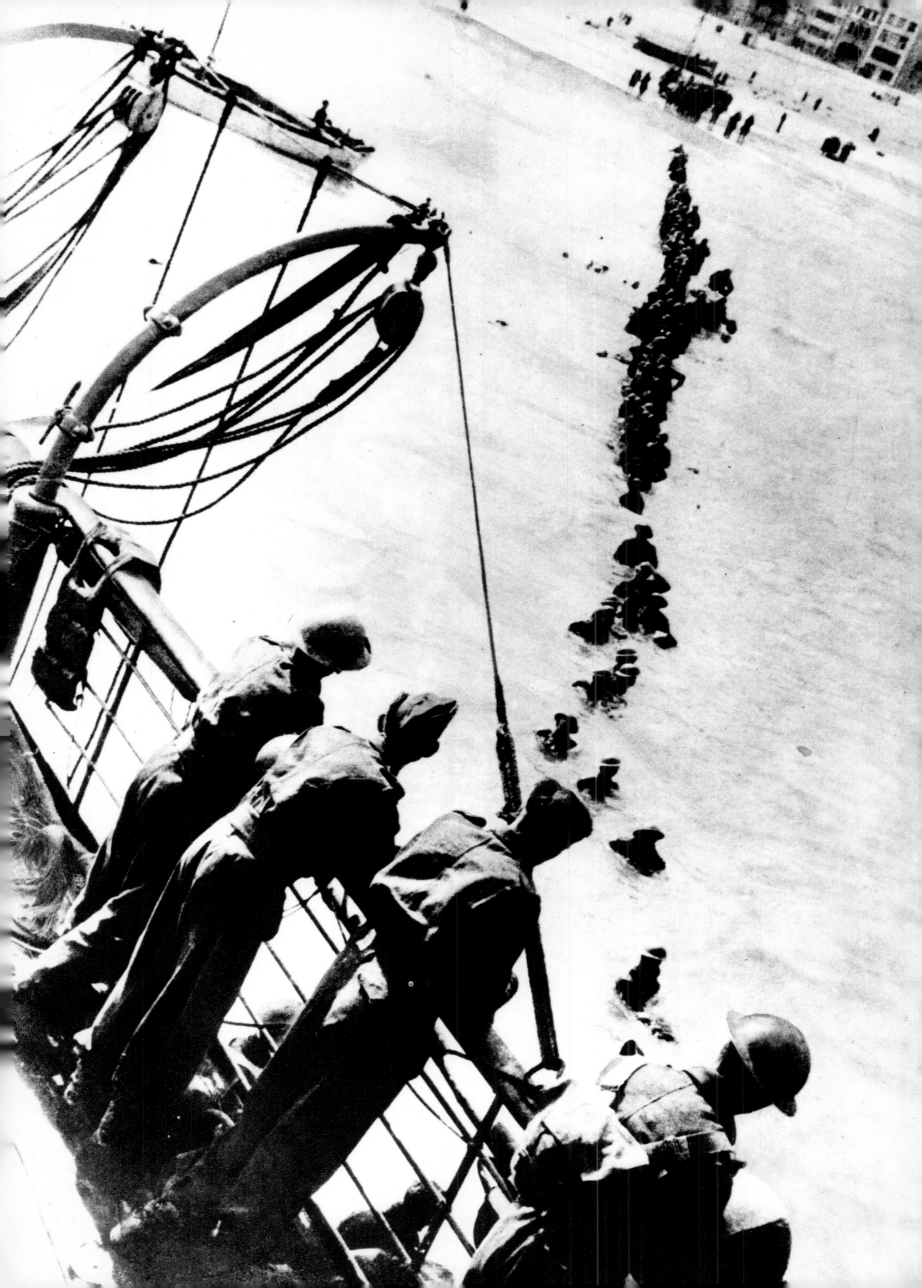

THE FUEHRER IS PLEASED

The same lightning move that isolated Dunkirk outflanked the "impregnable" Maginot Line, that $500 million exercise in static defense. But Hitler's army and air force were not static. The French Army, the experts said, was Europe's finest, a cadre of 800,000 men, trained reserves of 5,500,000. But it melted before the German storm.

On June 3, 1940, German bombers raided Paris. On June 6, Hitler's hordes—2,000 tanks and 100 divisions—exploded on the French countryside. The French Army disintegrated, and with it, the French spirit.

The roads south from Paris were flooded for 400 miles with fleeing civilians, and the ragged French infantry was dazed and weaponless. When cars and trucks ran out of gas, they were pushed to the next town, where there was still no gas. German planes bombed and strafed the refugees from the air. The highways were paved with corpses.

On June 10, Italy entered the war and Benito Mussolini sent 400,000 troops to the French Riviera. In America, President Roosevelt said bitterly, "The hand that held the dagger has struck it into the back of its neighbor." But the plight of France was a *fait accompli*. The Germans were already 35 miles from Paris. The next day the government fled to Tours.

On June 12, Winston Churchill flew to Tours to try to rally the dispirited French. He couldn't. Moreover, General Maxime Weygand, 72, the French commander, predicted, "England's neck will be wrung like a chicken's." On June 14, the Germans marched into a deserted Paris. Only one cafe was open on the Champs Elysees. In arrogance and insult, the Germans landed two planes in the Place de la Concorde, and delivered newspapers from home to the troops. On June 17, Marshal Henri Petain, 85, hero of Verdun in World War I, sued for peace. France had fallen in 35 days. Hitler had taken seven European nations in ten months . . .

June 21, 1940. In the forest four miles north of Compiegne, the old private railroad car is back where it stood November 11, 1918, when Marshal Foch dictated the German surrender in World War I. It is 3:15 p.m. A German automobile stops in front of the Alsace-Lorraine Memorial, a sword piercing the defeated eagle of the German Empire. Adolf Hitler emerges with Field Marshal Hermann Goering, and they walk slowly around the clearing and read the inscriptions. One says this spot commemorates that distant November when "the criminal pride of the German Empire" succumbed.

Hitler enters the railroad car and takes the chair where Foch sat. The French delegation arrives. There are no salutes, no handshakes. The honor guard comes to attention, but does not present arms. Hitler and his aides rise, a courtesy the French denied the Germans in 1918.

Hitler knows his history, and out of that comes his revenge. The lance corporal of World War I listens stonily as the terms of surrender are read. The document speaks of dishonor, humiliation, and suffering that began here 21 years before. It says Germany was not defeated in World War I, but betrayed. It blames the current war on Britain and France. It says Germany now comes to Compiegne to wipe out its "deepest humiliation."

Later, outside the railroad car, his symmetrical sense of history neatly wrapped with ribbons of irony, Adolf Hitler displays something rare for him, unrestrained public joy. He grins, he spreads his arms like the German eagle, he dances a little jig.

The band plays Deutschland uber Alles.

At the moment, in the dark and lowering sky of history, the title seems unchallengeable.

———————————

Photographer unknown.

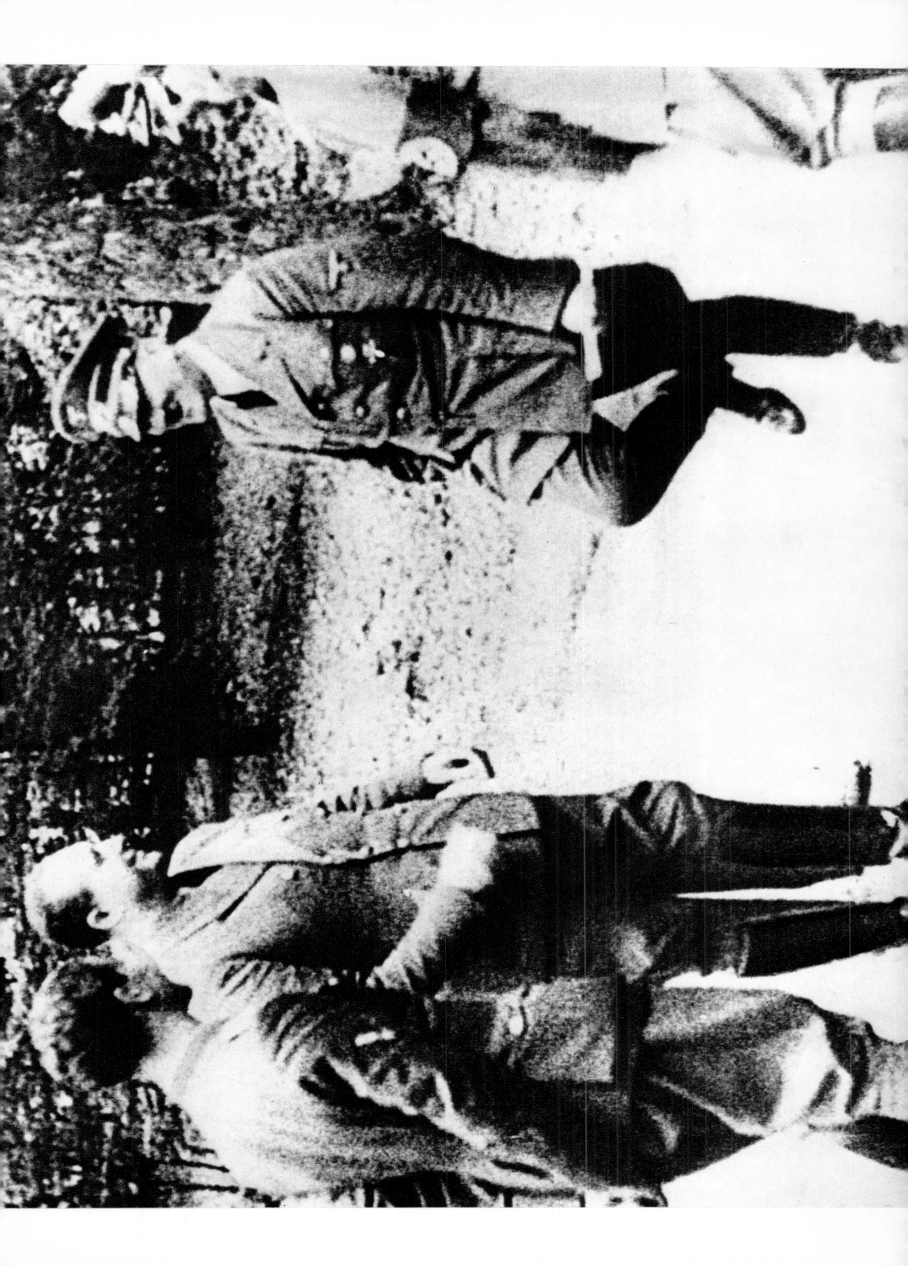

AU REVOIR, BUT NOT GOODBYE

Tears on the streets of Marseilles. Elsewhere, brave words. But how much real hope?

"Democracy is not dying," Franklin Roosevelt said, in his third inaugural. Dictatorship is not "the wave of the future."

The House passed his Lend-Lease bill. America was about to drop its facade of neutrality and begin a vast flow of war goods to beleaguered Europe. Would it come in time?

"Give us the tools," Winston Churchill told the United States," and we will finish the job."

Finish? It was hardly begun. It would be more than a year before the Axis tide would be stopped in Europe and Asia and Churchill could say, with more confidence, "It is, perhaps, the end of the beginning."

But now it is February 19, 1941, and Hitler holds the whole Atlantic coast of Europe. Norway, the Netherlands, Belgium and France have fallen. London is being pounded daily by bombing raids and searing fire storms. Invasion is expected any day from the greatest army in history poised across the Channel.

Germans occupy three-fifths of France. What is left, Vichy France, is supposed to be free to govern itself but Hitler keeps squeezing.

And in Marseilles, the flags of defeated French regiments, stranded in unoccupied France since the black armistice with Hitler, are now being carried down to the docks to be sent to Algeria for safekeeping. How long would they be safe there? How long would Frenchmen be safe, in Marseilles? They weep.

Photographer unknown.

CHANGING TIMES

General Motors had caved in. Chrysler had caved in. Among the big ones, only Henry Ford remained.

Lean, gray, stubborn Henry Ford, the last of the giants, who had put America on wheels with the assembly line and the Model T and the Model A. Henry Ford, the last of the rugged ones, who had startled the world in 1915 by paying a minimum wage of $5 a day. Henry Ford, the pacifist, the anti-Semite, the absolute boss of one of the last of the huge family empires. In a catalogue of hates, the old man despised labor unions the most.

He would close up the Ford Motor Company and throw away the key, he said, rather than deal with a labor union.

In 1937, when General Motors and Chrysler succumbed to the United Automobile Workers of the CIO after crippling sit-down strikes, Ford and his iron-backed chief of staff, Harry Bennett, wouldn't even tolerate union recruiters outside his plant. In the ensuing "Battle of the Overpass" at the River Rouge Plant, a combat that endures in labor's litany of horrors, a young UAW leader named Walter Reuther and others were beaten and bloodied, within an inch of their lives, by Ford goons for trying to pass out union leaflets. . . .

And now it is April 3, 1941, and the muscle is on the other arm. For the first time in its history, the Ford Motor Company, with 120,000 employes, is closed down by strike, and flying union squads make life difficult for strikebreakers.

Henry Ford finally caves in, suddenly turning full circle by giving the union its best contract in the industry. . . .

And in 1970, when Walter Reuther and his wife were killed in a plane crash, flags flew at half staff on Detroit city buildings and the central offices of the auto companies, and the funeral service was conducted in Henry and Edsel Ford Auditorium and among the cabinet members and senators and industrialists who joined the mourners and sang old union songs were Henry Ford II and the heads of General Motors and Chrysler.

At the Detroit News, Milton (Pete) Brooks was known as a patient, one-shot photographer, the man who would wait forever for The Picture and then go home. Covering the Ford Strike in 1941, he noticed a man arguing with the union pickets. "He had the wrong side of the argument and I figured there would be trouble pretty soon." While other photographers ran off in other directions for more promising fodder, Pete Brooks waited. The man arguing with the pickets tried to push his way through the line and the pickets grew more emphatic and Pete Brooks quietly took one shot, a winner.

☆ *First Pulitzer Prize for photography, 1942.*

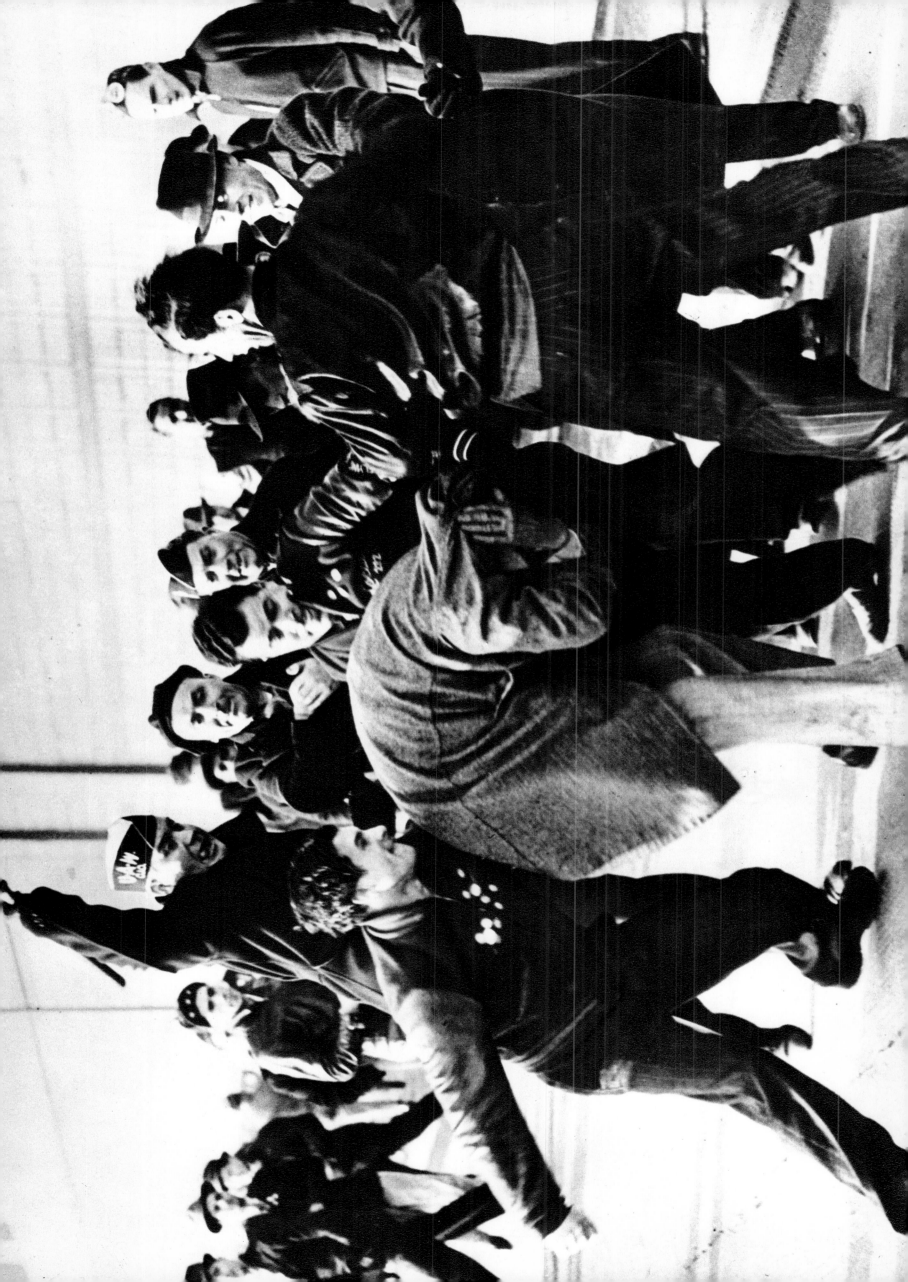

DAYS

All through the long year of 1941, the tempo quickens to an inevitable end—war. But where? When?

The Navy has broken the Japanese codes, but the signals are unclear. Indo-China? The Philippines?

Presumably safe behind its two ocean frontiers, the United States is arming. In four months Chrysler turns a farm into a tank arsenal and is busily building an initial 1,000 vehicles. Ford is going to build four-engine B-24 bombers, General Motors, the swift twin-engine B-25. Franklin Roosevelt, elected to an unprecedented third term, has called for 50,000 planes a year. Berlin sneers. "Bluff," says Joseph Goebbels. "A sick brain," says Adolf Hitler. (Before it is over, America will be turning out 60,000 planes a year.)

In January, Roosevelt homilizes that in case of fire one would naturally lend one's garden hose to a neighbor without first insisting on terms, and in March, after great debate, Congress passes his Lend-Lease bill providing arms to Britain and other countries fighting Hitler.

And none too soon, for in June Hitler's armies sweep into Russia, tank treads obliterating his non-aggression pact with Joseph Stalin. Japanese troops move, too, debarking in Indo-China while the French, defeated and out of the war, stand helplessly by.

Roosevelt reacts by freezing Japanese assets in the United States. The Dutch embargo oil shipments to Japan—and modern armies march on oil.

America moves out into the Atlantic, giving England 50 over-age destroyers for bases in the West Indies and landing troops in Greenland and Iceland. Port defenses are strengthened somewhat at Midway and Guam and garrisons bolstered across the Pacific.

In October, Gen. Hideki Tojo, the "Razor Brain," is named head of the Japanese government and appoints a cabinet "that smells of gunpowder."

The days tick down.

November 14. Tojo's special envoy, Saburo Kurusu, arrives in San Francisco "to make a touchdown" for peace.

November 17. Kurusu and Ambassador Kichisaburo Nomura tell Secretary of State Cordell Hull the U. S. must end its economic embargo, stop aid to China and recognize Japan's "Greater East Asia Co-Prosperity Sphere."

November 25. From Tankan Bay in the Kurile Islands, a large Japanese fleet sails east, under complete radio silence.

November 25. Hull rejects the Japanese demands, counters with U. S. demands: get out of China and Indo-China, withdraw from the Axis.

November 27. Secretary of War Henry Stimson warns Gen. Douglas MacArthur in the Philippines: "for all practical purposes," Japanese negotiations appear ended. Other alerts go out to the Pacific.

December 3. "East winds, raining." Signal for all Japanese diplomats in U. S. to burn their papers.

December 5. "Climb Mount Niitaka," the final, irrevocable signal. The Japanese fleet now moves at flank speed, southeast. . . .

With President Roosevelt looking on, Secretary of War Henry Stimson draws the first number—158—in the first peacetime draft in U. S. history, October 30, 1940. Photographer unknown.

MINUTES

There have been so many signals, some caught by American decoders, some missed. What does it all mean?

On December 6, Navy Capt. Alvin Kramer of the cryptographic section might have known if he had finished translating a radio intercept of a Japanese spy in Hawaii. But there is more pressing business. Tokyo is transmitting to Nomura: all U. S. demands rejected; inform Hull, Sunday, December 7, at 1 p.m. This is decoded. But what does it mean?

December 6. Roosevelt sends a personal peace plea to Emperor Hirohito. Gen. George C. Marshall, Army chief of staff, prepares an alert message to Pacific Army commands, including Hawaii.

The minutes tick down, to December 7.

Oahu, shortly after 7 a. m. On his mobile radar, Pvt. Joseph Lockhard sees what appears to be a large group of aircraft approaching at a distance of 137 miles. He is told it is surely an incoming American flight. He goes out to breakfast.

Washington, 1 p. m. Kurusu and Nomura ask to see Hull. He agrees to meet them at 1:45 p. m.

And at 7:55 a. m., Hawaiian time, which is 1:25 p. m., Washington time, a young man is riding a two-cylinder Indian Scout motorcycle out of Honolulu. His name is Tadao Fuchikami and he works for the Radio Corporation of America and he is carrying a message to the "commanding general" at Fort Shafter, when the bombs fall.

He dives into a roadside ditch, and it will be three hours before he delivers the message, which is the warning alert from General Marshall, which couldn't be sent via Army radio because of static and was turned over to Western Union and then RCA. In the end, the power and the genius of America had dwindled down to a boy on a two-cylinder motorbike . . .

The surprise is complete, and the huge naval base explodes in towering flames. The battleship Arizona takes a bomb through her stack and becomes a tomb for 1,000 men. Seven other battleships, lined up in a row and dead in the water, are hit and severely damaged.

Americans fight the attacking planes with anything at hand, machine guns torn from their mounts and fired from the hip, rifles, handguns, anything. Seaman William Clemons, raging in a frustration that was soon to seize a nation, stands on the deck of his ship throwing the most lethal weapon around—potatoes.

A clerk at Wheeler Field insists that Lt. Robert Overstreet sign a receipt for sidearms. "Hell, man," the agitated officer replies, "this is war!"

It is. December 7, 1941. Pearl Harbor Day.

The day that would "live in infamy." The day the oceans proved as useless a protection as the Maginot Line, and the back of the Pacific Fleet was broken in the mud off Honolulu, and 2,343 Americans were killed and 916 others were missing in the first attack on American territory since 1812. The day of ultimate shock and fear and rumors that the Japs were landing in California and Alaska, the day they could have. The day the great debate ended and the suspense ended and isolationists became interventionists and a leading convert, Sen. Burton K. Wheeler, said, "The only thing to do now is lick the hell out of them." The day everybody would remember, where they were, what they were doing when the word came, the day he looked at her and she looked at him and both of them knew he'd be going sooner or later. December 7, 1941, the day America went to war more united, probably, than ever before, more united, certainly, than any time since. "Praise the Lord and Pass the Ammunition!"

Photograph of Arizona by unidentified Navy photographer.

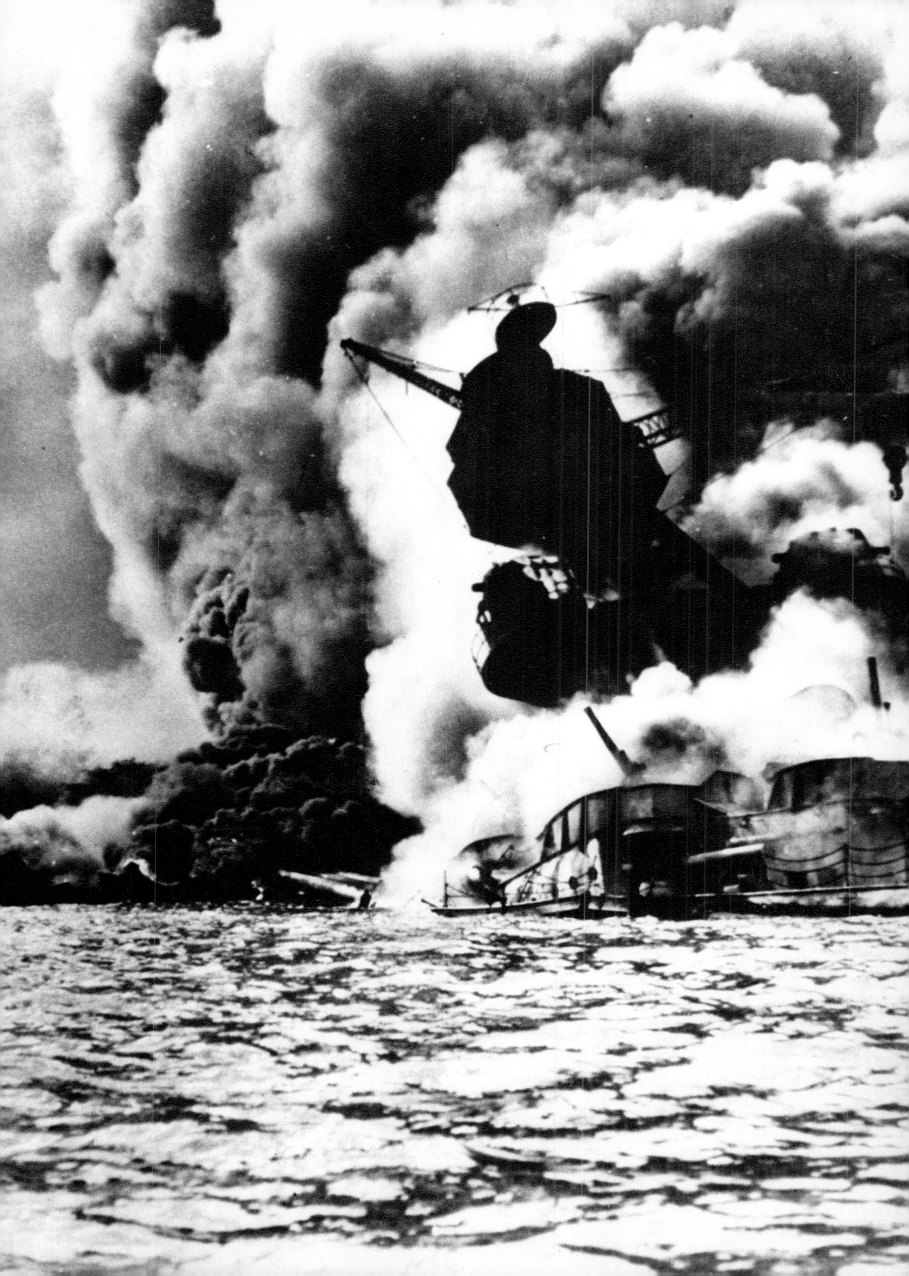

"WATER!"

Singapore, January, 1942. Americans still feel the shock of Pearl Harbor.
British, Dutch and American forces reel before the Japanese onslaught.
Luzon in the Philippines falls. Also, Guam, Wake Island, Hong Kong. MacArthur
withdraws his battered troops to Bataan. The British battleships Repulse and
Prince of Wales are sunk. When Japanese planes attack Singapore, Associated
Press photographer Frank (Pappy) Noel is amazed that the city is so unprepared
—the streetcars keep running through the raid.

Pappy Noel, balding, a little heavy around the middle, already a veteran
photographer, is now stranded in Singapore. He has tracked the weary
British through their jungle retreat. Malaria grips him. The AP orders him to
Calcutta. Singapore is about to fall.

He manages to book passage on a British ship leaving Singapore empty.
A Japanese submarine finds them at night 270 miles out of port. The torpedo
slams into the freighter. Noel is trapped in his cabin by a jammed door.
He picks up a heavy chair and batters the door down.

For five days, he and 27 other survivors of the ship's company of 77 wallow
in lifeboats under the withering Asian sun. One lifeboat passes near Noel's
and an Indian sailor pleads for water. Noel instinctively shoots the picture.
Ultimately, the castaways reach the coral reefs near Padang, Sumatra.

*Ordered home, Noel signs on as a crewman aboard an American freighter,
with only the clothes on his back and his camera. The trip covers 15,000 miles.
Fighting malaria and coral poisoning, he finally reaches America, where his
picture of the thirsty sailor wins a Pulitzer. Making out his expense account,
Noel notes: "One torpedoing—no charge."*

*For Pappy Noel, this is just the beginning of war. He carries his camera through
World War II in Europe, the Palestinian war of 1948, and the Korean War, in
which he is held 32 months in a Red Chinese prison camp. He dies in 1966,
in retirement at Tallahassee, Fla.*

☆ *Pulitzer Prize Winner, 1943.*

A LADY CALLED LEX

For several days the two fleets have been groping for each other like blindfolded boxers.

The Americans have radar, the Japanese none. But a tropical storm is skittering through the Coral Sea between New Guinea and Guadalcanal, making surface search difficult. The goal of the escorted Japanese troopships is Port Moresby, on New Guinea. If the enemy can establish a base there he will isolate Australia by cutting the shipping lanes to the United States.

Each side has already struck a blow, the Japanese sinking two American oilers, Navy airmen sinking the small Japanese carrier Shoho.

But the main targets of the opposing fleets are two carriers with the Japanese strike force—Zuikaka and Shokaku—and the two U.S. carriers of Task Force 17, Yorktown and Lexington. The "Lady Lex" is a big one, originally laid down as a battle cruiser and modified after the Washington Naval Treaty of 1921 that restricted fleet size.

She is one of the Navy's proudest ships. Every one of her skippers has made admiral. She has steamed 345,000 miles and landed 57,700 planes in her career. Some of her original crew are still on board the ship that has been so lovingly tended paint on some of her bulkheads is almost a quarter inch thick.

May 8, 1942: 0600 hours. The Japanese launch search planes, thinking the U.S. carriers are to the south.

0625: American scout craft take off for a 360-degree hunt. Capt. Forrest C. Sherman, the Lexington's skipper, thinks both sides will find and hit each other at the same time.

0815: Contact with the Japanese carriers. Lexington and Yorktown launch attack planes which hit Shokaku with three bombs, forcing her to retire.

1100: Japanese torpedo bombers find Task Force 17. They skim in on either bow of the Lexington so that no matter where she turns a torpedo will find her. Eleven miss but at 1118 one torpedo hits her port bow. Then another. Then two direct bomb hits.

Cmdr. H. R. Healy, damage control officer, and his men get the fires and leaks under control. "But I suggest, sir," he tells Sherman, "that if you have to take any more torpedoes, you take them on the starboard side."

1247: Gas fumes from ruptured fuel lines ignite, apparently from a sparking generator, and the Lexington is torn by explosions. The thickened paint feeds the flames. Healy and most of his crew are dead. Communications are all but worthless. The Lexington burns.

1707: Sherman is told by the task force commander, "Well, let's get the men off." They crawl down ropes over the steaming sides of the huge ship. Boats and rafts go into the water. Every one but those already dead gets safely off. Sherman checks the ship to make sure. Then he goes to his cabin for his best gold braid cap.

"They tell me there won't be any more real gold braid until after the war," he says. Then he, too, abandons ship, the last man to go.

2000: Still on an even keel, the Lexington goes down.

Tactically, the Japanese win. But the Battle of the Coral Sea marks the farthest Japanese penetration in the Southwest Pacific. Task Force 17 has turned back the landing on New Guinea.

Photographer unknown.

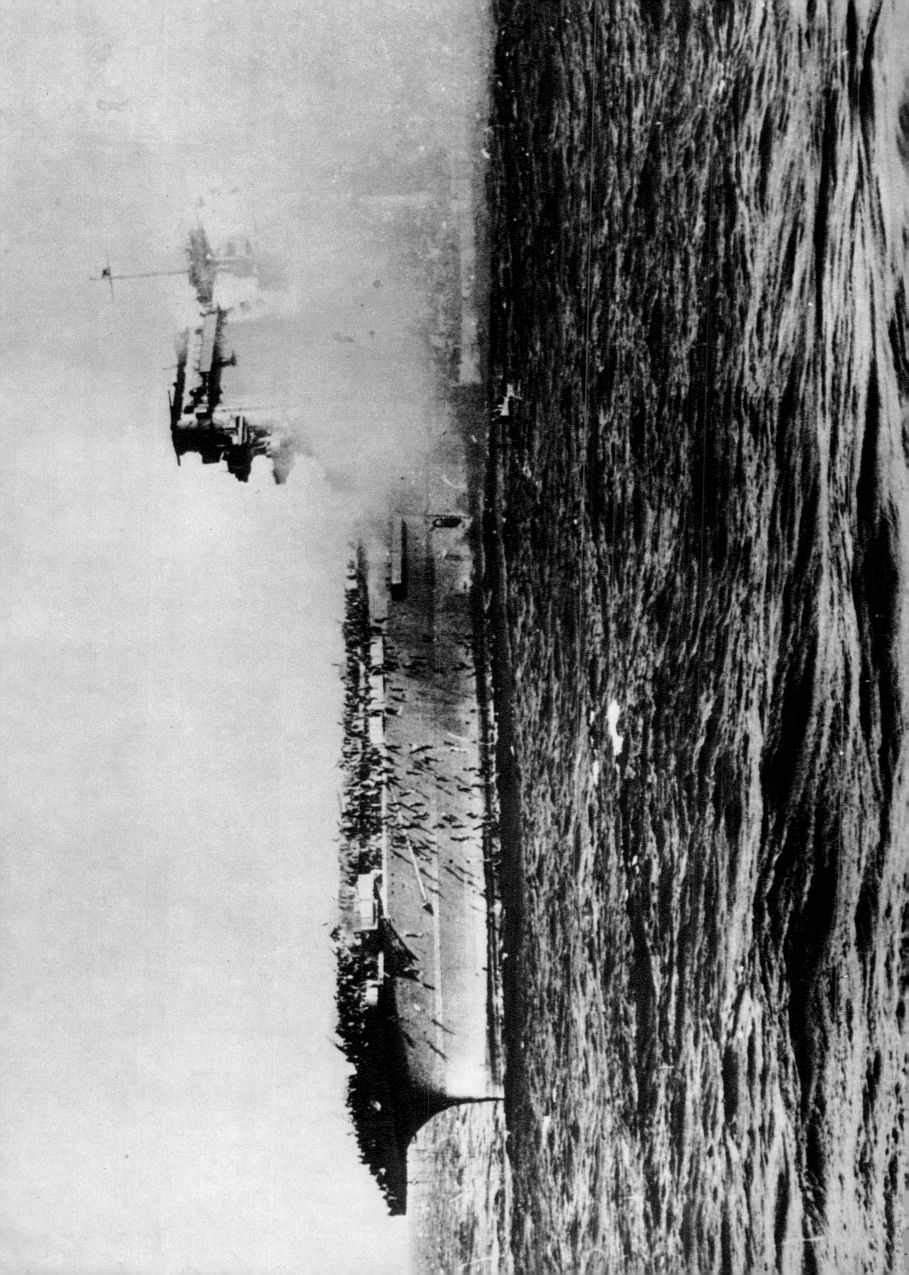

ON THE WAY BACK

He stands in the waist of a Flying Fortress, as always larger than life.

Theatrical? Yes, Gen. Douglas MacArthur was that. He may have been only pointing at a seagull off-camera, but he was a man who knew how to stage his great moments in history, moments in which he justly played major roles as one of the nation's greatest warriors.

This was the man who went over the top in World War I, armed with only a riding crop, and returned with a prisoner. A man ordered out of the inexorable trap of the Philippines in 1942 who said on landing at Alice Springs in Australia: "I came through and I shall return." And did, dramatically, three years later, with a corn cob pipe clamped in his jaws and his father's old revolver in a back pocket, and wandered along the beach saying, "This is what I dreamed about."

This is a first step back in realizing that dream. In September, 1943, MacArthur is flying over New Guinea where 1,700 men are parachuting into the jungle near Lae in a beginning of Operation Cartwheel, a six-month hop-skip operation to take Rabaul, the big Japanese base on the island of New Britain.

Other steps followed—Hollandia, Sarmi, Biak, Morotai—names now as overgrown as the battles they marked. But to get there, MacArthur had to fight his own people, particularly the U.S. Navy, which favored an amphibious campaign through the Central Pacific instead of MacArthur's advocacy of opening the route to an eventual landing in the Philippines.

Eventually there was a compromise, for there was a war in Europe, too, where plans were being made for the Normandy landing next year. GIs were already fighting in Italy and a massive air bombardment was leveling Germany.

MacArthur's obduracy left scars and controversy, both in World War II and later in Korea when he was fired from his command. Chief of Staff Gen. George C. Marshall said MacArthur was "oversensitive about everything."

But he was also a man who could tell Lt. Gen. Robert Eichelberger in a prelude to the Lae operation: "Bob, I want you to take Buna or not come back alive."

The picture was taken by an unidentified photographer of the U.S. Signal Corps.

TARAWA

The battle of the Pacific shifts, inch by inch. Behind now are allied victories at Midway, Guadalcanal, the Coral Sea. In March, 1943, the Japanese lose 22 ships in the battle of the Bismarck Sea. The slow, painful island-hopping continues.

In November, 1943, the U.S. battle fleet stands off the Gilbert Islands in the South Pacific. The bombardment is terrible. But the Japanese machine guns keep rattling their deadly pattern as the Marines wade ashore in neck deep water at Tarawa. It is perilous and tough going. The Japanese are well dug in, in bunkers and blockhouses made from sand, coral and coconut logs. Flame throwers and grenades finally turn them out. The conquest of the Gilberts costs nearly 1,100 dead, 2,700 wounded, in three days.

Associated Press photographer Frank Filan moves in with the combat waves as bombs and artillery chew up the idyllic archipelago before them. Filan's landing craft is hit and begins to sink. He hits the water with his heavy load of cameras, loses them all, and manages to swim the 50 yards to shore. A photographer without a camera. Somehow, he finds a Marine who lends him a camera and Filan moves forward with the troops. The Japanese are burned black by the flaming gasoline. As they die, the bullets in their cartridge belts explode from the lethal heat. The stench of burning flesh is nauseating. Filan aims his borrowed camera at the silent and broken mound of sand that was a Japanese bunker, strewn with the litter of war, bodies and tortured metal.

☆ *Pulitzer Prize Winner, 1943.*

HOME

In North Africa, he and his battalion of Iowa boys had held off two Panzer divisions for three days on a hill called Lessouda, held them off until his outfit was ordered out, and he led them back through 15 miles of German lines, through rifle fire and machine gun fire and artillery fire and he saw 35 of his rawest recruits die because they froze and wouldn't shoot back and then he reached Kasserine, where he was bombed and hospitalized and awarded the Distinguished Service Cross, and now he was home. . . .

Villisca, Iowa, July 15, 1943. Lt. Col. Robert Moore, who has been away 16 months, sees Nancy first as he steps off the train, seven-year-old Nancy darting out of the crowd at the station. He drops his bedroll and his helmet and moves quickly toward his daughter and she, toward him, and Dorothy, his wife, comes in a close but grateful second.

———————

By Earle L. Bunker of the Omaha World Herald.

☆ *Pulitzer Prize Winner, 1944.*

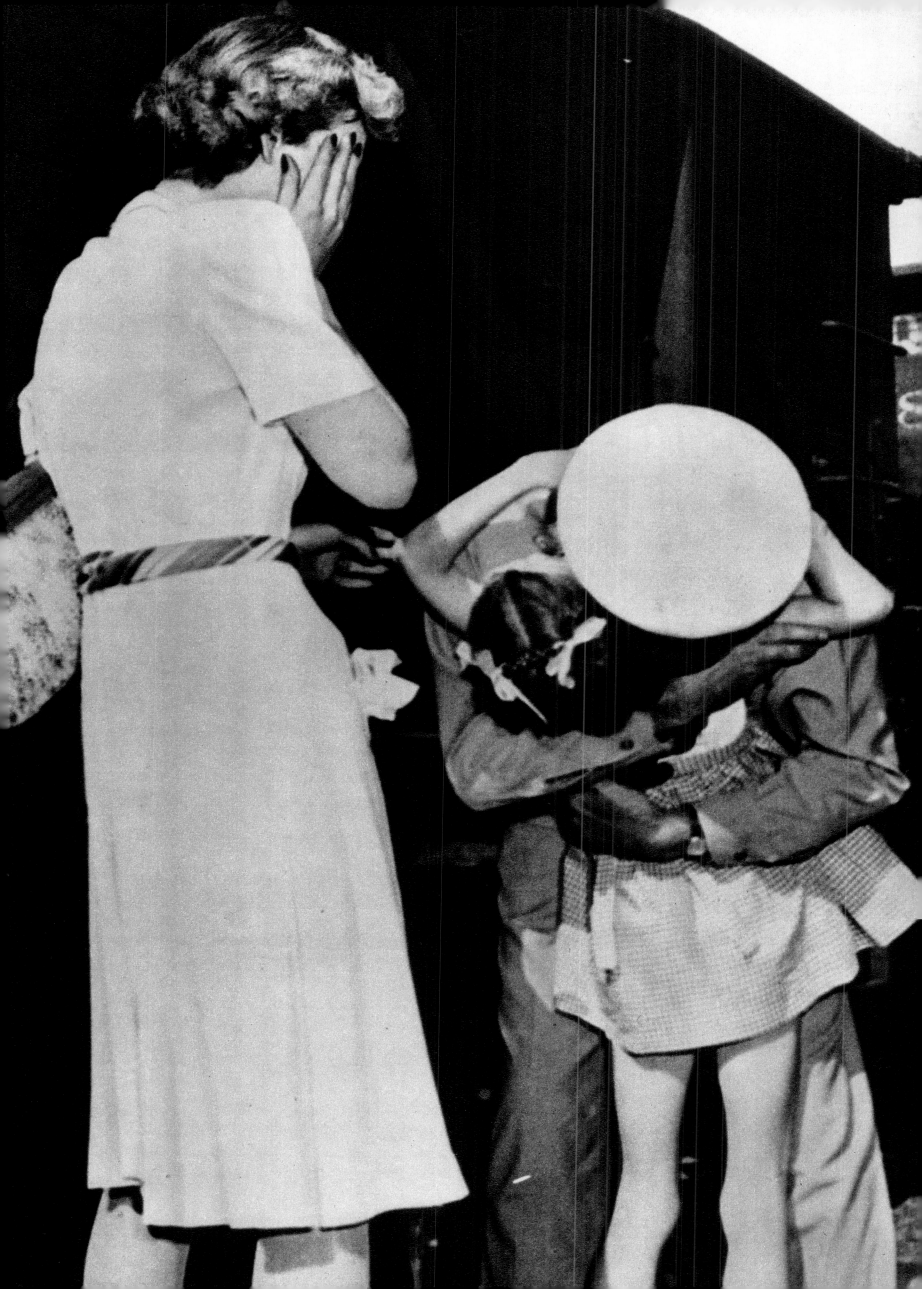

DIRECT MALE

It said right there in the Montgomery Ward catalog that the mail order house would "take orders from anybody."

But Sewell Avery, the absolute ruler of the firm, isn't moving out of his green leather chair for any one, particularly the government of the United States of America.

There's a war on and the Allies are about to invade Europe and the Marines are having a hellish time taking Peleliu but Sewell Avery ain't moving, period.

The government, headed by That Man in the White House, Franklin D. Roosevelt, wants a maximum war effort in general by American industry and for Avery in particular to extend an expired labor contract to end a strike. No soap.

FDR sends an undersecretary from the Department of Commerce to tell Avery the government is going to seize his Chicago headquarters if he doesn't give in. Nope, says Sewell.

Next morning shows up Lt. Ludwig Pincura with 43 MPs. No, says Sewell. He isn't moving.

NEXT morning shows up Attorney General Francis Biddle himself.

"We told Mr. Avery he would have to leave," says the attorney general. "Mr. Avery refused."

So the Army invades Ward's, April 27, 1944. Sgt. Jacob L. Lepak and Pvt. Cecil Dies take hold of each side of Sewell Avery and with undue process carry the 170-pound, $100,000-a-year executive into the hall, down the elevator and onto the street while the rest of the firm goes back to work.

But Avery has the last word. Before his departure he delivers the severest curse an industrialist could hurl at a Rooseveltian attorney general: "You New Dealer!"

Associated Press photographer Harry Hall is outside Ward headquarters doing what photographers do a lot of: waiting for something to happen. Then all of a sudden out of the door pops Avery cradled by his military escort. "Whaddya know, the army just carried out Sewell Avery," Hall tells his startled bureau and he had the picture to prove it. Let it be said, however, that by the time he gets to his car even Avery thinks it is funny and smiles as he drives off.

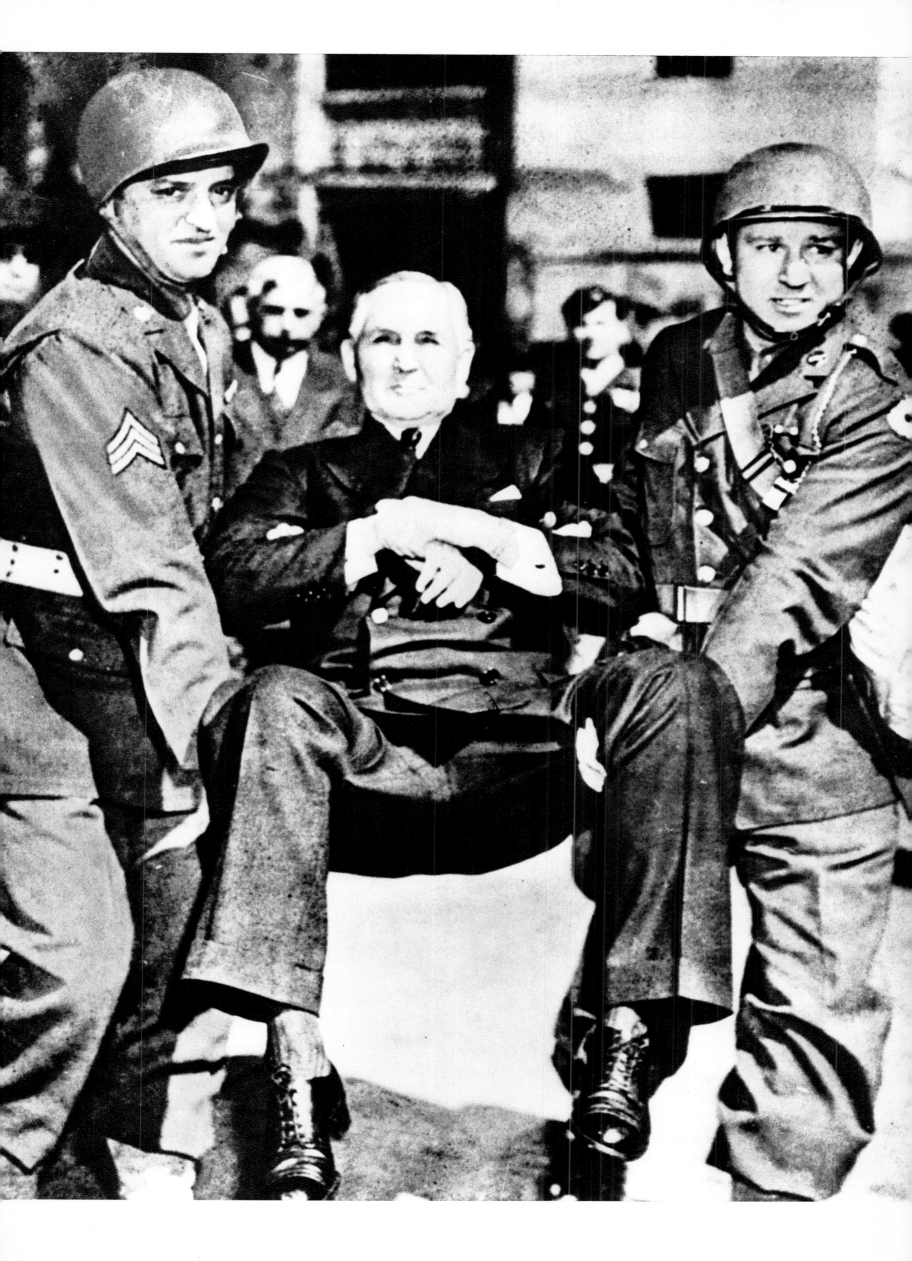

NORMANDY

It had been a long road to this place. . . .

With Pearl Harbor only 11 months old, the grand Allied strategy became clear: attack North Africa, trap Rommel in the desert, open the Mediterranean and outflank Europe; get Hitler first, Tojo later. Roosevelt and Churchill gave the job of getting Hitler to a nice guy few people had heard of, a lieutenant general named Dwight David Eisenhower.

With British troops breaking German steel at El Alamein, from the east, Eisenhower aimed a force of 850 ships, 185,000 men at North Africa, from the west. Rommel saw the trap and begged Hitler for permission to withdraw. But the Fuehrer, in one of a parade of errors, refused. Rommel hurled his Panzers at the Americans, who had not yet been blooded in battled, and broke through the surprised, green troops.

But reinforcements stopped the Germans at Kasserine Pass, and they were no longer asking, "Can the Americans fight?" They could, and Rommel's retreating army was chewed up in Tunisia and the Germans were pursued to Sicily and up the boot of Italy, and it was a long, bloody slugging match through Salerno and Cassino and Anzio and other places the transient Americans would never forget.

On the eastern front, the German tide that had swept through Europe broke on the rock of Stalingrad. Again Hitler overrode the advice of his generals and ordered his Sixth Army, 600,000 men, to stand and fight at the Volga. There it was trapped and destroyed by Russian troops and Russian winter, and the German commander finally had to surrender to a 27-year-old Russian lieutenant in the basement of a department store.

Hitler had been stopped and pushed back from the south and the east. . . .

And now he waits, behind the Atlantic Wall of Fortress Europe.

And now Eisenhower waits, in the south of England, with the greatest amphibious force in history.

And now is now, June 6, 1944. After one day's postponement because of weather, the wind is still high but the forecasts are better. For a full five minutes, he sits there silently. And then Eisenhower says, "We'll go."

And they go.

Men and ships and planes by the thousands. Airborne troops to isolate the landing areas from inland. Battleships and planes to clear the way. And men, wading ashore along a 60-mile front between Cherbourg and Caen, slipping, falling, drowning, clinging to tank traps, crawling, running, hugging the protection of the bluffs.

The initial cost is high, but less than expected: 10,724 casualties, including 2,132 dead. By D-Day plus 11, the Allies have 600,000 men ashore. By D-Day plus 20, there are a million. The Allies are on the Continent to stay.

———————

Photograph of action at Omaha Beach by Robert Capa of Life Magazine and Magnum.

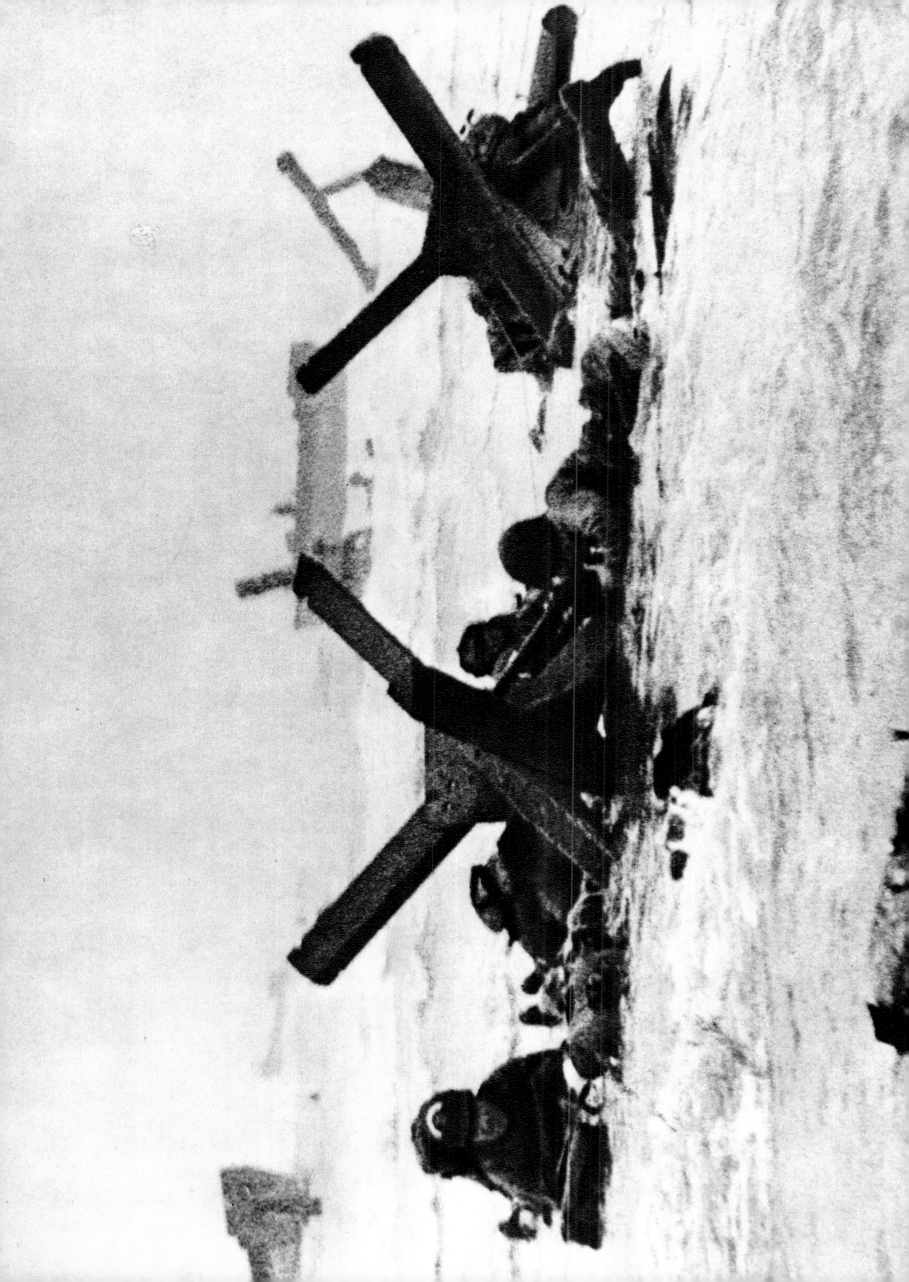

ONCE MORE, WITH FEELING

Frenchmen watch and do not forget. This is the route the Nazis marched every noontime for four dark years in the city of light, from the Arc de Triomphe down the Champs Elysees to the Place de la Concorde, arrogance on parade, rubbing French noses in defeat.

That is over now. Paris is again free. The last German sniper is dead. Four days after liberation, August 29, 1944, some 15,000 Americans march shoulder to shoulder down the famed Parisian boulevard.

To the Americans of the 28th Division, it is only a glimpse of the city, a brush with an old obligation. "Lafayette, we are here," their fathers said in World War I. "Lafayette, Kilroy is here," they say now.

They are here only briefly now, sent reluctantly by Dwight Eisenhower in answer to a plea from Charles DeGaulle for a show of force to establish order. By nightfall, they are back in the line against the Germans. . . .

The Yanks had fought all the way from the beaches.of Normandy, the worst being in the ancient hedgerows so thick only tanks with special huge blades could cut through. Finally, on July 25, they broke through the crust of German defenses at St. Lo. George Patton then raced through the breach, freed the Britanny Peninsula and its vital ports and turned east, trying to catch and smash as many retreating German units on the road as he could before they reassembled behind the Siegfried Line.

Now, after the fall of Paris, with more than 2,000,000 men stretched in a north-south line, four great spearheads of Allied armor raced east through France and Belgium at a clip of 20 to 50 miles a day. Ahead of them lay the Siegfried Line, the Rhine and a bridge at Remagen and a place called Bastogne, where Hitler would gamble for the last time in the death rattle of the Wehrmacht.

Pete Carroll, a young Associated Press photographer, was by now a veteran of Normandy and the sweep across France. He photographed the last street fighting in Paris ducking rifle fire. On the day the Champs Elysees was carpeted with curb to curb GIs, he shared the back of an army truck with Harry Harris of the AP. They tossed a coin for the shot and Carroll made the picture, desperately trying to steady his camera over the bumping wheels.

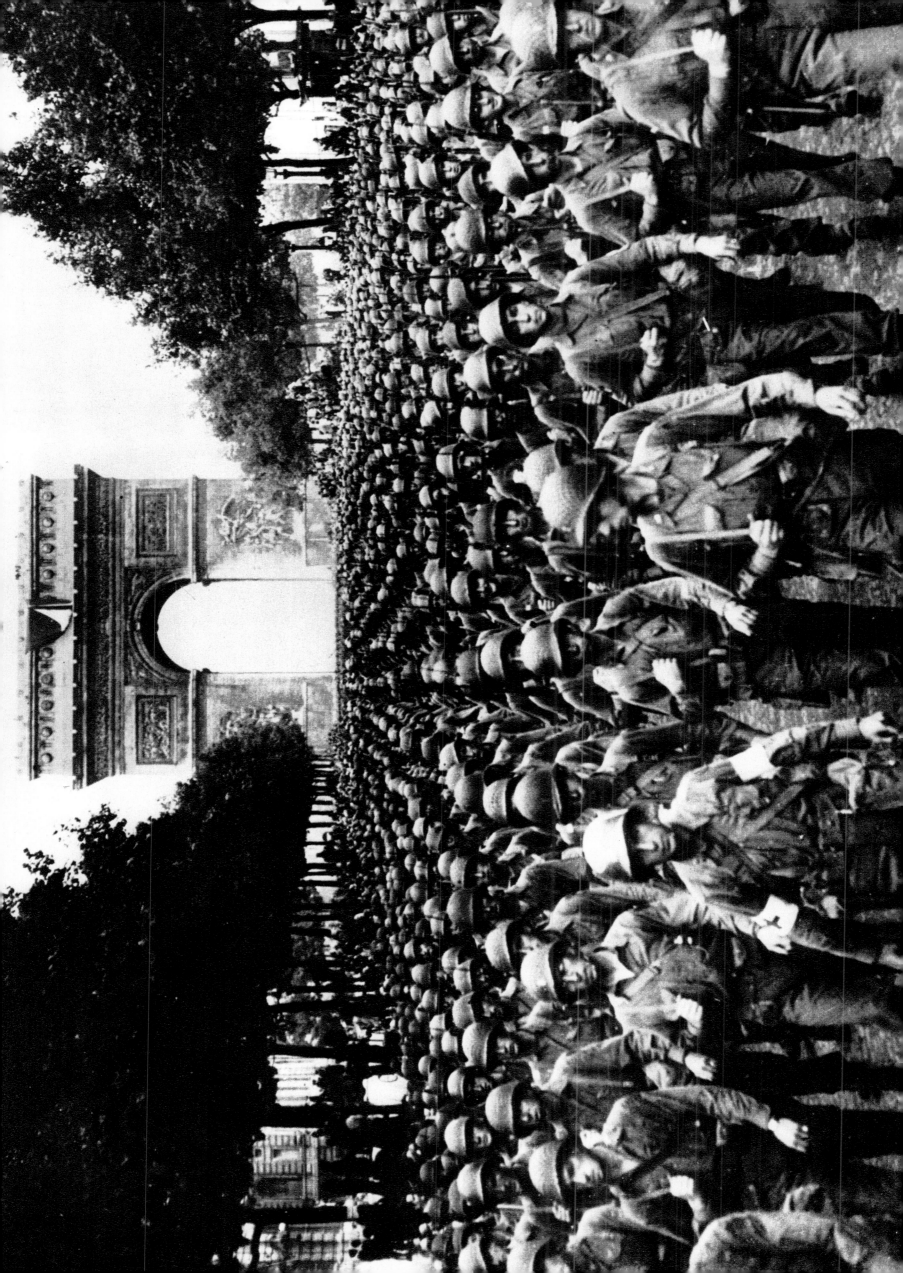

IWO JIMA

February 23, 1945. The morning of the fifth day.

Before it is over, 31 days later, there will be 6,821 Americans killed, 19,217 wounded in the bloodiest single battle of the Pacific. All this for a miserable piece of volcanic ash called Iwo Jima, an island five miles long and two miles wide at the widest. Tiny but crucial in the grand arc of island-hopping that began in Australia and now reaches within 700 miles of Tokyo.

10:15 a.m. Mt. Suribachi seems finally secured. The peak 550 feet above the sea appears still, the enemy caves empty and smoking. The Marines raise a small flag. Two Japanese dart out of a cave with grenades. They are shot down. Now, Suribachi is secure.

Offshore, a round, little, myopic man in glasses slips while transferring from the command ship to an LCVP. He bobs helplessly in the roiled sea until he is fished out, without his helmet. Finally, he makes it to the beach and borrows a helmet from a dead Marine near a burned out jeep.

They tell him the flag is going up atop Suribachi and the myopic little man, Joe Rosenthal of the Associated Press, huffs and puffs his way to the peak.

12:15 p.m. The Marines want no doubts; they will establish clear title to Suribachi. The first flag comes down. A new flag is going up, five by eight feet, twice as large as the first. Joe Rosenthal scampers around building a little cairn of rocks and stands on it for added height. He raises his 4X5 Speed Graphic. The Marines lunge forward, driving the new flag home . . .

Joe Rosenthal shoots, hoping he caught the scene "right at the peak of the action. One tiny part of a second off and you lose it."

Three Marines now steady the flag while the others search for rope to secure it. Joe Rosenthal shoots that. The whole group reforms. "Come on, fellas, this is historic," he says, kidding. The Marines wave their rifles and helmets at the camera. Joe Rosenthal shoots that, too, and wonders which of the three shots will make the papers. If any. He has, at the moment, no sense of history, certainly no intimation of a huge sculpture cast in epic bronze that would become the centerpiece of a nation's tribute to its valiant dead.

☆ *Pulitzer Prize Winner, 1945.*

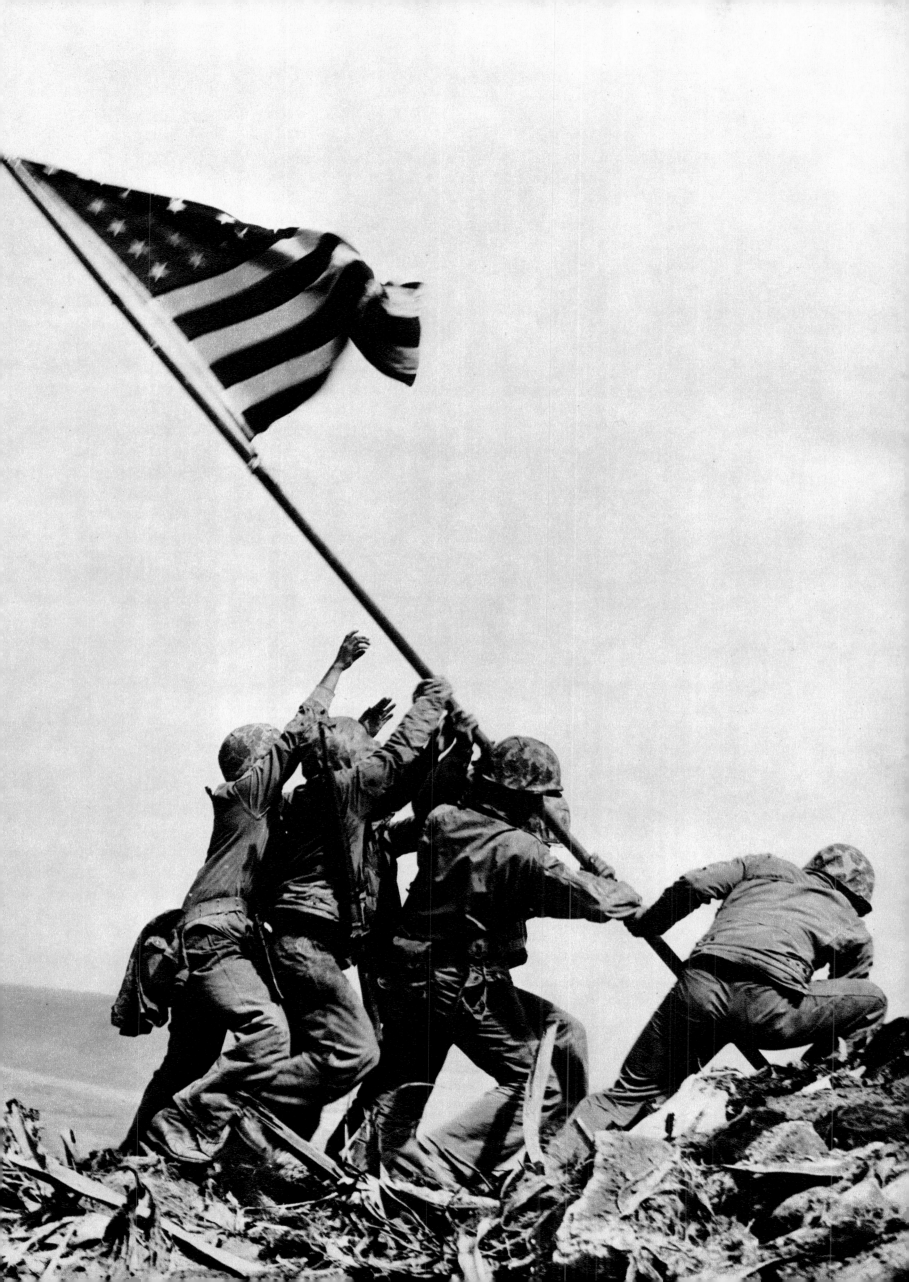

VENGEANCE IN THE PIAZZA

In the early days when he strutted his balcony and flashed his eyes and jutted his chin and promised the world, he used to say things like:
"I shall make my life a masterpiece."
Or:
"If I retreat, kill me."
In the end, Benito Mussolini, the first of the Fascist dictators, became the first of the bad Italian jokes.

In World War II, he waited until June, 1941, to come in, at a time when he thought his partner, Adolph Hitler, had it almost won. He attacked France, which already was in collapse and only 11 days from surrender. "The hand that held the dagger has struck it into the back of its neighbor," Franklin Roosevelt said.

During the war, Mussolini led Italy into a series of military disasters so bad Hitler quickly reduced him to a silent junior partner, who did not learn until the day before that the Germans were about to attack Russia. Thereafter, Hitler used Italian forces primarily as occupation or auxiliary forces.

By 1943, with Allied troops pushing up the Italian peninsula and Mussolini's generals plotting against him, Il Duce was dumped from power and had to be rescued by German paratroopers from the hands of his successors. He was set up by the Germans as head of a puppet government in north Italy, which carried out savage reprisals against those who had dethroned him. Among those executed was Count Ciano, his son-in-law.

The German army still controlled north Italy when the final year of the European war began, but it was retreating fast. Italian partisans swept through the streets without hindrance and about 6 a.m. on Thursday, April 26, 1945, Mussolini quietly sneaked northward, trying to reach Switzerland. At one point he joined a German truck convoy futilely disguised in a German officer's coat.

Two days later Italian partisans found him. The deposed dictator, then 61, and his mistress, Clara Petacci, 25, were holed up in a cottage on a hill outside the village of Dongo. A partisan commander dispatched 10 men and an officer with simple instructions: "Settle the matter."

Il Duce saw his countrymen approach and when he discovered they had come, not to liberate, but to arrest him, his huge face shook with fury and he roared, "Let me save my life and I'll give you an empire!" The partisans told him he had been condemned to death. They held a "trial," to certify the death sentence, then stood Mussolini, his mistress, and 16 other Fascists up before a hastily organized firing squad. Il Duce's last words: "No! No!"

The 18 bodies were hauled in a van to Milan—the city where Mussolini had formed his Fascist party 22 years before and launched his Black Shirt march on Rome. . . .

Friday, April 29. The bodies lie sprawled in a heap in the bright sunshine of the Piazza Loretto, a downtown square. Mussolini's head rests against the breast of his mistress.

Townspeople rush forward for a close look at Il Duce's battered, bullet-riddled body. Partisan guards fire vainly in the air to keep them back. One man tramps across the bodies and kicks the shaven head of Mussolini viciously. A woman empties five shots from a pistol into the corpse, screaming, "Five shots for my five murdered sons." Others complain: "He died too quickly. He should have suffered."

But most people say nothing. They can only spit.

By mid-morning the crush of vengeful viewers becomes dangerous: several are trampled. The partisans raise the bodies of the dictator and his mistress to a scaffold, hanging them by their feet for the world to view. . . .

———————————

Photographer unknown.

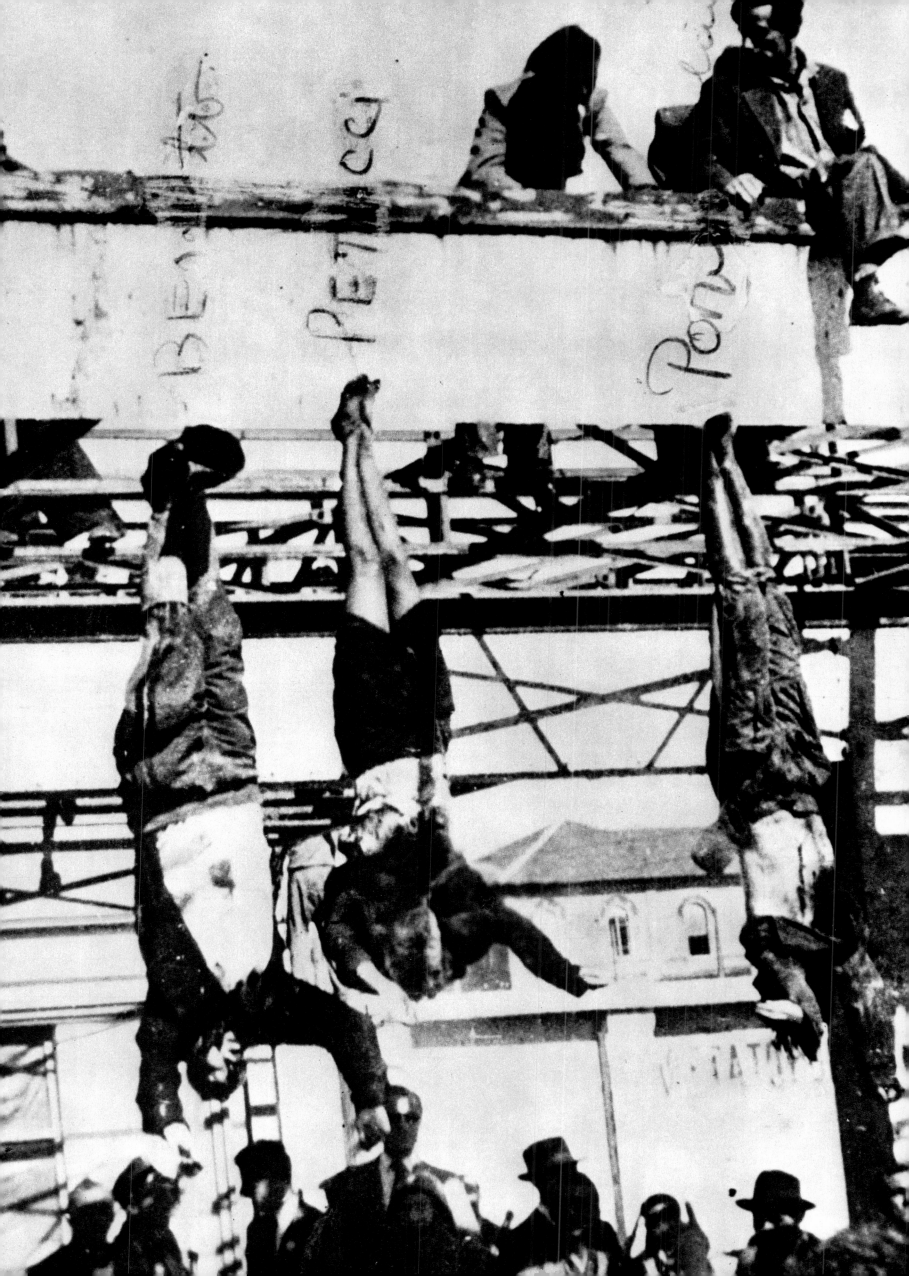

AUGUST 6, 1945

Throughout the war, Hiroshima had known only a dozen bombs, dropped by straying American planes. It had never been an intentional target. But the people of the city, a military depot, knew about the new U. S. bomber. B-san, they called it. Mr. B, translated. B-29.

The Japanese radar picked one up as day broke this August 6, 1945. At 7:09 a.m., air raid alarms sounded across the awakening city. The lone B-29, nick-named "Straight Flush," was a weather ship. It found Hiroshima a clear hole in a donut of clouds. Out went a coded message: "Advice: bomb primary."

Duty done, Straight Flush wheeled and flew south. The all clear sounded in Hiroshima at 7:31. But three more B-29s were approaching: an instrument plane, a photographic plane and the lead bomber, named "Enola Gay" after the pilot's mother. It carried a five-ton bomb, painted black and orange and containing a few pounds of uranium about the size of a grapefruit, that had taken hundreds of thousands of workers and scientists three years to make in a $2,500,000,000 project.

The bomb was 28 inches wide and 10 feet long and nestled in Enola Gay's forward bomb bay, connected by a web of cables to sensitive monitoring devices. It had never been tested before and was nicknamed Little Boy in contrast to the bulbous Fat Boy plutonium bomb which had been tested. With Little Boy, rode America's hope of a knockout punch that would end the war at a stroke, saving 500,000 to a million U. S. casualties predicted for the invasion of Japan.

"It's Hiroshima," said Col. Paul W. Tibbets, Enola Gay's commander, on unscrambling the message from Straight Flush.

Tibbets had taken off from Tinian Island at 2:45 that morning, just clearing the runway with the weight of the bomb and 7,000 gallons of fuel. The bomb had been loaded the day before, after crewmen had chalked it with slogans. "No white cross for Stevie," one major had written in the hope that now his son would not have to fight.

The three B-29s rendezvoused over Iwo Jima and as they neared the cloud-covered coast, Tibbets spoke to his men over the intercom. Voice recorders were turned on and the men heard for the first time: "This is for history so watch what you're saying. We're carrying the first atom bomb."

8:09 a.m. "Put on your goggles," Tibbets tells the crew.

8:11 a.m. At 31,600 feet, Enola Gay begins its bomb run toward Hiroshima 17 miles ahead. Ground speed: 285 miles an hour. Course: 265 degrees. The bombardier squints through his sight for his aiming point, the center of the main bridge over the Ota River.

8:15 a.m. "I've got it." he says. The bomb bay opens.

Seventeen seconds later, Little Boy drops horizontally, then noses sluggishly toward the city. It was timed to explode in 43 seconds at an altitude of 1,850 feet.

As the Enola Gay banks steeply away, a crewman counts off the seconds . . . 35 . . . 41 . . . 42 . . . "It's a dud," he thinks. Just then there is a flash as dazzling as a second sun. It is precisely 8:16, and the world will never be the same. . . .

Three days later, a second bomb was dropped on Nagasaki and Japan surrendered September 2, 1945, three years, eight months and 25 days after Pearl Harbor. As many as 200,000 people had died in the two Japanese cities. Americans who had vowed to remember Pearl Harbor now had Hiroshima and Nagasaki to forget.

Banking away from the light, the dust and the blast waves, the photographic plane was out of position. Thus, the photograph of the first atomic bomb explosion was taken by Sgt. George R. Caron, tailgunner on the Enola Gay, who was given a camera at the last moment and shot through his plexiglass bubble.

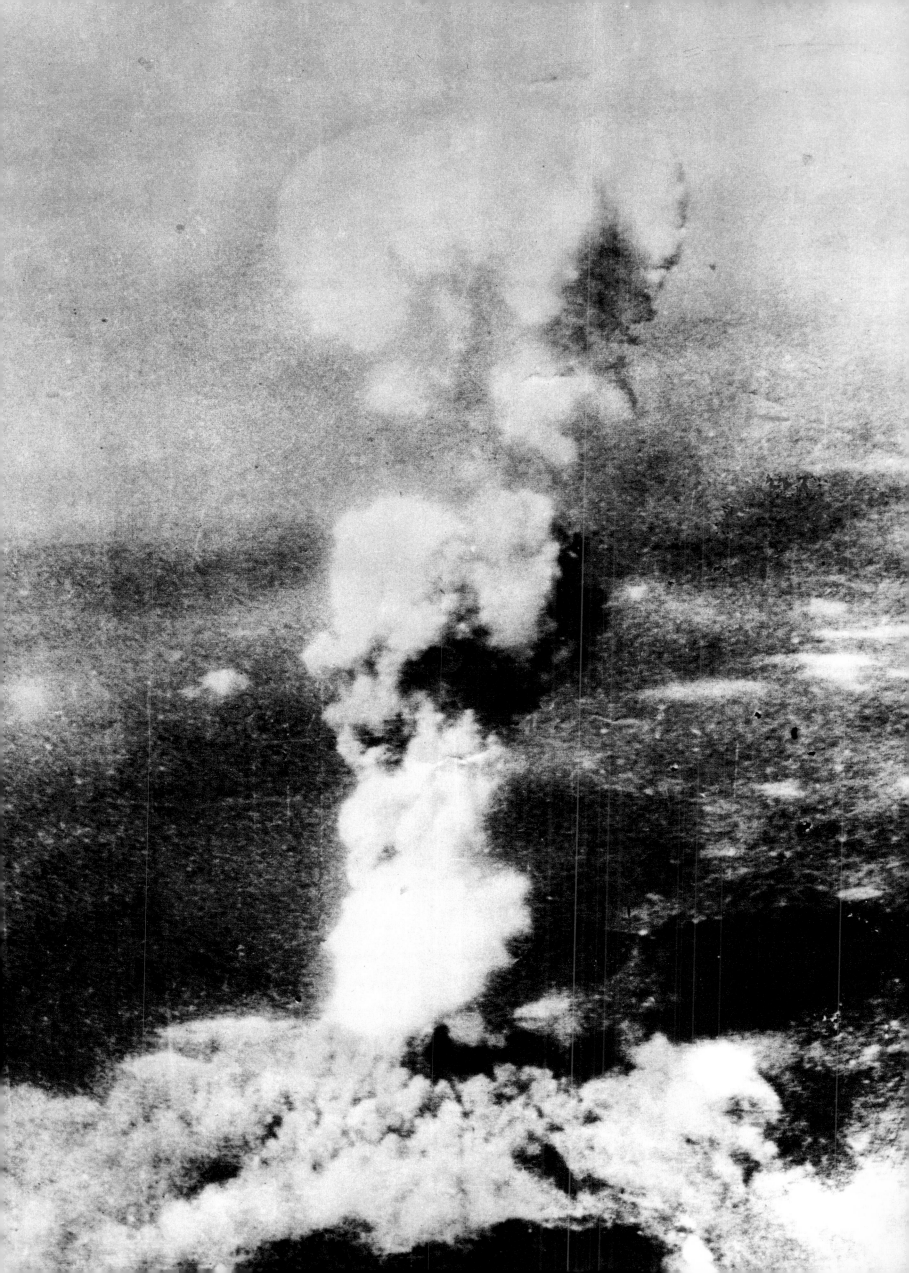

JOHN L.

"He who tooteth not his own horn," said John Llewelyn Lewis, "the same shall not be tooted."

Nobody tooted his louder during the stormy years labor came of age, or did more in the rearing, than the union leader with the eyebrows like hedges and jaw like a coal stove. John L. took on most everybody and most always won.

"Organize the Unorganized" and "Never a Step Backward" were the slogans of the ninth grade dropout who could quote Shakespeare and Scriptures to the low and the mighty and tell an armed man to "take that gun out of your pocket or I'll shove it down your throat."

The former coal miner who dug his way to the top of the United Mine Workers and founded the Congress of Industrial Organizations battled presidents of companies and presidents of the United States from Wilson to Truman. Feeling he had been double-crossed by one President, he said to his face: "Nobody can call John L. Lewis a liar and least of all Franklin Delano Roosevelt!"

He called Vice President John Nance Garner "a poker playing, whiskey drinking, labor baiting, evil old man." About the best anyone could manage in retaliation was one company executive who stammered: "Mr. Lewis, I-I-I am not afraid of your eyebrows."

Lewis brought unionism to General Motors and numberless other firms and, with seemingly incessant strikes, raised the pay of his 800,000 coal miners from 50 cents an hour in 1933 to $1.47 in 1945, harrumphing, fist banging, door slamming or dropping an exquisitely tuned barb as the occasion demanded.

Battling even within labor's house, he once put the leadership of the American Federation of Labor in its place, saying it had no head. "I think its neck has just grown up and haired over."

Tough or courtly, imperious or impish, Lewis set the pattern that other labor leaders were to follow. He made the sit-down strike, which he said dated back to the builders of the Pyramids, a national weapon of the late Thirties. Even high school students in Cleveland sat down in protest that their newly arrived class pins "were a lot of junk." There was violence, often, but Big Labor had been born.

Midwife Lewis was always in the news. In 1937, about four per cent of the stories in the New York Times for the whole year revolved around John L. But no headlines were bigger than when he pulled his men out during World War II contrary to a union no-strike pledge. "John Lewis, damn your coal black soul," cried Stars and Stripes from Europe. Unbowed, Lewis won but was magnanimous in victory. One day when he found Roosevelt maneuvering some miniature ships on a battle map, he offered to send him a set of electric trains for Christmas . . .

Now, on this November 19, 1946, Lewis has done it again. The government has seized the mines, but Lewis has called his men out anyway. He's demanding a 40-hour week instead of 54, with no loss in pay.

With a toss of his cane to the curious and a tip of his hat to a lady, Lewis, chewing on a cigar, drops into the lobby of Washington's Carlton Hotel to read in peace about one of the few battles he was to lose.

It was to cost him $10,000 personally and his union $700,000 in court fines, but no one could forget the debt labor owed the man who made management listen to a favorite quote from the Bible: "Thou shalt not muzzle the ox that treadeth out the corn."

Bill Smith, photographer for the Associated Press in Washington, had often taken pictures of Lewis even though Smith thought "he wasn't too easy to get along with." During the uproar of the 1946 strike, Lewis was hiding from the press, and employes of the Carlton kept shooing photographers away. Finally, after two days of waiting, Smith found a side door to the lobby and there was the Great Man alone, reading his paper. "It was a grab shot, no flash. He didn't even know I had taken it."

"DON'T JUMP"

At 3:32 a.m., a light on the switchboard winks.

Comer Rowan, a night clerk at the Winecoff Hotel in Atlanta, plugs in. A man in room 510 wants some ice and ginger ale. Rowan sends up bellhop Bill Mobley with the order. Mobley waits several minutes in the hall while the guest finishes a shower. He finally opens the door and Mobley enters.

When the bellboy comes out, the hall is a curtain of flame. Rowan, notified, calls the fire department.

They, of course, know the Winecoff, located on the city's main street, Peachtree. The 15-story brick building was built in 1913, thirty-three years before. In fact, the man who built it, Frank Winecoff, lives in a suite on the 10th floor. He had not built an outside fire escape on his building. Nor installed a sprinkler system.

On this night, December 7, 1946, there are 285 guests registered, most asleep.

And as they sleep, flames finger along the corridors. As the heat builds, elevator shafts become flues, spreading the fire through the building.

Guests, roused now, stand at the windows in terror.

"Don't jump!" firemen yell. But the fire offers no choice. A woman on the seventh floor throws out her small son, then her small daughter, then herself. They hit the pavement with a sickening sound. Another woman jumps, crashes into a fireman carrying a woman down a ladder and all three smash to the ground. A man throws a rope made of bedsheets out a fifth floor window, steps away and is not seen again. Others lower themselves on bedsheet ropes as far as they can, and fall the rest of the way, to death.

A girl on the seventh floor cries, "I hope I live, I hope I live," and jumps. And does. Other jumpers don't. They bounce off the edge of the marquee and are dead on the sidewalk. A woman on the 12th floor leaps, her white nightgown trailing over her head, and hits a cable supporting the marquee. It snaps and one end wraps around her, holding her there, dead.

In all, 119 bodies are found in the ruins, some burned black, some, the asphyxiated, looking as if they were merely asleep.

And on the 10th floor, they find Frank Winecoff, dead.

———————————

"You all got any pictures of the Winecoff fire?" a sleepy voice asks on the phone.

"Lots. Lots," says Jim Laxson, wirephoto editor of the Associated Press in Atlanta.

"You got any of people jumping, in mid-air?"

The voice is invited down to the office immediately and turns out to belong to Arnold Hardy, a college student and amateur photographer, with a bunch of damp negatives in a paper towel.

He had come late from a dance, heard the fire engines and rushed to the hotel with his month-old Speed-Graphic, balance due: $282.

"From almost every window, I saw men, women and children screaming for help. Suddenly I heard someone behind me shriek. I looked up, raising my camera. A woman was falling down to her death. As she passed the third floor I fired, using my last flashbulb."

Soon after, Arnold Hardy was able to pay off the balance on his camera.

☆ *Pulitzer Prize Winner, 1947.*

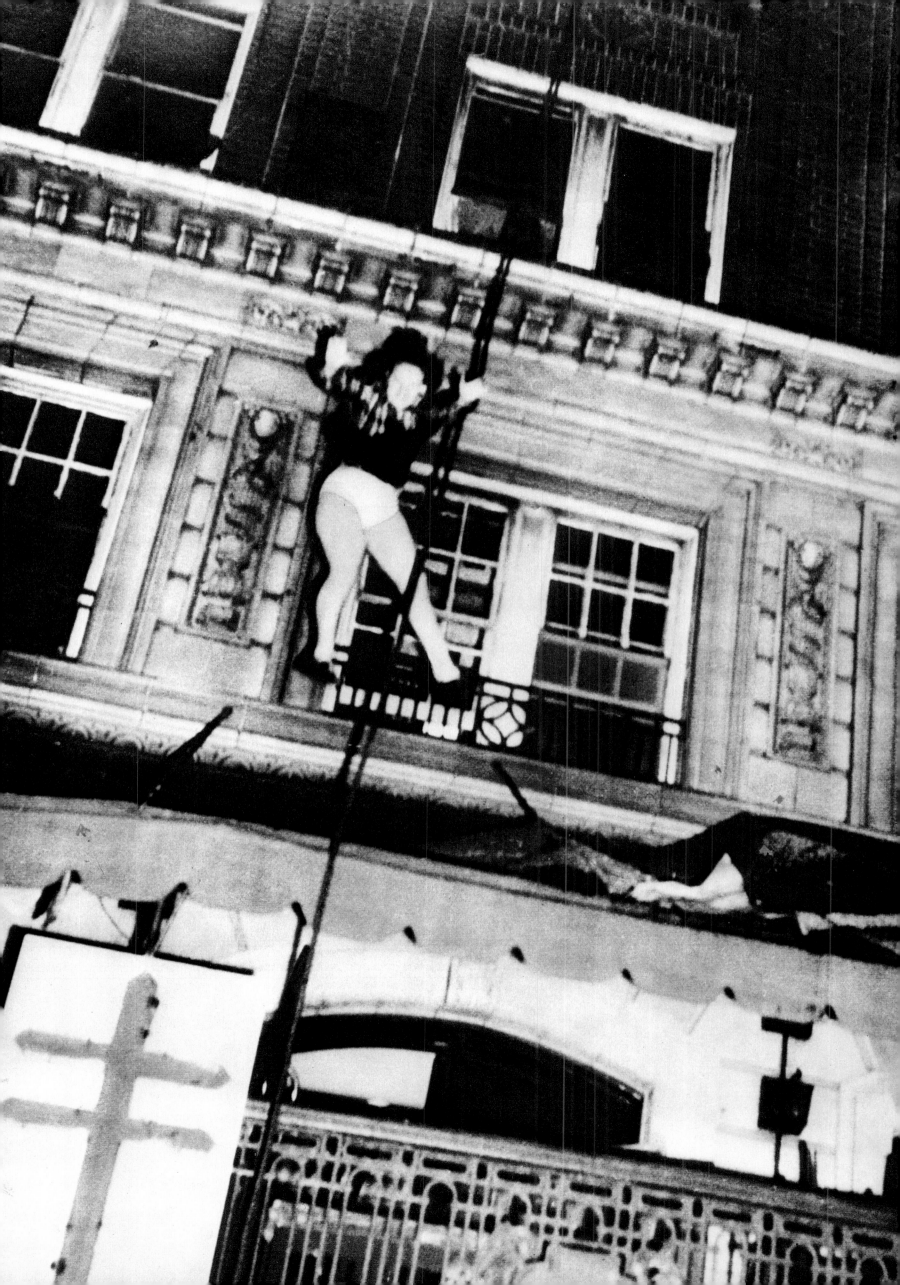

SHIELD

Against the rest of the week's tribulations—a gangster killing in Los Angeles, floods in Omaha, strikes against the Taft-Hartley law—the stickup at a Howard Johnson's restaurant in Boston rated little attention. . . .

But then, on June 23, 1947, police stop to question a 15-year-old about the holdup, and the youngster, Edward Bancroft, pulls a revolver and starts shooting. He dashes past a school and jabs the gun into the ribs of unsuspecting William Ronan, who happens to be 15, too, and forces him to come along.

Using the Ronan boy as a shield, young Bancroft darts into an alley and stands off 27 policemen with shotguns and tear gas. He shoots one policeman in the shoulder and peppers squad cars with bullets.

Police seal off both ends of the alley. They try to close in.

"Don't come any nearer or I'll shoot him!" screams young Bancroft, aiming at the Ronan boy's back.

Silently, on his stomach, Officer George Toland crawls behind a fence along the alley. As the Bancroft boy eyes the platoon of policemen blocking his ways of escape, Toland stands up, reaches over the fence and stuns him with the butt of a riot gun. . . .

Later, it turned out the boy had nothing to do with the holdup. But he drew two and a half years in the House of Correction for kidnaping and assault. . . .

———————————

Frank Cushing of the Boston Traveler flattened himself on a sunporch, over-looking the two boys, and carefully, very carefully, made his picture. "I was wondering if the kid would shoot me. But I wanted that picture."

☆ Pulitzer Prize Winner, 1948.

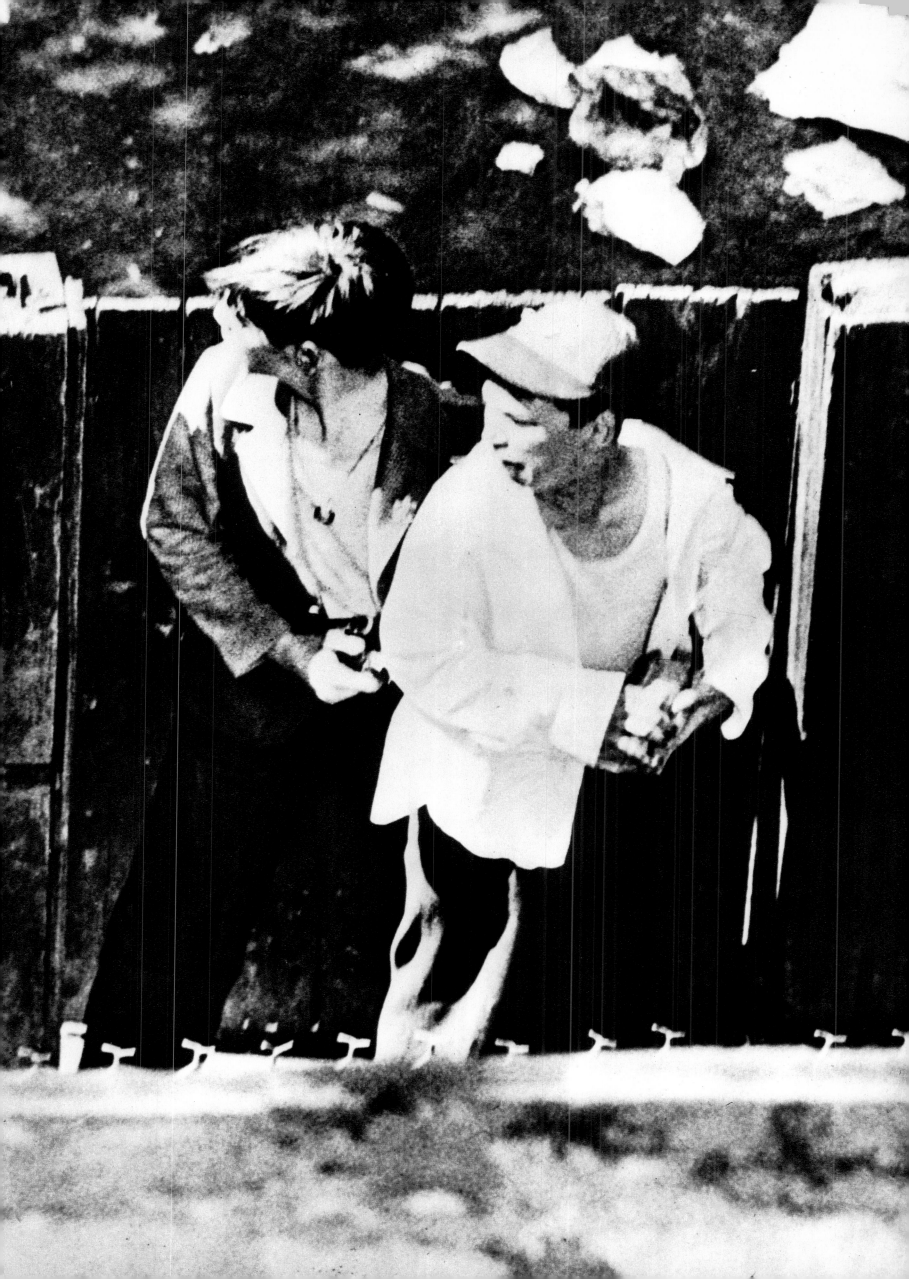

AVE ATQUE VALE

It seems almost a twilight of the gods as the man, old before his time, stands silently while the cheers shower down around him.

It is Babe Ruth's formal farewell to baseball. Two months later, August 16, 1948, he will be dead. But the thousands saying goodbye to Ruth this muggy day in Yankee Stadium are saying it to an era, as well. The Golden Age of Sports.

Jack Dempsey, Bobby Jones, Paavo Nurmi, Earl Sande, Red Grange: national heroes in a time of innocence, a time before Olympians clenched their fists at their national anthem, a simpler time when reality was suspended for a worshipful glimpse of the immortals at play. It was a lazy afternoon of the nation's history, before instant replay and strikes and million dollar contracts, and all you had to do was watch the Babe's massive shoulders coil and unwind and hope he hadn't had too many hot dogs before the game.

Sports were a game in those years between the World Wars, not a road show traveling from city to city hoping to hit gold. Fans and their teams mated for life, and if the fans grew older, the players remained ageless, even in the memories of their passage.

Ruth pointing to the stands where he was to hit a home run; Dempsey standing in savage triumph over Jess Willard. Memories frozen in time and nostalgia.

And now their throats thicken from cheers and a deeper emotion as they say farewell. They retire Ruth's number that day. But something else, too, lies buried out there near home plate.

Chunky Harry Harris of the Associated Press, who has covered World War II and does not suffer from romantic illusions, is nonetheless moved on this overcast day. He stands to the side of home plate, he hears the national anthem, he looks at the slightly stooped figure, the barreled body, the spindly legs, the packed stands, and knows "I can't miss." He doesn't. And works the ball game that follows.

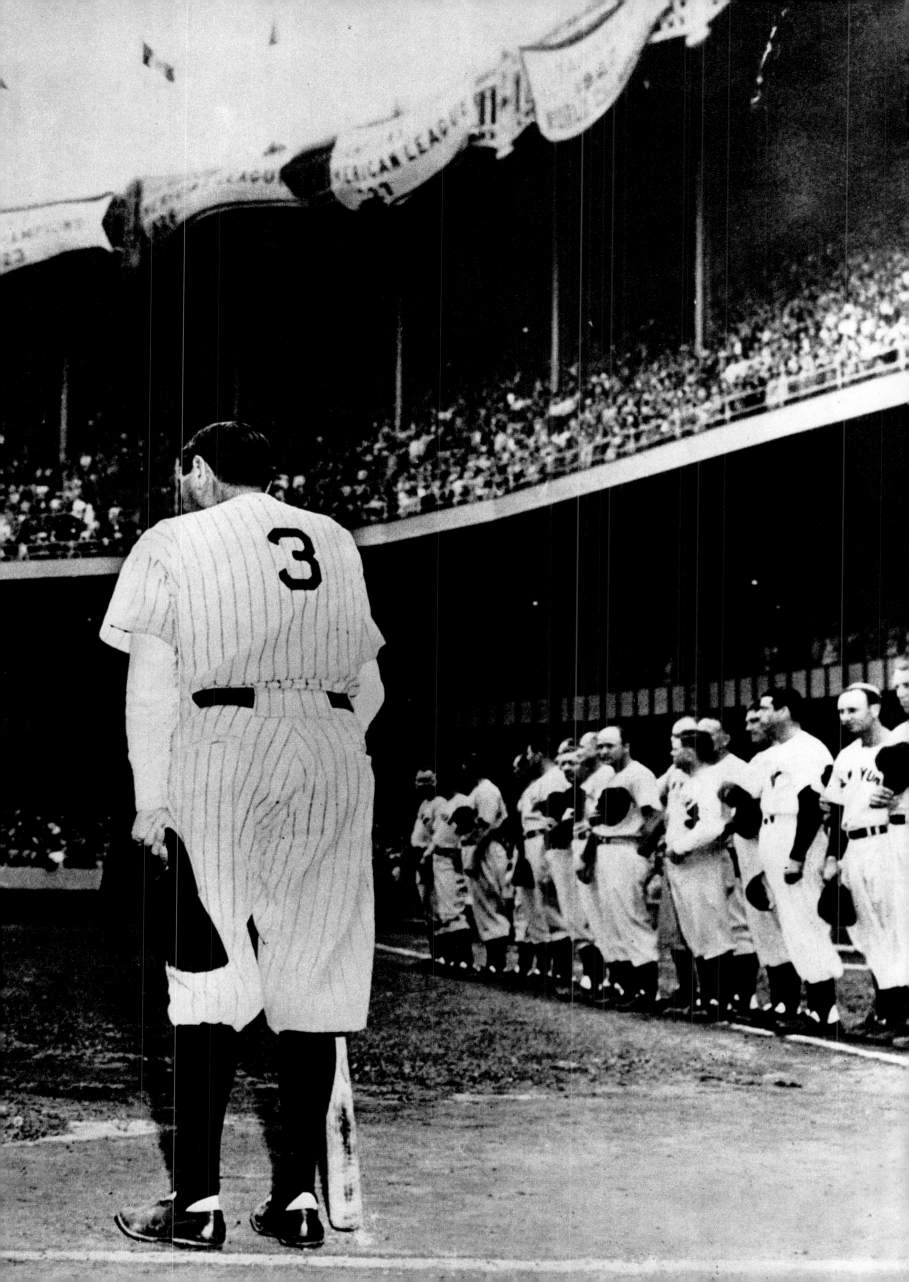

HOW SWEET IT IS!

"Mr. President . . ."

"I wish you didn't have to call me that," Harry Truman told reporters in the first shock of Franklin Roosevelt's death.

Three and a half years later, many Americans were still loath to call him that. Just how many was a question that would bring the sweetest triumph for an underdog in the history of presidential politics and the loudest pratfall among experts since the first colonial bookmaker.

Writers, public opinion pollsters, politicians—everyone was saying Truman couldn't possibly beat Thomas Dewey in 1948. Haberdasher, infantry captain, Pendergast machine graduate, senator, compromise nominee for vice president, President by accident, feisty, testy, spontaneous and all Missouri— they said the little man from Independence was too small to fill those outsize shoes.

Truman already had made much history by 1948—at Potsdam, Hiroshima, the first United Nations conference in San Francisco, the airlift for the Berlin blockade, the launching of the Truman Doctrine, the Marshall Plan, the NATO alliance. Still, they were saying he couldn't possibly be elected in his own right, with all those five-percenters, strikes, high prices, the birth pains of the civil rights fight, the fragmentation of the party by a presidential candidate from the Deep South and a radical from the Midwest.

Election night, Nov. 2. 9 p.m., Truman trails in early returns. 10 p.m., Truman losing in heavier returns. Midnight, something begins to turn. 4 a.m., Truman wins.

The morning after the long night, he heads back to Washington by train. In St. Louis, someone hands him the edition of the Chicago Tribune that would traumatize experts for decades. . . .

———————————

Traveling with the President, Byron Rollins of the Associated Press lumbers to the back of the train, shoots two pictures, unloads them with an AP stringer, lumbers back to his car and hits his berth with absolutely no thought of anything special except his first sleep in 20 hours.

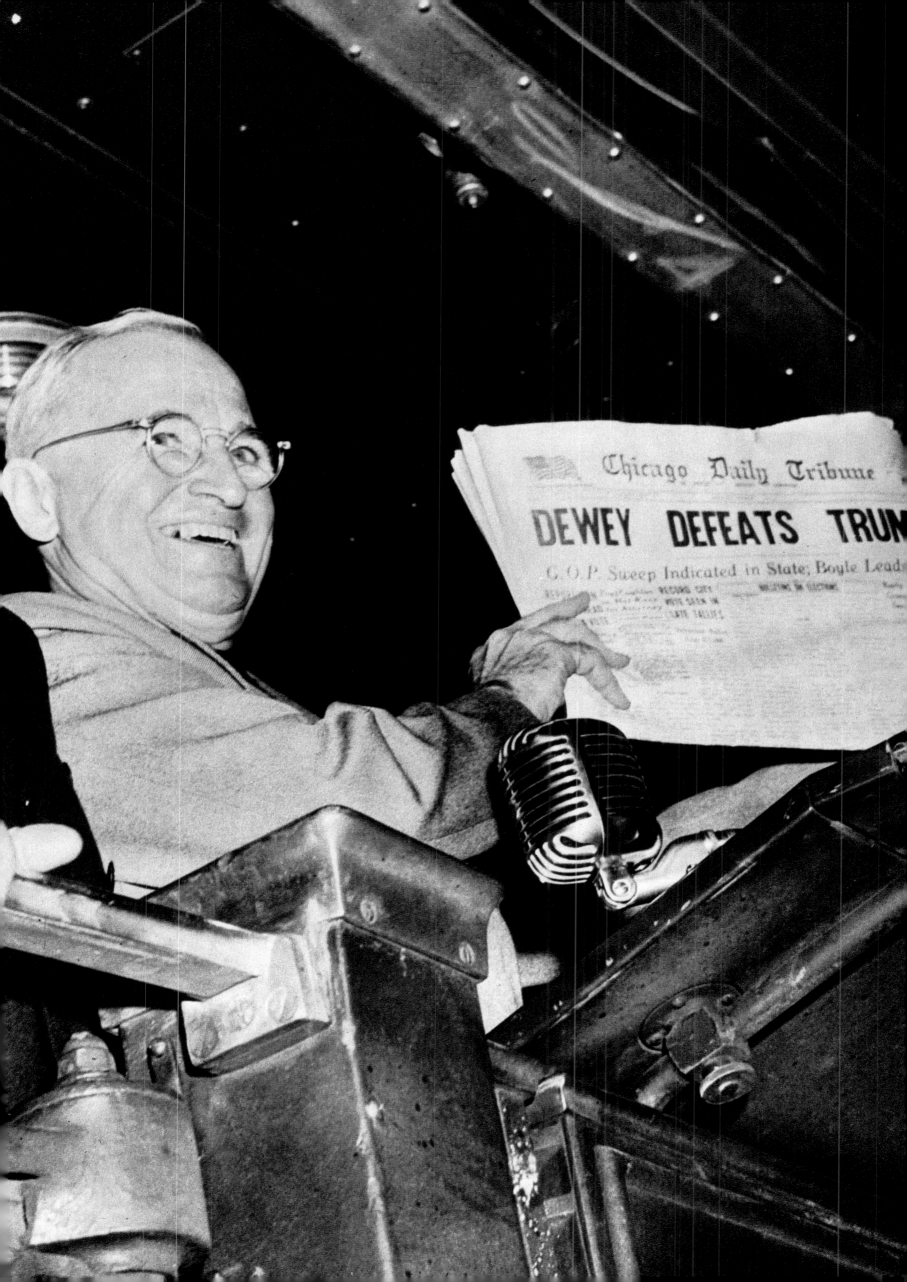

THE AGE OF FRIGHT

The best laid plans of mice, men and pilots sometimes seem all up in the air.

Having learned to fly, man immediately began testing his wings. If you can fly right side up, can you fly right side down? Some intrepid but forgotten airman tries it. You can. Then, there are loops and rolls and picking handkerchiefs off the ground with a wing tip and daredevils balancing outside the cockpit and all the aerobatics that put cricks in the necks of countless cow pasture spectators.

Then there is Chet Derby, another air pioneer.

Derby is putting his old biplane through its paces at an air show at Oakland, October 2, 1949. Hang on to your seats and watch closely, folks, because this daring young man in his flying machine is going to loop upside down over the field trailing smoke to leave a pretty circle in the air.

In fact, Derby is doing it right now. And, oh wow, here come three B29 Superfortresses in formation for a low level flyover. Up, up, up upside down comes Derby. He scoots a scant five feet beneath the wing of one of the bombers. Some stunt, huh?

Sure was, except no one told Derby the bombers were coming in early and he couldn't see them upside down and when he landed right side up he had that sinking feeling, like a sword swallower who had hiccuped.

————————————

Bill Crouch of the Oakland Tribune was aiming his camera into the sky. "I was concentrating on shooting pictures of the stunt plane. I saw the bombers flying in and thought it might make a different picture with them in the shots. It did."

☆ *Pulitzer Prize Winner, 1950.*

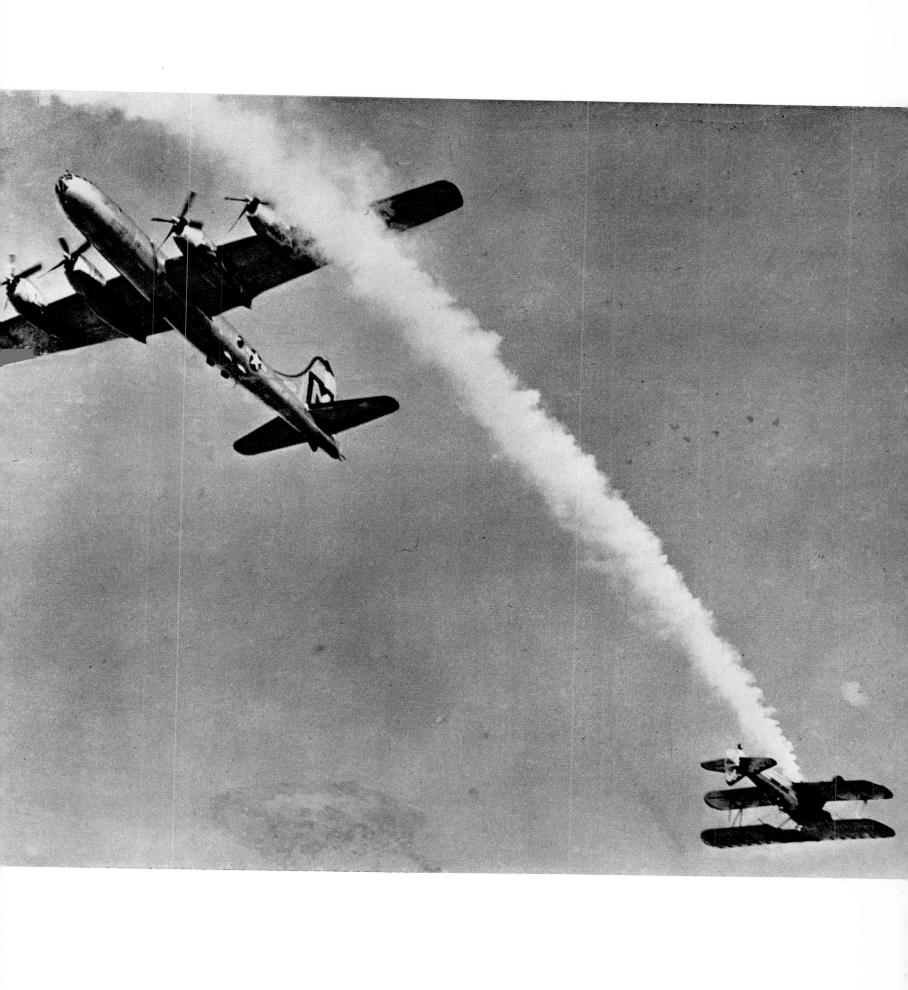

THE BRIDGE

"Without victory there is no survival," Winston Churchill said of another war, another time. During the cruel winter of 1950 the South Korean people, fleeing southward before a locustlike swarm of Chinese Communists in a war that does not promise victory, learn that survival is sufficient when there is nothing else, nothing at all, and life itself worth any risk.

After four months of fighting, the North Koreans have been pushed all the way back to their Chinese border, the Yalu River, and Gen. Douglas MacArthur has promised his men they will be home by Christmas. Instead, winter comes to the mountains and bleak fields of North Korea not only with bitter cold but also with chilling bugles and whistles and the brazen clang of cymbals as the Chinese horde pours across the Yalu; by Christmas the U.N. forces will be in headlong retreat.

At Pyongyang in early December, amid the cries and confusion of frantic evacuation, Associated Press photographer Max Desfor finds a pontoon bridge across the icy Taedong River still intact. He hitches a ride across in a crowded jeep with other correspondents and on reaching the far side heads downriver. Suddenly he stops, his eyes not believing the sight he sees. Across the jagged skeleton of a bombed-out bridge thousands of refugees are crawling like ants, but slowly, so slowly, each carrying a pitiful bundle. Some have fallen into the nearly frozen water below. Others cling to the twisted girders motionless, exhausted beyond endurance, perhaps dead.

In wartime the word "refugee" tends to lose its significance, merely another category among numbing lists of ever increasing numbers—dead, wounded, missing; rarely, in fact, are numbers of refugees accurately known, rarer still their misery appreciated.

Desfor leaps from the jeep and runs out on the slippery bridge as far as he dares, a drop of 50 feet between him and the water. He shoots four pictures and makes the statistics of the homeless forever real.

Max Desfor parachuted with his camera deep in North Korea and by the time he made his way south to Pyongyang he had seen war's cruelties as close as one can. He is an expert on misery. Still, the sight of the refugees crawling across the bridge stuns him. "Those poor, miserable souls," he whispers. He cannot help them. There is no purpose in remaining. He makes his way to an airfield, asks the pilot of the last plane leaving to take his film to Tokyo, then helps the retreating army burn the field. That done, Desfor rejoins the troops trudging south. His picture was published December 5, 1950.

☆ *Pulitzer Prize Winner, 1951.*

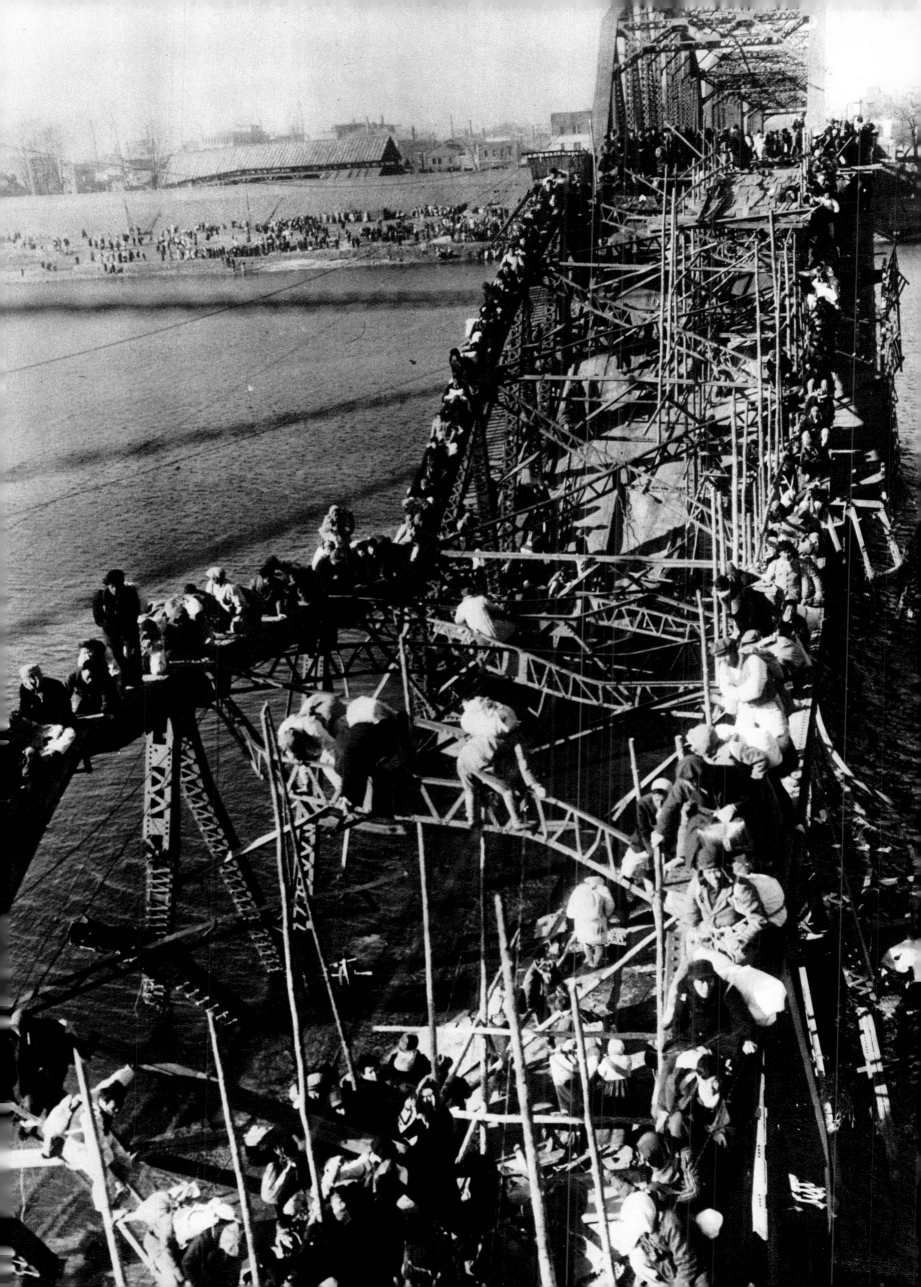

WINTER, 1951

American and United Nations troops pursue the North Koreans in the see-saw of the Korean War. Associated Press photographer Max Desfor is with advance elements of the U.S. Third Division trying to catch up with the North Koreans at Yangji, north of Seoul. In the wake of the retreat lie death and destruction.

January 27, 1951. Desfor is with troops probing the outskirts of a village. It is a bitter winter, and the snow is deep. Suddenly he sees a pair of hands, together, "rigid and blue, pointing skyward through the deep snow as if in prayer. Near the hands is an another opening in the snow."

His camera records this quiet symbol whose story he does not know. Then, soldiers brush away the snow and find the body of an old man. His hands were bound before him, and he apparently had been shot and left alive by the retreating North Koreans. The snow came and covered him thickly. His last warm breath carved the second opening in the crusty blanket. And then he died.

The soldiers went on across the field and found many more bodies, old men, women and children, all bound, some behind their backs, shot and left. Intelligence determined that the North Koreans had taken the civilians with them in retreat, killed them when they could not keep up.

For Max Desfor, the image of those two hands produced an incredible sadness. "The starkness of the scene gripped me. I could only think of the futility of deliberately killing innocent people."

HALLELUJAH!

For all the rest of his life Sam Smith, farmer, would remember Easter Saturday, March 24, 1951, as the day it rained.

To a Texas farmer, drought is his most merciless enemy. Surely it is the most sinister. Unlike other natural perils—tornado, hail storm, brush fire—the drought does its evil by degrees. It tortures the earth bit by bit, inexorably, so that the farmer can never tell the exact day the cottonwood tree died, the precise hour the stock tank went dry, the specific moment the crack opened in his pasture wide enough to swallow a calf. In a long drought, the death of the earth is agonizingly slow and painful.

By the spring of 1951, Texans have endured seven years of drought. Seven years of watching crops die aborning, cattle die, wells go dry, seven years of watching great dust clouds lift on the hot afternoon breeze and turn the setting sun into a mocking sky of fire from horizon to horizon, day after day. This spring even the deep-rooted oaks are giving up the struggle, withholding their leaf buds for the first time in memory as every day for a solid month the temperature goes over 100 degrees without a drop of rain.

And on Easter Saturday . . .

———————————

As the rain begins, the excitement in the news room of the San Antonio Light is as unrestrained as on the outlying farms. Reporters, editors, deskmen, secretaries rush to the windows to watch. Harvey Belgin, photographer, gets in his car and heads for the vegetable belt southwest of the city, where the fields are most severely parched. Along the way he sees children playing deliriously in mud puddles, men and women running around joyously in their yards. Then he sees Sam Smith standing next to his fence, standing in the rain, rejoicing. Harvey Belgin gets out of his car and shoots two pictures. Usually he shoots at least a half dozen to assure a good selection. "I don't know why I even bothered to shoot the second one," he says later. "I knew I had what I wanted when I saw the old man through the view finder. The rain meant life to him and his face showed it. I said, 'Well, that's it,' and went back to the office."

LIGHTNING ON OLYMPUS

There is between soldiers a common language of kinship born of discipline, danger and responsibility. Especially between professional soldiers who must commit men to battle.

Nonetheless, there were profound differences between General of the Army Douglas MacArthur and General of the Army Dwight Eisenhower. Both were popular heroes of war but somehow MacArthur always seemed larger than life, Eisenhower humanly containable. People called the one Ike; nobody called the other Doug.

MacArthur was flamboyant where Eisenhower was quiet. MacArthur was outspoken where Eisenhower sought harmony. MacArthur, the son of a distinguished general, finished top in his class at West Point; Eisenhower, the son of a Kansas mechanic, finished at the bottom edge of the top third. MacArthur was mentor; Eisenhower, student. Ike served as MacArthur's aide for nine years in Washington and the Philippines. At the start of World War II, MacArthur was already a figure of legend and dash; nobody had heard of Ike. During the war, each was supreme commander in his half of the world and it was frequently argued that men and material were going to Eisenhower in Europe at the expense of MacArthur in the Pacific.

Now, in 1951, they are again on different continents. Eisenhower is Supreme Commander of Atlantic Pact Forces in Europe where he is courted as a presidential candidate; MacArthur is United Nations Supreme Commander in the Far East.

MacArthur is in Korea fighting a frustrating war, inhibited by higher decision not to cross the Yalu River for fear it will bring Chinese regulars openly into the war. MacArthur insists this is unrealistic, that the enemy must be hit in his "privileged sanctuary." He says it again and again. President Truman, determined to limit the war, insists there will be no violation of the Yalu.

And another issue begins to emerge, as old as the Constitution of the United States, the supremacy of the commander in chief. Then, the last straw. MacArthur is ordered by the Joint Chiefs of Staff not to make any policy statements without clearing them. He breaks the rule twice in ten days. On April 10,1951, the little man in the White House has had enough. Truman orders MacArthur home, creating a national furor.

The next day, inspecting French troops at Coblenz, the Supreme Commander of Atlantic Pact Forces in Europe hears the news that his former boss, the United Nations Commander in the Far East, has been summarily fired. A Stars and Stripes cameraman, Francis R. (Red) Grandy catches that special look on that especially photogenic face. "Well, I'll be darned," says Ike, supplying his own caption.

THREE QUEENS

Monarchs in mourning.

It is one of the few displays of emotion they may share with the commoner, for royalty must stand apart as a symbol, more faultless, more indomitable, more serene. But even in their rare public grief there is regality.

The King of Britain, George VI, is dead. He died after a day's hunting at his country estate at Sandringham. "It's been a very good day's sport, gentlemen," he said after shooting 50 hare. He died that night in his sleep. Woodsmen and gamekeepers carried their monarch's coffin to the parish church where a piper piped a lament.

But now, this February 11, 1952, the great of the world have gathered to pay homage. Prime Minister Winston Churchill. The royalty of Europe. Gen. Dwight Eisenhower, commander of the NATO forces. Dukes of the realm. And the people, by the thousands.

In a moment of national mourning, miners lay down their picks, clerks put aside their pens. Even in airplanes all over the vast but dwindling Empire, passengers stand briefly in silence.

The King's elder daughter, Elizabeth had been on a tour in Kenya when her husband, Philip, heard and broke the news at a riverside. At the foot of the King's bier is a wreath with a note: "Papa: From your loving and devoted daughter and son-in-law, Lilibet and Philip."

She is daughter no longer but Queen, Elizabeth II, monarch of Britain and the Commonwealth at age 25. Now, at Buckingham Palace, waiting for the coach that will take them to Westminster Abbey, she stands with her grandmother, Dowager Queen Mary, and her mother, Queen Mother Elizabeth, the first commoner to be a British queen since Henry VII married one.

Ron Case, photographer for Keystone, a photo service, rests his camera on an old beer crate while working inside the palace yard. It is cold, and he has been working on the King's funeral all day. The queens emerge and stand together for a moment. Case sees them, "not as queens, but as grieving women," and captures a timeless frieze.

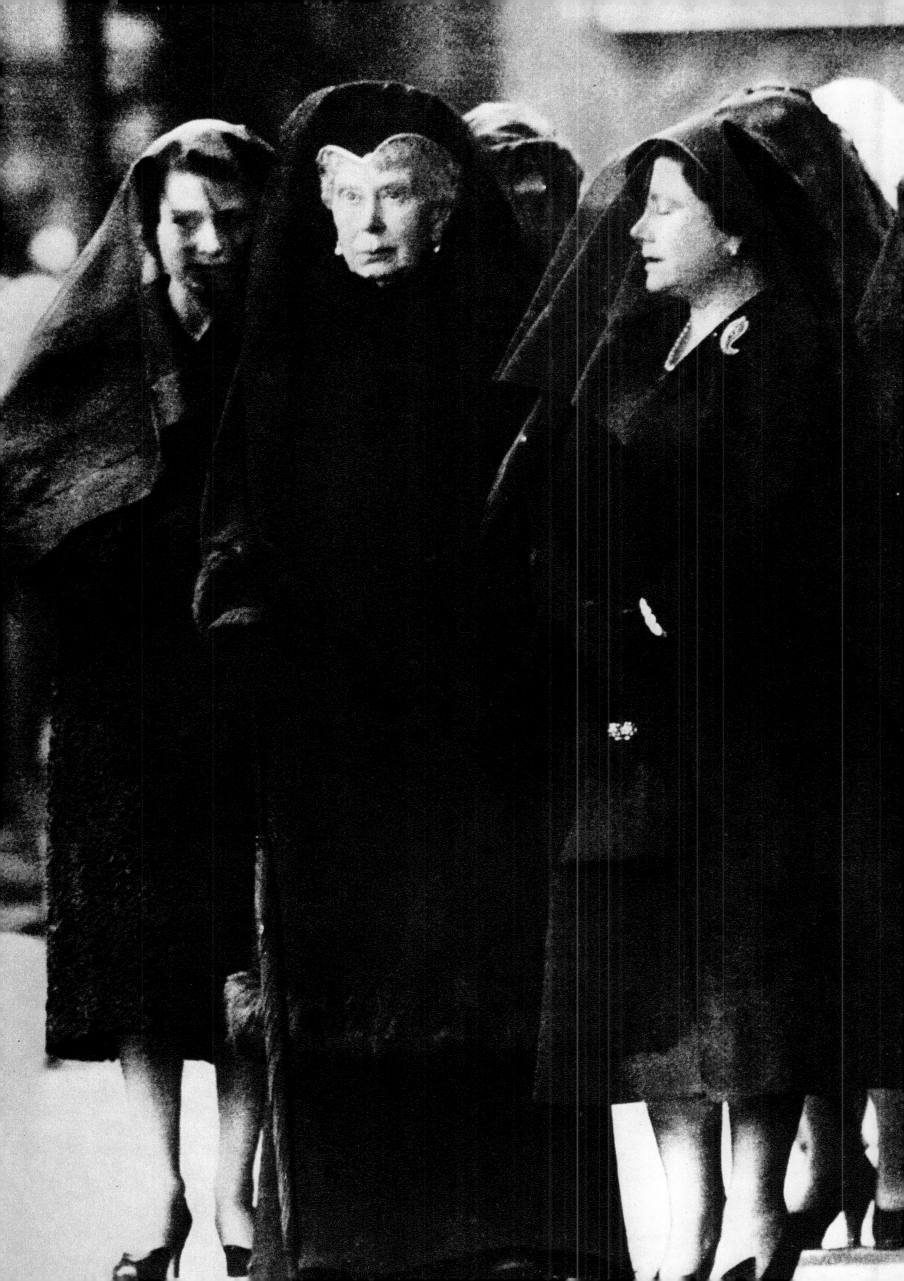

THE CANDIDATE

There's a long, long trail to Washington.

Shaking all those hands, talking all those words, eating all that chicken, and, oh, those achin' feet.

In fact, Adlai Stevenson, governor of Illinois, had been dragging his feet all year.

While Sen. Estes Kefauver of Tennessee was running like a jack rabbit for the Democratic presidential nomination in 1952, Stevenson was saying no, no, a thousand times no.

In April: "I cannot accept the nomination to any other office this summer."

In July: "I am temperamentally, physically and mentally unfit" for the presidency.

And what would he do if the convention drafted him? "Shoot myself, I guess." He guessed wrong.

In his acceptance speech, after winning the nomination by 617½ votes to Kefauver's 275½, Stevenson pledged: "I will fight to win with all my heart and soul . . . I ask of you all you have. I will give to you all I have."

And so he set off on the long journey that would cover more than 30,000 miles, 100 speeches in Denver and Kasson, Minn., and Cheyenne and Bridgeport and Kansas City and Los Angeles and New Orleans and wherever the train stopped, the plane landed or the motorcade paused.

He had much to say, at a time of emerging nations abroad and Joe McCarthy at home.

"Let us talk sense to the American people. Let us tell them the truth, that there are no gains without pains. . . ."

"When an American says that he loves his country, he means not only the hills of New England . . . the prairies . . . the wide and rising plains, the great mountains and the sea. He means that he loves an inner air, an inner light in which freedom lives and in which a man can draw the breath of self-respect. . . ."

"A hungry man is not a free man. . . ."

"The time to stop a revolution is at the beginning, not the end. . . ."

"Your public servant serves you right."

"Those who corrupt the public mind are just as evil as those who steal from the public purse. . . ."

Adlai kept on traveling, telling the nation he was not soft on Communism; yes, there might be something of a mess in Harry Truman's Washington and yes, he liked Ike, too, but as for the Republican platform, "no one can stand on a bushel of eels."

The 52-year-old diplomat-lawyer-newsman-politician was destined to be swamped by General Eisenhower in the 1952 election, but he brought a rare eloquence to the political scene, an eloquence sweetened with wit.

At the end, he would quote Lincoln's story about the little boy who stubbed his toe in the dark. Defeat, he said, left him like the child. He was too old to cry and it hurt too much to laugh.

But now on September 2, in Flint, Mich., Adlai is seated with Gov. G. Mennen Williams making last minute revisions for a Labor Day speech. He is for repeal of labor's bete noire, the Taft-Hartley Act, "a recap job with reclaimed Republican rubber."

Okay, Gov., but speaking about recap jobs . . .

Bill Gallagher of the Flint Journal was a bit miffed. He had to work Labor Day. It was misty, "the kind of day you want to be some place else, and I was working for a Republican paper . . ." But he spotted the shoe and thought the shot had prospects. It did and when he was awarded the Pulitzer Prize for the picture, Stevenson wired, "Glad to hear you won with a hole in one."

☆ *Pulitzer Prize Winner, 1953.*

IN BROAD DAYLIGHT

Who knows what evil lurks in the heart of man?

The camera knows.

But where, alas, is the camera when the safecracker cracks, when the pickpocket picks, when the purse snatcher snatches? Where was the lens when the boys in Boston dropped in on Brinks? When Clifford Irving sat down at the typewriter? When Jesse James did his ride-in banking?

Out to lunch, that's where.

But here we have crime most foul with 70,536 eye witnesses. Crime not on the streets but crime on the basepaths.

See Yankee pitcher Johnny Sain hit the ball to second baseman Jackie Robinson of the Brooklyn Dodgers in the 1952 World Series.

See Robinson scoop up the ball and fling it towards first baseman Gil Hodges.

See Sain's foot plop on the bag.

See Hodges lunge for the ball that has not yet arrived.

See coach Bill Dickey coil in relief.

And see umpire Art Passarella start to give the out sign.

Didn't you see it, ump? Didn't you see it? rages Dickey. He's out, says Passarella, and so it stands.

For, as every fan knows, the ump is always right. Even when he's wrong.

Through some 40 World Series, photographer John Lindsay of the Associated Press peered down his telephoto cameras with but one thought: "Follow that ball." This could mean 300 or more shots a game, squeezing off his sequence camera on every close play. "Sometimes people try and save film, but I never was afraid to use it." Once before, during the 1948 Cleveland-Boston World Series, Lindsay was the only photographer to come up with the picture proving an ump's call in error. As Sain touched the bag, Lindsay had another exclusive. "I was sorry about the umpire, but since it happened, I was glad I had it. Twice."

PAST, PRESENT AND FUTURE

A bright, cold winter day, January 20, 1953, the Capitol steps. The leadership of the most powerful nation in the world changes hands again. The hero of the crusade in Europe takes the oath of office. The blunt-spoken Missourian, the man who made the fateful decision to drop the bomb on Hiroshima and Nagasaki, steps down. And watching, the man who was once the arch villain of the Great Depression, only recently resurrected in the public esteem. There are three Presidents and one president-to-be on the platform, lost in their own private thoughts as they stand at attention for the Star Spangled Banner. Herbert Hoover, Harry Truman, Dwight Eisenhower and Richard Nixon. But between the last three there is a wordless animosity, the bitter aftertaste of politics.

Bob Goldberg, 18, an Associated Press copyboy aspiring to be a photographer, can't believe his luck. He is in Washington as a free lance for the Brooklyn Daily. The press passes are gone. But a press aide who once worked on the Brooklyn Eagle takes pity on the fledgling cameraman, hands him a platform pass. Photographers are not allowed on the platform, but miraculously Goldberg, lugging his camera bag and his Speed Graphic, passes the guards, the ushers, the Secret Service. Acting as if he belonged, he nudges within six feet of the phalanx of Presidents, shooting rapid fire. His exclusive close-ups sweep the nation's press. Long after the event, Goldberg seeks the signatures of the men in the photograph and obtains all but one. Truman still refuses to sign a picture with Richard Nixon in it.

"SCHOOL'S OUT"

On the way south, when they crossed the Pit River Bridge across Shasta Lake, Hank Baum and Bud Overby saw another trucker who'd blown a tire and whose rig had hit the curb, stopping short of the steel rails. "It would be a hell of a note," they agreed, "to go through these rails and out into the lake."

And now, on this sunny May 3, 1953, they are on their way back north, hauling radishes and carrots and the first watermelons of the season from Los Angeles to Portland. They reach Bailey Hill, about 10 miles north of Redding, Calif., and Bud Overby, who has just relieved Hank Baum at the wheel, eases their green and aluminum Sterling diesel down toward the same Pit River Bridge. As Baum gets ready to climb into the sleeper behind the cab, he hears Overby mutter, "Uh oh."

"What's the matter?"

"We just lost our steering."

Then, all they can see are the steel rails, and all they can feel is the front wheels hitting the curb, and all they can hear is the sound of tearing metal, and all Hank Baum can think is, "School's out."

There's a sickening plunge. And then it stops.

They are practically standing on the windshield. Forty feet straight down are the rocks at the edge of the water.

"Well," suggests Hank Baum, "let's get out of this thing."

"Wait," cautions Bud Overby, still not quite believing. "Let's just sit a minute and try to figure what's holding us."

"Hey down there," comes a voice from the bridge.

"Yeah!"

"Are you all right?"

"Yeah!"

"We got a rope up here and we'll try to pull you up."

The rope comes down, and smoke from burning diesel fuel sifts into the cab, and Bud Overby climbs out the window on the driver's side and says, "Good luck, Hank. I'll get the rope back down to you just as soon as I can."

Smoke fills the cab and Hank Baum hears Overby yell as he reaches the roadway and sees the rear wheels of the cab caught under the trailer, "It's well anchored, Hank." The smoke gets thicker. Hank Baum climbs half way out the window for air.

The rope returns and Baum is pulled up.

Then Bud Overby is holding him and they are saying how lucky they are and how "the man upstairs really had his arm around us," and then the cab and trailer burn and fall to the rocks.

————————

Walter and Virginia Schau of San Anselmo, Calif., went fishing that opening day of the season and followed the green and aluminum diesel up Bailey Hill and down onto the bridge. They watched it swerve and plunge. Walter Schau stopped his car and yelled for a rope. The man in the car behind him had one. While they dropped it over the side and hauled Bud Overby and Hank Baum to safety, Virginia Schau ran to a knoll across the bridge, and, with the exposures left on the film which had been in her Brownie for more than a year, she took pictures of the rescue, and won a Pulitzer Prize.

☆ *Pulitzer Prize Winner, 1954.*

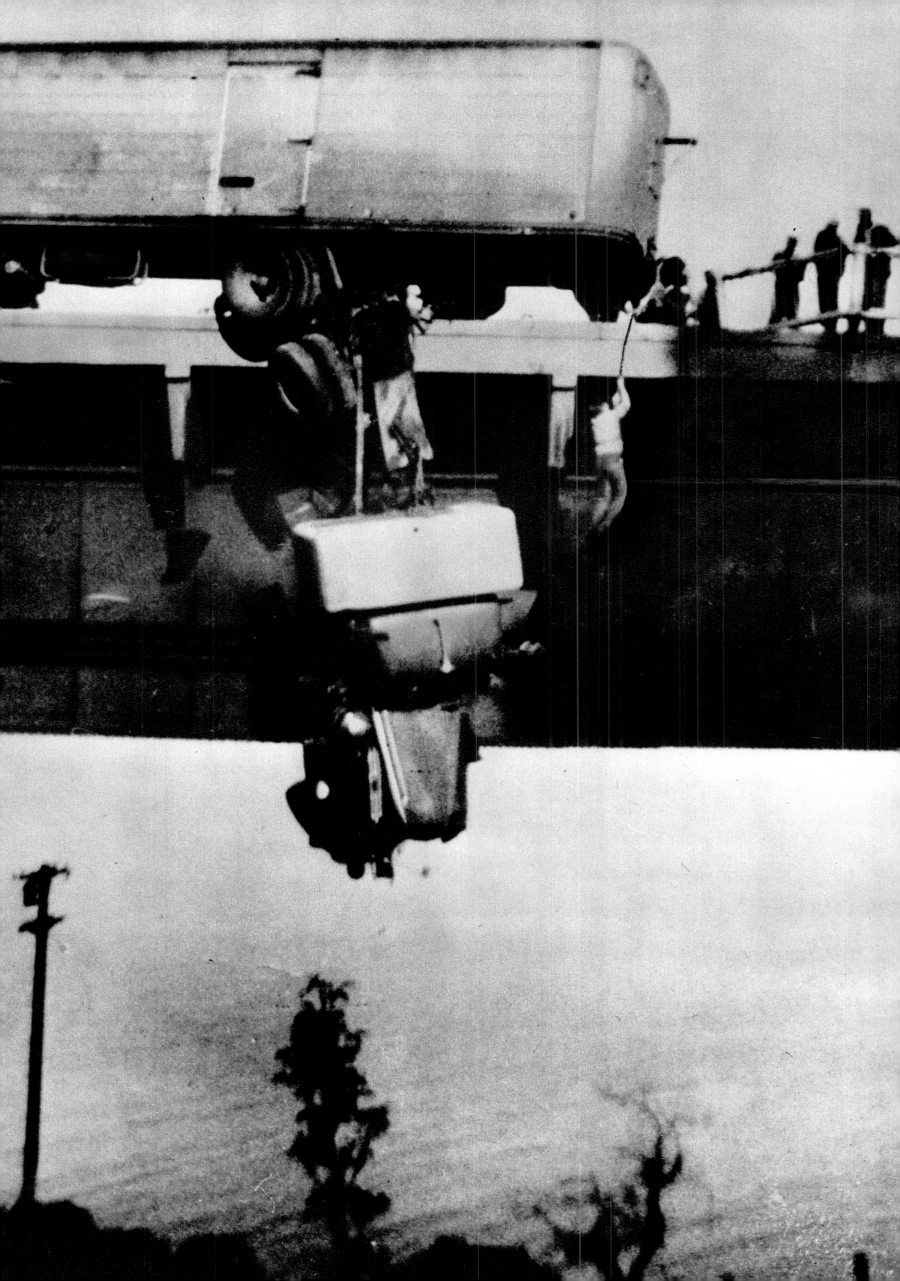

IVAN, GO HOME

Berlin, 1953, a city divided by its conquerors, a monstrous afterbirth of the war against Hitler. East and West, the rubble of one cataclysm is still there while former allies compete in a new struggle of ideology, of move and counter-move called the Cold War. Each tries to make a showcase of his part of the city for the propaganda effect it might have on a world which once more may be choosing up sides.

West Berlin is clearly doing better. More new housing, more consumer goods on the shelves begin to give the city an air of revival. With a few exceptions of new gaudy buildings, East Berlin plods along in grim, gray scarcity. The proletariat in the land of the proletariat is grumbling. Das Kapital cannot replace the meats and eggs and potatoes missing from the stores. Defections to the West reach a new high.

June 16, 1953. On Stalin Allee, a small group of plasterers and masons gathers to protest new work quotas and hours. The crowd grows to 5,000 and somehow, remarkably, no one is arrested. Communist officials watch from the sidelines; some are even smiling as if all this was a temporary aberration, a fluke whirlpool in the serene sea of Marx.

But the next day, the crowds grow to 50,000 angry East Berliners. Two young men climb the Brandenburg Gate and haul down the red flag of Russia and burn it. Chants of "Ivan, Go Home" rumble through the roving mobs and now the Soviets respond with force.

Troops, tanks, an entire armored division moves into Potsdamer Platz, where shouting, fist-shaking demonstrators have gathered near government buildings. Near the ruins of a department store, shots ring out from Soviet rifles, some on roof tops. Most of the crowd retreats. But two young men hold their ground, rip up paving stones and hurl them futilely at an oncoming tank. Futilely but dramatically, in a singular demonstration that East Berliners are mad enough to fight their Soviet rulers with anything on hand. Before it is over, the Berlin uprising takes 38 lives and wounds hundreds of others. By June 28, an uneasy peace returns to the city and Russian force prevails. The crack in the Iron Curtain is mortared over. But by then the whole world has had a revealing peek.

Wolfgang Albrecht, a young photographer for Shirmer, a small West Berlin photo service, seeks protection in a ruin when the Russians start firing and the tanks roll. Two protestors are wounded right next to him. Albrecht shoots pictures from behind the remains of a column. Two tanks move within 50 feet of him, cannon generally in his direction, when two other young protestors run out and start throwing paving stones at the clanking armor. Albrecht shoots another picture. Somehow he and they survive. Years later, he will recall: "I was so absorbed in the pictures I didn't realize the danger. I was only 22 then."

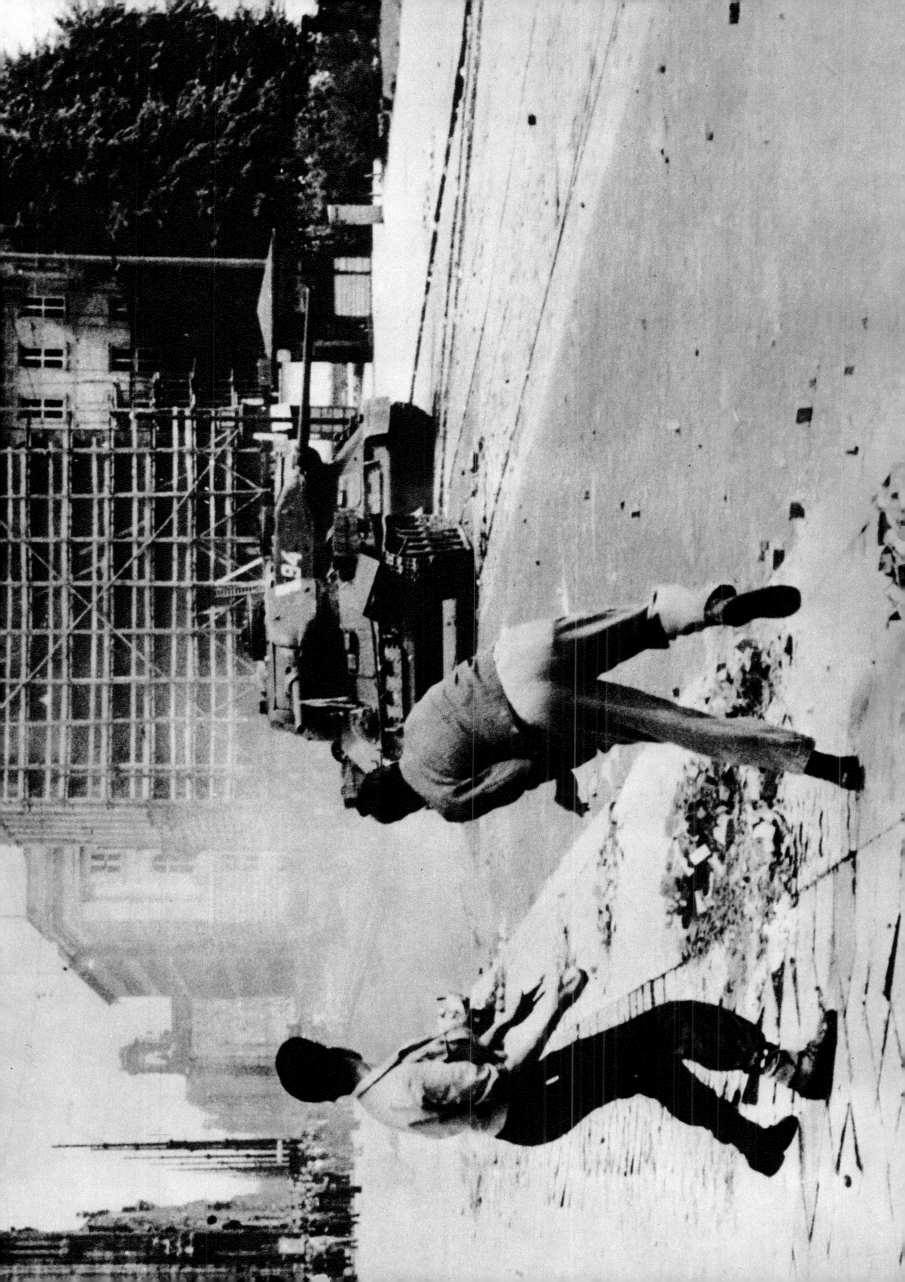

WYNKEN, BLYNKEN AND NOD

For the United Nations, it is another classic moment of arrested motion, numbing futility, weary bombast, parliamentary pretzels.

The question before the U.N. General Assembly is of major consequence: whether neutral nations, specifically India, should participate along with the belligerents in the forthcoming peace conference to settle the Korean war. Even so, debate can be wearing, especially should it include a 71-minute harangue by the Soviet delegate, white-thatched Andrei Vishinsky. For the United States delegate, Henry Cabot Lodge, it is especially trying because it represents the first time in the seven and a half years of U.N. existence that the United States has found itself in a minority on a major issue. The delegate from the United Kingdom, Sir Gladwyn Jebb, is in the equally unsettling position of splitting with the Americans over the matter.

From the American point of view, "two sides" should negotiate the Korean peace—on the one side, the 16 nations that sent troops to Korea; on the other, the Communist foe. Lodge feels that Communists would be more likely to yield ground in two-party talks—as indeed they had after two years of wrangling over a Korean truce at Panmunjom—than they would at a round-table affair. The British see advantages in the latter, viewing a broad-scale conference on many global matters as a prelude to a general "settlement of the Cold War." The Russians, for their part, are primarily anxious to enlarge any potential split among the western allies.

A dicey moment, then, this day of debate, August 26, 1953, and visitors who pour into the air-conditioned chamber from New York's 95-degree summer are treated to an equally heated exchange inside.

Shouts the Soviet delegate, shaking his fist:

"You cannot dictate the terms of this conference. You didn't win a victory. Are you flying through the clouds on wings of ideas that you represent the master race?"

Replies the United States delegate, in icy Bostonian tones:

"Mr. Representative of the Soviet Union . . . has missed another one of several great opportunities in his life to keep quiet."

The result: 21 votes for the U.S. position; 27 against; 11 abstaining; 1, India, not participating. Thus, neither side wins the two-thirds majority necessary to carry the day and the matter is put aside to debate anew. But the spectacle of watching old friends—England, Norway, Mexico, Canada, indeed all except two of the 16 nations with troops in Korea—depart from the U.S. position in the vote is enough for Americans to count it as their first U.N. defeat.

A camera with a 20-inch lens—Big Bertha, the Associated Press photographers call it—is a cumbersome thing to work with. Not just bulky, but it takes an agonizingly long time to change the slides, and the constant worry of the photographer is that he will fire the shutter an instant too soon, missing a better picture while he reloads. Big Bertha is the camera John Lindsay is using today, stationed in a booth at the far end of the U.N. chamber. Lindsay has covered the U.N. many times. Much as a sharp-eyed batter learns by a pitcher's motion when to expect a fast ball, Lindsay has in the course of his work detected a peculiarity of the Russian delegate, Vishinsky. John Lindsay does not know Russian. What he does know is that an instant before the demonstrative Vishinsky winds up to deliver an arm-swinging debating point, his voice rises. Every time. So John Lindsay listens, his finger on the trigger of Big Bertha. There it is—the rising voice. Click.

LOST

The wind was strong and the surf was high when the baby wandered off from their beach house. . . .

And now they are still searching and the young father runs up and down the beach, desperately picking up bits of seaweed, anything, looking for a trace, looking out to sea, to the big sea, where to look, where to go, and his wife restrains him and tries to tell him there is nothing he can do, nothing. . . .

Michael McDonald, 19 months old, had drowned.

This photograph of John McDonald and his wife was taken April 2, 1945, at Hermosa Beach, Calif., by Jack Gaunt of the Los Angeles Times. Gaunt was sitting in the front yard of his suburban beach house when he heard the sirens and a friend told him a boy was missing. Gaunt ran up the beach and snapped the picture from about 200 feet, not knowing what he was shooting but sensing the worst. The baby was found later, a mile up the beach.

☆ *Pulitzer Prize Winner, 1955.*

THE GODDESS

Wow!

In the great national tradition of reigning wowers—Lillian Russell, Clara Bow, Jean Harlow, Rita Hayworth—now it is Marilyn Monroe's turn to wear the uneasy crown.

Besides the basic ingredients, there is the invitational walk, the wet-lipped giggle, the breathless whisper, the ingenuous response, all that it takes to make a sex queen.

The cameras roll for a scene in "The Seven Year Itch" on a street in Manhattan. The star moves over the subway grating. Updraft. Squeal. Skirts up. Gorgeous symmetry. Like a lovely big luna moth. Perfect, baby, perfect. They'll love it.

In just a few years, the scene would be regarded as a case of over-dressing. But now, September 9, 1954, it is the squealy epitome of female dare. And Marilyn Monroe is perfect in the part. There may even be a hint that she can act.

"Is it true you had nothing on when you posed for that calendar portrait?"

"I had the radio on."

Marilyn Monroe had all the right answers for the press, few for herself in a private life that defied answers. Both her maternal grandparents and her mother were committed to mental institutions. Her uncle killed himself. Her father died in a motorcycle accident three years after her birth. The girl was in and out of foster homes, as later the woman would be in and out of psychiatric hospitals, followed by photographers. Her three marriages ended in divorce, the last two, to Joe DiMaggio and Arthur Miller, screamingly recorded by photographers relentlessly chronicling the life of a sex queen.

By the time she was 36, eight years later, she had starred in movies that had grossed $200,000,000 and in a life that ended, alone, on a bed in a small Hollywood bungalow, one hand hanging limply to a phone, near an empty bottle of sleeping pills.

A few days later, someone remembered, someone always remembers, that she used to say, "Isn't it a terrible thing about life, that there always must be something we have to live up to?"

———————

Matthew Zimmerman, Associated Press photographer.

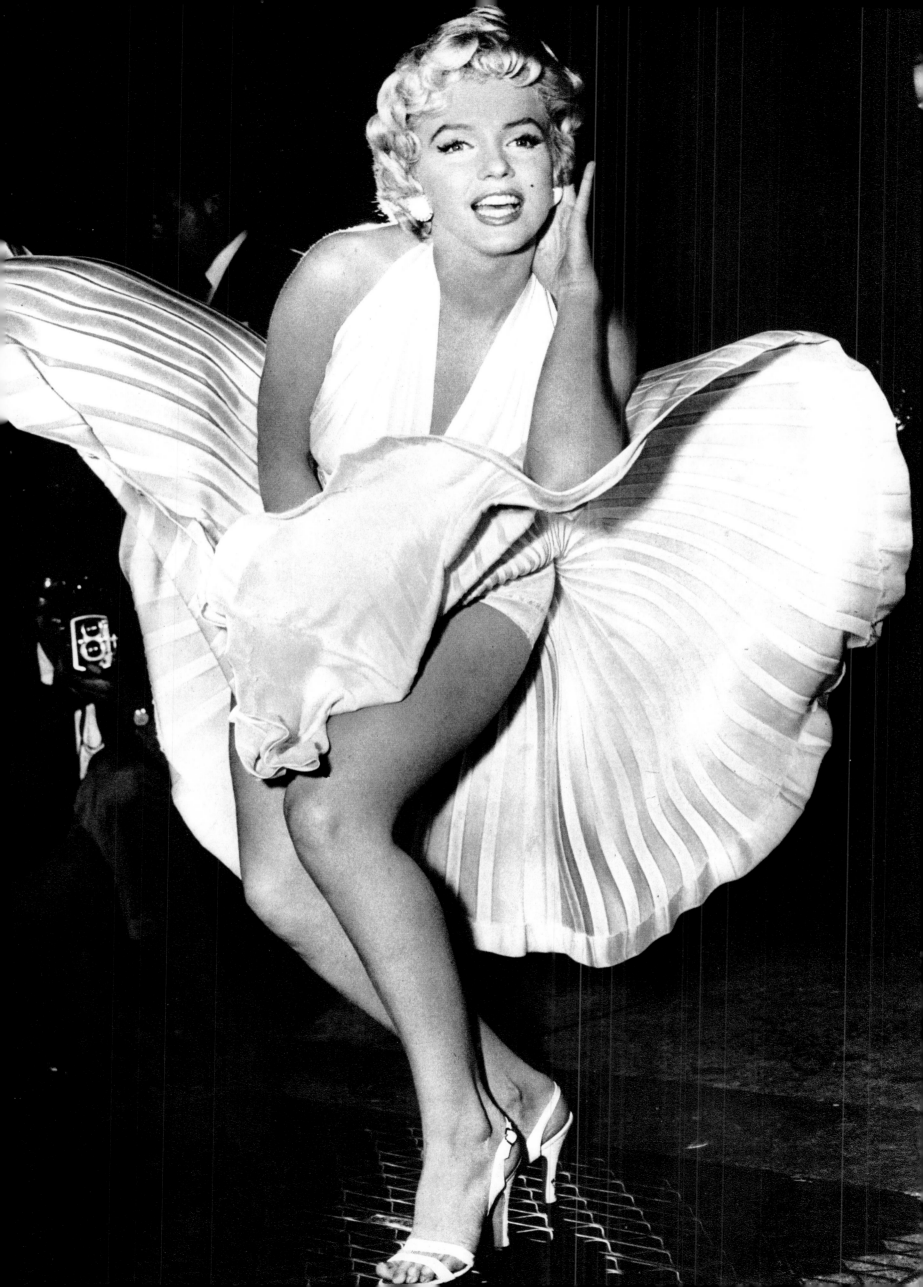

"GET THE BABY OUT OF THERE!"

November 2, 1955, a lovely day in the suburbs.

Not a cloud in the sky, and everybody on Barbara Drive in East Meadow, Long Island, is savoring the afternoon sun.

Henry Hartmann is out for a drive. Leon Johnson is playing golf. Ted Kelly is raking his lawn. And Michael Black, who is eight, is playing in the street in front of the house next door.

The house is empty. Paul Koroluck, who lives there, is at work. His wife, Susan, and their daughter, who is five and whose name is Susan, too, are a few blocks away, returning from a stroll. They hear an airplane overhead. Routine. Mitchel Air Force Base is a mile and a half away.

In the cockpit of the plane, Capt. Clayton S. Elwood, veteran of World War II and Korea, senses trouble. He and Staff Sgt. Charles Slater are returning to Mitchel Field from a routine training flight, and something is wrong with the two propellers on their B-26. They fight the controls but they lose altitude. Elwood radios Mitchel Field. They clear Meadowbrook Hospital by only 500 feet. Then the plane spins.

Ted Kelly hears a "God-awful roar." He looks up from his yard. Slowly, flatly, like a sick gyro, the B-26 is turning . . . falling . . .

Kelly drops his rake, dashes into his house, grabs his four-year-old son and sees his wife running across the lawn with their year-old daughter.

"Get the baby out of there!" he screams, and both parents race down the sidewalk, carrying their children.

The B-26 pancakes into Paul Koroluck's front yard . . . left wing on Barbara Drive . . . right wing against the house . . . one engine at the doorstep . . . the other at the driveway . . .

Fiery magnesium flies like shrapnel. Chunks hit Kelly's parked car, igniting it.

Flames crackle along the Korolucks' roof. Henry Hartmann, safety director of the Nassau County chapter of the American Red Cross, brakes his car to a stop. He runs inside the Korolucks' Cape Cod dwelling. Empty.

He turns, "scared silly," expecting the plane in the yard to explode. He gags on the acrid smoke and makes his way back to the street.

Muriel Black remembers her son, Michael, playing outside the Korolucks'. Her first impulse is to grab the telephone, but she realizes there is no time. She picks up her baby and runs down Barbara Drive. Somehow, Michael is safe.

Leon Johnson, lieutenant general in charge of the Continental Air Command, interrupts his game at Mitchel Field Golf Club. Soon, he, too, is rushing down Barbara Drive.

Then he stops, astonished.

"I don't know how it got in," he mutters, eyeing the burning plane . . . the houses 20 feet apart and 25 feet from the street . . . the telephone poles and utility lines over the sidewalk. Only one wire is broken.

Miraculously, only the two men in the plane are dead.

As firemen carry the bodies from the wreckage, Paul Koroluck returns from work, not knowing the house is empty. Neighbors drag him away from his burning home.

His two Susans, still a few blocks away when the plane struck, are safe at a neighbor's.

George Mattson is flying over Long Island in a New York Daily News plane when he sees the puff of smoke in the distance. "Let's take a look," he tells the pilot. As they approach Barbara Drive, Mattson sees the B-26, broken and smoking, on the ground. His pilot circles for 10 minutes while Mattson makes pictures before firemen have time to turn their hoses on the wreckage.

☆*Pulitzer Prize Winner, 1956.*

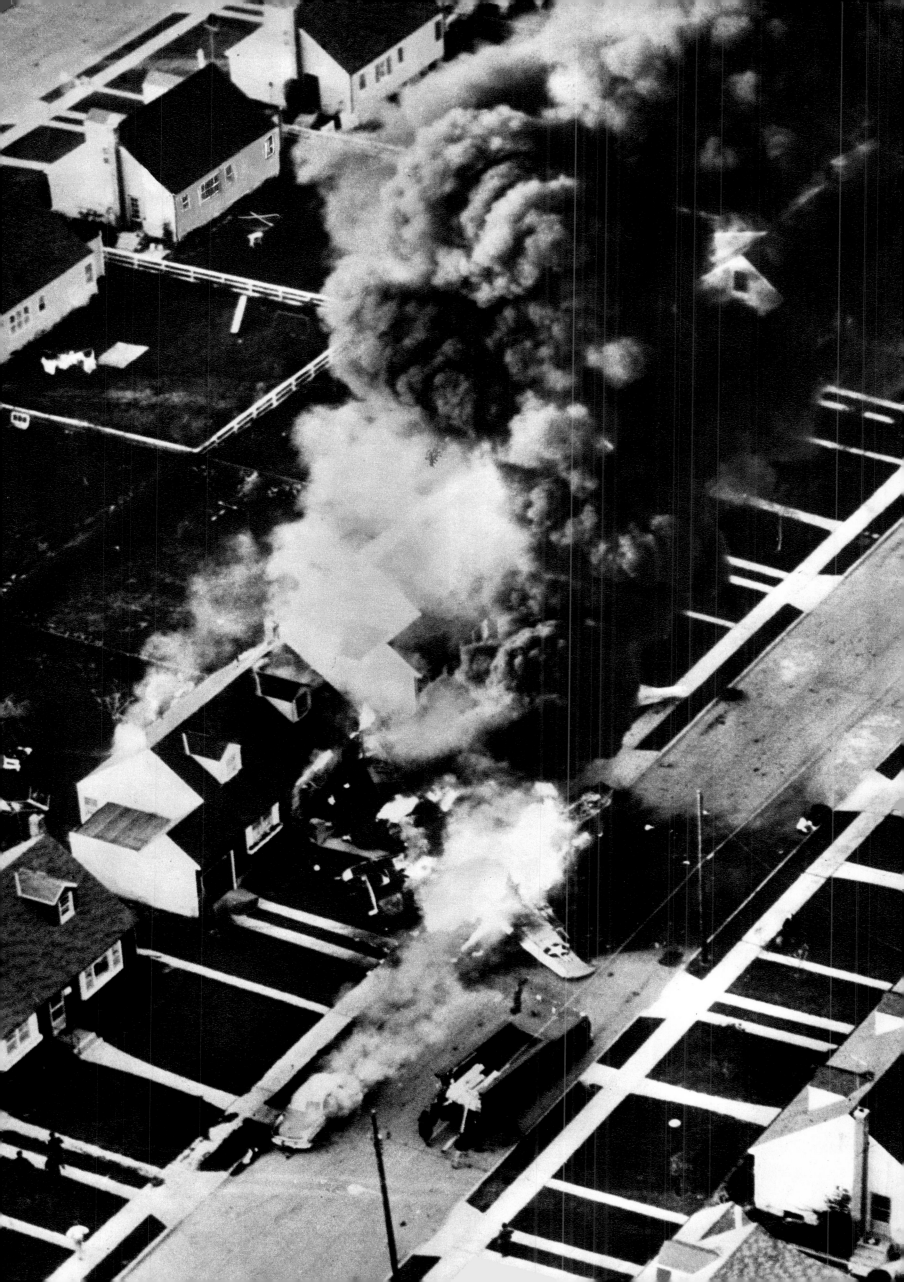

"ARRIVEDERCI, ROMA"

Outside, the fog was thick. Inside, the mood was warm and cozy. In the plush Belvedere lounge, men and women sipped their cognacs or danced to the sentimental music of an eight-piece orchestra. A murmur of quiet bidding rose from the cardroom. In the cabins, some passengers were already asleep, their last night out. On the decks, the late strollers were getting their last whiff of sea air. In the passageways, others picked their way around the luggage, packed, tagged and ready for customs. The orchestra signed off the evening with "Arriverderci, Roma." The Italian liner Andrea Doria, sailing southwest in a gentle sea, would be in New York in the morning.

A few miles away, the Swedish-American liner Stockholm steamed northeast on her first night out of New York en route to Copenhagen. A lovely wave danced off her sharp bow, which had been reinforced for ice in northern ports. Fog spoiled the view, but ship's officers assured passengers there would be pleasant nights ahead.

By 11 p.m., July 25, 1956, both ships were sailing in opposite directions through the busy lanes south of the Nantucket lightship, a stretch of sea off Massachusetts which sailors call "The Times Square of the North Atlantic."

At 11:21, one of the bridge players on the Andrea Doria looked idly out of a starboard window and thought her heart would stop. There in the heavy fog were the lights of another ship.

And at 11:22 p.m., the mighty prow of the Stockholm hit the starboard side of the Andrea Doria aft of the flying bridge and, in a great roar of grinding, crunching metal, penetrated 30 feet. Then, there was a shudder of ship frames and a shower of sparks, and the two vessels jerked apart.

On the Andrea Doria, deck strollers were slammed against bulkheads and cardplayers were thrown to the floor and the tables were torn from their sockets and sleepers were jerked from their beds and bounced against the walls, and in the screaming confusion, passengers racing for the decks met passengers racing back to their cabins for their families and their lifejackets. The ship began to list badly, and water and oil sloshed through the corridors.

Death made incredible choices. Linda Morgan, aged 12, was lifted from her upper bunk and somehow ended up alive on the retreating bow of the Stockholm. Her younger stepsister, in the lower bunk of the same cabin, was killed. In the adjoining cabin, her mother lived; her stepfather died.

And down the hall, movie actress Ruth Roman ran back to her cabin where her three-year-old son still slept. "Wake up," she said calmly. "We're going on a picnic."

An SOS went out from the Andrea Doria, and the old Ile de France, 45 miles to the east, came hard about and raced west. The Stockholm, navigable despite her wounded bow, launched lifeboats, but the Italian ship was listing so badly, she could only lower eight.

Before dawn, nearly all of the 1,650 survivors were safely aboard rescue vessels. Fifty-one others were lost, some under crashing steel, others in the dark sea. . . .

And at 10:09 a.m., July 26, 1956, the Andrea Doria raises her stilled propellers to the sky and sinks in 225 feet of water. . . .

Up above, Harry Trask of the Boston Traveler is having trouble maneuvering his Speed Graphic and his 200-pound, five-foot-four frame in the tiny Beechcraft Bonanza. The Andrea Doria lies over on her side. "Circle her as tight as you can," says the photographer. "Lean forward." He finds the room to play the camera behind the pilot's back. The ship lunges and Harry Trask shoots. . . .

☆ *Pulitzer Prize Winner, 1957.*

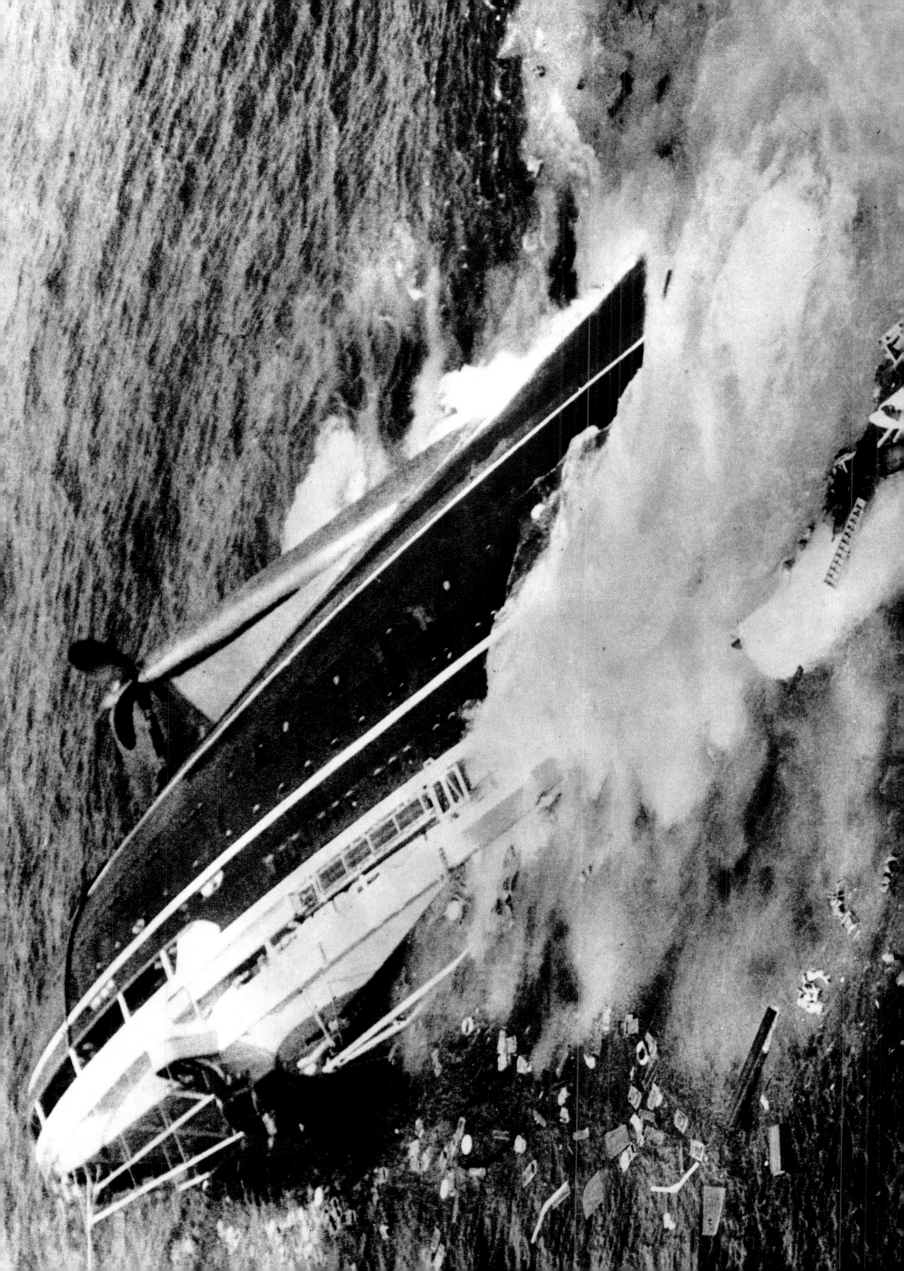

FIRST OFFENSE

After 23 years of teasing pictures out of everyday events, this was just another parade to Bill Beall of the Washington Daily News. But the editor had a fondness for the Chinese, and the Chinese had a fondness for parades.

So when the Hip Sing Chinese Merchants' Association dedicated a new building in Washington's tiny Chinatown, they held a parade. And Beall drew the photo assignment. It was a hot, sultry tenth of September, 1957, and Beall, at 204 pounds and 36 years, had one main thought: get the picture and get back. He stood there clicking away at the great paper dragon as it went by, steeling himself against the rattle of firecrackers. Out of the corner of his eye. . . .

Beall sees the little boy step from the curb, intrigued by the floating paper dragon with people legs. But after two unsteady steps he faces no paper dragon but two long legs in blue. The policeman bends down like some vastly older brother, and says in essence, "The firecrackers will get you if you don't watch out." Beall whirls and catches the picture.

Whatever else was said was lost in a fresh barrage of firecrackers, and the fickleness of memory. All that is left is the picture. Back in the newsroom, Beall developed his film, confirmed what his eyes saw through the camera sight. He told the editor, "I think I have a real one."

The picture won prize after prize. The boy, Allen Weaver, grew up. The cop, Maurice Cullinane, became assistant chief of police. Some years after the parade, the newspaper brought cop and boy together again. But the same gentle electricity was not there; the magic of an instant was gone.

☆ *Pulitzer Prize Winner, 1958.*

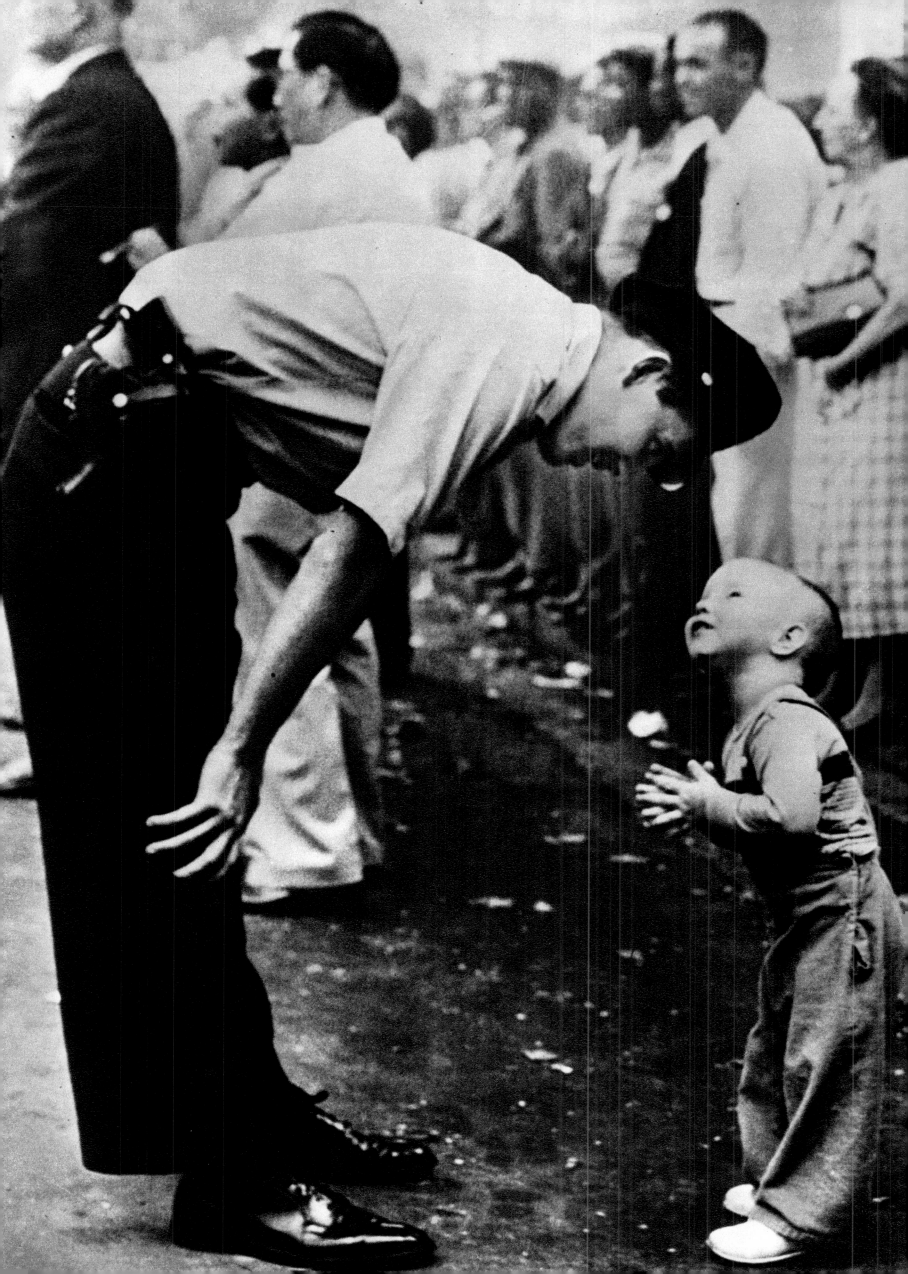

READING, WRITING AND BAYONETS

It was a shriek that spoke for much of the outraged South.

"Oh God," the Little Rock woman cried, "the niggers are in school."

Six Negro girls and three Negro boys were entering Central High School in Little Rock, Ark., after a struggle that had touched the rim of violence. At an unlikely place.

Little Rock, a moderate town with a liberal mayor, congressman and paper, had become the battleground where the South would stand firm against the 1954 Supreme Court decision to desegregate schools.

In keeping with that decision, federal courts had approved a plan by the Little Rock school board to enroll a few Negroes at Central in September, 1957. Then, unexpectedly, on the eve of school opening September 2, Gov. Orval Faubus, considered a moderate on race, went on television to declare: "It would not be possible to restore or to maintain order if forcible integration is carried out tomorrow."

Next day, 270 National Guardsmen patrolled the school. No blacks appeared. The day after, nine Negroes showed up.

"A nigger! They're coming! Here they come!" the mob outside the school shouted. The Guardsmen barred the way. A woman tried to comfort one of the black children.

"What are you doing, you nigger-lover?" someone cried.

"She's scared. She's just a little girl," the woman answered.

Meanwhile, President Eisenhower, who had said, "You cannot change people's hearts merely by laws," said of the crisis: "The federal constitution will be upheld by me by every legal means at my command."

After courtroom wrangling, the Guardsmen left and on September 23 the nine children entered the school. A mob of about 1,000 had gathered.

"Where are the niggers? . . . we'll lynch them all . . . look, they're going into our school . . . they've gone in . . ." the mob cried. Three hours later, authorities gave in and sent the students home.

Calling it a "disgraceful occurrence," President Eisenhower reacted by sending federal troops into the South for the first time since Reconstruction, to protect the rights of Negroes. One thousand were Army paratroopers, along with 10,000 Guardsmen. . . .

It is the next day, September 25. Twenty-four soldiers patrol inside the school. Outside, the curious as well as the haters gather.

Paratroopers with bayonets prod some smiling schoolgirls to be on their way. The girls still smile; it is all so unreal in 1957 in the U.S.A. One man is bloodied when he tries to grab a soldier's rifle.

But, at the point of a bayonet, the nine blacks enter Central High School and the mob goes home.

Photograph by Perry Aycock of the Associated Press.

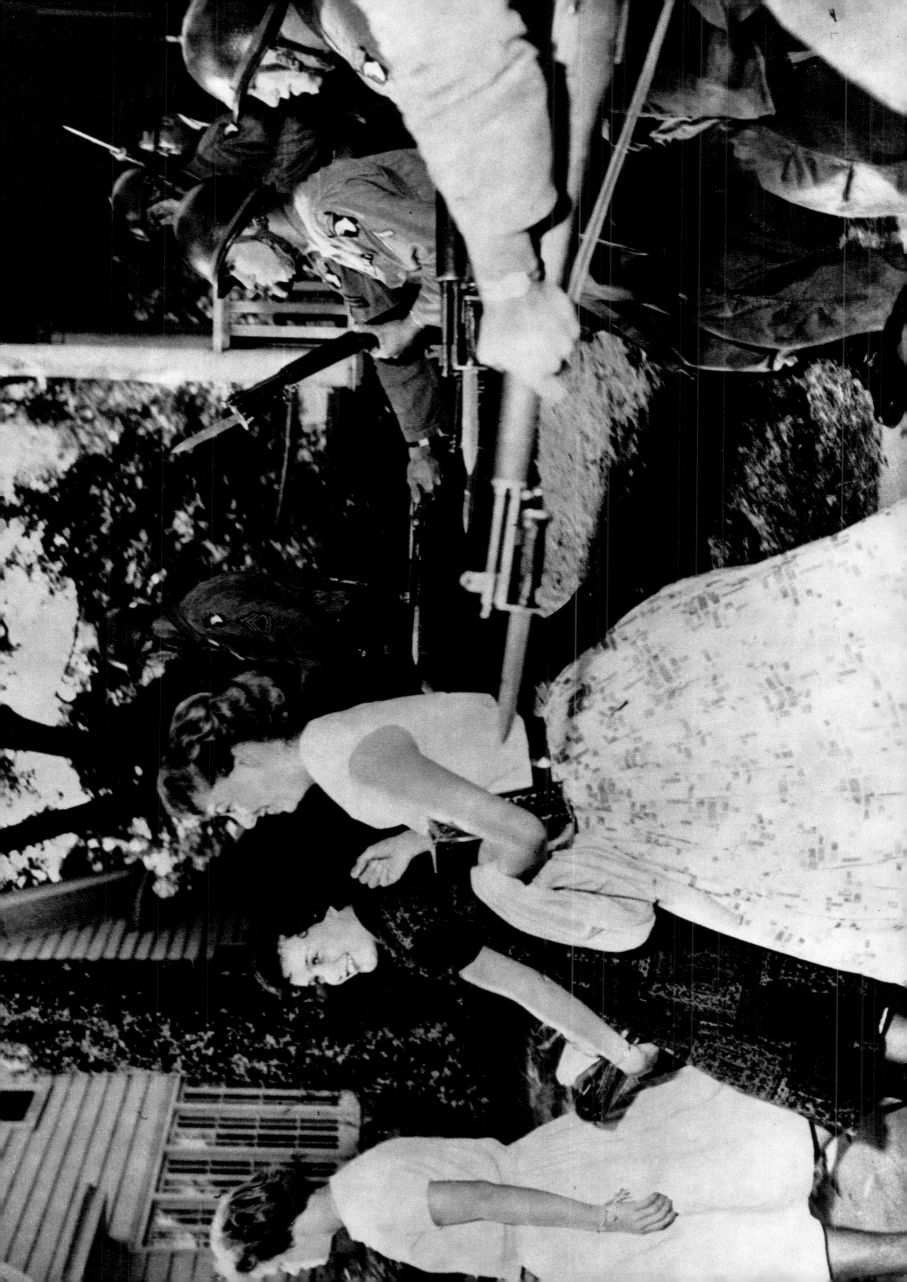

AT RIVERSIDE AND 27th . . .

A boy and his red wagon. . . .

He steps off the curb.

The light changes. He hesitates. He turns around and returns to the sidewalk with the wagon.

The light changes again. He steps off the curb again, his red wagon obediently behind.

And at 12:20 p.m., May 16, 1958, at the intersection of Riverside and South 27th Avenue in Minneapolis, Minn., a rubbish truck bears down on Ralph Fossum, who is nine, and his red wagon. . . .

———————————

Bill Seaman, a photographer for the Minneapolis Star, was stopped at the intersection when he saw Ralph make his first attempt. Seaman was about to shout, "Go back," when the boy did. The photographer drove on until three blocks later he heard, on his police radio, that a boy had been hit. Seaman turned quickly around, heart sinking. . . .

☆*Pulitzer Prize Winner, 1959.*

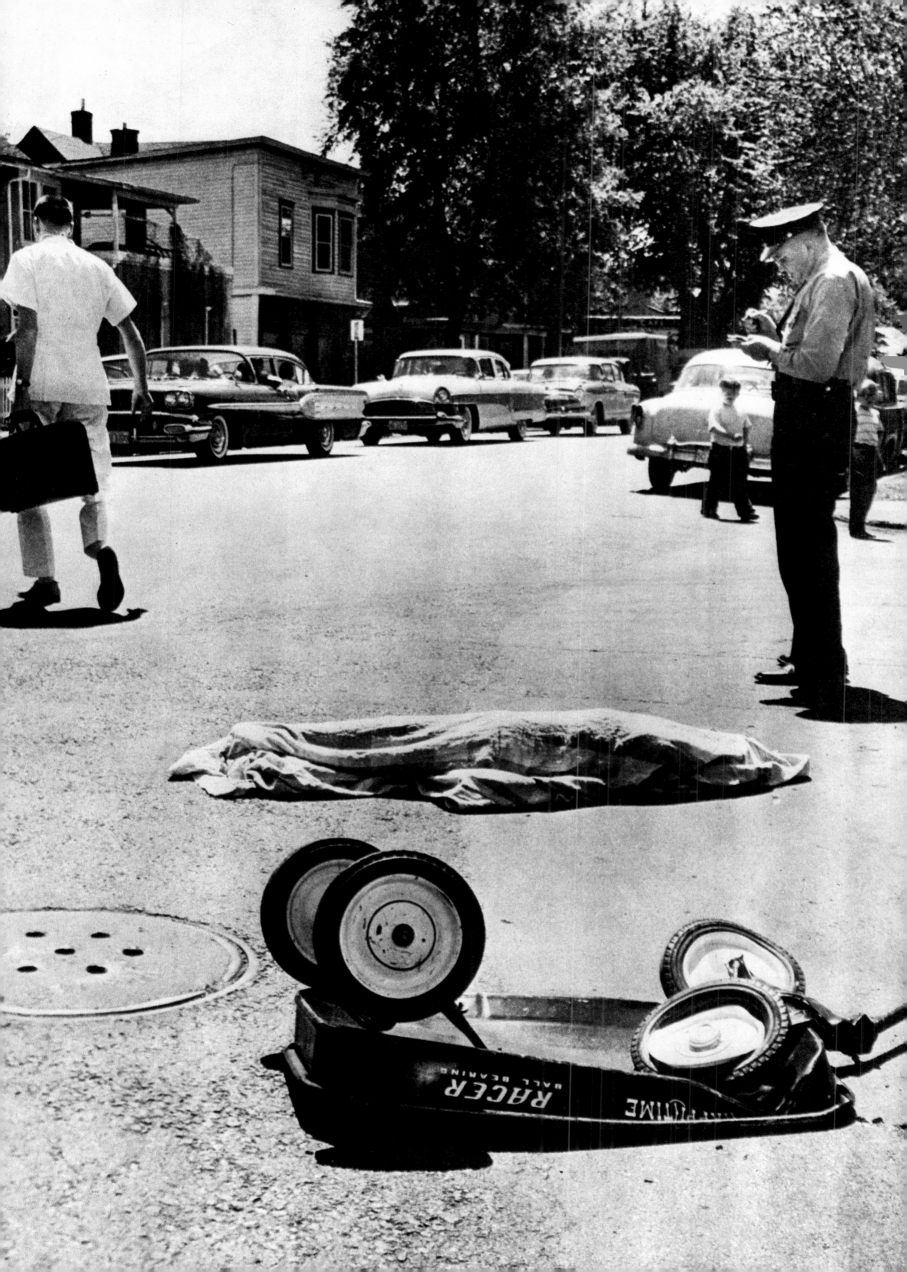

THIS ONE'S ON YOU

The sun that blinds you,

the lights that confuse you,

the background that distracts you,

the fans that boo you,

the nuts that run out on the field and chase you,

the sprinklers that trip you,

the potholes that maim you,

the wall that decks you,

the loose dog that tries to bite you,

the long, long road trips that bore you,

the hotel rooms that dismay you,

the batting average that sinks you,

the inflation that robs you,

the war that worries you,

the crime rate that scares you,

the kids that confound you . . .

Dear God, isn't it sufficient unto the day that this was a home run?

By what vast eternal plan was it necessary to spill the beer?

On October 2, 1959, Ray Gora of the Chicago Tribune is in the photographers'
perch over third base, Comiskey Park, second game of the World Series between
the Chicago White Sox and the Los Angeles Dodgers. The Sox lead 2 to 0 when
Dodger second baseman Charlie Neal belts one toward left field and Al Smith
races back to the stands.

Gora focuses on Smith, thinking, perhaps, there might be a spectacular leap
at the wall. He snaps his picture at the golden moment, noticing through his
view finder what looks then like a box of pop corn spilling. A second later he
sees Smith wiping his dripping face and knows he has something wetter
and better.

"I always say," Gora will say later, "that it was the greatest beer I never had."
The Dodgers, incidentally, went on to win that game and the Series, facts
less memorable than Gora's exquisite study of insult added to injury.

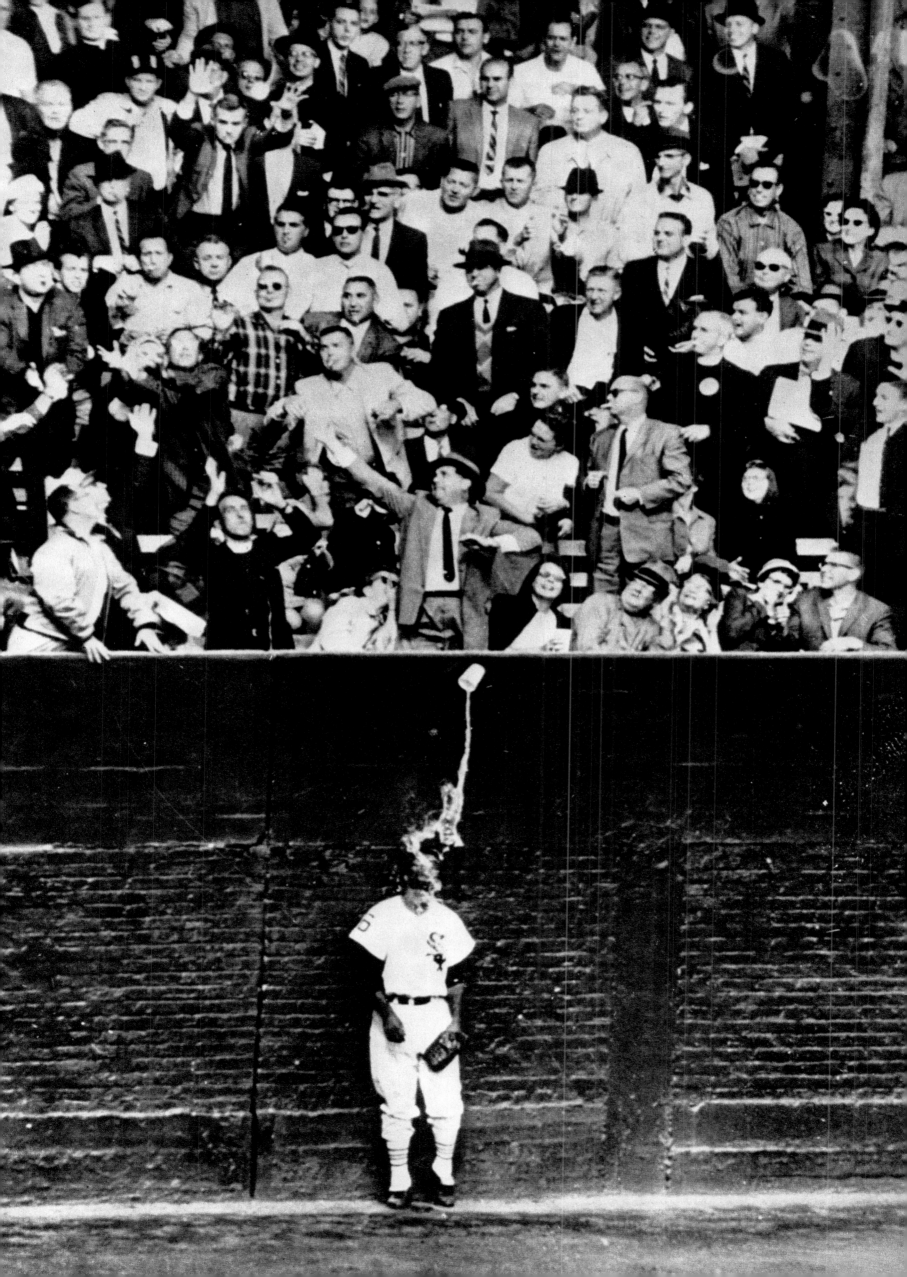

COLLAPSE....

The night before, the old track is nearly deserted with only an occasional lion's cough of an engine getting a last minute adjustment down in the rickety row garages of Gasoline Alley.

But at daybreak a signal rocket spurts into the gray dawn and Middle America storms through the opened gates.

The Indianapolis 500 says it is the world's largest spectator event, and as the cars whip through the underpasses to break into the infield with a fanfare of horns and blatting mufflers, it's hard to believe the whole country hasn't showed up.

They come for as many reasons as the means of their arrival. Hot-rodders gunning their motorcycles in anticipation of watching the ultimate speed. Families in station wagons setting up picnic hampers under a tree while Dad, in line all night, naps in the growing heat. College kids, sweatshirts labeled in gothic letters, lug in the beer, drinking what they can't carry on the way.

The ghosts are there, too, over there on the back turn or there on the home stretch where the jaunty bright colors of a racer suddenly became mangled tin.

Death is a fact of life at Indianapolis, though few who come will admit that's what draws them there. But then, on Memorial Day, 1960, the crowd brings death with it . . .

J. Parke Randall, a young architect, is a professional photographer only one day a year. Race day at the 500. A racing car buff, he works for the Indianapolis News at the northeast corner of the track, the fastest turn. On the pace lap this day, when upwards of 175,000 fans have turned out for the big race, he begins shooting his Leica as the cars blur past. Then he hears screams behind him where 125 people have paid $5 to $10 to clamber up a 30-foot temporary scaffold of wood and aluminum for a better view. As the tower begins falling under the weight of jostling spectators, Randall snaps off frame after frame to catch a classic sequence, and two more deaths and seventy injured are added to the bloody toll of the Indy 500.

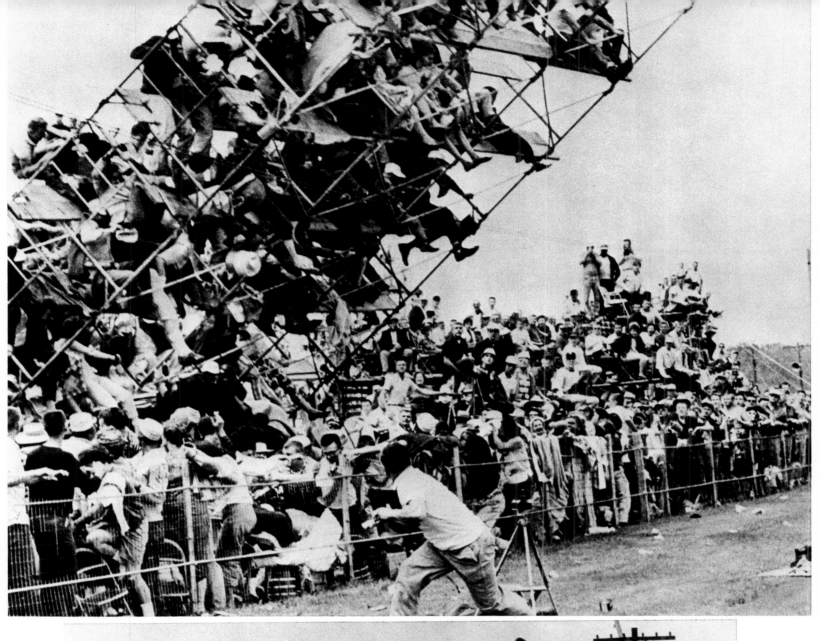

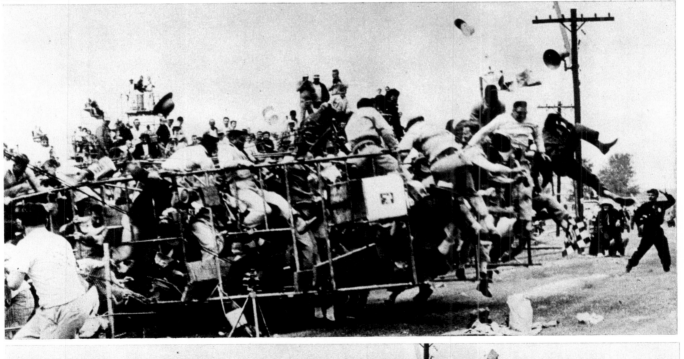

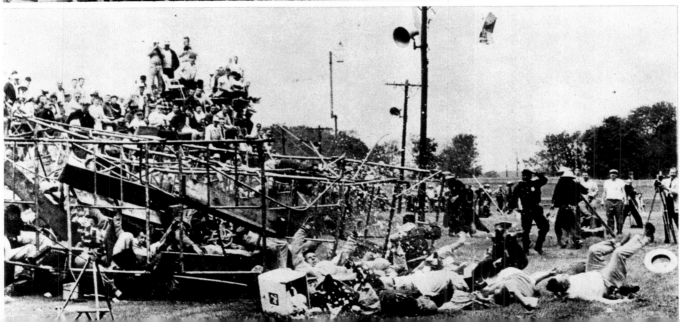

ALONE AT THE TOP

The moment will come to symbolize what he is only beginning to learn now.

Thomas Jefferson called it "a splendid misery"; Harry Truman, "the big white jail"; William Howard Taft, "the loneliest place in the world."

Kidding about the presidency, John F. Kennedy said the job was good, the pay was fine, the working and living conditions were superb and, besides, it involved only a small commute between home and office.

Not kidding, he said, after two years, "The problems are more difficult than I imagined them to be. The responsibilities placed on the United States are greater than I imagined them to be, and there are greater limitations upon our ability to bring about a favorable result than I had imagined them to be. . ."

On February 10, 1961, Kennedy has been in the job only three weeks. On this day, which begins at nine and ends at eight, he sees more than 100 people, singly or in groups, cabinet members, agency heads, diplomats, congressmen, staff assistants, a variety with a variety of purposes, ranging from the Mardi Gras queen to the director of the CIA.

At 5:01 p.m., awaiting the French ambassador, the President rises from his desk. Sitting in one place for more than 15 minutes makes him restless because of his back brace. He goes to the window overlooking Dwight Eisenhower's putting green and opens a newspaper to the editorial page . . .

George Tames, who is shooting a-day-in-the-life-of layout for the New York Times, moves in from an open doorway where he has been watching his prey. He is not thinking of the ages or the burdens of the presidency but only that here is a dramatic picture, the man silhouetted against the twilight and framed by the drapes and the flags. He shoots three versions. The President looks up. "George," he asks, "where do you suppose this columnist gets all this junk?"

"THEY LOOK SO LONELY"

It is three months and two days since John F. Kennedy took the oath of the presidency with a ringing summons to faith and courage.

Now he is in trouble. Now he seeks the support of the man before him, Dwight D. Eisenhower.

April 22, 1961. The new President, only 43, has called the old President, who is 70, to help him forge a position of national unity in the disastrous aftermath of the Bay of Pigs. It is just a week since the Cubans' bloody landing in Cuba, into overpowering Cuban gunfire. Only two days since Soviet Premier Nikita Khrushchev fired off a brusque diplomatic warning to the United States. The world is involved in the crisis. The missiles are yet to come.

Aboard helicopters, President Kennedy from Washington, and General Eisenhower from his farm in Gettysburg come to the Catoctin Mountain retreat in Maryland that Franklin Roosevelt called Shangri-La and Ike renamed Camp David, for his son. It is Kennedy's first trip there as President. Eisenhower knows the place well.

At 2:33 of a cloudy, brisk Saturday afternoon, the new and the old President meet briefly with the large press corps. Ike recognizes many, calls some by name. "Like old home week," he says.

And he issues the statement Kennedy wants: "I am all in favor of the United States supporting the man who has to carry the responsibility for our foreign policy."

Quickly, Press Secretary Pierre Salinger clamps down "the lid"—no more pictures, no more questions. Secret Service men move in to screen the area, shoo the press away.

Paul Vathis of the Associated Press, a frequent visitor to Camp David from his base in Harrisburg, Pa., hears Ike say to JFK, "I know a place . . ." Vathis looks over his shoulder to see the two men walking side by side up a stone-paved path toward the stark trees of reluctant spring and the piled leaves of an autumn past.

Vathis quickly drops to one knee, swings his camera. A bulky Secret Service man partly blocks the view. "Move, Moose," Vathis calls. The man moves. And in a moment, Salinger is back scolding, "I said no more pictures!"

It doesn't matter; the walking men have gone beyond camera range. Anyway, Vathis has the picture. The Pulitzer will come later.

"They look so lonely," Vathis muses. "The young guy asking the old guy."

146 ☆ *Pulitzer Prize Winner, 1962.*

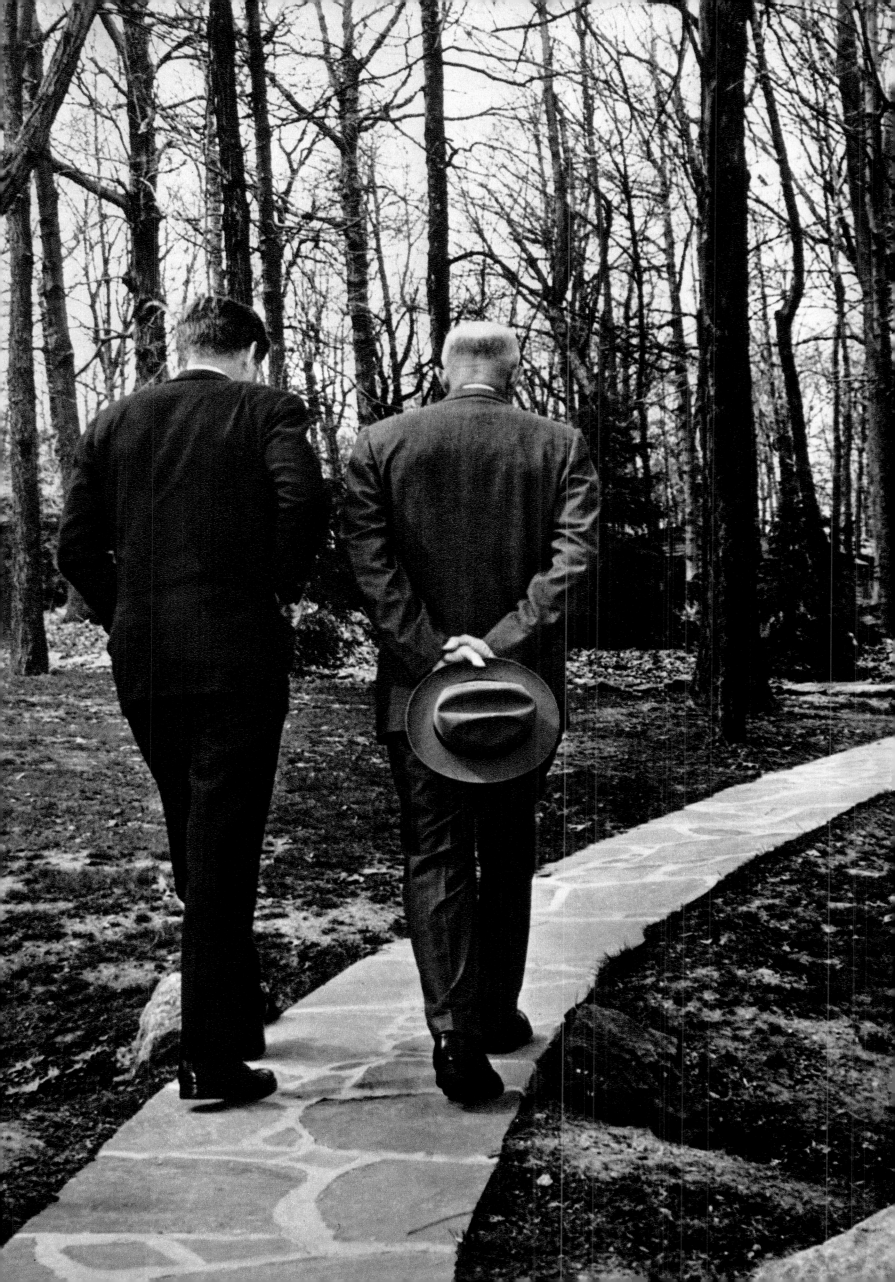

UBER ALLES

Conrad Schumann doesn't remember World War II. He was only three when that ended and the armistices were signed, creating a divided Germany.

Now, at 19, he is an East German border guard along the 26-mile stretch of barbed wire that bisects Berlin itself. It has been up only a few days when Schumann reports for duty at 2 o'clock on a Wednesday afternoon, August 15, 1961, in the sixteenth year of the Cold War between former allies.

The son of a shepherd, he often listens to the West German radio stations and the American station. Life in the West. He wonders.

On this day, several West Berlin youths, about his own age, stand near the fence on the free side. "Come over, man, come over," they keep saying. Schumann hesitates a long time. He smokes a lot. Then he fingers the barbed wire and finally decides. He nods discreetly to his new friends across the tempting border, hoping the gesture isn't noticed by two other East Berlin guards stationed nearby with machine guns.

On the West side of the wire, police bring up a small truck, open the rear door and motion. Schumann looks at the two other Communist guards. Their backs are turned. He dashes and hurdles the fence. Somehow, there is no fire from the East and he is sped away in the truck. At four o'clock, just two hours after he came on duty, Conrad Schumann is a free man.

Peter Leibing, a photographer for the Hamburg Picture Agency Contipress, is tipped by police that an East German guard may be coming over. Leibing goes to Bernauer Strasse and quickly spots his man, the one smoking nervously. He feels the other two guards are watching Schumann closely, but as they turn their backs he senses this is the moment. He positions himself in what could be a line of fire and, hoping for the best, he gets it: no gunfire but a memorable picture symbolic of man's hunger for freedom in a barbed wire world. Leibing rides back to the police station with Schumann and takes up a collection. With liberty this day, first come bread and liverwurst.

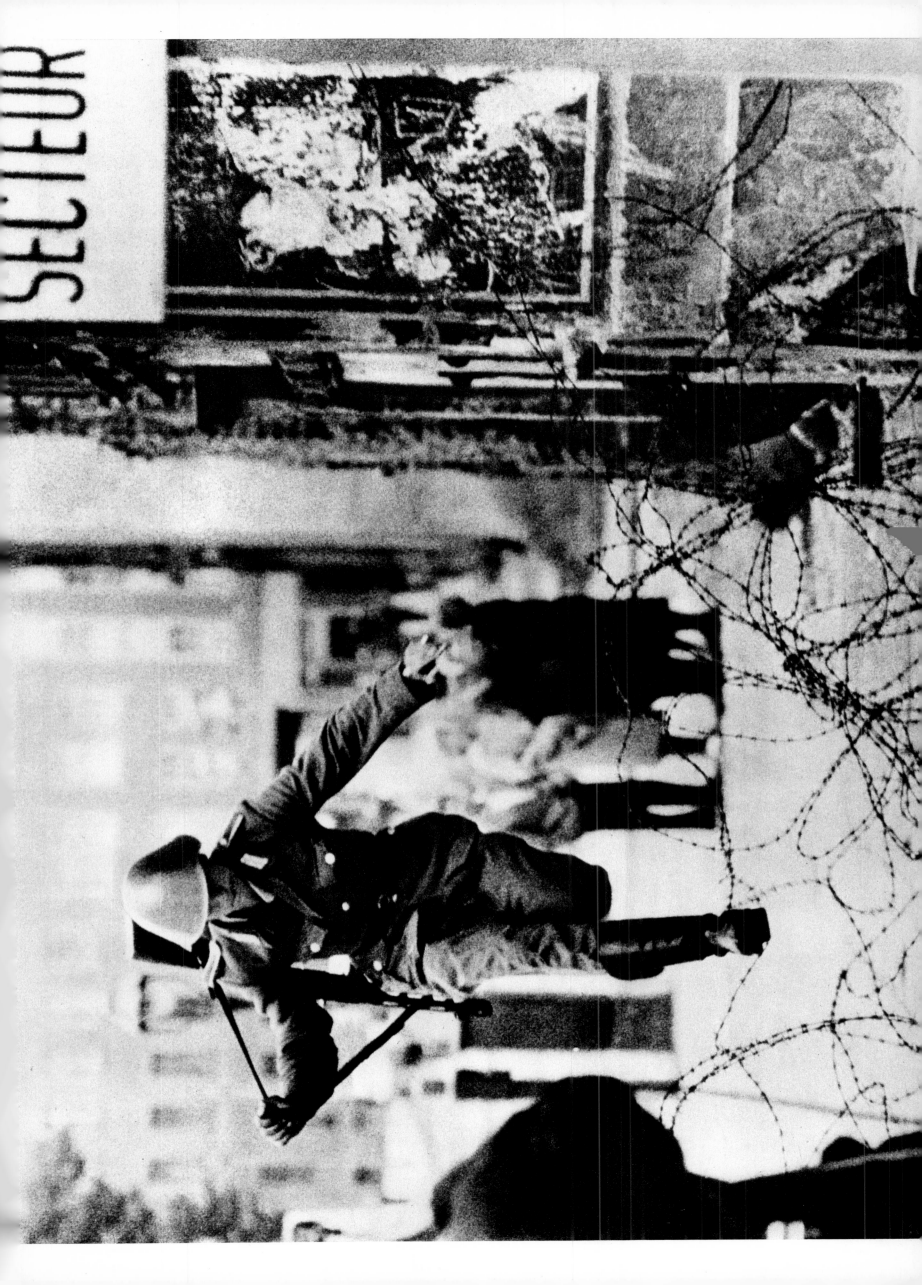

CHURCH AND STATE

President Romulo Betancourt of Venezuela is in the fourth year of his five-year term, elected by universal vote, his nation relatively prosperous. But in Latin America, where poverty and wealth dwell so close together, where the politically in and the politically out are nervous companions, peace is as unstable as the torrid weather.

The new constitution is only a year old. Already it is tested by bullets. In the first week of June, 1962, 500 marines revolt at the naval base at Puerto Cabello. Snipers in the buildings put down a withering fire at government tanks and troops that advance against them.

––––––––––––

Hector Ronden, a cameraman for the newspaper La Republica, ducks the bullets and follows the government force against the marines. In two days, more than 200 are killed, the revolt put down, and Ronden has a prize winning series of pictures—the most vivid, Father Manuel Padilla holding a wounded government rifleman.

☆ *Pulitzer Prize Winner, 1963.*

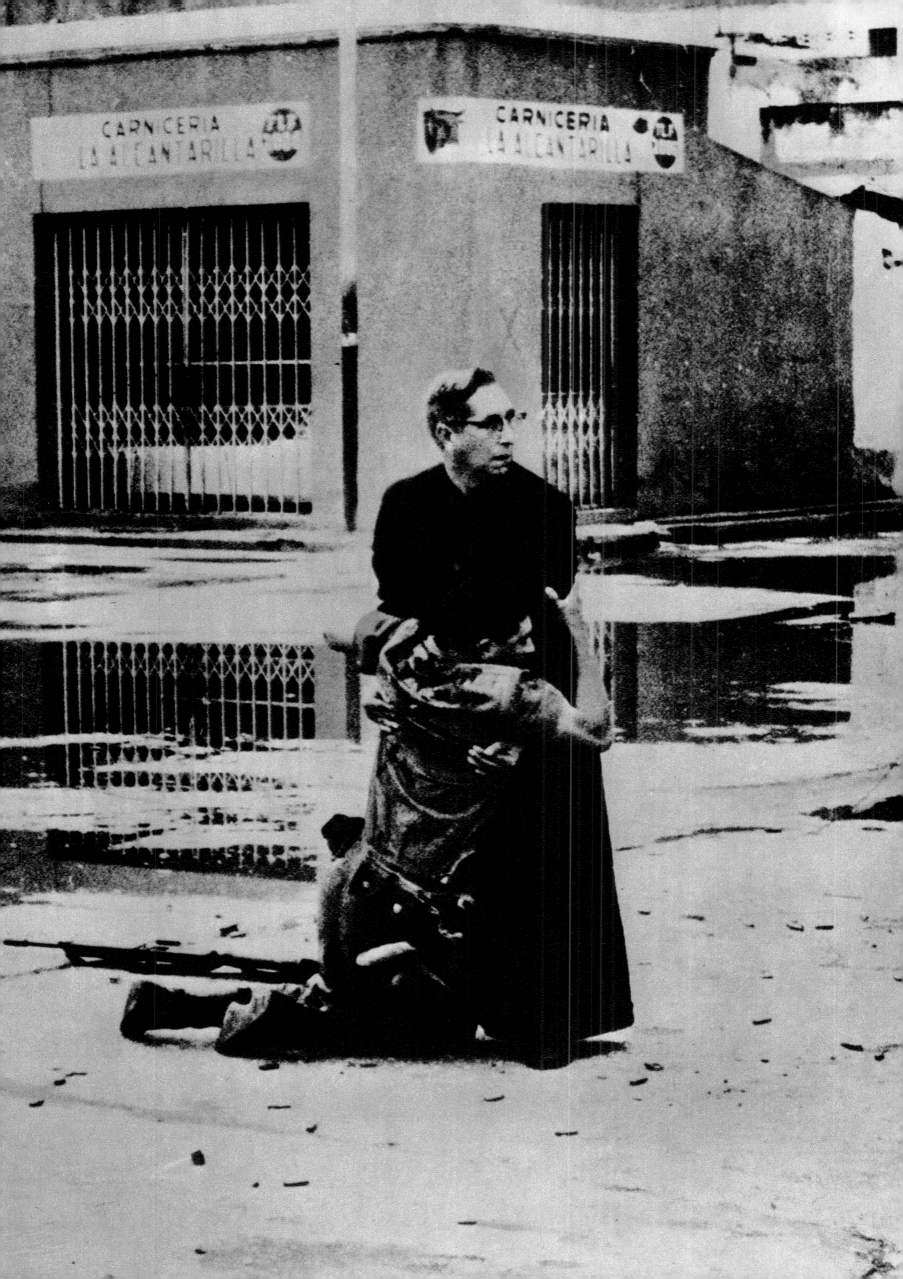

WHY?

The Congo, the first week in January, 1963.

Albert Verbrugghe, a Belgian cement worker, is driving down a quiet street with his wife and another woman in the copper town of Jadotsville. Suddenly . . .

Machine gun fire.

Verbrugghe stumbles from his car. Inside, his wife is already dead and the other woman is dying. Blood streaming from a wound under his eyes, he cries out:

"Why, why, why?" . . .

The anguished question was not new to emerging Africa, especially the Congo where senseless killing and bedlam marked the first 30 months of independence.

The Congo was set free in 1960 after 80 years of frequently harsh and always profitable rule by the Belgians. It had no experience in self-government and no time to learn. It was hurried overnight from the slow step of the ox to the roar of the jet. A country one-third the size of the United States, it had not a single Congolese college graduate, not one Congolese doctor or lawyer, engineer or military officer or anybody trained in government.

And many natives were led to believe that, with independence, they would immediately inherit the white man's world, his house, his car, his woman. Thus, the new Republic of the Congo began in a nightmare of killing, looting and rape, and Europeans fled by the thousands.

Postal clerks became cabinet ministers and government became a roaring farce played by the Marx brothers and no one knew the size of the army because many garrisons existed only on paper while the local commanders pocketed the payroll. Soldiers mutinied or refused to fight or left a vital roadblock because it was raining or it was Sunday or it was after five o'clock. Teachers went unpaid for two years in many places because higher authority had gotten to the payroll first. The feuds of ancient tribalism continued and in one 300-mile stretch of railroad the train crew had to be changed nine times to avoid slaughter.

In Katanga, the copper-rich province which provided half the revenue for the central government, Moishe Tshombe led a secessionist movement. Without Katanga, where Belgium and England were heavily invested, the new republic would fall apart. United Nations troops came in at the behest of the central government, which cried of "colonialist machinations."

And so, in the first week of January, 1963, nervous Indian troops opened fire on a Volkswagen on a quiet street in Jadotville. Why? Because, they said, the driver refused to halt for a routine inspection.

———————————

Picture by Roger Ansong, free lance photographer.

"ALL LITTLE GIRLS"

A gentle afternoon designed for gentle endeavors. The city of Savannah is holding its annual spring art festival along the brickways of Factor's Walk, the waterfront. People browse among the paintings, sketches and photographs or stop to listen to artists speak of art.

The sun hangs low and shadows dwarf the people. The high school band begins a medley of classical themes. Suddenly the music seems to lift a two-year-old girl out from the crowd, and there, alone in the sunlight, she dances, a tiny spirit more artful than art itself.

————————————

It is a little after 5 p.m., April 20, 1963. Andrew Hickman of the Savannah Morning News and a fellow photographer are tired from a day of hanging pictures for the festival. Hickman gives a small talk on photography for a group of maybe 20 people. Then he sits on a park bench with two women and they chat about art. But something catches Hickman's eye. The dancing girl.

"It'd make a great picture," Hickman suggests to his friend, who replies that it is after five and he's off duty.

Hickman grabs his Leica and tries to get closer. The little girl sees him and runs to her mother. Hickman melts into the crowd and waits. In a moment the little girl is back again in quick, little pirouettes, and Hickman clicks his shutter. Later, when the picture is hung in his living room, his own two-year-old daughter would tell guests that the picture was of her. "That's the charm of it," Hickman says. "It's all little girls."

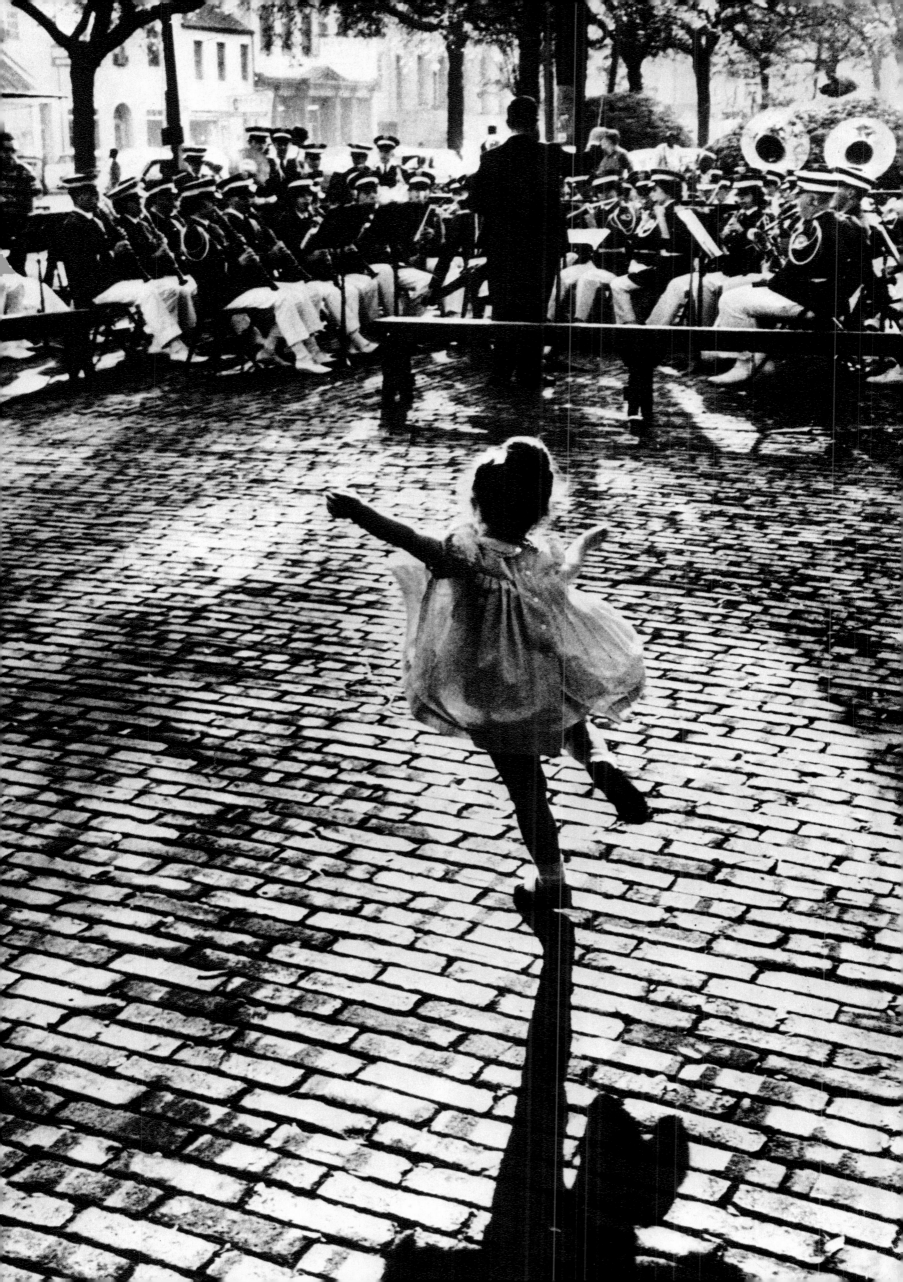

"LET 'EM SEE THE DOGS WORK"

"Break Birmingham and we break the South," intoned the Rev. Martin Luther King in the spring of 1963. "Amen" answered his black legions. After five years of struggle in a century-old crusade they were never more determined.

The times are exhilarating, but risky, and certainly not fun. In his ongoing battle to destroy the unyielding system of segregation in Birmingham, Ala., King now decides on a dramatic new tactic: along with the adults in his line of marchers, who for five days have confronted Police Commissioner Eugene "Bull" Connor's angry ranks, there now appear school children.

Out of their Sixteenth Street Baptist Church sanctuary, they stream into the streets of downtown Birmingham, wave after wave, singing. As they march, in defiance of a local "parade" ordinance, Connor's patrolmen toss the protestors, mostly children, into jail—where they go happily, clapping and chanting "Freedom now!" from the paddy wagons.

By Friday, May 3, there are 800 in jail. There is no joy this day. The marching children, who range from first graders to high schoolers, pass several hundred black adults in a park near the church and head toward a massed line of lawmen. A police captain tells them to stop. They do not stop. On a signal, black-booted firemen turn on stinging firehoses. Children fall backwards from the crushing streams, and lie there, bleeding. From the park, the black adults shout threats at Connor's cops, threats and taunts: "Bring on the dogs!" Furious, the commissioner roars for his dogs. The blacks in the park edge back. A group of whites edges forward, trying to see. An officer restrains the whites. "Let those people come to the corner, sergeant," Connor yells. "Let 'em see the dogs work. Look at those niggers run!"

Some blacks do run. Some stand their ground and stare in terror as the snarling dogs lunge and snap from long leashes. Others hurl rocks, sticks, bottles at the dogs and at the police. Five blacks are hurt—dog bites, cuts, bruises; two policemen are bruised; another 250 blacks go off to jail.

As night settles over troubled Birmingham, King's message of pride and hope sinks deep into 1,000 black souls gathered at the church. "The eyes of the world are on Birmingham," he tells them. "We're going on in spite of dogs and fire-hoses. We've gone too far to turn back. We're going on. We're going on."

And from the pews a response swells up and moves through the South and moves through the North, and becomes an anthem in the unfinished business of the American Negro: "We shall overcome . . ."

His news photographer's instinct tells Bill Hudson of the Associated Press that Bull Connor will use the dogs this day. He had seen them caged in trucks parked nearby and knew the blacks had seen them, too, and were angry. He takes a position in the park across from the church. As the first dog lunges he fires his camera. In the confusion that follows he loses sight of the dog's victim and curses his luck. He wants to know his name so his picture will be complete. Tediously he begins tracking him down, asking questions, and at length, later that evening, knocks at a door in Birmingham's black ghetto. Yes, this is the right place, a man says, but he is apprehensive. His son is 17, he tells Hudson, and is not hurt. But the situation in Birmingham is tense: if the picture appears in the newspaper and reveals a name and address there might be retribution. He asks Hudson to keep his son's identity a secret. Over the years the picture is republished many times, and each time Bill Hudson explains: "I gave my word and have never been released from that promise."

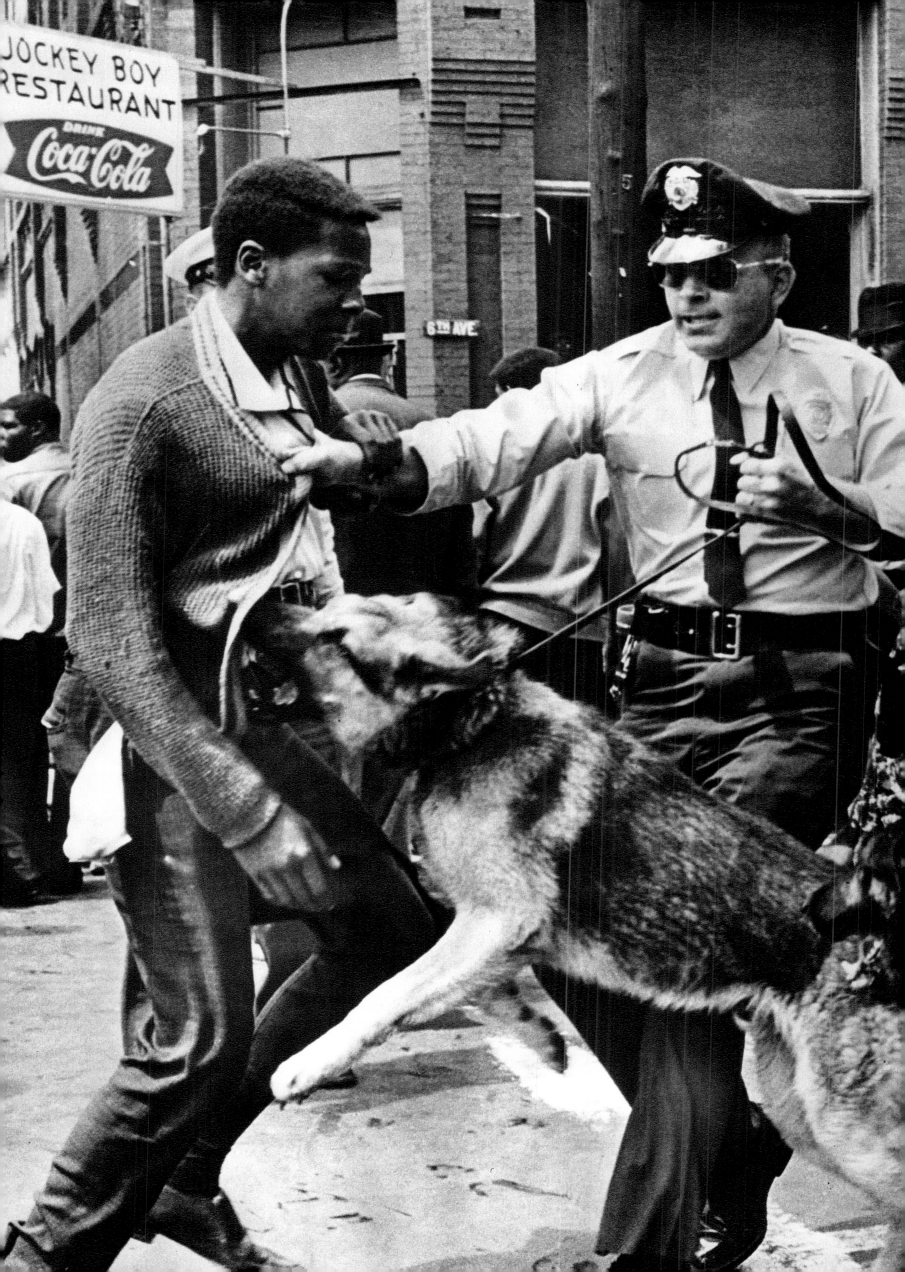

THE ULTIMATE PROTEST

Like twisting a violin screw, tighter, tighter, President Ngo Dinh Diem's militantly Roman Catholic regime had brought the Buddhists of South Vietnam —80 per cent of the divided country's populace—to the limit of their endurance. They demonstrated. Lines of monks and nuns chanted endless prayers in processions of protest from pagoda to pagoda. Diem pretended not to see. They raised their religious flag. Diem had it ripped down. When, at length, Diem's police waded into a Buddhist demonstration and left eight of their number dead, the taut string snapped.

The Xa Loi pagoda is not one of the more important ones in Saigon and the solemn gathering there of 350 monks and nuns at 8 a.m. on Tuesday, June 11, 1963, attracts little attention. A few lay women are there, dressed in white robes of mourning, weeping as they serve tea. This seems strange to Malcolm W. Browne, Associated Press correspondent, who also is there, for he knows of no recent death.

At 9 a.m., the mesmeric prayer chants cease. The monks and nuns, in ceremonial yellow robes, file out of the pagoda in silence, two by two, a pungent aroma of incense following them into the narrow streets. The procession winds slowly toward downtown Saigon, following a gray car in which five monks ride. This, too, seems odd to Browne; none of the many previous processions had been led by a car.

At 9:17 a.m., the procession reaches the intersection of Phan Dinh Phung and Le Van Duyet streets and halts. The monks and nuns form a circle. Three monks step from the auto, one of them an aged man, by name Quang Duc. A brown cushion is placed on the hot pavement and Quang Duc lowers himself to it wordlessly, without emotion, and pulls his feet over his thighs in the Buddhists' traditional cross-legged position. Quang Duc exchanges a few words with two younger assistants, bows his head slightly, and the two pour gasoline over him from a white plastic container. When Quang Duc's saffron robe is saturated the assistants step back. At 9:22 a.m., with an almost imperceptible motion, Quang Duc strikes a match.

Through the lens of Correspondent Browne's camera the flames of Quang Duc's self-immolation leap the seas, and horrify the world, and neither Diem nor the government in Washington which supports him can pretend not to hear the wails of the old monk's mourners.

"I thought the car had simply stalled," Malcolm Browne recalled later," and continued to think so when a monk opened the hood and took out the gasoline can. But when the monks and nuns formed their tight circle around Quang Duc, I realized at that moment exactly what was happening and began to take pictures a few seconds apart. I was standing about 20 feet to the right and a little in front of Quang Duc. I clearly saw him strike a match in his lap and with a slight movement touch the robes. His expression slightly grimaced when the flames engulfed him, but he never cried out or said anything. By 9:35 a.m. Quang Duc had fallen over backwards, and after a few convulsive kicks was clearly dead and charred. Another monk told me later that Quang Duc was adept at yoga and possessed tremendous powers of physical control."

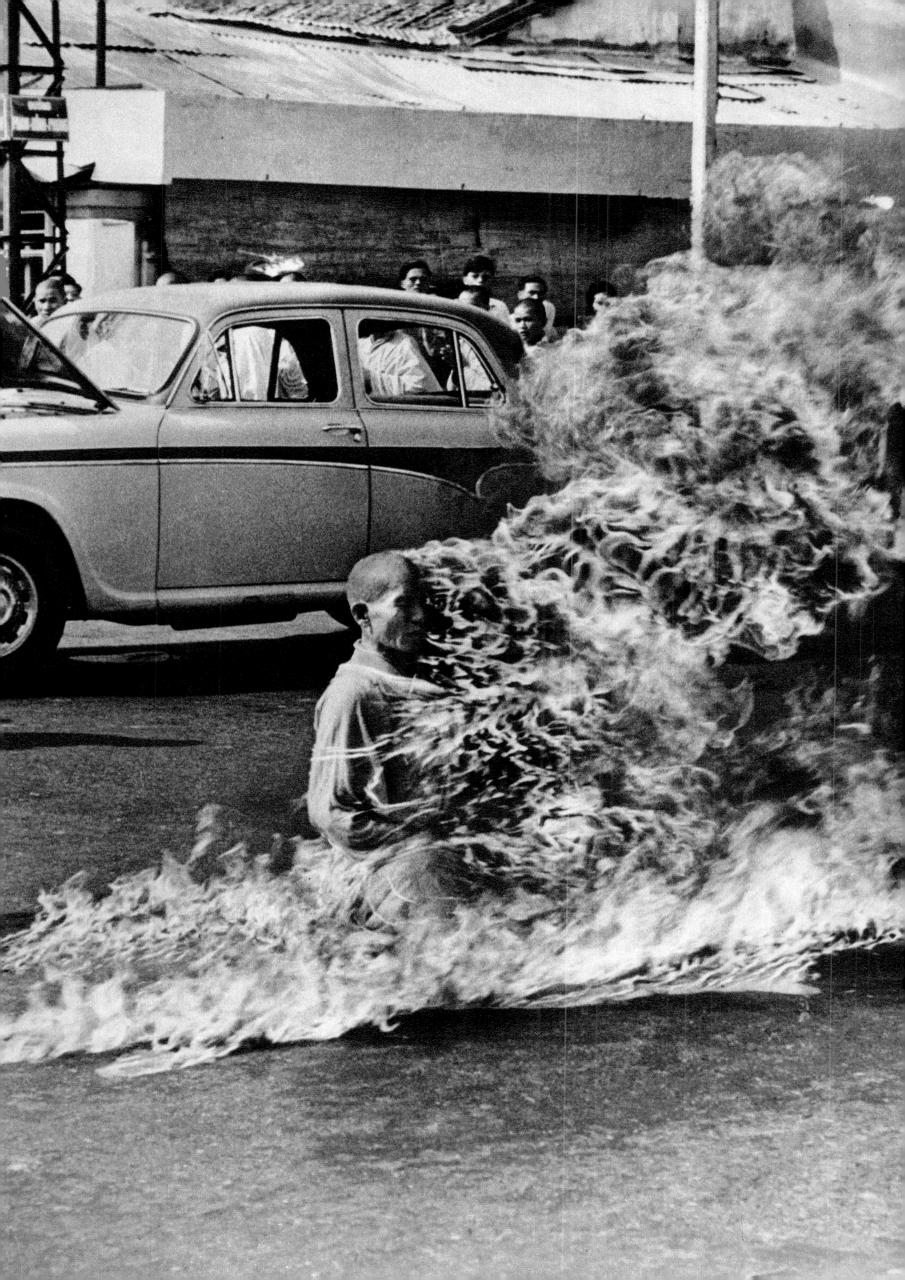

AFTERMATH

Sam and Mary Nocella of Philadelphia are combining work and pleasure abroad. After years as a news photographer Sam is a free lance and they are touring Yugoslavia and Greece taking travel pictures Sam will sell when they return home.

They arrive in Skopje, Yugoslavia, Thursday, July 25, 1963. It is about 8 p.m. The night clerk at the Hotel Macedonia shrugs hopelessly and tells them there is no room. He points the way to the Jordan Hotel down the street. Tired and lugging suitcases and camera equipment, the Nocellas find a vacancy there. They have dinner and by midnight are asleep.

They awake with a shock. There is what seems a roaring explosion. The walls are swaying, and the chandelier is doing a crazy dance on the ceiling. Their thermos of water falls from the night table and shatters. By the time they reach the door they realize in terror that it is no explosion. Earthquake. The key won't turn. Plaster is falling all around them. Finally Sam manages to get the door open.

Mary rushes downstairs in her pajamas. Sam stops long enough to pull on a pair of pants and grab his camera. In the square, in the early morning light, the air is full with a mist of mortar as dense as smog. Dust still rises from a mound of debris—and, terribly, voices rise from it too. It was, minutes before, an apartment house, home for thirty families. While the Nocellas stand there among the dazed and screaming, two survivors are pulled from the tomb of brick and rock, an old man and a baby. The earth tremors have stopped now. Sam is aiming his camera everywhere, but he stops as an anguished father approaches, still in his night clothes and barefoot, his dying baby in his arms.

Down the street the Nocellas find the Hotel Macedonia. There is nothing left but litter. Two hundred and sixty sleeping guests perished in the wreckage of the four story building. Mary suddenly remembers the night clerk. "He saved our lives," she says.

It takes days to clear the debris in this Macedonian city of 270,000 people. In the end, the dead number 1,100; the injured and homeless are in the thousands.

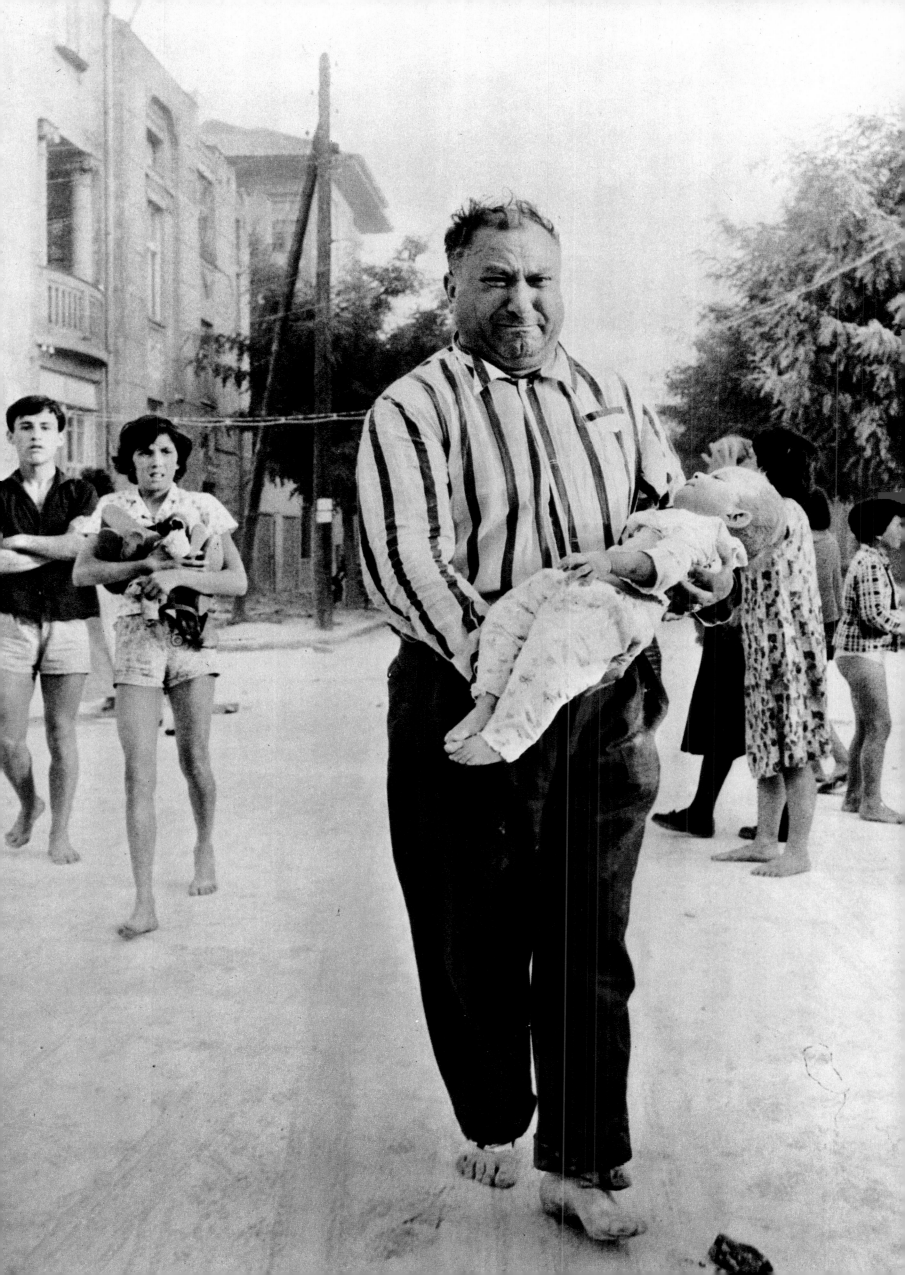

ME!

Peoria, Ill., 1963. Harold Whittles, who was born deaf and is now almost five, has recently acquired a hearing aid and at this exquisite instant is hearing, on a recording, his own voice for the first time.

———————

By Jack Bradley of the Peoria Journal-Star.

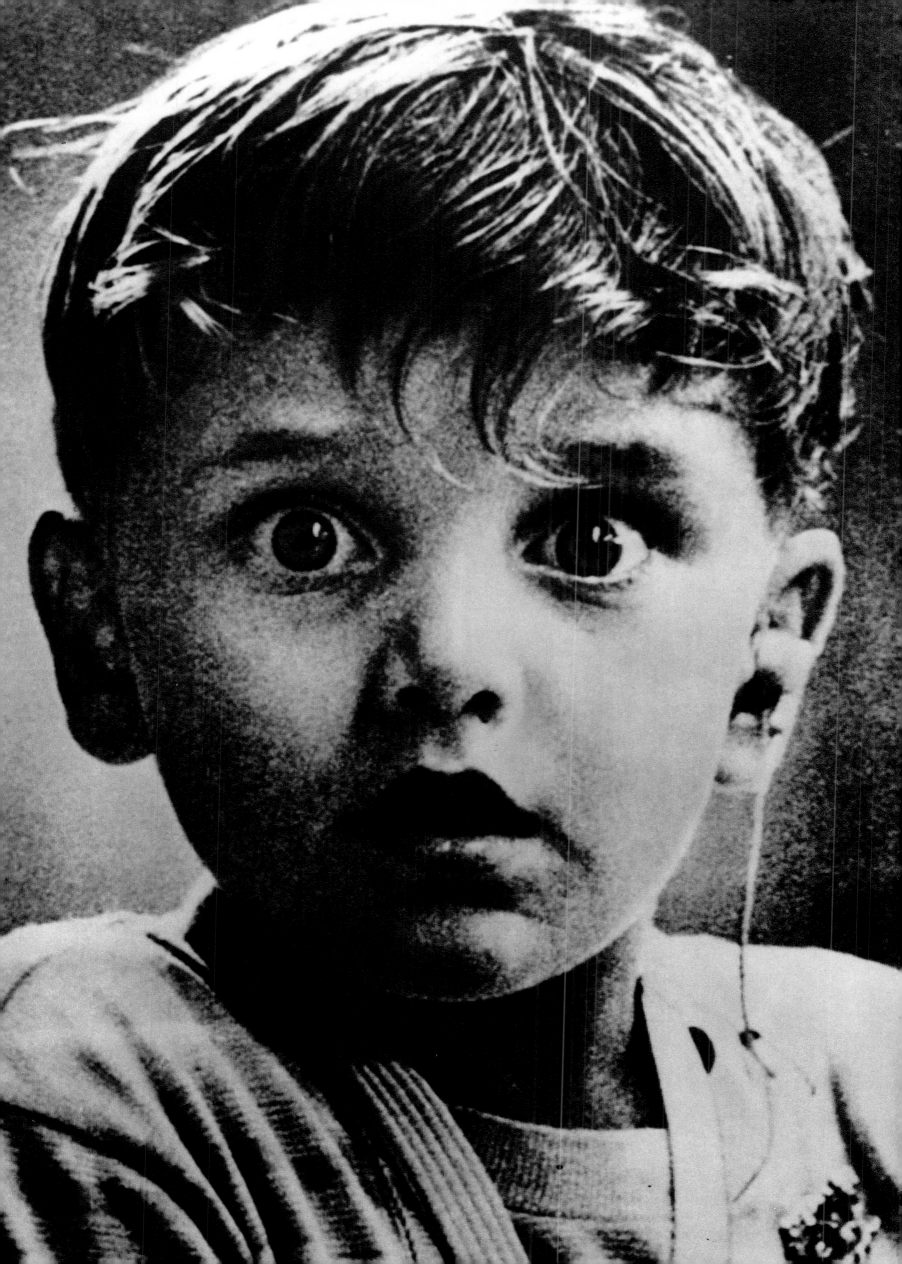

"DADDY!"

It had been a summer of pain and burden. Two weeks before, he had buried his second son, who died in infancy. He used to say he wanted a big family, at least five children. Now . . .

On this hot muggy weekend, he leaves Washington to join his family on Cape Cod. Behind him, but never really behind him, he leaves problems, particularly how to react to the brutal assaults by the Diem government in Saigon on the Buddhist pagodas, which have shocked the world; how to ensure passage of the Test Ban Treaty signed a month before and now running into heavy weather in the Senate, how to . . .

The big blue and white jet with "The United States of America" emblazoned along its length rolls to a stop at Otis Air Force Base. The door swings open. Fifty yards away, a boy breaks loose from his nurse and takes off. At the foot of the ramp, father and son meet in a ballet of joy.

It is August 23, 1963. John Fitzgerald Kennedy bends stiffly, his back still in a brace from a revived injury. Nothing in time or circumstance inhibits John Fitzgerald Kennedy, Jr., whose father is home, whose third birthday is still three months and two days off, on November 25, 1963 . . .

———————————

Bob Schutz of the Associated Press, a distance away with the rest of the traveling Washington press corps, has his telephoto lens zeroed in on the ramp. Out of the corner of his eye, he sees the running boy . . .

"It's a beauty, it's a beauty," he keeps telling himself, in one of those rare moments of news photography when a man knows while shooting that he has caught a tender instant. He can't wait to get to town to see the negative.

THE LONGEST WEEKEND

Friday, Nov. 22, 1963, 12:29 P.M., Dallas time. One minute left in Camelot . . . Crowds. Cheers. The wife of the governor of Texas turns back in her seat. "You sure can't say Dallas doesn't love you, Mr. President." He smiles: "No, you can't." So far, so good; maybe he could pull Texas Democrats together. **12:30 P.M.** Firecrackers. Firecrackers? No, shots. SHOTS! Two? Three? It would matter more later, but not now. Not now. The President slumps. The car races forward . . . **12:38 P.M.** Parkland Hospital admits case "24740, white male . . ." **1 P.M.** John Fitzgerald Kennedy is dead . . . **1:50 P.M.** A sullen young man named Lee Harvey Oswald is arrested . . . **2:38 P.M.** In the hot, jammed stateroom of Air Force One, the big, beautiful, blue and white jet with "The United States of America" lettered majestically along its length, Lyndon Baines Johnson is sworn in as 35th President, standing next to the widow of the 34th, blood still on her clothes . . . And in Washington, John McCormack, Speaker of the House, asks for a nation: "My God, what are we coming to?"

Saturday, Nov. 23, 1:30 A.M. Lee Harvey Oswald is charged with murder . . . **4:34 A.M.,** Washington time. Two straight lines of Marines lead the way along the gracefully curving drive between the elms. Glistening bayoneted rifles held across their chests at port arms, they march oh so slowly up the drive and all that can be heard, in the land, is the sound of their shoes sliding along the macadam. From out of a stark gray Navy ambulance, John Kennedy is carried back into the White House. Home from Texas . . . **1:31 P.M.** Two rocking chairs are rolled out on a dolly from the White House and bounced over the cobblestones in the street and it is all on TV, as everything, the magnitude and the minutiae of tragedy are on TV this relentless weekend . . .

Sunday, Nov. 24, 11:21 A.M., Dallas time. A free lance avenger named Jack Ruby shoots Lee Harvey Oswald. In the basement of the city jail. On television. "My God, what are we coming to?" . . . **1:08 P.M.,** Washington time. The caisson leaves the White House for the Capitol Rotunda . . . **2:02 P.M.** Senator Mike Mansfield begins the eulogies . . . "And so she took the ring from her finger and placed it in his hand . . ." **1:07 P.M.,** Dallas time. Lee Harvey Oswald dies in Parkland Hospital . . . **2:17 P.M.,** Washington time. Jacqueline and Caroline Kennedy kneel before the flag-draped catafalque. The mother kisses the coffin. The child caresses the flag. **8:18 P.M.** The line of people waiting in the rain to pay their respects in the Rotunda now numbers more than 200,000. . . .

Monday, Nov. 25, 2:03 A.M. The line outside the Capitol is now three miles long. . . . **11:35 A.M.** Once again the procession from the White House. The riderless horse. The relentless drumbeat. The caisson. Now, the widow in black strides gallantly forth on foot, leading the kings and the queens, the presidents and the prime ministers, along American streets, past American drugstores and American office buildings, with men holding rifles, on the rooftops. . . . **1:21 P.M.** On the steps of St. Matthew's Cathedral, John Fitzgerald Kennedy, Jr., three years old this day, salutes as his father's coffin passes. . . . **3:07 P.M.** Taps is sounded over the rim of the hill at Arlington, with one broken note like a catch in the bugler's throat, and the flag of his country is raised from the coffin and folded with loving care and passed to the widow of John Fitzgerald Kennedy. . . .

The long weekend ends without ending, Washington time, Dallas time, Memphis time, Los Angeles time, Detroit time, Watts time. We have heard only the overture in a cacophony of the unthinkable: "My God, what are we coming to?"

James W. Altgens, Associated Press, was 15 feet from the car.
"I made one picture at the time I heard a noise that sounded like a firecracker. I was looking at the President just as he was struck. It caused him to move a bit forward . . . It stunned me so that I failed to do my duty and make the picture I was hoping to make (a closeup). The car never did stop . . . I stepped out in the curb and made another picture as the Secret Service man stepped up on the rear step of the presidential car and went to Mrs. Kennedy's aid . . ."

Abraham Zapruder, Dallas dress manufacturer, was in Dealey Plaza to see the President that first day. At the behest of his secretary, he brought along an 8mm movie camera for some souvenir film.

"As the car came almost in line . . . I was shooting through a telephoto lens . . . I heard the first shot and I saw the President lean over and grab himself, leaning toward Jacqueline . . . I heard the second shot . . . Then I started yelling, 'They killed him, they killed him,' and I just felt that somebody had ganged up on him and I was still shooting the pictures until he got under the underpass. I don't even know how I did it . . . It was an awful thing. I loved the President . . ."

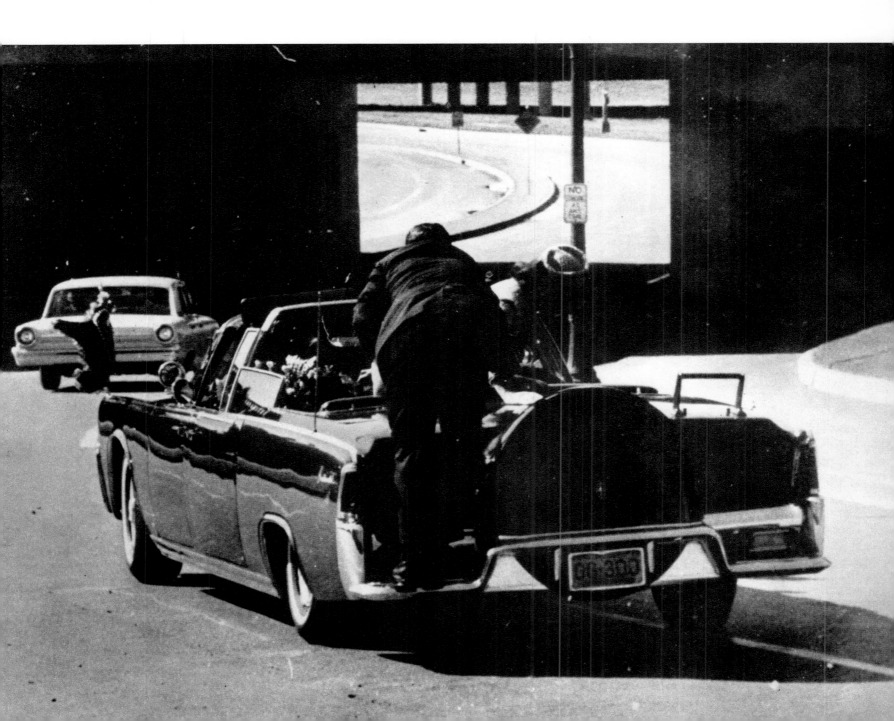

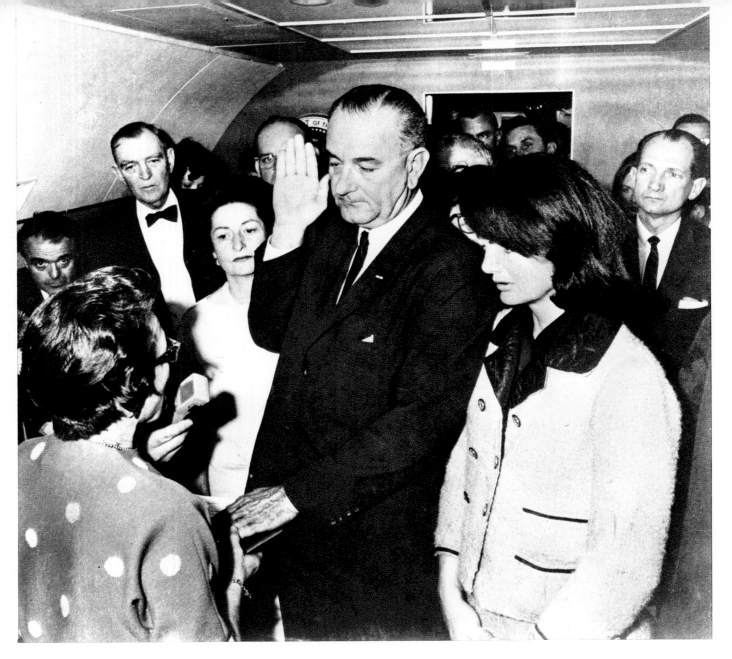

Capt. Cecil Stoughton, Army Signal Corps and John Kennedy's White House photographer, was sweating in the crowded stateroom of Air Force One. . .

"It was not only the heat, but the tension of the responsibility of photographing history, the swearing in of a new President. I arranged the people as gently as I could, the judge here, the Johnsons there and Mrs. Kennedy on the right.

"I was standing on a divan, my back to a wall, my head brushing the ceiling. Instinctively, without thinking it, I wanted to avoid the blood stains on Mrs. Kennedy's skirt. I had two cameras, the Hasselblad and the Alpha Reflex. I shot first with the Hasselblad and died; the flash didn't go off. I somehow fixed that and with the second camera managed 21 frames before it was over.

"At the time, I was too busy for sadness. That came later . . ."

Bob Jackson, photographer of the Dallas Times-Herald, was 11 feet away when Jack Ruby lunged out at Lee Harvey Oswald.

"Originally I was assigned to cover the Oswald transfer to the county jail and then to go out to Parkland Hospital for a press conference with the wife of the governor. But the transfer was delayed and it was now clear I couldn't cover both events. The desk said, 'Forget Oswald and get to the hospital.' I argued. I said there had been a lot of talk, something might happen.

"Oswald appeared. I raised my camera and became aware of someone moving out of the crowd. He took three steps. I pressed the button. I was not aware of what was happening until I heard the shot. I quickly took another picture as people swarmed over Ruby. But the strobe unit didn't work; it hadn't had enough time to recycle.

"I kept worrying about the first picture. Had I pressed the button too soon? It was nearly two hours before I was relieved at the jail and got back to the office and developed the picture. It was not too soon."

☆Pulitzer Prize Winner, 1964.

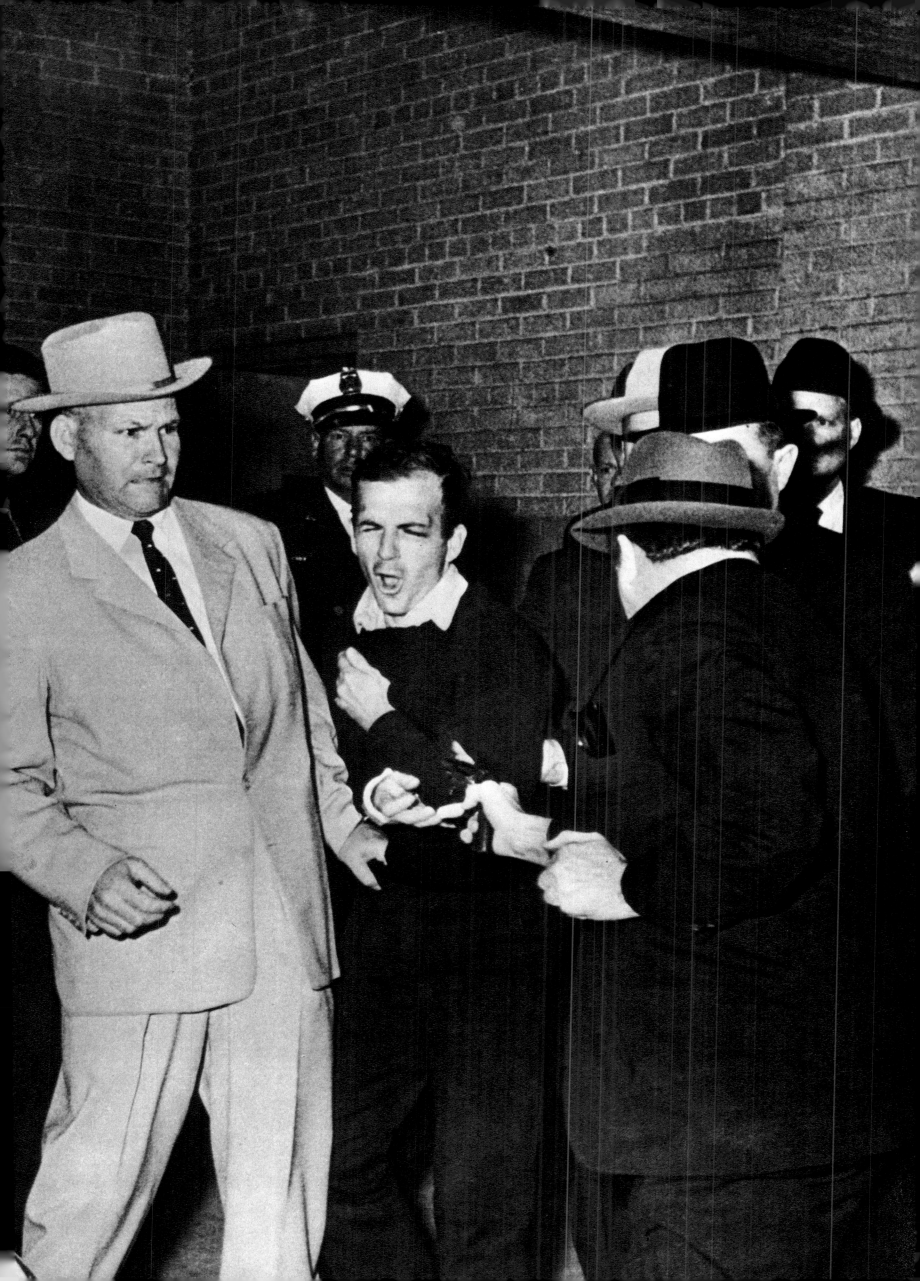

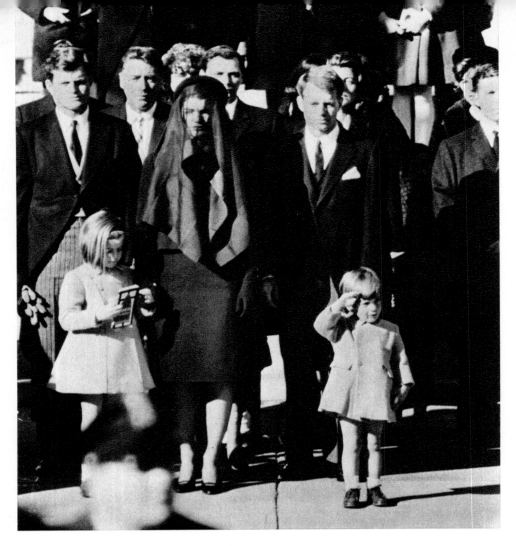

Dan Farrell, tall, tough Irishman and photographer of the New York Daily News, was about 100 yards away, on a flatbed truck with other photographers, when the little boy saluted.

"By then I was having trouble in myself. I felt like crying. I looked through the view-finder but as I shot the picture I couldn't be sure who was saluting. I had covered a lot of things but this was . . . well, difficult."

Eddie Adams, AP photographer who had covered war, disasters, tragedies of all kinds, was having his trouble, too. He was standing some distance away in an area roped off for photographers at Arlington when the flag was passed to Jacqueline Kennedy.

"All weekend I had tried not to let this happen but now it was. There were tears in my eyes.

"Like all good pictures, this one just happened. You don't know it's good; you just do it. Sometimes it seems you have no control and your fingers just move by themselves . . ."

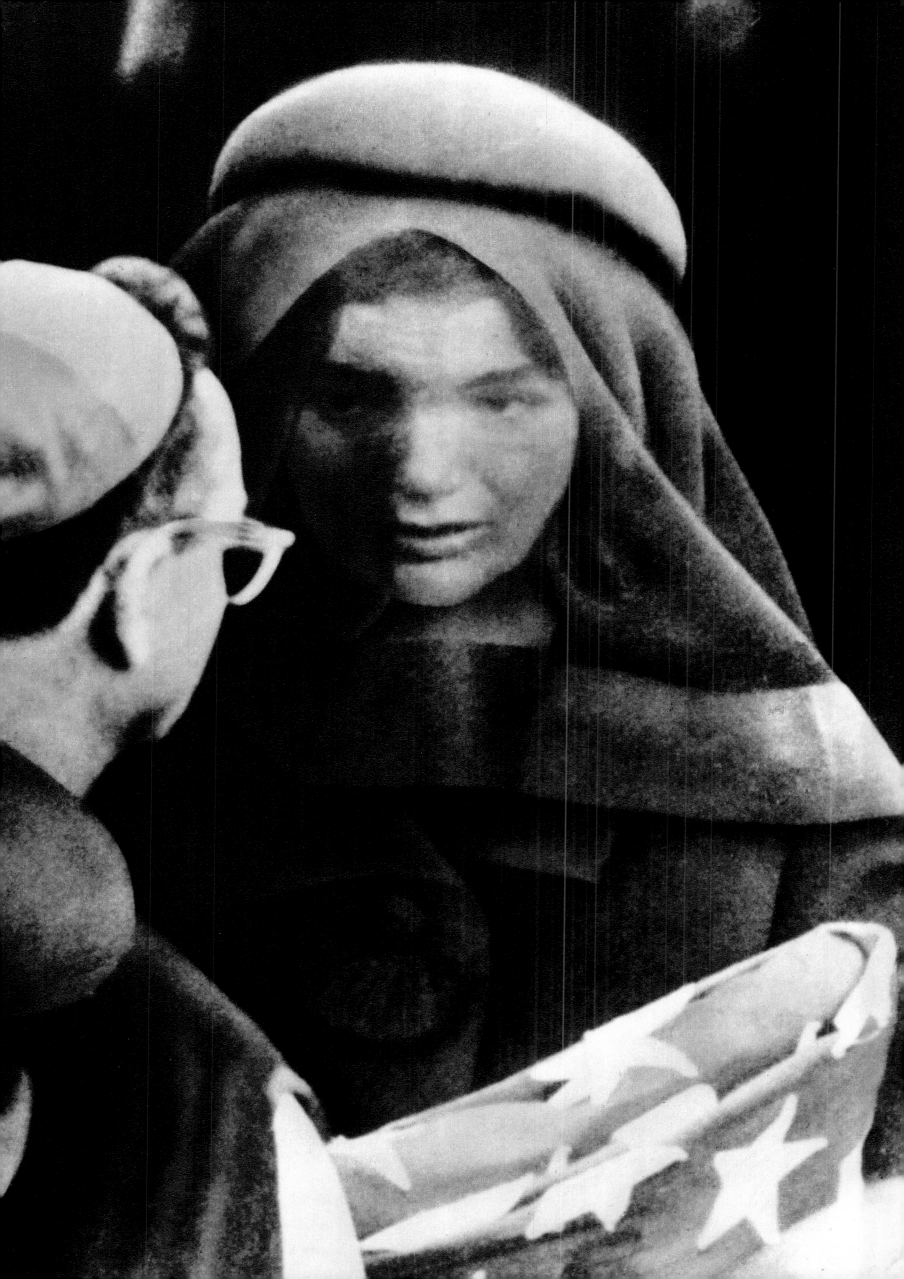

HIM AND HER AND HIM

In office only five months, Lyndon Johnson was roaring down the tracks like a highballing freight, with a greater drive than anyone since Teddy Roosevelt and more corn pone, probably, than anyone since Andy Jackson.

He was popping his bills out of Congress like candy bars from a vending machine. The economy was soaring and he was riding high in the public opinion polls and, if you didn't believe it, Lyndon Johnson would pull out little slips of paper to prove it. But on April 27, 1964. . . .

He risks the animal lover vote.

There, out on the back lawn, are his beagle pups, Him and Her, and the President calls them over for the benefit of some visiting bankers. He feeds them sugar-coated vitamin pills (the dogs, not the bankers, who had already had theirs). He rolls them over and then startles his guests by tugging Him up by the ears.

Him yelps.

"Why did you do that?" asks a puzzled reporter.

"To make him bark. It's good for him. And if you've ever followed dogs, you like to hear them yelp." And he does it again, this time with Her. . . .

The head of the Chicago Humane Society was not amused: "A dog has a front end and a back end and appreciates support from both ends."

The doghouse proved less than fatal, and Lyndon Johnson went on to win election by the largest popular margin in history. It was a whirlwind campaign in which he derided Barry Goldwater as a man who would escalate that small war in Vietnam, where there were now 25,000 American "advisers." Johnson said repeatedly: "We don't want our American boys to do the fighting for Asian boys."

But the war he had inherited escalated under Lyndon Johnson and by the time he left office, American boys—500,000 of them—were doing the fighting for Asian boys.

By the time he left office, he had gotten more civil rights legislation out of Congress than any president in history, but the racial problem was greater than ever. He had gotten more social legislation through than any president since Roosevelt but he lost the liberals. He had spent more federal money on education than ever was spent in history but he lost the intellectuals and the students. He had won the biggest majority in history but in the end it did not seem safe for him to go to his party's next convention. He had gotten much done, this whirlwind of a man, but he couldn't get out of Vietnam.

In the White House press room, Charles Gorry of the Associated Press was late in getting the word that the President could be photographed with the bankers. He raced out, adjusting his camera on the run. Within 15 feet of the President, he set his lens at half the distance, skidded to a stop and snapped as Her's forepaws left the ground.

A SPORTS EVENT

"In the long run," race driver Eddie Sachs once said, "death is the odds-on favorite." Sachs was speaking of the Indianapolis 500, America's traditional Memorial Day auto race, and clearly he was right. By 1964, the year of the 48th running of the race, the track had claimed 54 lives. Drivers come and go, auto styles change, engines get bigger and faster, but at Indy the only constant is danger.

The field for the 1964 race is the biggest ever—33 cars. Sachs, driving in his eighth straight 500, lines up in the fifth row directly behind Dave MacDonald, driving at Indy for the first time. The green starting flag drops and the mass of slowly orbiting cars spurts forward with an ear-splitting roar.

Just as the leaders head into their third 2½-mile lap, Dave MacDonald, back in the pack at a point where the homestretch begins, loses control. His blue car spins, smacks the inside wall at 150 miles an hour and bounces into the middle of the track. The buzzing of the 260,000 fans turns suddenly into screams and the exploding fuel tank belches a fiery tower of black smoke.

Blinded by the smoke and flames, six other drivers, unable to stop, boom into MacDonald's car; Sachs hits it broadside. Flaming wreckage leaps the guard fence. Sachs, trapped in his cockpit, is dead when rescuers reach him. Two hours later, at about the time the wreckage is cleared and the race resumes, as it always does, MacDonald dies in a hospital. The odds-on favorite wins again: Indy has claimed its 55th and 56th victims.

—————

From an eighth of a mile away, Associated Press photographer Bob Daugherty can feel the heat of the flames. He leans far out from the photographers' perch 40 feet above the track—his favorite position in several years of covering the race —and shoots picture after picture through a telephoto lens as car after car plows into the burning wreckage. He senses that what he has in his camera is dramatic, and decides to take the film personally to the AP darkroom nearby rather than entrust it to a courier. "Who was the guy who was killed?" he asks, unloading his camera. "Eddie Sachs," someone says. Daugherty gasps. He hands over his film and walks out, not waiting to see the prints. Eddie Sachs was Bob Daugherty's pal, a cheerful, helpful, good friend. The photographer, dazed, returns to his perch and makes a few more perfunctory pictures as the race drags on. The following year, assigned again to photograph the Indy race, Bob Daugherty selects a position from which the stretch of track where his friend died is completely out of his vision.

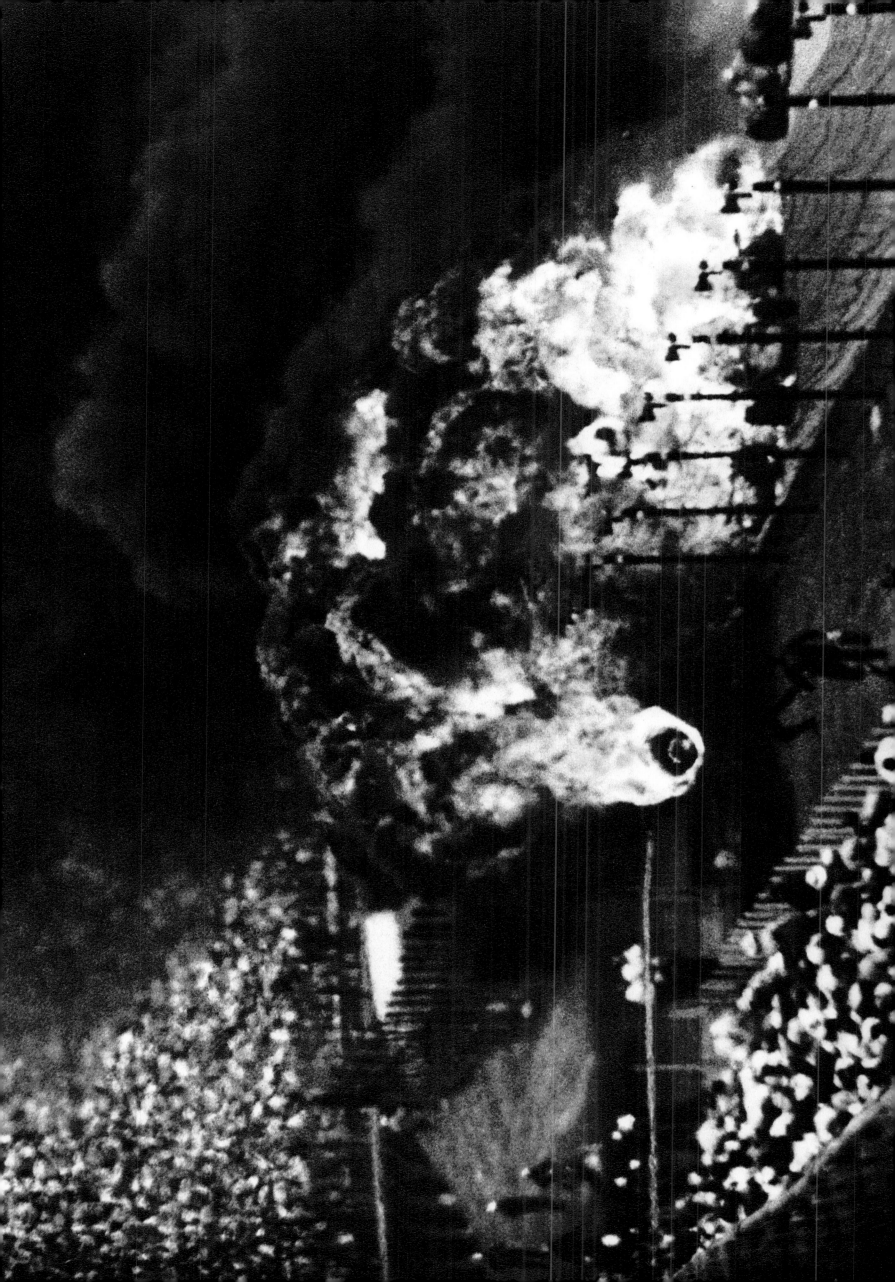

A THOUGHT SLOWLY FORMING...

The New York Giants with Y. A. (would you believe Yelverton Abraham?) Tittle at quarterback were a power in the National Football League for three years—1961, 1962, 1963—tops in their division. In 1963, Tittle led the league in passing. . . .

But now it is 1964. Everyone is a year older. Especially Tittle, who is 38.

Pittsburgh, September 20, early in the season. The Giants are having trouble putting things together. The ball is on their own ten. Tittle eyes the Steeler line and barks the signals. He dashes back to his own end zone to pass and doesn't see disaster coming.

Two hundred and seventy pounds of a mountain named John Baker crash down on him and, for one of the few times in his career, the gallant old Giant quarterback goes down without a chance to break his fall. Or control the ball. It squirts into the air from whence it is plucked by Steeler Chuck Hinton and carried six yards for a touchdown.

Tittle rises to his knees, blood leaking from two cuts on his forehead, helmet gone like the ball—a classic picture of pain, exhaustion and futility. The real hurt is in his ribs. And maybe elsewhere, in a thought slowly forming. . . .

Y. A. didn't play the rest of the game, which the Giants lost. He tried again the following week but his ribs hurt too much. It was weeks before he was back in the lineup, and at the end of the season, the Giants in last place with only two wins, Y. A. Tittle quietly retired. "I had so many good memories, so many good years, and I could see myself going downhill," he said.

Dozier Mobley, Associated Press photographer, was 30 feet away, on the sidelines, when he shot the picture. "But I missed the best shot, we all did. After that picture, we put our cameras down. Then, there he was, looking up at the sky with a terrible grimace. And there was no time to get it."

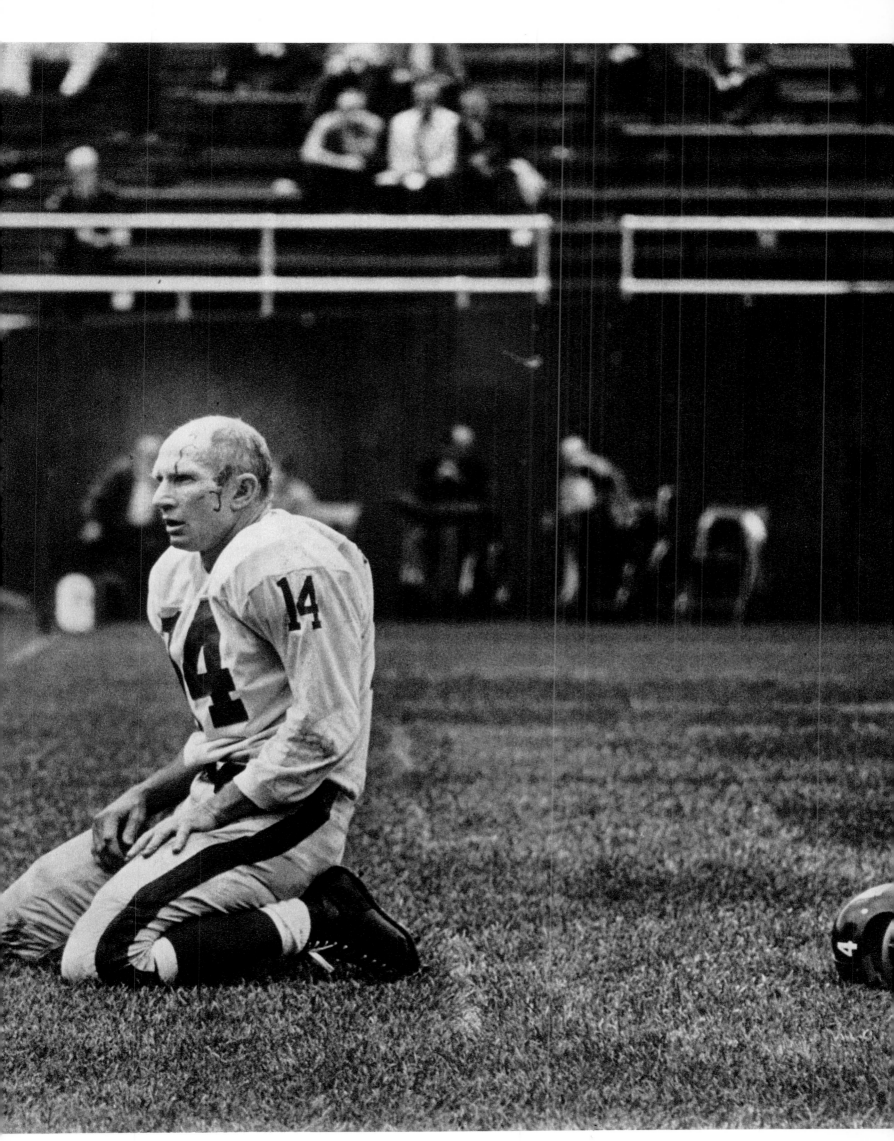

THOUGHTS OF A COMBAT PHOTOGRAPHER

Few other people, civilian or military, saw more of the war in Vietnam than Horst Faas of the Associated Press, who took these pictures in 1964.

He began there in 1962, when almost all the faces were Vietnamese, when he used to be certain to carry $50 cash into combat with him, in the event he was wounded and his litter bearer needed persuasion. He was there when almost all the faces were American and again when the Vietnamese predominated.

On December 6, 1967, on his third American patrol in a week, he was hit in the thigh and leg by rocket fragments. After several weeks in a hospital, he was out again on patrol, seeking again to record on film "what war did to people, to those who had to kill and those who had to suffer and die."

Throughout the war, he remained concerned about the impact photographs were having on the divided American public. He talked often of the need for perspective and the role of the combat photographer. He wrote this:

"There was no censorship that protected the unprepared psyche of the public back home against the stark brutality, the upsetting and often revolting actions of allied and American soldiers and the stirring tragedies from the Vietnam war fronts.

"The pictures showed that in South Vietnam reporters could go almost anywhere and stay up front with the soldiers as long as they liked and lived.

"Photo reporters jumped from helicopters in the first wave of an attack. They could trudge for days through the swampy paddies, bombed villages and jungles, waiting with the soldiers for an ambush or sudden contact with the enemy.

"They could crawl to the forward trenches of a beseiged outpost, wait beside riflemen in night ambushes, witness brutal interrogations and executions and merciless street fighting. While the enemy—the Viet Cong and the North Vietnamese invasion forces—operated in secrecy, American and allied troops and government civilians performed almost always under the probing eyes and lenses of newsmen.

"The many casualties among newsmen show how close they stayed to the action. Photographers were shot down in planes and helicopters or died in hand to hand combat or were executed after capture by the Viet Cong after crossing, mistakenly, the unmarked frontline during city fighting. More than a score of reporters taken by the enemy are still missing.

"There were few war lovers among combat photographers, but most were welcome companions to the men who did the fighting. The uniforms, helmets and flak jackets and occasional pistol that reporters wore were necessary to keep up with the soldiers, as a precaution and to avoid becoming a burden to them. Civilian newsmen never became part of the military effort; they were guests and observers. Those who died or were wounded did so with the tools of their trade in hand, with their cameras and their notebooks."

————————————

The pictures: Buddhist monks and women yank at a barbed wire barricade set up by police in Saigon to halt a demonstration; (overleaf) Vietnamese Rangers look down from their tank at a man holding his child who was killed in a battle with the Viet Cong near the Cambodian border; bristling with weapons, a member of a Vietnamese special force carries a comrade wounded by a Viet Cong mine.

☆ *Pulitzer Prize Winner, 1965.*

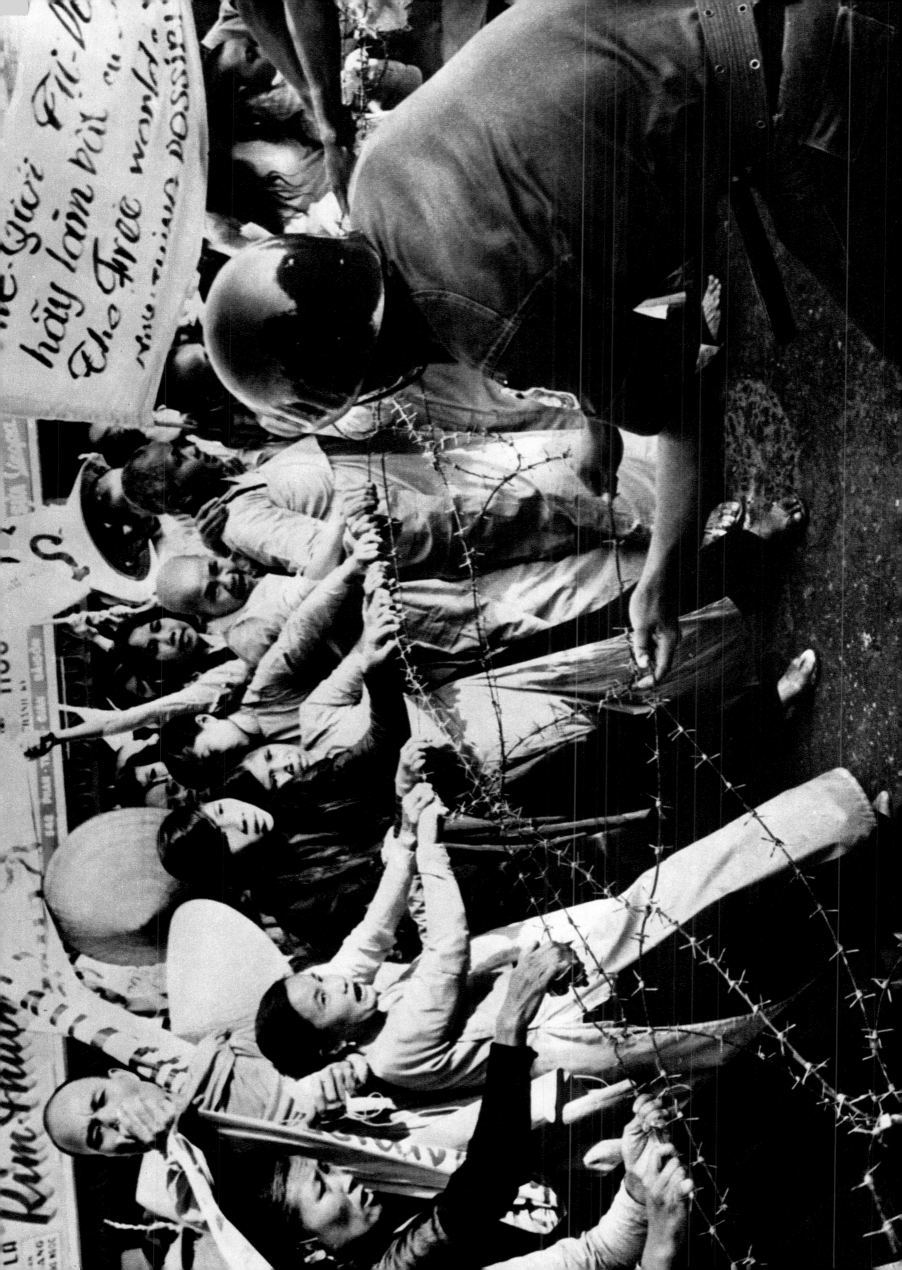

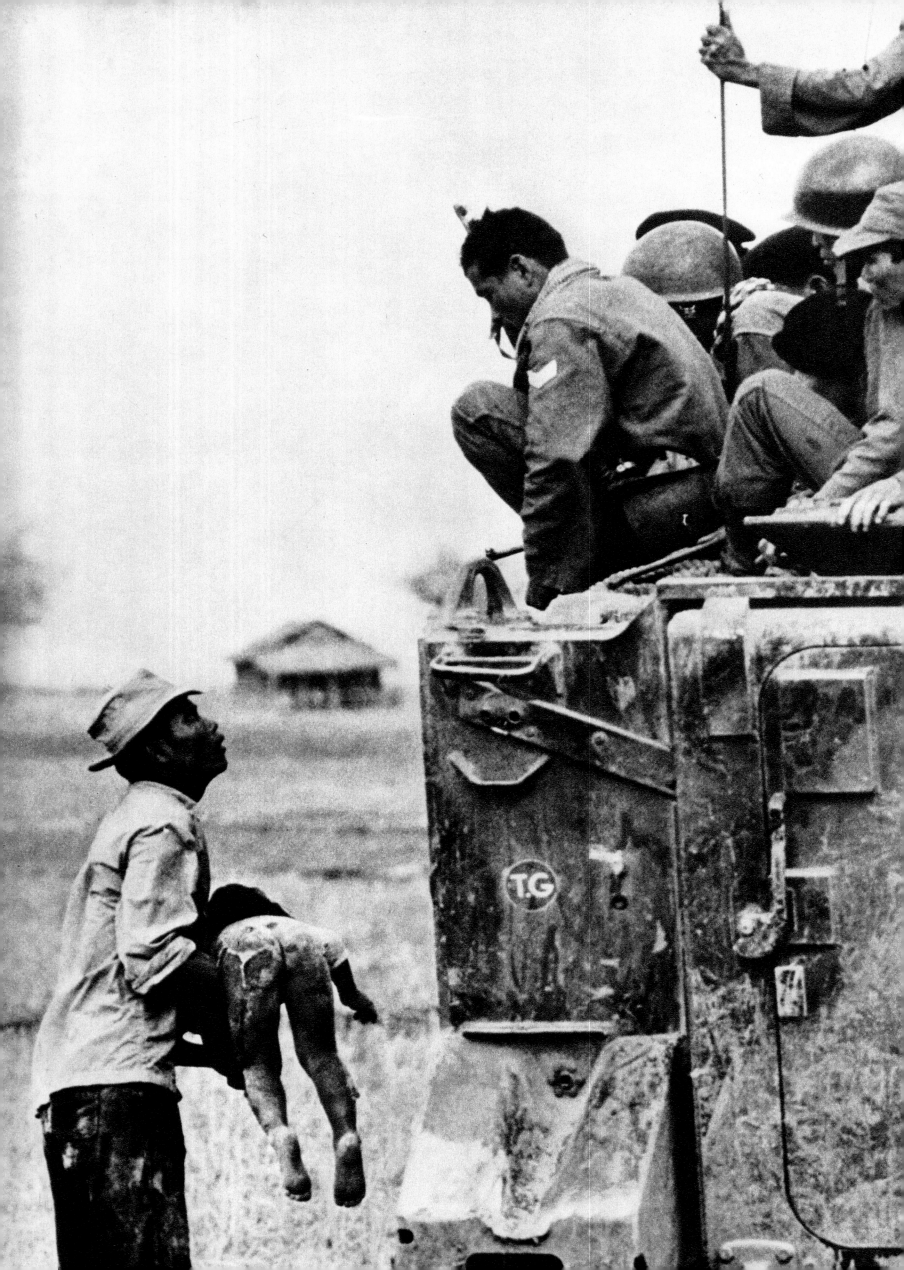

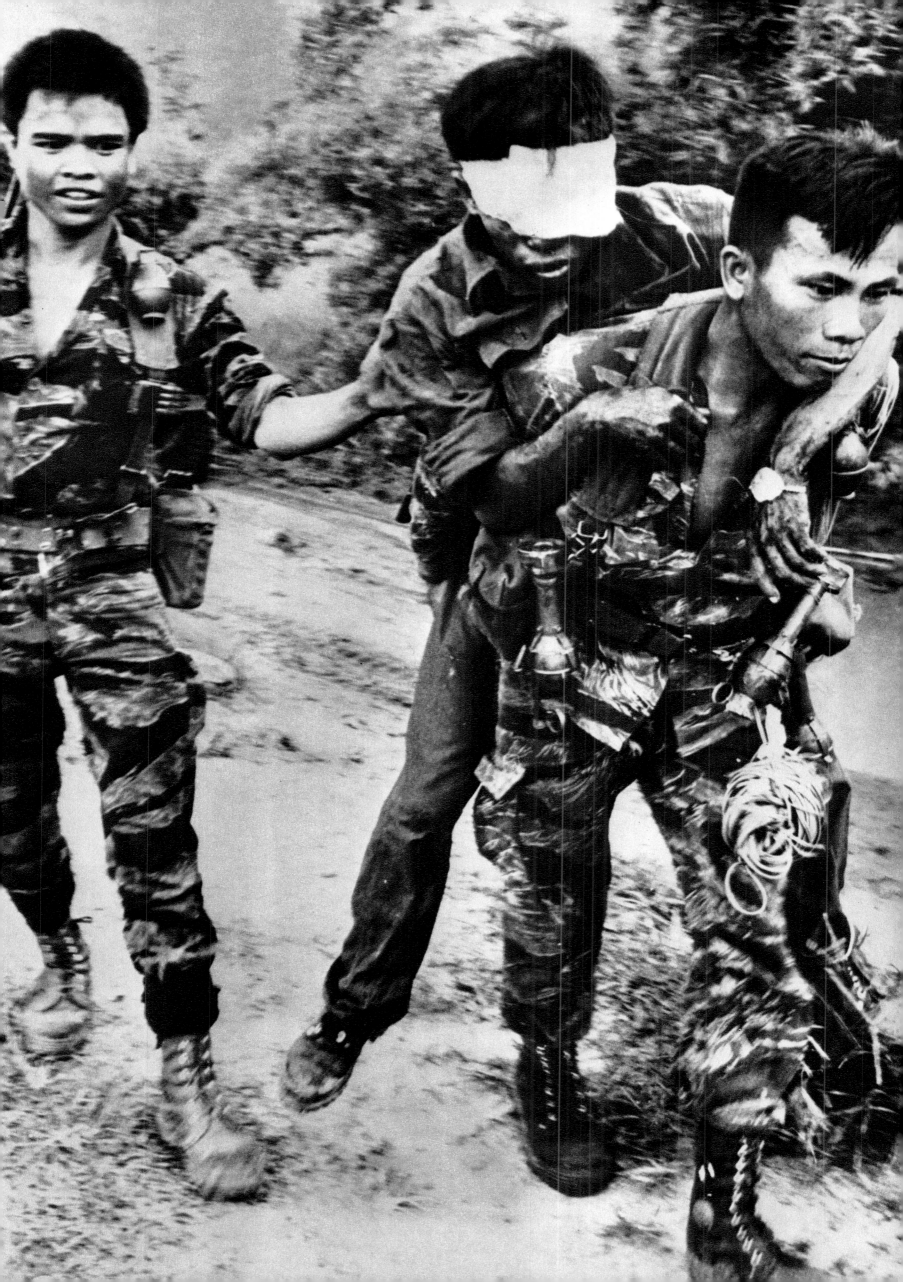

FLOAT LIKE A BUTTERFLY, STING LIKE A BEE

If the personality seems dazzling, obnoxious to some, he is a helluva fighter, nonetheless, and the heavyweight ranks have needed one for a long time.

Opponents may survive Cassius Clay's propaganda attack and rhyming predictions before the fight but so far none has been able to withstand the battering of those flashing gloves, that hypnotic dance in the ring. The man from Louisville is a surgeon in the ring, who moves with the speed of a lightweight, the power of the biggest heavyweight and the flair of an old Shakespearean trouper.

He was national Golden Gloves heavyweight champ in 1960, Olympic light heavyweight champ in the same year and, turning pro, racked up 17 knockouts and four winning decisions against no defeats. He became world heavyweight champion on February 25, 1964, when Sonny Liston failed to answer the bell for the seventh round in Miami Beach. Some experts thought they detected a suspicious odor but "This was no fix," the victorious Clay shouted into the microphones.

Now it is May 25, 1965, Lewiston, Me., and Liston is back for a return crack at the title and Clay, who has begun to call himself Muhammad Ali, still has his doubters. The bell rings. Liston lumbers out like a man looking to end it in one punch. Clay, hands down, dances and circles in his mesmerizing choreography. Suddenly a short hard right to the jaw and Liston goes down like a 218-pound rock. He falls on his back, rolls over, gets up on one knee and falls back again to stay. Clay stands over the still form screaming, "Get up you bum!"

Liston is counted out—the official time is one minute flat—and many fans scream "fake" and insist they never saw a knockout punch delivered. Says Clay: "That was my secret. It was a phantom punch. It was as fast as lightning and booming as thunder."

It would be a while before most fans would accept the champ's repeated claim, "I'm the greatest."

———————————

White-haired John Rooney, Associated Press photographer, has no complaint. He has been praying it wouldn't be a long fight. For a ringside photographer, a long fight is like a long night of deep knee bends, popping up and down the ring apron under the weight of color and black and white cameras. But then a very short fight is risky because it's too easy to miss the best picture. Rooney doesn't this night.

182

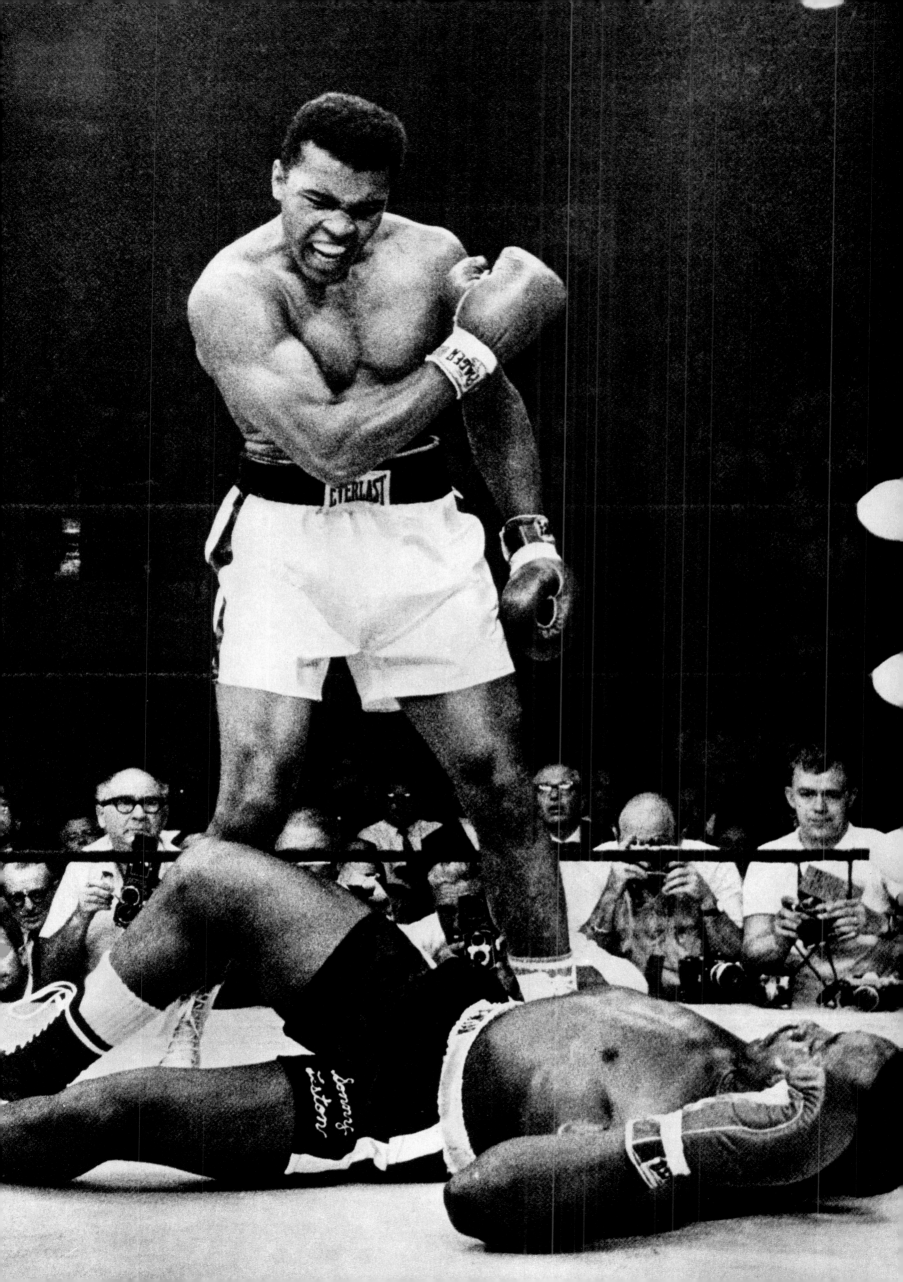

POSTSCRIPT

The tyrant was dead. Anarchy remained.

For 31 years Rafael Trujillo had held the Caribbean island country of Santo Domingo in a stranglehold. His were the customary tools of banana dictatorship —torture, prison, murder, secret police, theft. Then, in 1961, he fell in a fusillade of machine gun fire, victim of an ambush. Predictably, the have-nots scrambled to see what they could have.

A new president, Juan Bosch, was ousted in 1963. A junta replaced him. In April, 1965, rumors of further upheavals rustled among the palms. Senior military officers, heirs of Trujillo, were plotting. Their opulent incomes were gone and their numbers were being winnowed by Donald Reid Cabral, head of the new junta.

But, deep in their barracks, younger officers were plotting, too. They wanted Bosch back. They wanted their corrupt seniors purged. Cabral temporized. The plottings whirled back and forth in a complex blur. Finally, on April 25, fighting began. Cabral was seized by the young officers and deported. They began handing out arms to angry civilians in the capital of Santo Domingo who tore through the streets tracking down political enemies. Leftists egged on the rebels over seized radio stations. The beleaguered senior officers set up a rival junta and asked for U.S. intervention. They got it.

President Johnson took to television April 28 and said: "American lives are in danger. These authorities are no longer able to guarantee their safety . . . I've ordered the Secretary of Defense to put the necessary American troops ashore . . ."

They came. The 82nd Airborne, on April 29, the Marines on May 3. By mid-May there were 38,000 American men in Santo Domingo, the largest U.S. force ever landed in the long history of American intervention in the Caribbean. Washington said it had also acted to prevent a Communist takeover of the island nation so near Cuba. The extent of Communist participation would long be debated.

But the United States broadened the legitimacy of its act by obtaining the support of the Organization of American States which created a precedent-setting inter-American peace force, largely of the U.S. soldiers. Gradually the fighting subsided and the OAS set up a provisional government under lawyer-diplomat Hector Garcia-Godoy. Elections were promised the following year. . . .

But tensions remain. The OAS forces have taken over five schools for offices and barracks. On September 27, students gather outside the government palace to protest. They want their schools back.

Guards ignore the youths at first. The students start to disperse. Then a guard fires his rifle into the air. An 18-year-old student runs back, shaking his fist: "You see. You're nothing but a bloody assassin!"

The student turns his back, and the guard fires. A small postscript in a year's chaos, the boy drops dead.

James A. Bourdier had been covering the troubled island out of the Associated Press bureau in Miami. He had had his camera trained on the youth, but "I really didn't think they'd shoot him. I thought it would make a good picture, him shaking his fist at the guard." When the guard shot his rifle, Bourdier fired his camera reflexively. "You feel very badly about it later, but you can't let yourself get overcome by emotion. I was wondering if that crazy bastard would get me next."

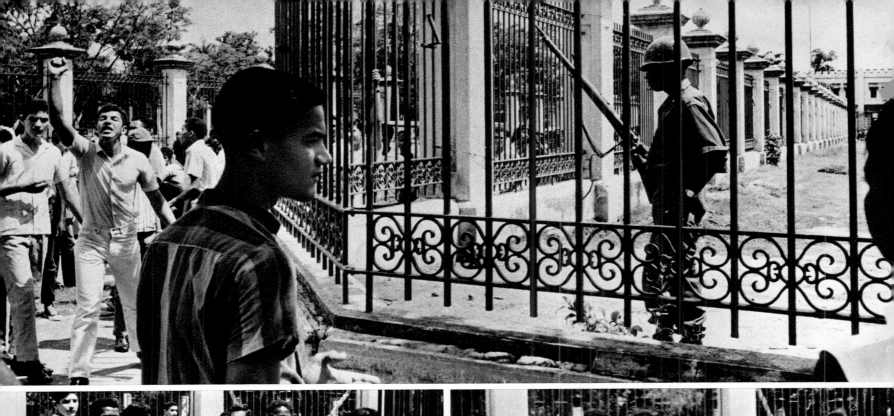

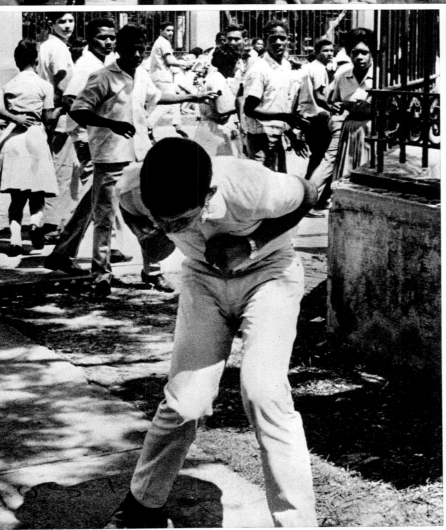

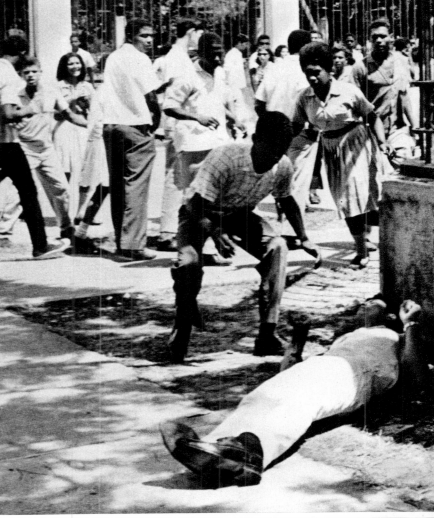

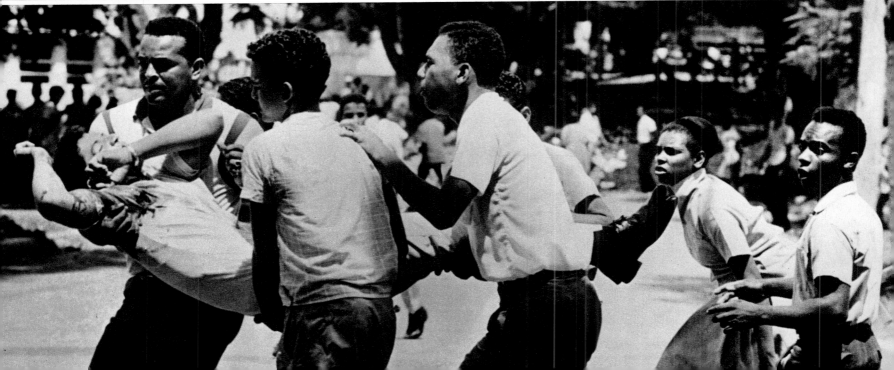

SUMMIT ON THE TIBER

John XXIII "opened the windows" of the musty old Roman Catholic Church, as he characterized the signal act of his papacy, the convocation of Vatican Council II, "to let in a little fresh air." His successor, Paul VI, took a deep, refreshing breath and opened a door. At Paul's invitation, the Most Rev. Michael Ramsey, Archbishop of Canterbury and Anglican Primate of All England, visited him at the Vatican.

The light of amity casts out the shadows of ancient enmity when Archbishop Ramsey arrives at the Vatican,March 23, 1966. It is the first time an Archbishop of Canterbury has paid a formal call on a Bishop of Rome since Archbishop Arundel went to see Boniface IX in 1397—long before Henry VIII broke with the Roman church.

The prelates meet in a site suitable to the encounter, the Sistine Chapel, where popes are crowned and, on death, lie in state. Beneath the fading colors of Michaelangelo's vision of the Last Judgment, the two sit on identical red brocade and gilt chairs. "Your Holiness, dear brother in Christ," the Archbishop says, "It is only as the world sees us Christians growing visibly in unity that it will accept through us the divine message of peace." Paul replies in Latin. The meeting, he says, is "one of friendship" . . . an effort to rebuild "a bridge that for centuries has lain fallen between the Church of Rome and Canterbury; a bridge of respect, of esteem and charity."

The two prelates rise, smile warmly, and seal their friendship with an embrace, a gesture known in church ritual as a "kiss of peace."

Associated Press photographer Mario Torrisi is too preoccupied with his work to be awed. To keep order, the Vatican has set up a lofty platform upon which all the reporters and photographers, 120 of them, must stand. The platform is shaky. "The main thing I was concerned with was simply holding my camera still," Torrisi recalls. The session over, Torrisi packs his cameras and the two prelates adjourn to Paul's study for a private, less formal talk. As they part, Paul removes from his finger a diamond-and-emerald episcopal ring and slips it into the hand of his new friend.

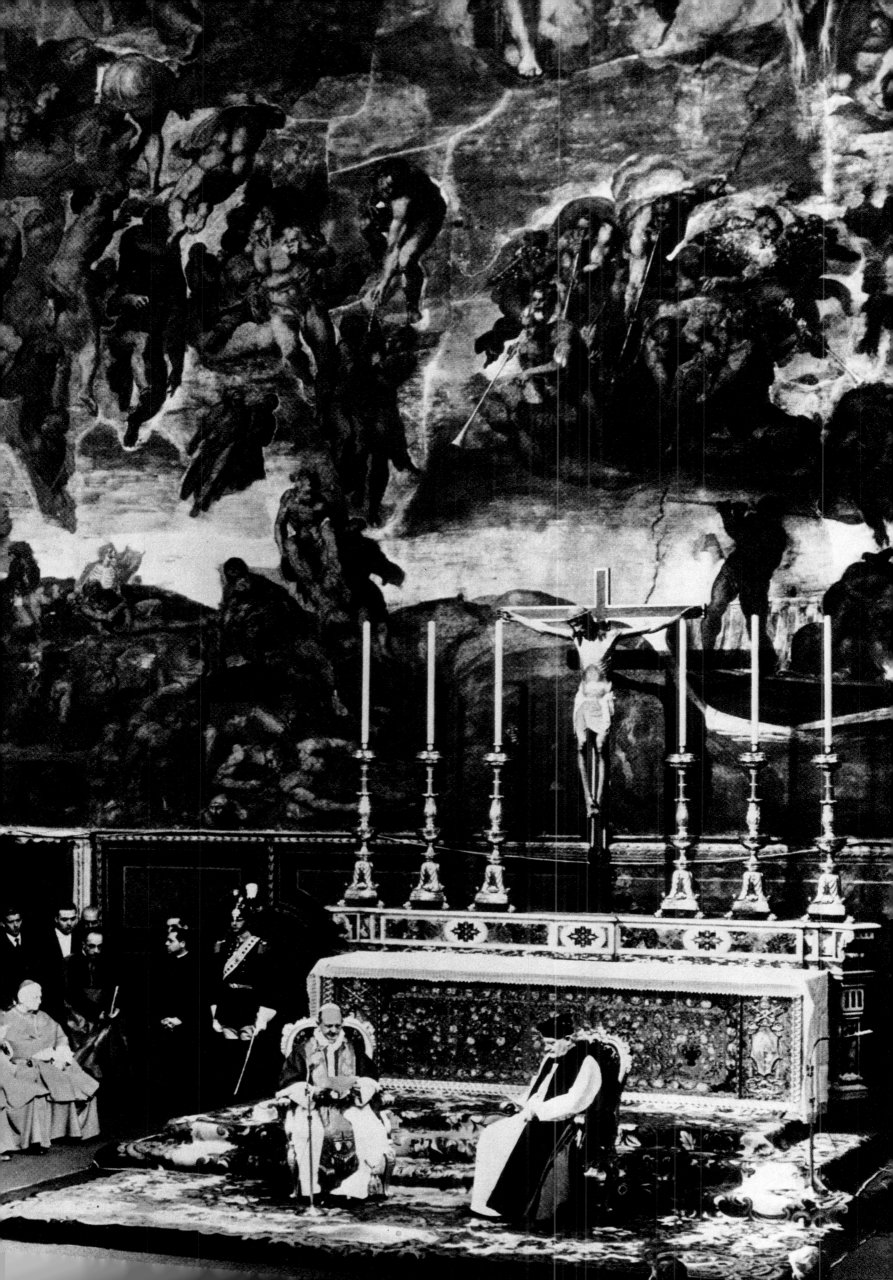

HOMECOMING

It's hot. There's an earthy Mississippi smell in the air—wateroaks damp from the morning rain, moisture on the honeysuckle along Highway 51.

James H. Meredith, who has been away, is now coming home—on foot. He is walking the 220 miles from Memphis, Tenn., to Jackson, Miss., to make a point: that Negroes in Mississippi no longer need be afraid to pursue their civil rights. True or false?

Four years ago Meredith became the first Negro student admitted to the University of Mississippi, with the help of the President of the United States, 538 U.S. marshals and 22,000 combat troops, after a wild night of rioting in which two people died. Two years ago, the bodies of three young civil rights workers were found in a red earth dam near Philadelphia, Miss.

Now it is June 6, 1966. A black Don Quixote who talks of his "divine responsibility," James Meredith seems lonely and a little bizarre on the second day of his walk. He has sought no support from traditional civil rights groups, and they have offered none. Only six other people, three blacks and three whites, walk with him, followed occasionally by press and police. He wears a yellow pith helmet, swings an ivory-tipped cane and carries no arms.

Carrying a gun, he had decided, would be inconsistent with his hope of symbolizing blacks walking erect and unafraid. "We want to tear down the fear that grips Negroes in Mississippi and we want to encourage the 450,000 Negroes remaining unregistered." If James Meredith can walk half the state unharmed, he reasons, Negroes can vote safely.

An hour out of Hernando, just inside the Mississippi line, he comes to a long, gradual dip in Highway 51. A black friend from New York catches up and reports breathlessly, "I met a man down the road who said someone's waiting for you with a gun."

Meredith shrugs.

An old black farmer and his family come down the highway to give him water. Meredith thinks things are going well. Then he hears a voice, soft and icy cool, from a thicket of wateroak. "James."

There, chest deep in the honeysuckle, stands a white man, balding, smoking a pipe and leveling a 16-gauge shotgun at him. "James," the man says. "I just want James Meredith."

The marchers dive for the pavement and crawl frantically toward the side of the road. Pith helmet and cane clatter away.

Birdshot skitters across the macadam.

Meredith crawls toward a gully. Another blast. It hits home, striking him in the back. A third shot, this time to the back of his head. It knocks him flat.

"Oh my God, oh, oh," he screams.

Hand over hand, he pulls himself over the pavement to the shoulder and sprawls in the dust. . . .

Later in a Memphis hospital, doctors removed some of the pellets. Others Meredith would carry for life.

Ultimately, Aubrey Norvell, 41, an unemployed hardware man, whose neighbors described him as a quiet Christian man, pleaded guilty to assault and battery with intent to kill and served 18 months and 24 days in the Mississippi penitentiary.

Jack Thornell of the Associated Press had been leap-frogging in his car, behind and ahead of Meredith and his fragile little march. In the long hollow, he parked at the side of the road. Meredith approached. Thornell heard the first blast, and instinctively stepped behind his car, crouched and made pictures. He drove to Memphis to develop, print and transmit across the country. Only after that did he pause to "feel the heavy load."

☆*Pulitzer Prize Winner, 1967.*

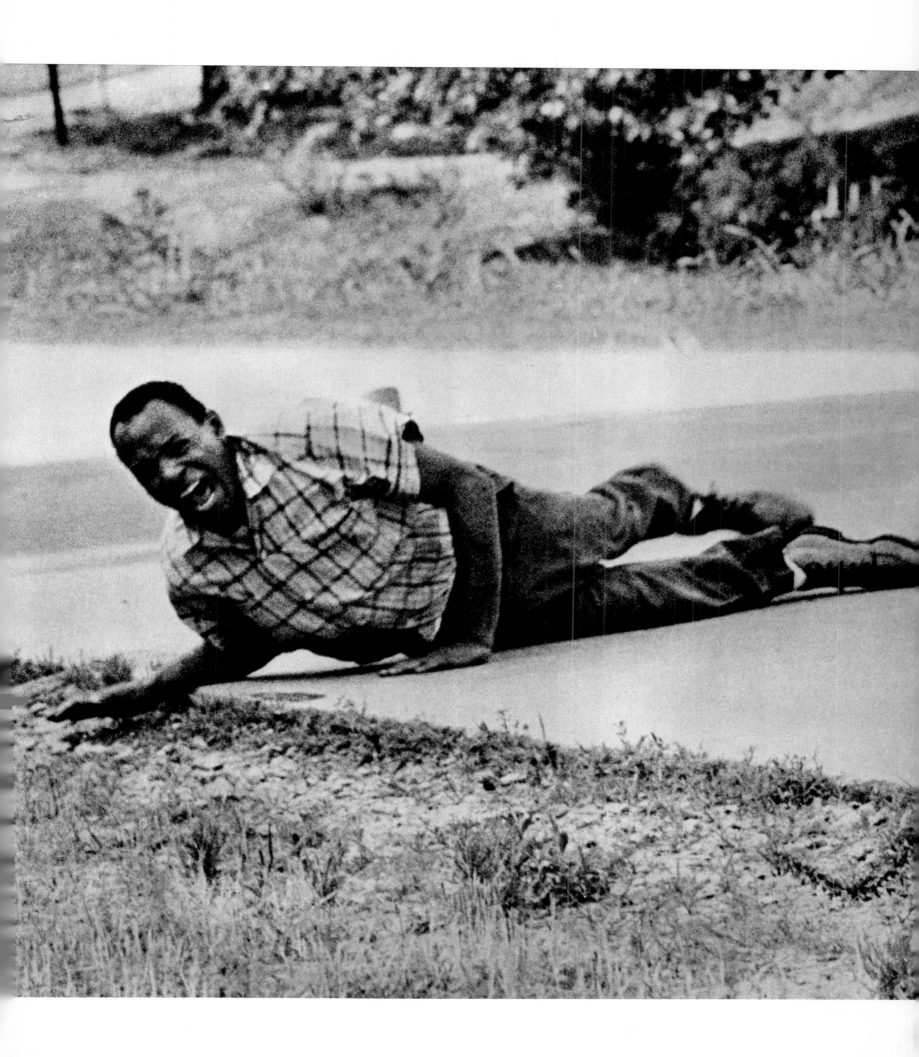

DO I MAKE MYSELF CLEAR?

Cliff Brown took this picture of Woofy, a walrus at Marineland of the Pacific near Los Angeles, who appears to be telling off his trainer, Eddy Asper.

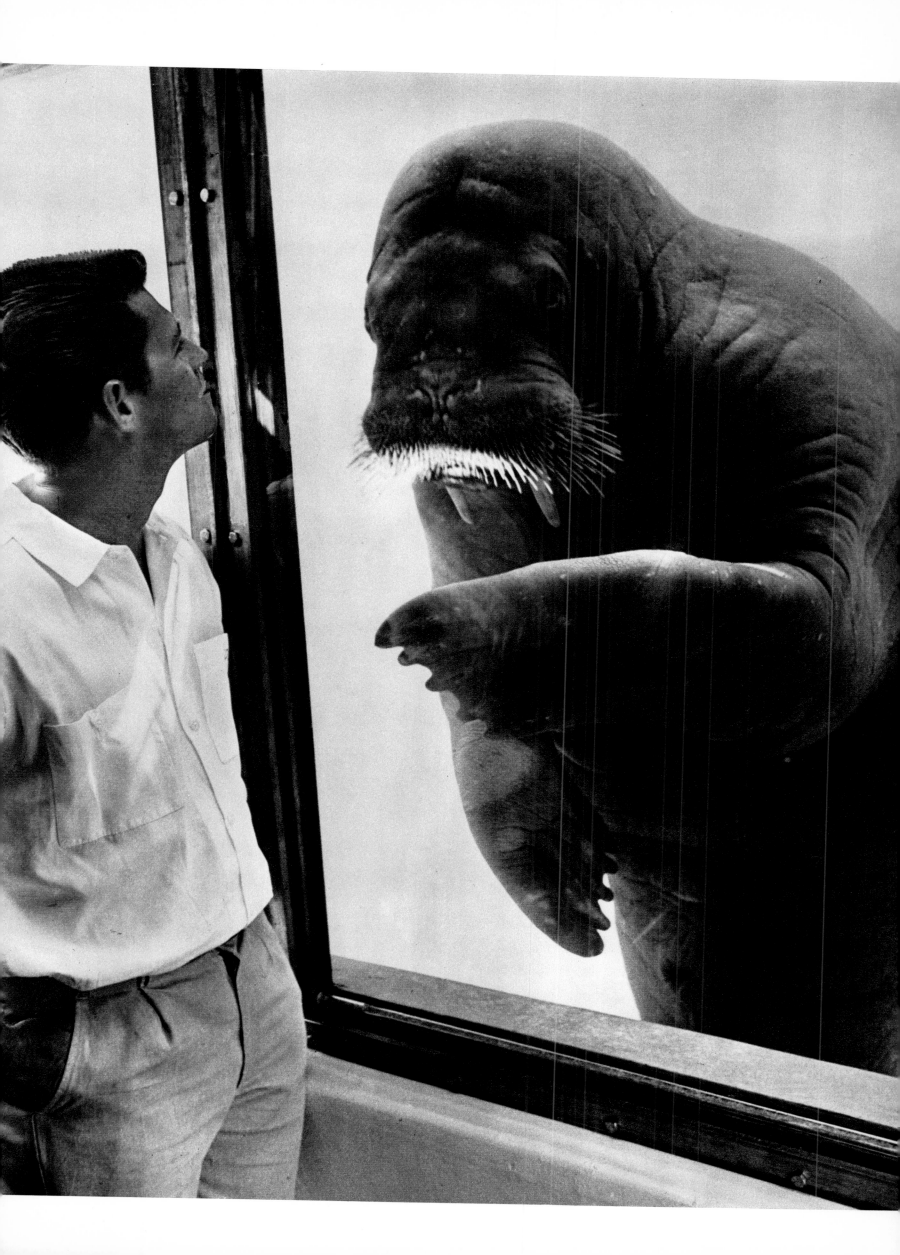

AT LAST

The speck in the sky grows larger and becomes the plane and circles the field and lands, twin engines racing. The ramp is wheeled up and the door opens and he is the first out. An airline agent helps him down the steps because crutches are still new to him.

She races from the gate, and, midway on the glistening runway in the rain, she catches him, her husband, home from Vietnam.

————————

Photograph of Lance Corporal Perron Shinneman and his wife, Shirley, by Ray News of the Argus-Leader, Sioux Falls, S. D., August 13, 1966.

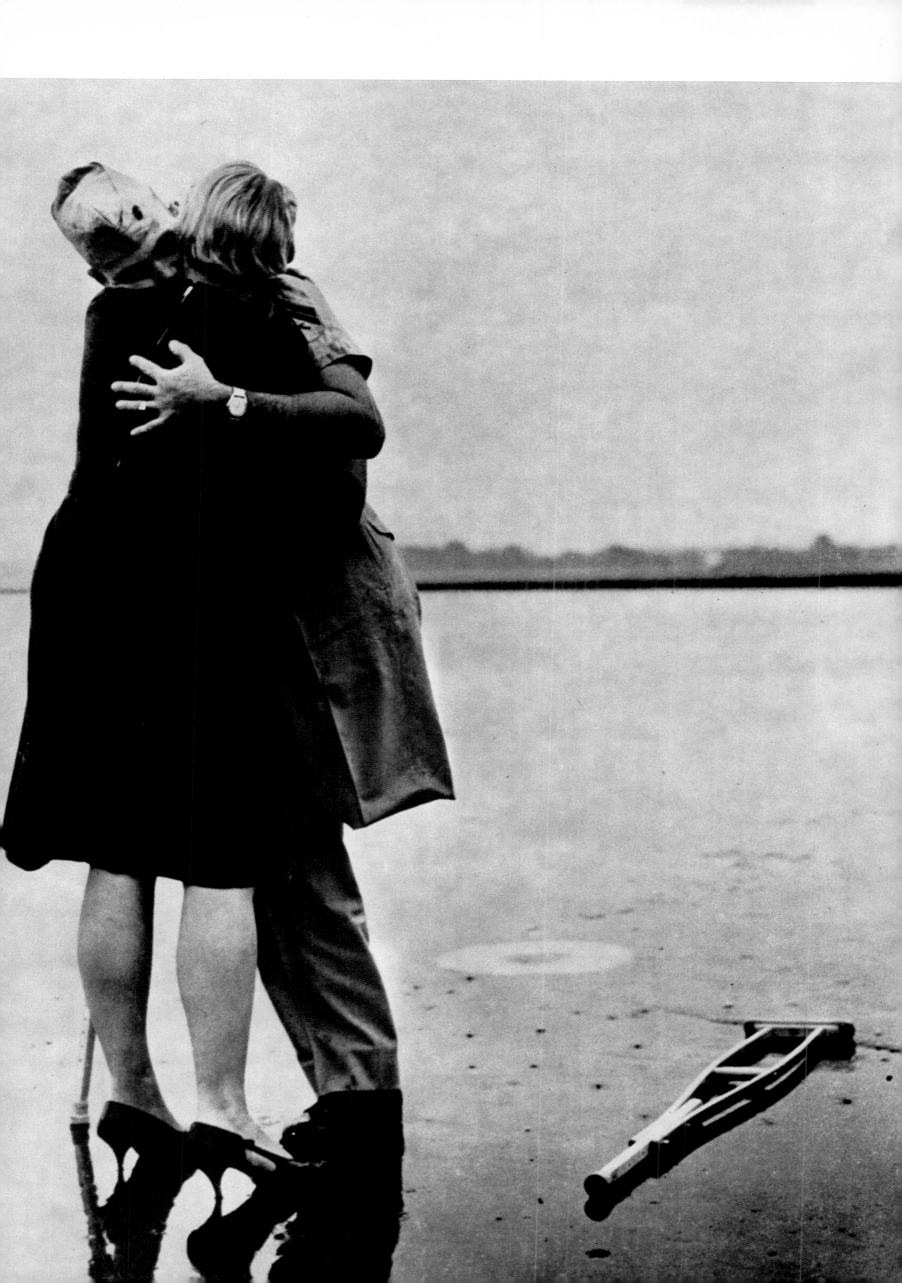

DISCORDS

Thanksgiving Day, 1966, and the smog rises over New York.

The standard of living rises while the satisfaction of living falls. We save our money to buy boats and car trailers, and in the great rush to see nature as it is, we see it as it never was. If you live in Denver, you have to go deeper into the mountains every year for solitude and if you live in Los Angeles you have to go farther every year for a pristine beach and if you live in New York, forget it.

We have polluted the land and the air and the water, defaced the horizon with commercial clutter and blurred our history and our symbols with dollar signs. We have left some lakes beyond redemption and other lakes beyond recognition. We have pasteurized our milk and put strontium 90 in its source and enough waste in streams and lakes to kill 15 million fish in one year.

We have built high risers that block the view of Mount Rainier in Seattle and the bay in San Francisco and the surf in Waikiki and countless other vistas that once nourished the soul of man. We have put enough smog in the air over Los Angeles to warn school children not to play too strenuously on the days of the amber cloud and enough toxics in the air over New York to make a day's breathing equal to two packs of cigarettes. And between the two coasts we have made eyes smart in mile-high Denver and not so high Phoenix and countless smaller places once idyllic.

We have mined enough coal and iron to sag and crack two-million acres of land and strip-mined enough to bring floods in Kentucky and West Virginia. We have made parking lots out of houses older than the American Revolution and rumpus room bars out of trees older than the discovery of America.

We have paved valleys with giant shopping centers and blanketed meadows with dreary housing developments and scarred mountains with utility poles. We have shaken our ecology with technology, our houses with huge diesel trucks and our teeth with monster jets, and we have put enough cars on the "freeways" of California to tie up, in a single accident, 200 vehicles like uncut sausage. We have built a "Walden Breeze—Trailer Sales" across from the Walden Pond of Henry David Thoreau and, in Hannibal, Mo., behind the boyhood home of Samuel Clemens, we have built "Vic Cassano's Pizza King."

We have suffered, in Lewis Mumford's words, "disorder, blight, dingy mediocrity, screaming neon-lighted vulgarity. . . . We have ceased to respect ourselves."

Thanksgiving Day, 1966, and the smog rises over New York, and we seem to have discovered a new phrase and a new value called "The Quality of Life."

The photograph of New York under its dirty blanket was made by Neal Boenzi of the New York Times, who went to the top of the Empire State building and shot 36 pictures, using an orange filter, a red filter, no filter and all combinations of light, until he got what he wanted. Boenzi, incidentally, chooses to live 40 miles from the city for "the fresh air."

KISS OF LIFE

Florida skies are overcast on a muggy day, July 17, 1967, as the linemen
report for a routine morning job in a Jacksonville suburb. The power lines are
dead, they're told. Except one. And lineman Randall Champion hits it and is
knocked unconscious. Other linemen, a block away, race down their poles to
help. Jimmy Thompson is first up the pole where Champion is hanging
upside down. He begins mouth-to-mouth resuscitation to his stricken buddy
who has turned blue. Another lineman follows Thompson up and together
they bring him down. He regains consciousness halfway down the pole and is
sped off by ambulance. He will be out of work a few months for skin grafts
on his feet, where the electricity burned out.

————————————

*It's a routine morning for Rocco Morabito, too. In fact, a slow day. The
veteran photographer for the Jacksonville Journal is in the same neighborhood
on another assignment and passes the men working on the lines on his way.
He finishes his assignment and decides to swing by the linemen again for
whatever they might be worth in the rest of his film pack. People are shouting
as he pulls up. He looks up and sees Champion, upside down, unconscious.
Morabito shoots one quick picture, feeling helpless as he races to the car-
telephone. "Get help," he tells the office, not knowing a distress call is already
out. When Morabito returns, Thompson is up the pole, supplying the "kiss
of life."*

*Morabito shoots again and again. He races back to the office and hand-develops
the film—three minutes past deadline but the paper is holding for these
pictures, which will earn him a Pulitzer.*

☆ *Pulitzer Prize Winner, 1968.*

SUMMER, 1967

In the long, hot summers of the Sixties the cities were tinder boxes awaiting but a spark.

Once lit, they burned with the fury of racial hate and frustration. A routine arrest for drunk driving in Watts in 1965—and 35 people died and $200,000,000 in property burned. Another traffic arrest in Newark in July, 1967—and 27 were left dead.

Then it was Detroit's turn.

"It was," said Police Sgt. Arthur Howison, "just an average raid . . ."

About 3:30 a.m. Sunday morning, July 23, 1967, Howison and three other officers break into a "blind pig," or speakeasy, on Detroit's 12th Street, the main stem of the only section of the racially quiet city that could conceivably be called a ghetto.

A crowd gathers. Someone lobs a brick at a patrol car, cracking the windshield. Lights flash faster and faster through the night on police switchboards. By morning it is clear Sunday will be no day of rest.

Instead, mobs teem into the streets. Looting begins. First, liquor and clothing stores, then appliance shops with looters muscling away that favorite prize, a color TV set. It is more of a spree than a riot: whites mingle with blacks and one black helps boost a white youth through a broken window.

But the police are outnumbered. Two detectives spot two Negroes hefting a refrigerator onto a convertible. Two guns against a mob of 100. They drive on.

And now, at an increasing tempo, Detroit burns, baby, burns. A store up the street is ignited. Then one down the block. Then another. Firemen snake their hoses from one to another, always a jump behind the arsonists. From the air, Detroit looks like the camp of a mammoth army hazed with the smoke of a hundred campfires.

By Monday afternoon, there have been over 900 alarms. There are gunshots at the fire engines, and Gov. George Romney orders in 7,000 National Guardsmen and 600 state troopers. Monday night, President Johnson orders 4,700 paratroopers, many of them Vietnam veterans, into the burning city. In the dancing shadows of the night there is growing gunfire. By morning, 23 are already dead. The madness continues.

Tuesday night, troopers wearing black hoods for concealment, like medieval headsmen, prowl the streets in armored carriers. Tanks roll up to shatter a tenement with tracers where a suspected sniper lurks. A match flickers in a darkened window and a 4-year-old child is killed by gunfire from the troops.

Water drips in the rubble of fallen buildings, their chimneys and walls marking a Stonehenge of ruin. Three young blacks are rounded up in the Algiers Motel by police and later are found shot to death. A lady from Connecticut watches from a window and is hit by a stray bullet, saying "Oh!" as she falls dead.

Wednesday, Guardsmen and police weave in and out of commuter traffic in a house-to-house search for a suspected sniper. None is found. A Negro teen-aged sniper says, "I'm just gettin' even for what they did to us. That's where it's at. Man, they killed Malcolm X just like that, so I'm gonna take a few of them with me. I'm after them honkies . . ."

By Thursday the frenzy is spent. The blood is let. The embers cooled. Forty-three have died. Five thousand have been burned out of their homes. Thousands are jobless because the places where they worked no longer exist. And Detroit, a trademark of American industry, is now a landmark of something else.

Photograph by J. Alvan Quinn of the Associated Press.

STREET SCENE, SAIGON

It may have been one of the most important gunshots of the war, not because it was heard around the world, but because it was seen.

It was a remarkable instant of shock and revulsion, to be sure, but it was the time it was taken that made the photograph significant. This was February 1, 1968, when the Tet offensive swept through South Vietnam—a time when the enemy was supposed to have been drained of his strength and, as the U.S. commander said, "The end is beginning to come into view."

The offensive, during which Viet Cong commandos managed even to fight into the U.S. Embassy compound in Saigon, brought something else into view. This was an accelerating doubt not only of the enemy's strength but of the American role in the war.

Not only: Can we win it? But: Is it worth it? Is this the democracy and freedom we're fighting for in South Vietnam? . . .

Lt. Col. Nguyen Loan, police chief of South Vietnam, removes his revolver from its holster and summarily executes a Viet Cong suspect, whose hands are tied behind his back.

As the pistol is returned to its holster, Loan says: "They killed many Americans and many of my people."

Those words and the facts of life in Vietnam—Viet Cong guerillas had just beheaded a South Vietnamese colonel in his home and killed his wife and six children—do not catch up with the impact of the picture. It became part of a myriad of little pieces that shaped the attitude of a country, one more straw laid on a camel's back.

"I made the picture by instinct. Any idiot could have taken it," said Eddie Adams of the Associated Press, who prefers deliberate pictures of poetic insight. A former Marine combat photographer, Adams was roaming the streets of Saigon when the Tet offensive opened. "Loan gave no indication that he was going to shoot the prisoner until he did it. As his hand came up with the revolver so did my camera but I still didn't expect him to shoot." Loan later told Adams his wife had criticized him for not confiscating the film.

☆*Pulitzer Prize Winner, 1969.*

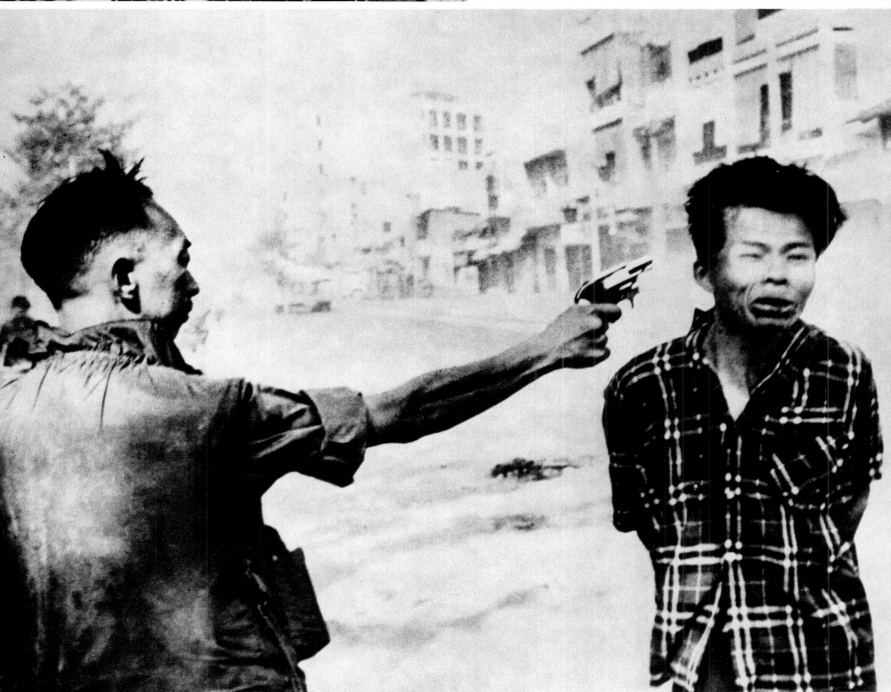

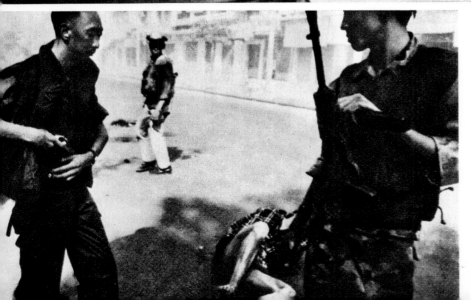

END OF THE PATROL

Vietnam, April, 1968.

In the textured jungle west of Hue, in the steamy sunlight of a clearing, paratroopers of "A" Company, 101st Airborne Division, return from a five-day patrol, which made no headlines or difference in the war that wouldn't go away. They stagger forward, the able helping the disabled, the wounded in unspeakable pain, the leader guiding a medical helicopter in, reaching up into the sunlight for salvation.

They were at one end of a long suction pipe. They were the successors to the handful of American advisers who were in Vietnam in 1961, when the first American casualty occured.

Now there were more than 530,000 of them in Vietnam and the casualty count read 27,000 Americans dead, 171,000 wounded, and peace was nowhere in sight.

They were fighting a war that had divided their country more than any since the Civil War. A war rounded in bitter irony. It began, for America, with advisers, with the idea that the U.S. would arm and train the South Vietnamese to fight their own war. But now, in 1968, Americans were fighting the war as they had been since escalation began after the attack in Tonkin Gulf and the appearance of North Vietnamese regulars in the South.

This, too, did not work, and the war turned full circle. In 1970, America returned to the idea of arming and training the South Vietnamese to fight their own war, and this was called "Vietnamization," and the war went on, with a change in the color of bodies.

By summer, 1972, American casualties totalled 45,000 dead and 300,000 wounded, but the current rate was way down; American ground troops were reduced to a few thousand, but American bombers were hitting North Vietnam harder than ever and the war went on. Communist troops from the north were still coming south to fight; the American ally in Saigon was still a dictator; the American President had gone to Peking and Moscow to exchange toasts with the suppliers of the North Vietnamese, but the war went on.

———————————

Photograph by Art Greenspon for the Associated Press.

AND YET AGAIN

Boris Yaro, a reporter-photographer on the suburban section of the Los Angeles Times, has had too many tacos this day, June 4, 1968. So he leaves work early and, cuddled up to the TV with his Pepto-Bismol, he watches the California primary returns.

Robert Kennedy is clearly ahead and Boris is certain he will take it all—the primary, the nomination in Chicago, the White House. Recovered from his upset, the reporter-photographer picks up his camera and heads for the Ambassador, strictly on his own. No strobe unit. He will use only available light for something different, perhaps dramatic, to hang on his wall. He happens to like Bobby Kennedy.

A few minutes after midnight, the candidate delivers his victory statement in the Embassy Room of the hotel. A small joke about the unfair attack on his dog, Freckles. The peroration: "I think we can end the divisions in the United States . . . the violence, the disenchantment with our society . . ."

The last crescendo: "So my thanks to all of you and it's on to Chicago and let's win there."

12:16 a.m. To avoid the crowd, the candidate moves toward the kitchen, where, among others in the crush, Boris Yaro waits. Also a dark little man named Sirhan Bishara Sirhan, a Jordanian Arab, who does not like the candidate's support of Israel.

Yaro hears what sounds like the pop of firecrackers and feels his face stung. Probably bits of the firecracker paper, he guesses, not yet thinking of gunpowder.

Suddenly, people are pulling back and only three or four feet away Yaro sees Sirhan fire at Robert Kennedy again and again and he watches in numbed horror and he begins to react only when someone yells, "Get him!" Two men grab Sirhan and shove him face down on a metal counter and the gun slips from his hand and Yaro grabs it and someone else takes it from him.

He first thinks about mechanical things. "The fire from the gun is orange. The color of the walls is . . ."

Then, the full thought erupts: "My God! My God! This is happening again— to another Kennedy!"

Robert Kennedy sinks to the floor and Boris Yaro begins shooting pictures and a lady next to him, in the hysteria of the instant, pulls his arm, shouting, "Don't take pictures. I'm a photographer and I'm not taking pictures." Boris Yaro yells, "Let go, lady. Godammit, this is history!" and he shakes her loose and takes more pictures, six in all, and it is not until an hour and a half later, back in the office, all pictures processed, all information given to his news desk, that he goes alone into a tiny darkroom and, like many of his countrymen this night of revived shock and shame, he weeps.

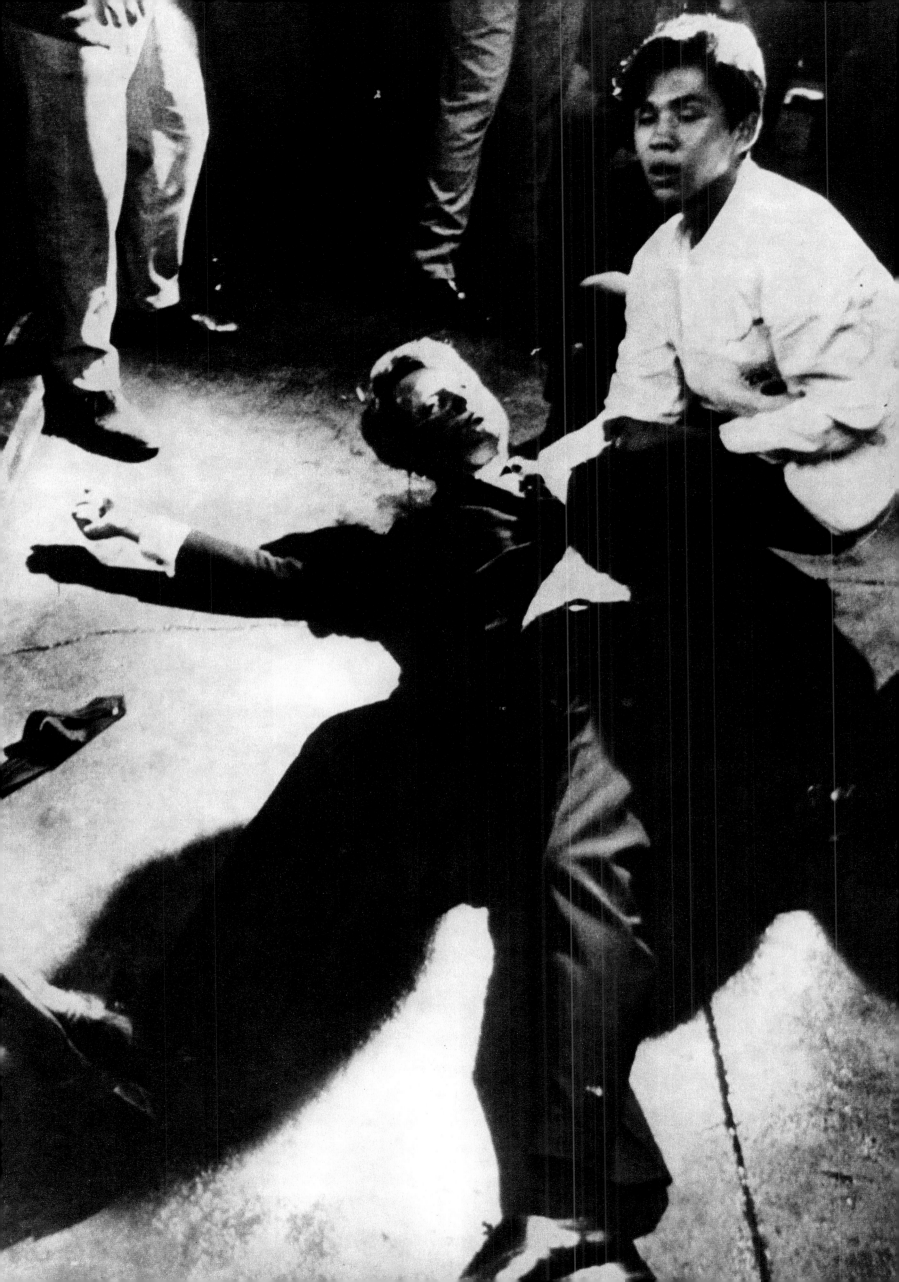

A TRAIN OF POWDER

Hate staggered through the year 1968 like a blinded giant and horror mounted on horror and each time one thought this was the ultimate it wasn't.

The year began with a touch of youthful hope in the snows of New Hampshire when that mystic Pied Piper, Eugene McCarthy, led his Children's Crusade of young supporters to an astonishing 42 per cent of the Democratic vote in the state's presidential primary.

Nineteen days later, Lyndon Baines Johnson, the man they all said would never let go of power, let go. The President spoke on television to the nation and announced a bombing halt in North Vietnam. Then, almost as an afterthought, he said, "I shall not seek, and I will not accept, the nomination of my party for another term as your President."

Politicians scurried. Robert F. Kennedy, brother of the slain President, had already declared. "I run," he said, "because I am convinced that this country is on a perilous course . . ."

The young and others opposed to the war and to Hubert Humphrey and Richard Nixon now had a choice of two leaders to follow. Maybe, they reasoned, they could work within The System after all.

April 4, the Lorraine Motel, Memphis. The man of peace, whose crusade for non-violence had won him a Nobel prize, walked to a balcony in the chilling evening, and a rifle shot blasted away his throat. The Rev. Martin Luther King fell mortally wounded. Washington burned. Baltimore burned. Chicago burned. Black rage fumed in scores of cities. Eighteen died.

April 23. Radicals of the Students for a Democratic Society and the Afro-American Society seized a building at Columbia University and cried defiance from behind barricaded doors and the other side of the generation gap. Sit-ins for black rights and local issues spread to campuses across the nation. Police finally broke up the Columbia demonstrations in a bloody post-midnight raid. But a train of powder had been lit.

June 6, Los Angeles. "It's on to Chicago," Robert Kennedy said, seconds before he fell mortally wounded. . . .

August 26, Chicago. Mayor Richard J. Daley has put the city's 12,000 policemen on 12 hour shifts. Tension and anxiety pile up like thunderheads over Lake Michigan. Inside the hall, it looks like a bitter fight between Humphrey and McCarthy, with Humphrey sure to win. But the fighting is soon elsewhere, out in the streets downtown where the kids, who had seen so much blood, felt so much frustration over the distant war and their own campus battles, come face to face with Daley's police.

Later, it would be called a police riot, but they don't know the term now. They only know the bitter smoke of tear gas, the thud of night sticks, the seeping blood from their numbed bodies. A shocked nation sees it all, courtesy of television. It has seen so much this year.

In Convention Hall, Sen. Abraham Ribicoff of Connecticut speaks above the catcalls from Daley and his delegates: "How hard it is to accept the truth!"

The truth. Where?

Sen. Edward S. Muskie of Maine, nominated as Humphrey's running mate, pledges "to build a peace, to heal our country."

To heal. How?

———————

Photographed by Robert Scott, Associated Press.

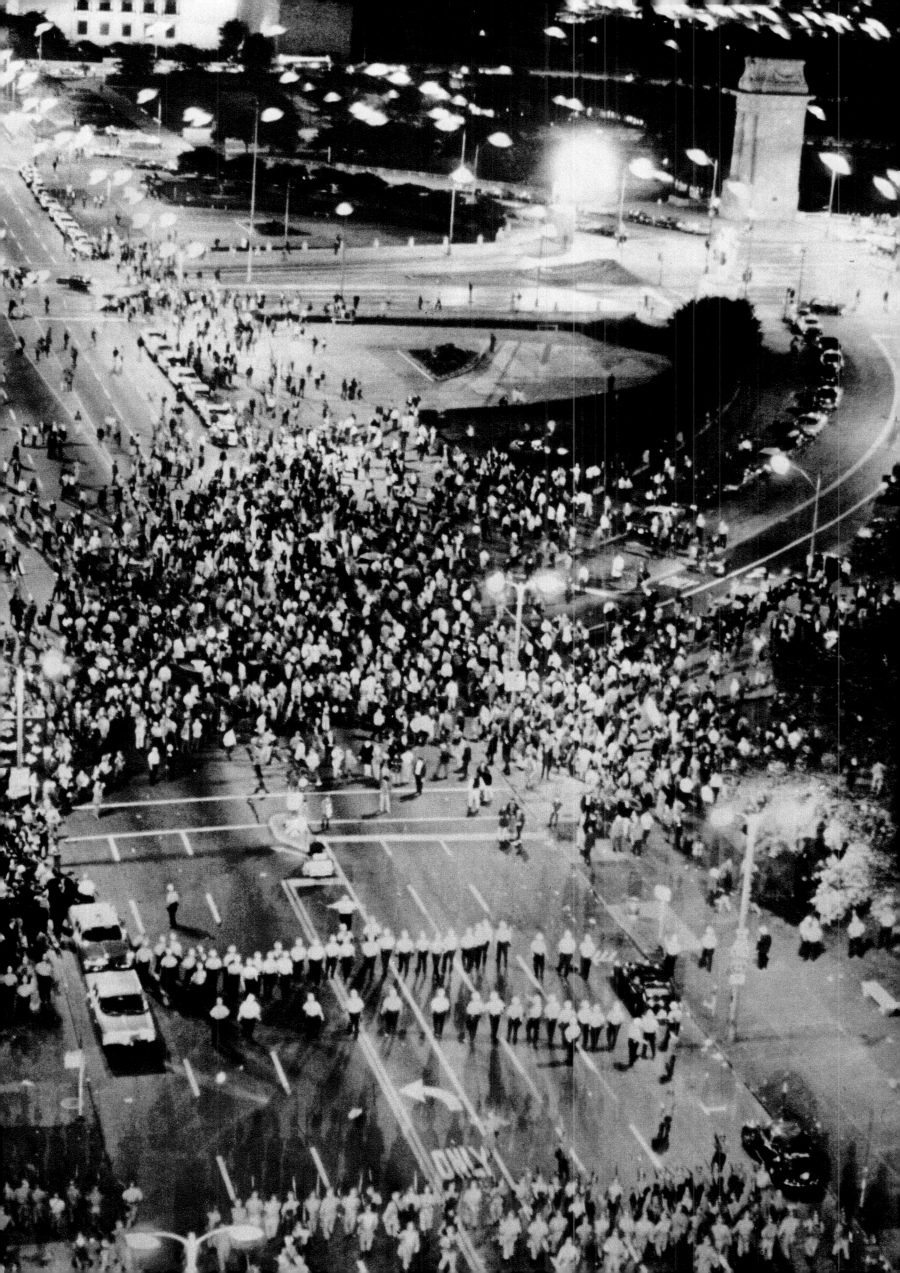

NO RESPECT

In a world of upside-down values, where cats do look upon kings and tiny nations tweak the beards of the mighty, where children frustrate adults and midgets confound giants, it is altogether understandable that Lucy, the boxer, is perplexed and saddened by the effrontery of the unnamed mouse walking calmly under her nose.

———————————

By Terence McNally, South African photographer, on whose porch this confrontation occurred. After the picture, McNally removed the mouse before it had pressed its luck too far.

GUNS AND IVY

"You brought us up to care about our brothers," a white student leader told the board of regents at the University of Colorado. "You brought us up not to run away from injustice. . . . And now you castigate us because we think and we care."

"When I was 10, I was totally fascinated by cars and read all the catalogues," said a white student at Harvard. "Later it dawned on me that maybe a system which put that much into tail fins and left a lot of people hungry was all screwed up."

"My father thought the better world would come through the ballot box and people like Adlai Stevenson," said a black student at the University of California, "I think it can come only through revolution and people like Malcolm X."

With varying degrees of eloquence and logic, American youth denounced The System, widened The Generation Gap and raised Unmitigated Hell in 1969. They protested from Massachusetts to California, from Louisiana to Minnesota, from Wilberforce and Stony Brook to Wisconsin and Harvard. Small schools of still-damp cinder block and great universities of vintage ivy were shaken with violence, sit-ins, seizure of buildings, and picket lines where faculty frequently marched with students. They were protesting Vietnam, racial injustice, poverty, university alliances with government, and curriculum, among other things.

In April, it was Cornell's turn.

Since the university began recruiting ghetto blacks in 1965, Cornell had set up an Afro-American center and a private dormitory for Negro coeds, and planned a black studies program.

But this spring, feeling was running high among Cornell's 250 Negroes. They wanted the black studies program to be a separate college run entirely by blacks. They wanted amnesty for seven blacks who had rampaged through the administration building the previous December.

Tension increased after the university decided to discipline three of the December protestors and after someone burned a cross in front of the Negro coed dorm.

Came April 19, Parents Weekend. At 6 a.m., Saturday, 120 blacks seized the student union, Willard Straight Hall, rousted out 30 sleeping parents and seized the campus radio station to broadcast protests about Cornell's "racist attitudes."

University President James A. Perkins suddenly had to cancel a speech scheduled for that day. The title: "The Stability of the University."

A group from the Students for a Democratic Society formed a protective picket line around the student union. About 20 fraternity boys from Delta Upsilon tried to crack the line and were beaten back. When a rumor spread that armed whites would try to liberate the hall, rifles and shotguns were smuggled in to the blacks inside.

They held the hall for 34 hours, without bloodshed, until Perkins agreed to grant amnesty to all. . . .

And now, at 4 p.m., Sunday, the blacks emerge from the student union, presenting the country with yet another shock: the sight of rebellious college students carrying guns. Once more, the refrain of the sixties runs through the land: "My God, what are we coming to?"

Associated Press photographer Steve Starr, up all night, could have kicked himself Sunday. He had missed a shot of one of the blacks standing in a window with a gun. It would have been the first such. When rumors spread that the blacks were coming out, Starr was at the door. When they did emerge, carrying weapons, he made his pictures "in a hushed silence."

☆ *Pulitzer Prize Winner, 1970.*

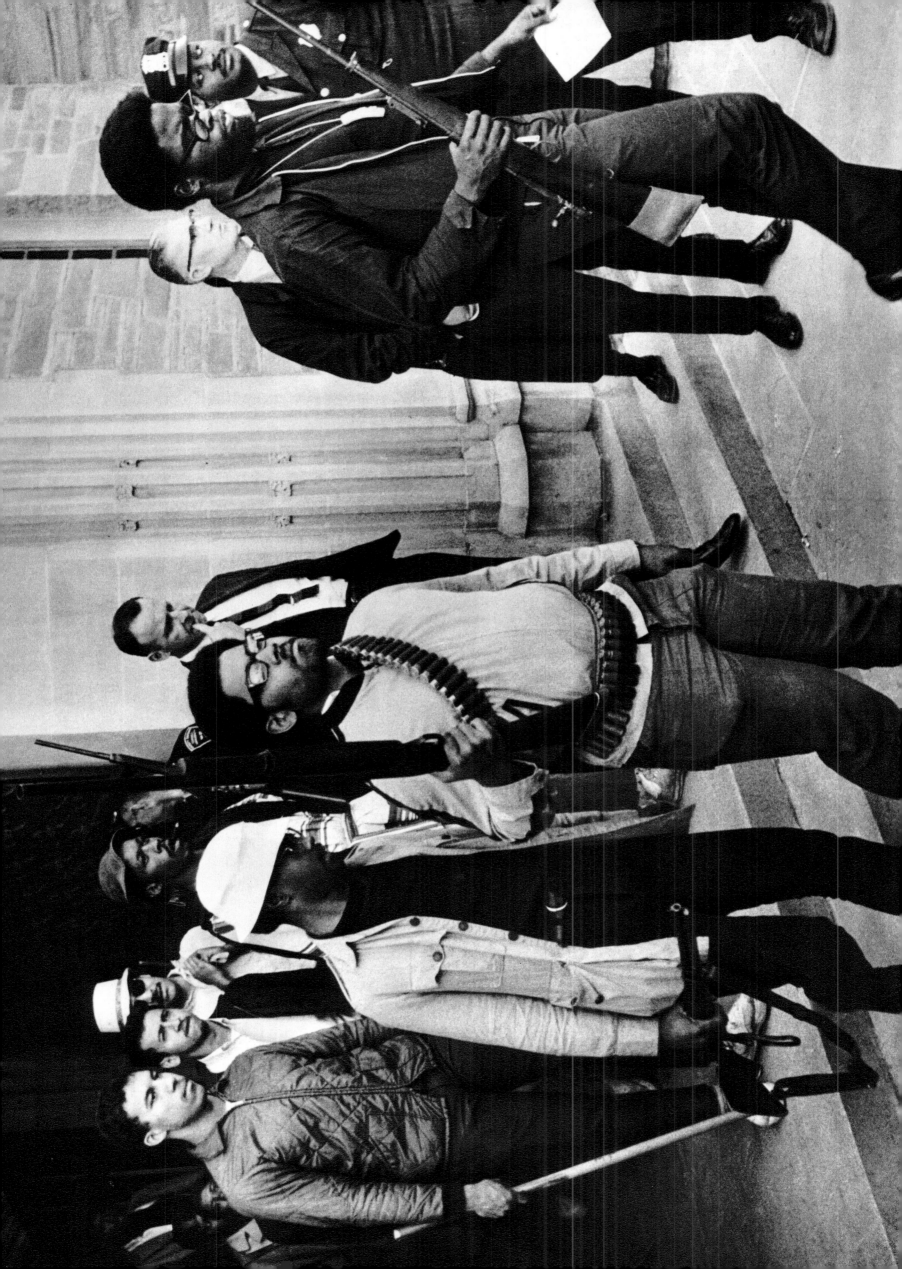

AND IN JAPAN...

The rest of the world was not immune.

In 1968, students rioted in Paris, where protest spread to much of France's work force and shook the foundations of Charles DeGaulle's regime.

This year, 1969, they were rioting in Bolivia, Colombia, Ecuador, Honduras and, again, in Japan.

For two years, Japanese students in steel helmets, armed with stones, sticks and Molotov cocktails, had been creating an uproar, seizing buildings, locking up university officials, attacking professors and battling police. They, too, were demanding an end to the Vietnam war, and more autonomy for themselves.

On September 20, 300 students took over buildings at Kyoto University, blocked campus gates, barricaded streets with desks and chairs, overturned cars and set them afire. . . .

And now riot police charge the barricades against a hail of student firebombs. A police truck ignites and the fire spreads. Two students emerge from the melee and run, on fire. They roll on the ground to extinguish the flames and then vanish in the crowd. . . .

———————————

Photograph by Katsui Aoi of the Asahi Shimbun.

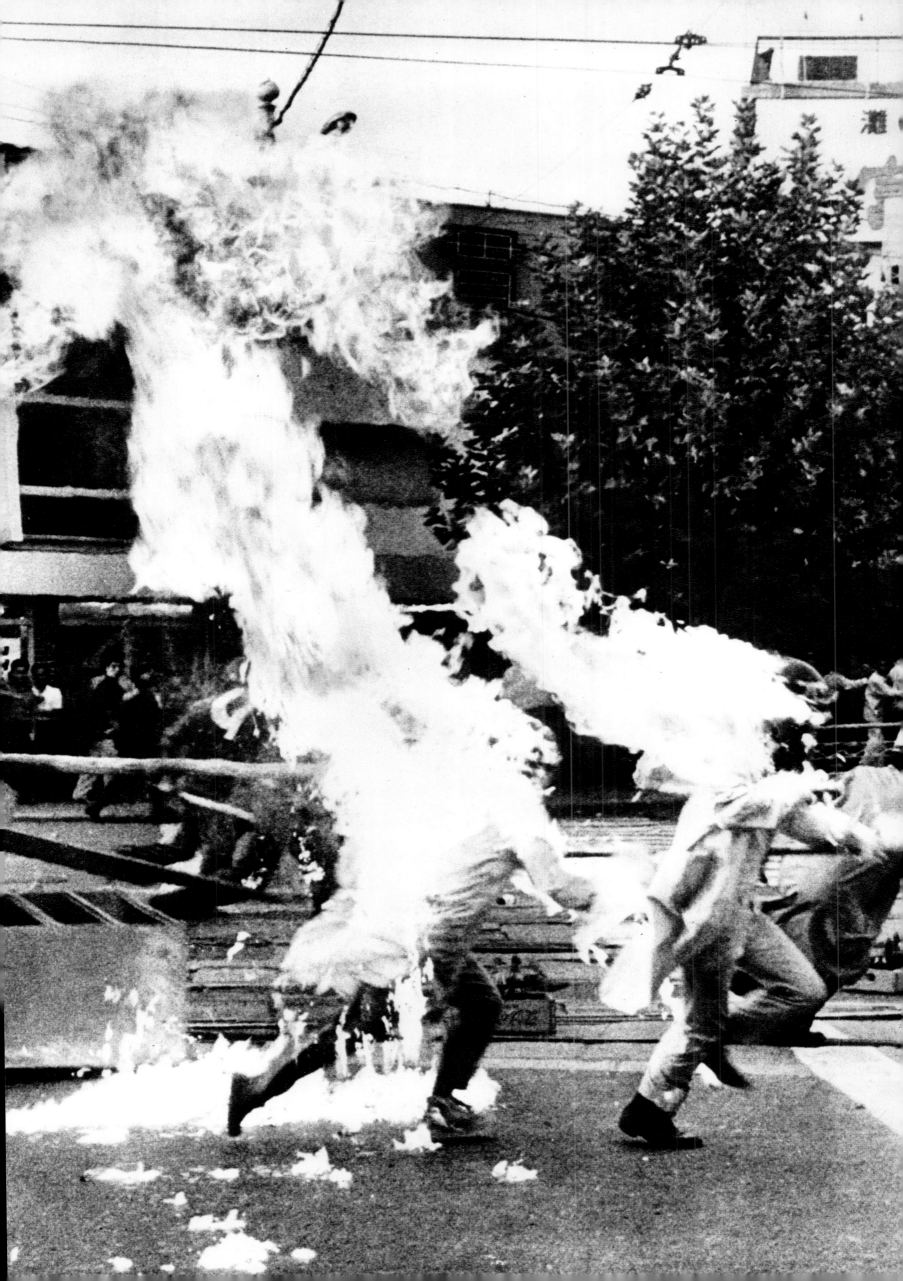

AT LAST, THE MOON

Sunday, July 20, 1969 . . . 4:17:42 p.m. Eastern Daylight Time.

"Houston. Tranquility Base here. The Eagle has landed."

"Roger, Tranquility. We copy you on the ground. You've got a bunch of guys about to turn blue. We're breathing again. Thanks a lot."

The culmination of centuries of dreaming: a ten-year, $20 billion drop in the bucket of time.

Now it is 10:56:20, the same day. A cautious left boot searches for the surface, and the shadowy figure steps off. "That's one small step for a man, one giant leap for mankind."

The staticky voice presses across 238,000 miles. And almost all the world watches and listens. Neil Alden Armstrong, 28, from a place called Wapakoneta, Ohio, on the planet earth, a man with an ordinary size 9½ foot, takes the first step on the moon.

"The surface is fine and powdery. I can pick it up loosely with my toe. It does adhere in fine layers like powdered charcoal to the sole and sides of my boots . . . I can see the footprints of my boots and the treads in the fine, sandy particles."

Vanguard, Explorer, Shepard, Grissom, Glenn, and always behind the Russians. Trailing the Sputniks, the Gagarins, the Titovs. Three men dead in a burning moon ship. But now, suddenly, the race is over. An American flag is unfurled on the moon. President Nixon says, "As a result of what you have done, the world has never been closer together."

––––––––––––––

Odd the way it happens. A picture taken by a robot television camera aboard a disposable landing craft named Eagle records the imperishable moment. Later, like tourists everywhere, the moon visitors photograph each other and Armstrong snaps his co-pilot, Edwin E. Aldrin, setting up a solar wind test. And man wins a new planet to walk on because two nations are locked in a contest for prestige on earth.

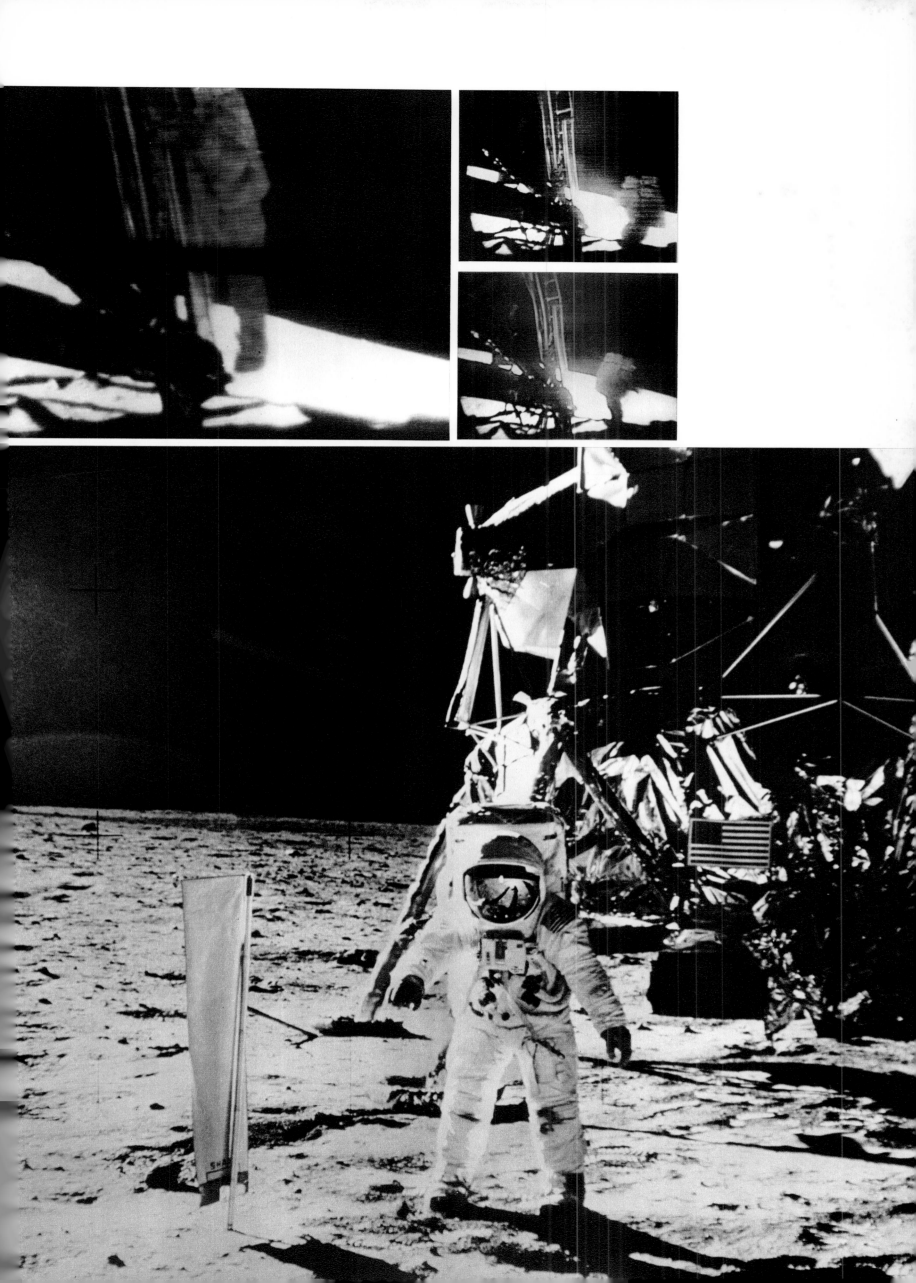

SPRING, 1970

With unintended irony, it was called Operation Total Victory.

This was the combined South Vietnamese-American attack into Cambodia. A somber President Nixon announced it on television April 30, 1970, saying: "We will not allow American men by the thousands to be killed by an enemy from privileged sanctuaries."

The reaction on American campuses was predictable and immediate: an unprecedented uproar of protests and demonstrations. Duke law school removed from a wall a picture of alumnus Nixon. At normally peaceful Nebraska University, the ROTC building was seized by students.

But some students at Kent State University in Ohio had their minds on other matters. They were at play, drinking beer downtown. Some were watching the Knicks-Lakers' playoff on TV. The drinkers eventually moved into the street and began a snake dance. An impatient motorist raced his motor and the kids began pounding the car. A crowd gathered and things got rough. The cops appeared and broke up the mob with tear gas.

Next day there was a rally of about 800 students. They began tossing rocks at windows of the ROTC building. Then railroad flares. The building caught fire. Firemen came and the kids threw rocks at them and cut their hoses.

Gov. James Rhodes ordered in about 900 National Guardsmen, already weary from three days' duty policing a Teamsters' strike. They came with loaded guns.

The county prosecutor advised Rhodes to close the school. Instead the governor declared a state of emergency and banned demonstrations. . . .

Now, it is Monday, May 4, a lovely spring day on the greening campus. Students pass to and from classes under the wary eyes of the soldiers clustered near the ruins of the ROTC building. The night before there had been another fight, this time involving 500 students who threw rocks at the Guardsmen. One hundred and fifty were arrested.

So, about noon when someone begins ringing the Victory Bell, used infrequently during football season, about 1,000 students rally round.

Two jeeploads of officers approach the crowd. "Evacuate the campus area. You have no right to assemble."

"Pigs off campus. We don't want your war," is the answer.

The Guardsmen form two skirmish lines and point guns toward the crowd. Some students begin tossing rocks. They fall short. The soldiers respond with tear gas. The students advance, some throwing the gas cannisters back. The Guardsmen move slowly backward up a hill, still facing the students, guns pointed.

Then this (according to a student): an officer, pointing a .45 calibre pistol, raises a "swagger stick." Then he drops it and the soldiers fire. . . .

The question of whether the soldiers were actually ordered to fire, or fired because they thought they would be overrun, remained confused in subsequent investigations.

But what was certain was that four students lay dead beneath the leafing trees of Kent State, one of them a girl who only a few hours before had put a flower in the barrel of a Guardsman's rifle saying, "Flowers are better than bullets."

John Filo, a photography student in the journalism school, was working in the photo lab when he heard the bell ringing. He borrowed a camera from the yearbook office, ran outside and on the way met a friend with a zoom lens. He borrowed that. Like others, he thought the Guardsmen were shooting blanks until, through his range finder, he saw a bullet splinter a sculpture. After the shooting, he saw Jeffrey Miller lying 30 feet away in blood. Filo had four frames left on his camera roll. "Then this girl came up and knelt over the body and let out a God awful scream. That made me click the camera. I didn't react visually." He knew he had something. He put an "X" on that roll, and there among the last frames was the picture that won him a Pulitzer Prize at age 21.

☆*Pulitzer Prize Winner, 1971.*

IN THE REFLECTING POOL

The anger over Cambodia was compounded by the shock of Kent State, and a contagion of protest spread to at least 760 campuses in the nation's first country-wide strike. Nearly 200 schools closed.

And now Washington, May 9, 1970. Protesters gathered again in the capital as they had the previous November, but this time the mood seemed more volatile. Buses lined bumper to bumper barricaded streets around the White House.

President Nixon didn't get to bed until about 2:30 a.m. and dozed only fitfully then. An hour later, he awakened his valet, Manolo Sanchez, and asked if he had ever seen the Lincoln Memorial by night. With Sanchez and a few Secret Service Agents, who were described as "petrified," the President of the United States went out into the predawn to talk to the young.

The beleaguered Commander in Chief defended himself to about 50 of the bearded, the long haired, the love beaded. He said he, too, wanted peace.

"There were fine kids from all over the country, and I told them, 'sure, you can have your demonstrations and shout your slogans on the Ellipse. That is all right. Just keep it peaceful. I feel just as deeply about this as you do.

" 'I know that this is awfully hard to keep in perspective. In 1939, I thought Neville Chamberlain was the greatest man living and Winston Churchill was a madman. It was not until years later I realized Chamberlain was a good man, but Churchill was right.' "

Joan Pelletier, a 20-year-old coed from Syracuse University, wasn't mollified. "Here we come from a university that's completely up tight, on strike, and when we told him where we came from, he talked about the football team, and when someone said he was from California, he talked about surfing." . . .

And now, with the sun well up, they are gathered in the heat on the Ellipse, listening to the loudspeakers: "Stop the war machine. . . . Shut down the offices. Shut down the factories. Shut down until we end the war."

They chant obscenities at the President only a few hundred yards from his house. Speakers denounce and mock him. Some students from New York hold dripping animal entrails in their hands, saying: "This is the blood of victims of the war."

There are only 100,000 protesters this time and little of the expected violence. (In November there had been a quarter million.) And when the temperature climbs above 90, the veterans of Woodstock cool their anger and themselves in the Reflecting Pool of the Ellipse, not far from the White House but on the far side of the generation gap.

Even a souvenir vender is a little weary. Business is slow. "People are wearing the same old buttons," he says. And the war goes on.

Photograph by Chick Harrity, Associated Press.

REFUGEES, YET AGAIN

As a nation, it was always more of a curiosity on a map than a people, two halves split 1,000 miles apart by a hostile neighbor.

They were split in other ways. West Pakistan had the capital, the army, the wealth. East Pakistan, or Bengal, had the teeming, hungering masses typical of the subcontinent, masses who made their subsistence living in the low delta country. In a poor nation created almost by whim, they had only one tie to West Pakistan, a common faith in Islam.

"We have never been anything but a colony of the West," said one Bengali leader. They didn't speak the same language—Urdu as against Bengali; weren't the same color—light in the West, dark in the East; and widely differed in temperament—desert and mountain warriors as against easygoing delta peasants.

The Punjabis of the West held 85 per cent of the government jobs. The West took 75 per cent of any foreign aid and 60 per cent of export earnings even though the East had half the population and earned most of the nation's foreign exchange.

And 95 per cent of the armed forces of Pakistan were Punjabis.

Not surprisingly, then, a movement for autonomy had arisen in East Pakistan. This was the Awami League, led by Sheik Mujibur Rahman. Confronting him from West Pakistan was the country's leader, Gen. Yahya Khan, who said: "I'll be damned if I'll see the country divided."

After a cyclone in late 1970 killed several hundred thousand Bengalis, relations between the two halves were further strained. Bengalis thought West Pakistan had been shockingly slow in delivering aid.

In a subsequent election, the Awami League won 167 of the 169 seats allotted Bengal in the national assembly. Yahya flew to Dacca for talks with Mujib. And, quietly, the army doubled its forces in East Pakistan to 60,000 men, flying them in on jets commandeered from the nation's airline. . . .

On March 25, 1971, Yahya breaks off the talks and leaves for the West. Five hours later his army strikes. It is like a tiger unleashed midst a flock. The Punjabis show no mercy. Whole villages are wiped out. Wells are stuffed with bodies. Blood flows everywhere across the Florida-sized land.

The Bengalis try and fight back in that most savage of all combats, communal war.

And the people, what of them? The Bengalis flee by the millions in a mass migration of terror. Some are caught by the West Pakistan soldiers along their torturous route across the innumerable streams and rivers. But most make it, swelling into the border areas of India which can't even adequately support their own populations.

The pictures are taken and the world sees. A man cowering in stunned fear in a drain pipe. A child shrieking—from what unnamed terror? A woman dazed beyond emotion.

They have ridden with the Four Horsemen and the journey shows. Death. Pestilence. War. Famine.

By Raghu Rai, chief photographer of the Statesman of New Delhi.

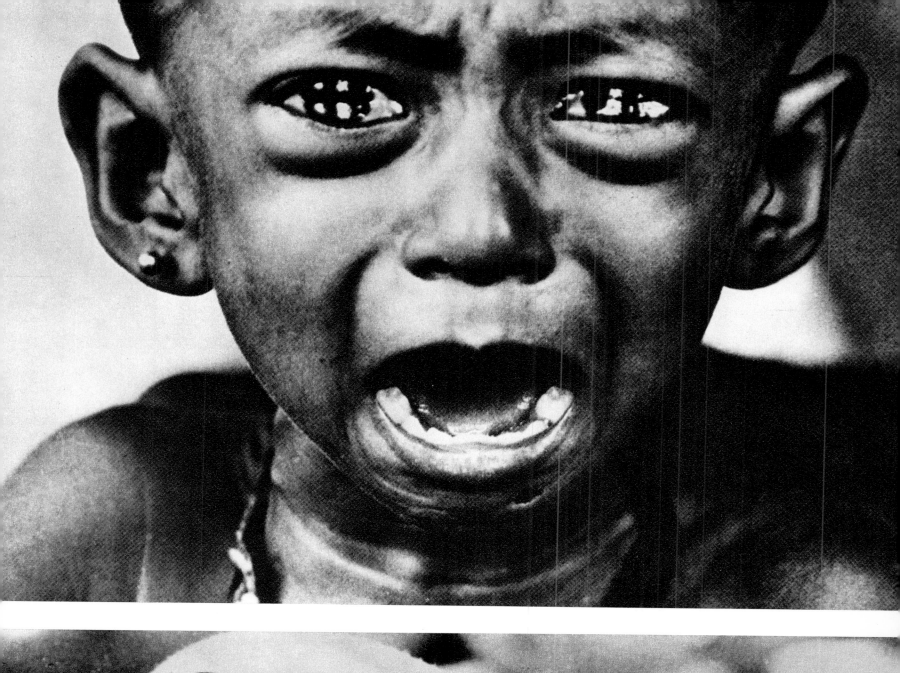
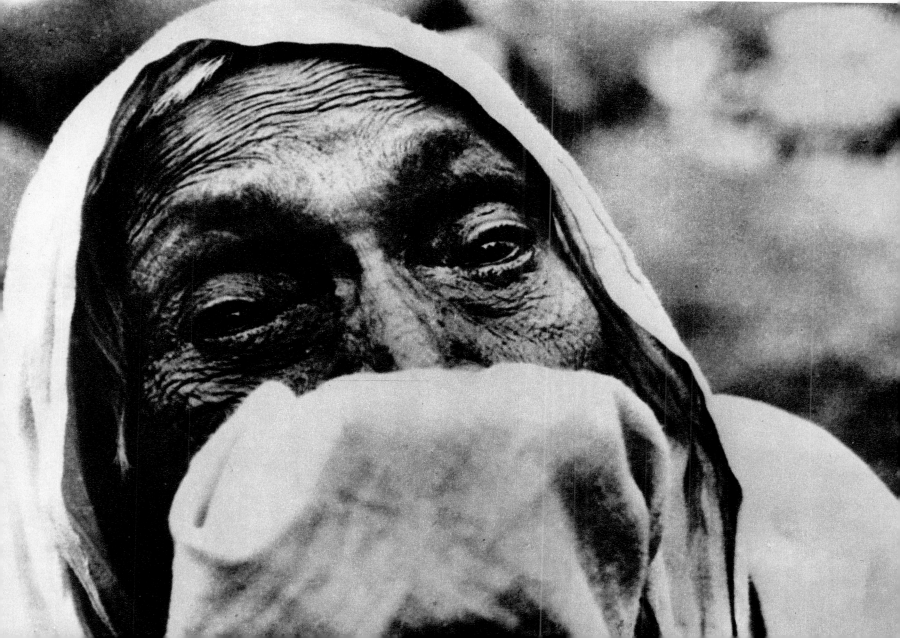

BREAKOUT

It was just another run-of-the-court day, so routine only those who had to be were present.

Superior Court Judge Harold J. Haley, 65, presiding in the Marin County Civic Center, San Rafael, Calif. James David McClain, 37, a prisoner from nearby San Quentin, on trial for knifing a prison guard. Ruchell, 31, also a convict, testifying for the defense. William Christmas, 27, another convict witness, waiting his turn. District Attorney Gary W. Thomas, 32, prosecuting. Twelve jurors. Some court attendants. No onlookers.

At 10:45 a. m., a youth with a bleached Afro hairdo walked in and took a seat. He carried a small zippered bag. A courthouse idler? The trial proceeds.

Suddenly the newcomer, 17-year-old Jonathan Jackson, stands up, waving a pistol and a carbine he had concealed beneath his coat.

"This is it. I've got an automatic weapon. Everybody freeze."

Jackson tells the bailiffs to remove the convicts' handcuffs. He orders lawyers and jurors to lie on the floor, then tells McClain to tape a sawed-off shotgun to his wrist and around the judge's neck so it will go off in the judge's face if he tries to pull free.

McLain orders Judge Haley to call down to the sheriff telling him to clear an escape route. Then he shouts into the phone: "You're going to call off your pig dogs. We're going to get out of here." Taking three women jurors and the district attorney as hostages, the armed procession moves into the hall.

This August 7, 1970, had begun routinely, too, for Jim Keane, a 47-year-old photographer for the San Rafael Independent-Journal. Then he hears an alarm over his police radio in his car: armed man in the courtroom. Keane races to the Civic Center in time to see the gunmen and their hostages in the hall.

"Take lots of pictures," one of the men shouts, "we are the revolutionaries." Keane does.

"You can come along with us if you want," says a man with a rifle to Keane. "Of course, you could get killed." Keane declines.

"Tell them we want the Soledad Brothers released by 12:30," shouts McClain, still taped to the shotgun. The Soledad Brothers are three convicts in Soledad Prison charged with murdering a guard. One of them is Jonathan Jackson's brother.

The gunmen move outside and climb into a bright yellow van with their hostages.

An officer runs in front of the vehicle. "Halt!" he commands. There's a shot from the van and the officer shoots back, apparently killing McClain, the driver. A shotgun blast echoes from inside the van. Then more gunfire, going and coming.

At the end, the judge is dead. So are Jackson and Christmas. Magee is wounded and so are the hostages. Thomas is paralyzed by a bullet in his spine.

Later, black militant Angela Davis will be charged with having bought the guns, tried and acquitted. But, for the cast in Judge Haley's courtroom, the routine trial is over.

Later, writing in "The National Photographer," Keane said: "Most news photographers rush into situations from which others rush away. They cover themselves, I think, with a self fabricated umbrella of immunity, hiding behind their lenses, telling Fate they are not really involved. I did what had to be done. Tomorrow, like most news photographers, I will probably do what has to be done."

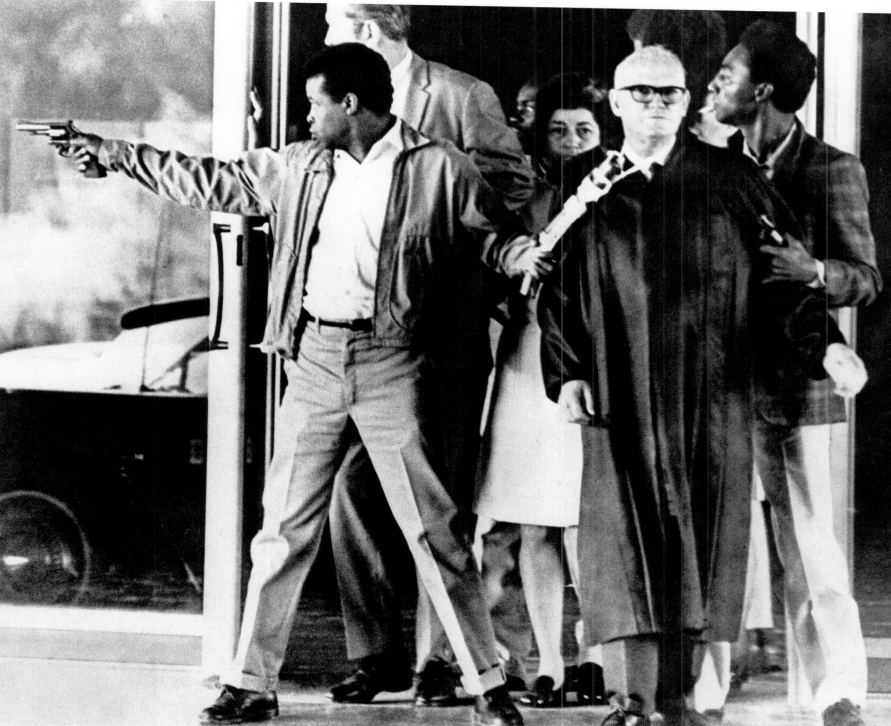

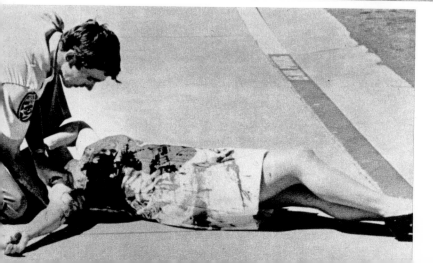

END OF A DREAM

The timeless lure of faraway places finally proves too much for Keith Emanuel Sapsford, who is 14 and lives in Sydney, Australia. He will go to exotic Tokyo, home of the Geisha and the Ginza.

Problem: money. Solution: stow away.

On February 22, 1971, he makes his way to the Sydney airport and somehow climbs up into the wheel housing of a huge Japanese jet without anyone noticing. The DC-8 roars down the runway and lifts off. At 200 feet, the pilot hits the switch to retract the wheels. The housing flaps open wide to accept the wheels and the boy who dreamed of seeing the world falls to his death.

———————

John Gilpin, 22, student accountant and amateur photographer, is off work this Sunday. He decides to go out to the airport and try out a new lens. He zeroes in on the big Japanese jet moving down the runway, hoping to catch the instant of liftoff.

Another plane blocks his view. He waits until the DC-8 is up at 200 feet and shoots anyway. Through his viewfinder, he sees only the plane and does not think he caught anything special.

Later, television cameramen come by and tell him about Keith Sapsford. They suggest Gilpin may have the picture. He does, and it becomes the first and only photo of his ever published. He says, "I'm not all that keen about photography. I got no great satisfaction out of that fluke shot. No, I wouldn't think of having a print on my wall at home."

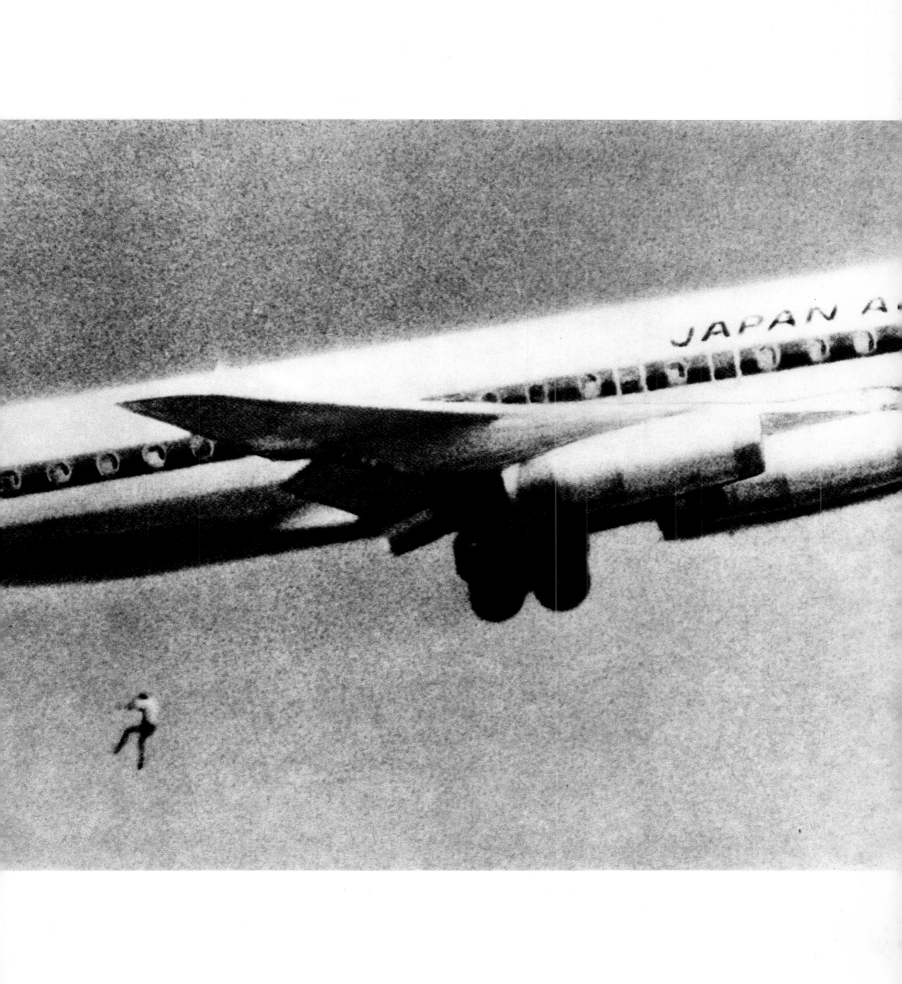

SILKEN MEMORY

This picture of Rita Hayworth was taken in 1941 and is used here, out of sequence, on the grounds that it is needed more now, 30 years later, than then.

It was carried around the globe by the citizen soldiers, sailors and airmen of World War II but any attempt now to recapture the thoughts of the men who looked at her from their bunks and hammocks would still be an intolerable invasion of privacy.

Suffice it to say that for millions of balder, heavier, middle-aged warriors she remains a symbol of a simpler time, when men were not ashamed of their war, when the world seemed to make more sense and the times were less contentious and a man could look forward to a wife who would love him, a home that would shelter him, neighbors who would not confound him, a paycheck that would be all his, and children who would honor him.

By Robert Landry, Life magazine.

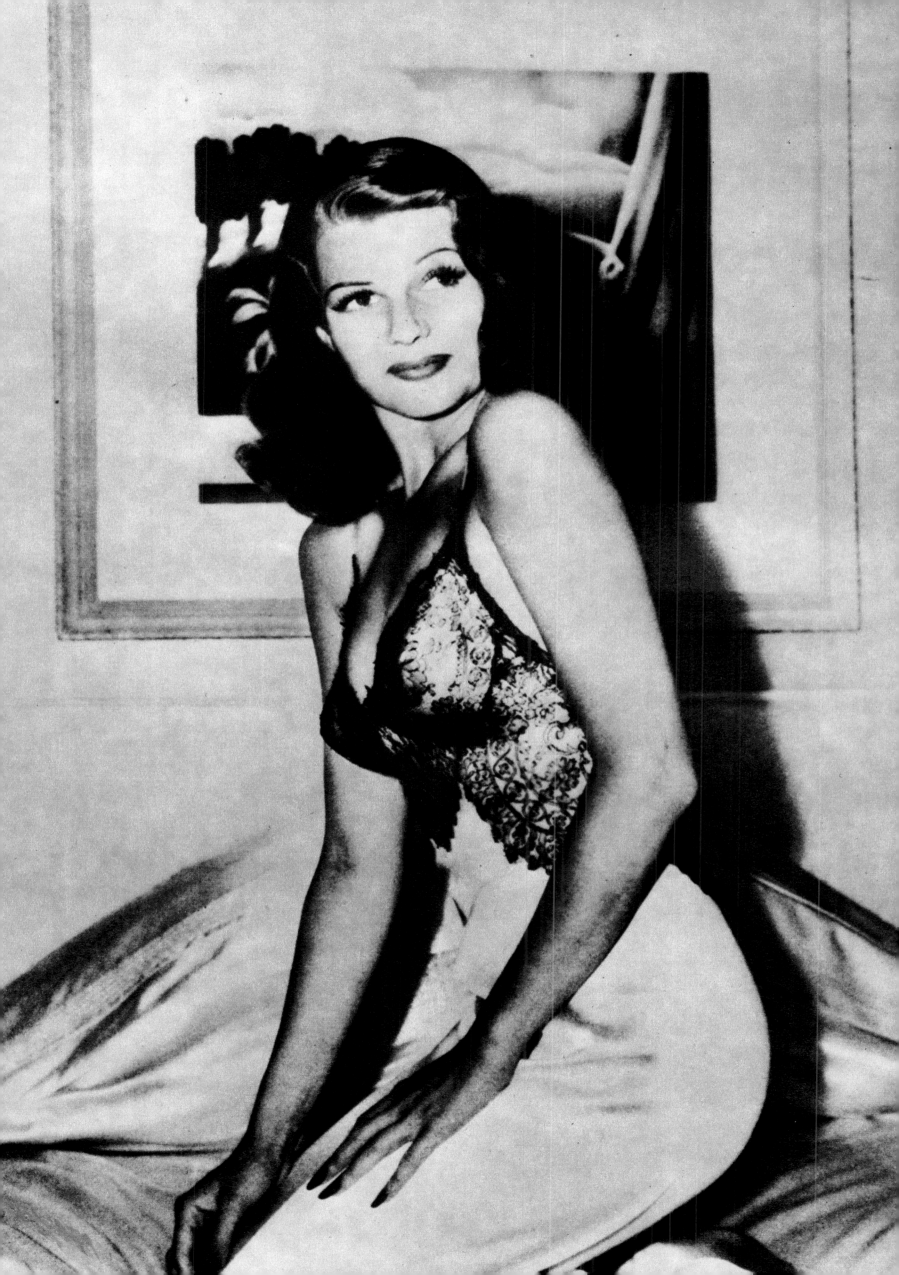

BIRTH OF A KILLER

It is called "Tornado Alley," that flat, broad stretch of midwestern geography where cool northern air and warm Gulf air, in wild celestial embrace, beget with reckless frequency nature's most capricious killer. Thus it is a function of the Kansas Highway Patrol to stand watch in the countryside when conditions favor this ominous union and give radio warning should they spy one of these wanton daughters of Thor at loose upon the prairie. Dull duty, usually.

On a stormy night in May, 1971, however, Trooper Henry Perez, 28, sitting in his patrol car alongside Interstate Highway 70 about 20 miles west of Salina, Kan., sees a quarter of a mile away a boiling bulge suddenly protrude above the horizon. He reaches for a 35 millimeter camera, standard equipment in a patrol car, used customarily to photograph highway accidents. Perez uses it instead to record an event rarely witnessed and never before clearly photographed. Perez watches in fascination as the bulge becomes an elephantine snout and does a dervish dance across the naked plains. He snaps 20 pictures.

Back at his station in Salina he turns over his roll of film for routine processing at the photo lab in Topeka. There the film sits, pushed back as more pressing work arrives involving motor accidents. After two months, the pictures finally surface from the developing tank and eventually find their way to a bulletin board at the patrol's headquarters in Chanute. There they are discovered by a newsman, and, in turn, by the National Weather Service where they strike the awed meteorologists with the impact of—well, a tornado.

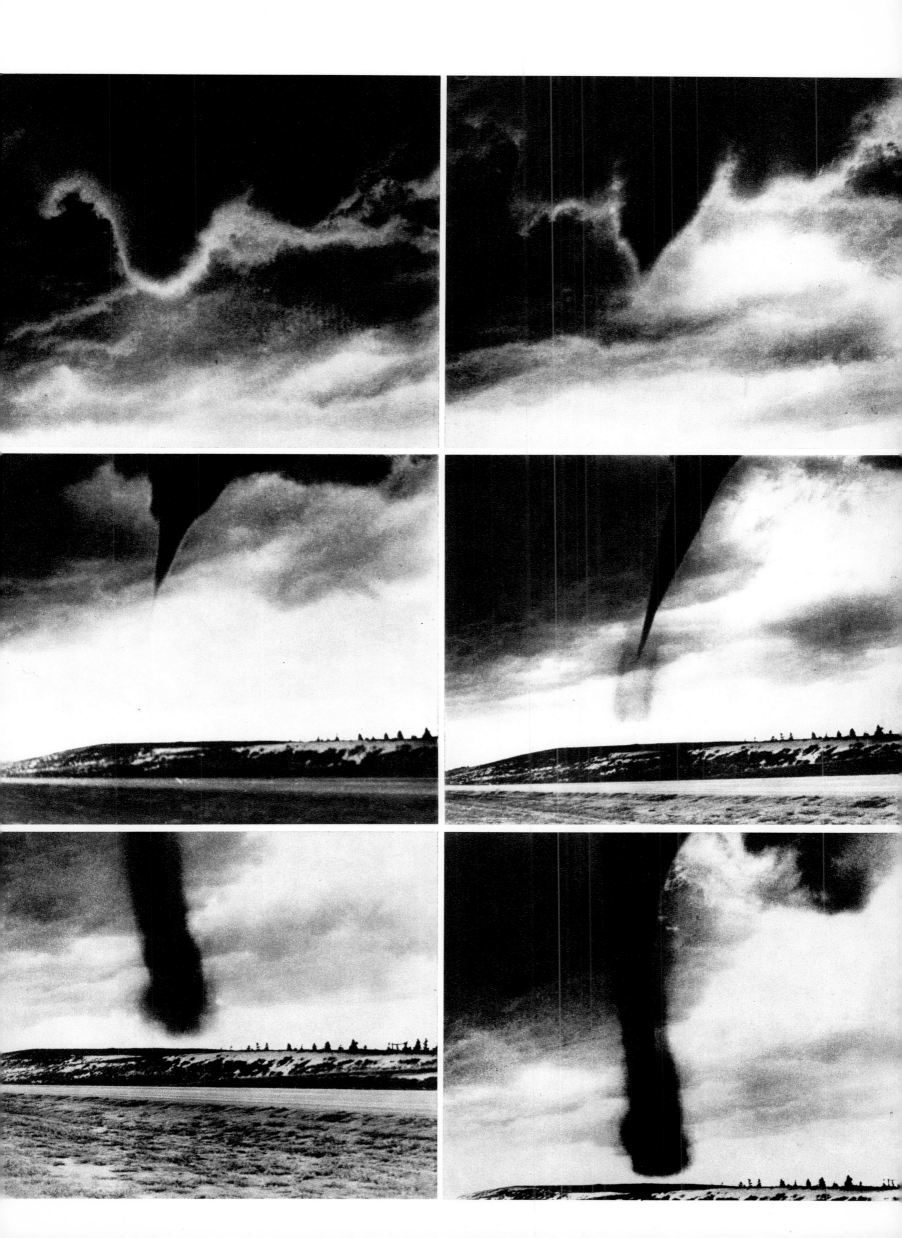

ATTICA

Most of the inmates were young, black or Puerto Rican and, in the words of their leaders, "political prisoners," victims of society rather than criminals. Prison conditions were bad because prisons had become "the fascist concentration camps of modern America." When the Commissioner of Corrections promised changes but said changes would take time, they shouted "cop-out."

And so a scuffle in the yard at Attica, a maximum security prison in western New York, grew into a full-scale confrontation September 8, 1971, and into a riot the next day. Now, 1,281 strong, the rebellious inmates held "D" yard and 43 guards and prison workers as hostages.

When the commissioner, Russell Oswald, offered them guarantees against reprisals, they called him a "liar" and "racist pig" and raised their clenched fists in a frightening show of power and insurrection.

On the weekend, three inmates were killed by fellow prisoners and one guard died of a beating during the takeover. Now, the rebels added to their demands: amnesty for crimes committed since the riot began.

Oswald yielded to 28 other demands but said no to amnesty. Gov. Nelson Rockefeller rejected pleas that he go personally to Attica. Finally, with the governor's approval, Oswald issued an ultimatum to the rebels: release the hostages and restore order, or suffer an assault by guards and state troopers.

"Negative," was the reply from inside Attica.

And on September 13, a helicopter dropped tear gas into the prison, where the inmates held their hostages at knifepoint. Troopers and guards with shotguns and high-powered rifles crept in on rooftops and when they saw "movement" among the prisoners they opened fire. They advanced onto the catwalks, still firing, and entered the prison corridors, still firing, and regained control of Attica. In six minutes of shooting they had killed 29 prisoners and, inadvertently, 10 hostages, and wounded 89 others. It was, state investigators said later, the bloodiest one-day encounter between Americans since the Civil War.

———————

Bob Schutz of the Associated Press accompanied Oswald into the prison yard. Inmates told Schutz to confine his photographs to the proceedings at the negotiating table. But as they began shouting and raising their clenched fists, he turned, aimed his camera into their faces and squeezed the shutter.

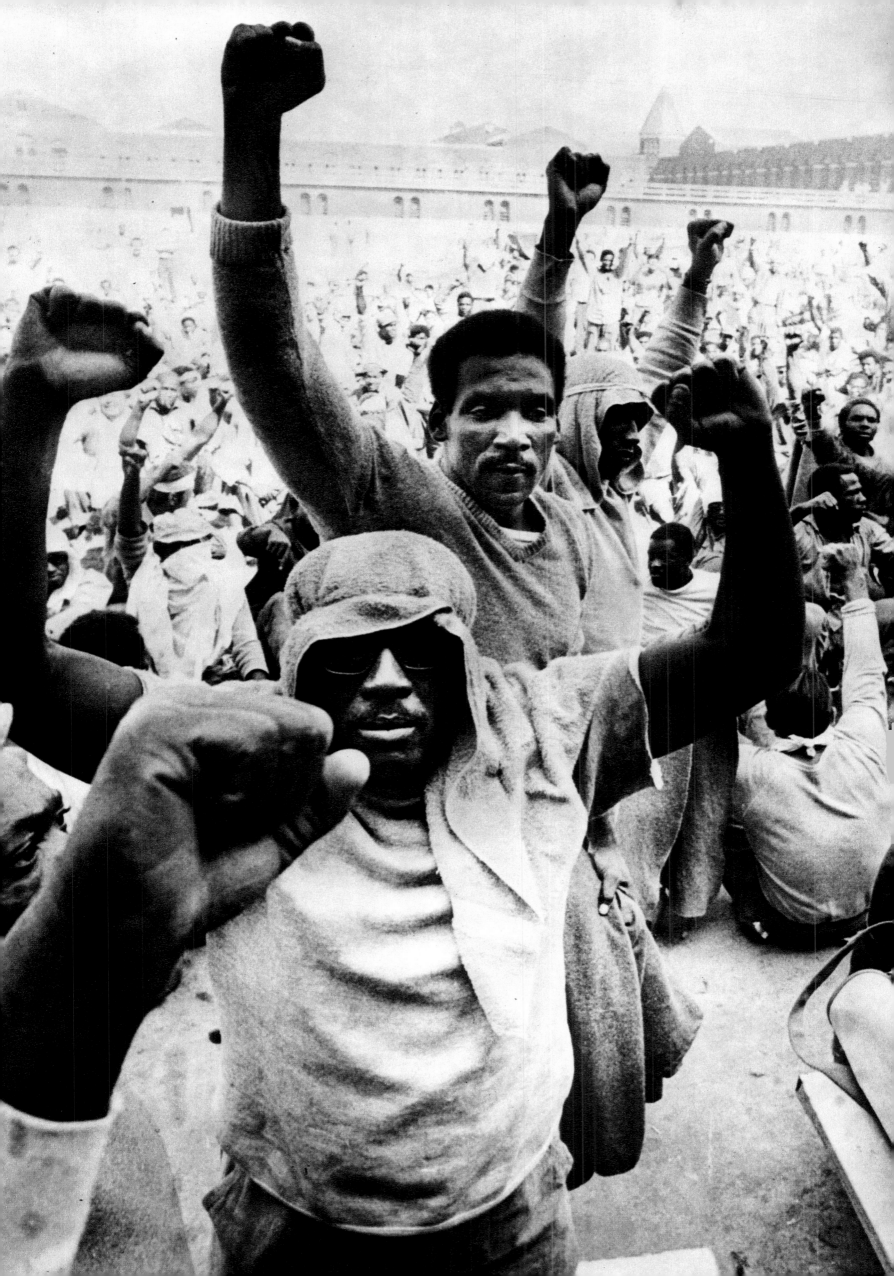

DESPERATION

Christmas morning, 1971. Even if it isn't, the world seems more at peace. The pace is slower. Families are reunited. The holiday spirit prevails, especially in prosperous South Korea, where the memory of war has faded and Christianity remains the largest organized religion.

The morning begins slowly for the 430 guests and employes of the Taeyonkak Hotel, 22 stories high and only two years old, in downtown Seoul. Breakfast orders begin and the coffee shop on the second floor is doing a brisk business. Until 10:00 a.m.

A propane gas burner suddenly explodes in the coffee shop and flames sweep through the hotel. Bellboys dash through the halls, banging on closed doors, shouting "Fire! Fire!" Confused, panicky guests are told to go to the roof; helicopters are on the way. Some helicopters airlift survivors but the intense heat drives others off. Trapped on the roof, some people put wet towels in their mouths to keep the smoke out.

Others find no time, no way to the roof and, in desperation, jump from the windows. A man on the ninth floor thinks he can cushion his fall and jumps with a mattress. He dies. A second man, on the eighth floor, watches the fatal leap but tries the same thing, anyway, with his mattress. He dies, too, as did 155 others this Christmas morning.

Kim Dong-Joon, photographer for the Seoul Simbun newspaper, arrives at the blazing hotel at 10:20. A screaming woman plunges from the hotel and smashes onto the pavement near him. Looking up through the billowing smoke and flames, he sees panicked faces in the windows of the upper floors. Then, the two men poised with mattresses. "I clicked the shutter instinctively as the man on the ninth floor jumped. A few seconds later, the second man jumped, as if drawn down by the kiss of death."

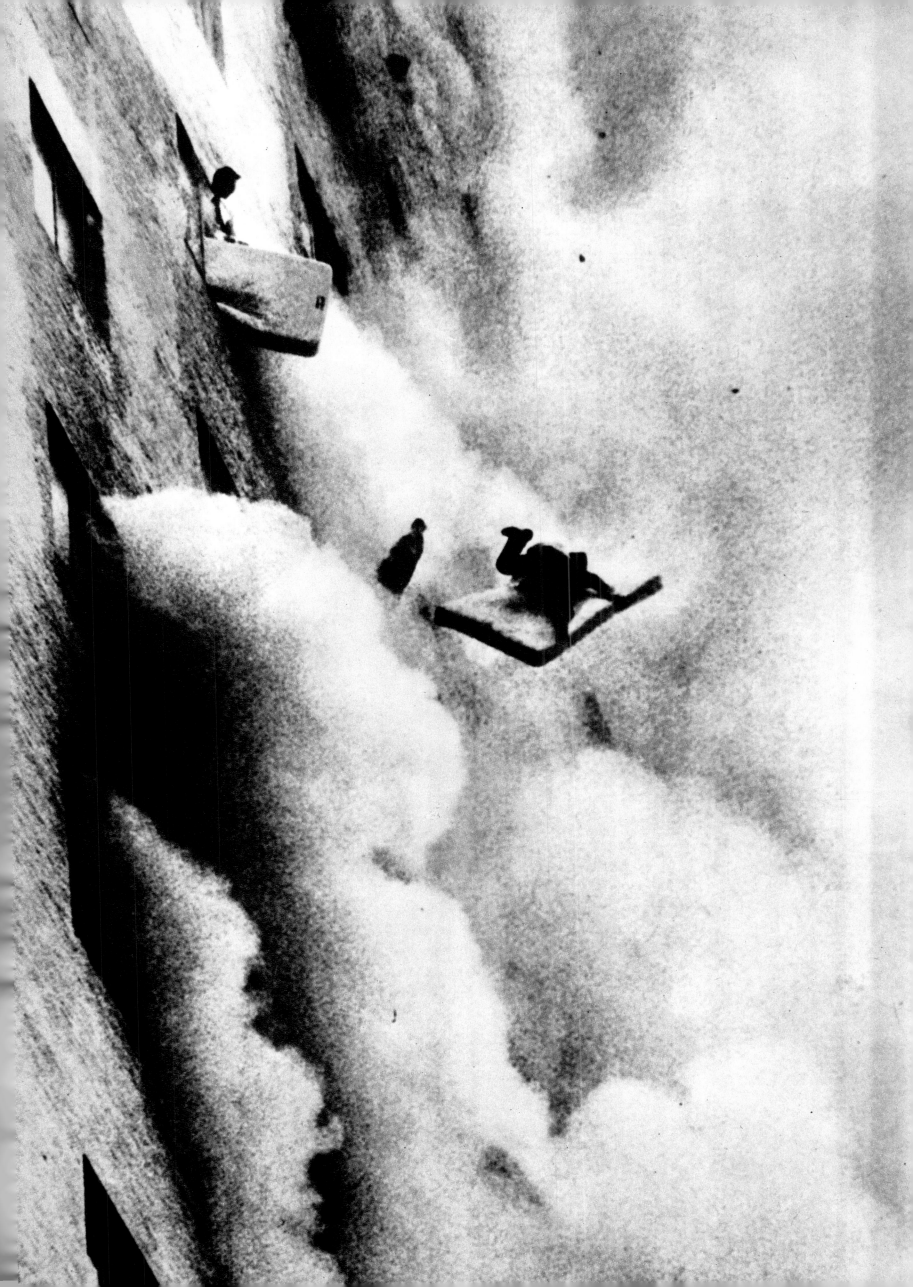

A DAY AT THE TRACK

Death lay over the land in the dark smoke from the cremating pyres, in the heavy flapping wings of bloated vultures, in the unnatural stillness.

Indian troops had waited edgily along the border of East Pakistan while West Pakistani soldiers had ravaged the countryside, killing as many as one million of their countrymen. On December 4, 1971, Prime Minister Indira Gandhi thought the time was right and India declared war, the third between the two nations in their 24-year history.

It was short—two weeks. Indian troops quickly forced the West Pakistani army back into the Bengali capital of Dacca, to the chagrin of the United States and Communist China, which had unofficially sided with Pakistan, and to the delight of Russia, which was backing India. Pakistan's leader, Gen. Yahya Khan, soon to be deposed in favor of Prime Minister Zulfikar Ali Butto, ordered his men to hold fast. But, encircled, they soon surrendered.

Then the scope of the butchery emerged. Survivors led the way to remote parts of Dacca and other cities where the intelligentsia of East Pakistan had been systematically eliminated by gunfire, by strangulation, by bayonet.

And now there would be revenge. Mukti Bahini, as the Bengali guerrillas were known, would see to it.

———————

Horst Faas and Michel Laurent had seen war around the world as Associated Press photographers. On December 18, after Dacca fell, they were at a race track on the outskirts of the city, where a mob had gathered, surrounding some non-Bengali East Pakistanis. The Mukti Bahini began burning the captives with lit cigarettes. Faas twice asked them to stop, to no avail. He and Laurent walked away, thinking the torture was being staged for cameras. It went on, anyway. Sickened, some newsmen stayed away. Faas and Laurent returned as the guerrillas stabbed at their victims with bayonets.

Faas: "During the terrible torture, sweat ran down my face and my hands were trembling so much I couldn't change the film. When the bayonetting started, Michel was just as pale as the victims. It went on and on. The crowd cheered and took no notice of us. I hoped the men would die soon, but it took almost an hour.

"Then the mob came in to finish the execution with their trampling feet. Michel and I felt numb when we pushed through the crowd. Somebody challenged us for taking those pictures but I think it was our job to report all that happened. And I hope and pray that no AP man has to see such horror again."

Indian authorities withheld some of their pictures, let others through. Faas, however, got the censored pictures out on a plane to London. Their work won both men Pulitzer prizes, the second for Faas.

234 *☆Pulitzer Prize Winner, 1972.*

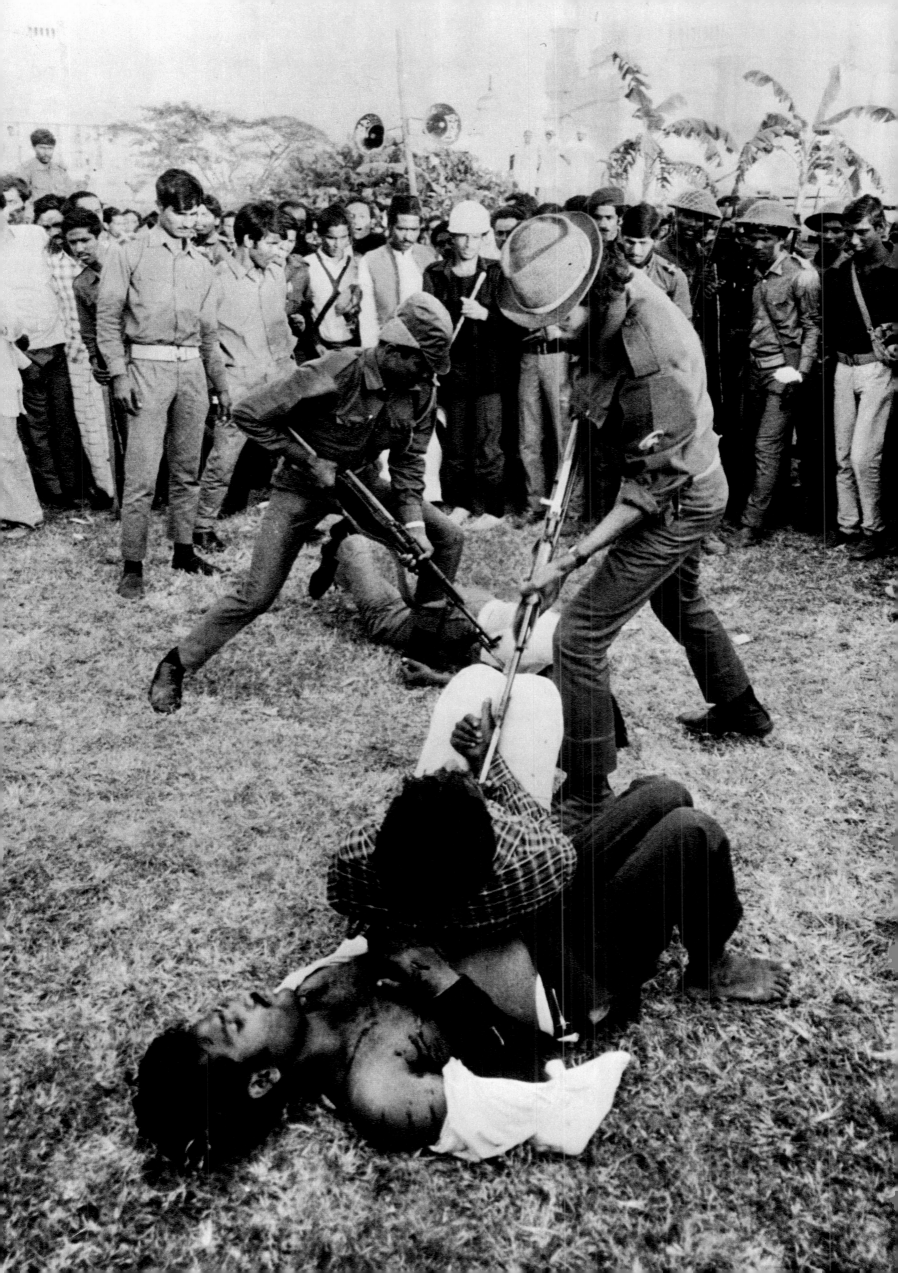

THE BLIND GOD OF WAR

For three days South Vietnamese troops have tried to dislodge the North Vietnamese from the marketplace of Trangbang, 25 miles northwest of Saigon. The communist troops blockade Highway 1, running from the capital to the Cambodian border. The battle is a standoff, a frustrating and costly draw in the sweaty heat.

On June 8, 1972, the South Vietnamese call in air support, hoping to break the deadlock. Two Skyraiders roar overhead. The South Vietnamese mark their positions with purple smoke grenades. The planes dive to the attack and at the command post Sgt. Nguyen Van Hai watches in disbelief. One of the planes unleashes its load of flaming napalm on huddled South Vietnamese troops and civilians. Six soldiers and five women and children are hit by the fiery jelly. The children, badly burned, tear at their clothing and run down the road screaming.

Nguyen Kong (Nick) Ut is a witness to the brutality of this war that grips his homeland. His older brother was a photographer for the Associated Press, wounded and then killed by rushing Viet Cong as he waited for medical evacuation helicopters. Nick, then only an AP film messenger, became an AP cameraman. Now he is at a different battle, an insignificant stanza in the larger opus of war. Suddenly flaming death rains from the sky. He sees the screaming children running toward him. He snaps the picture, still another horror in the war that won't go away.

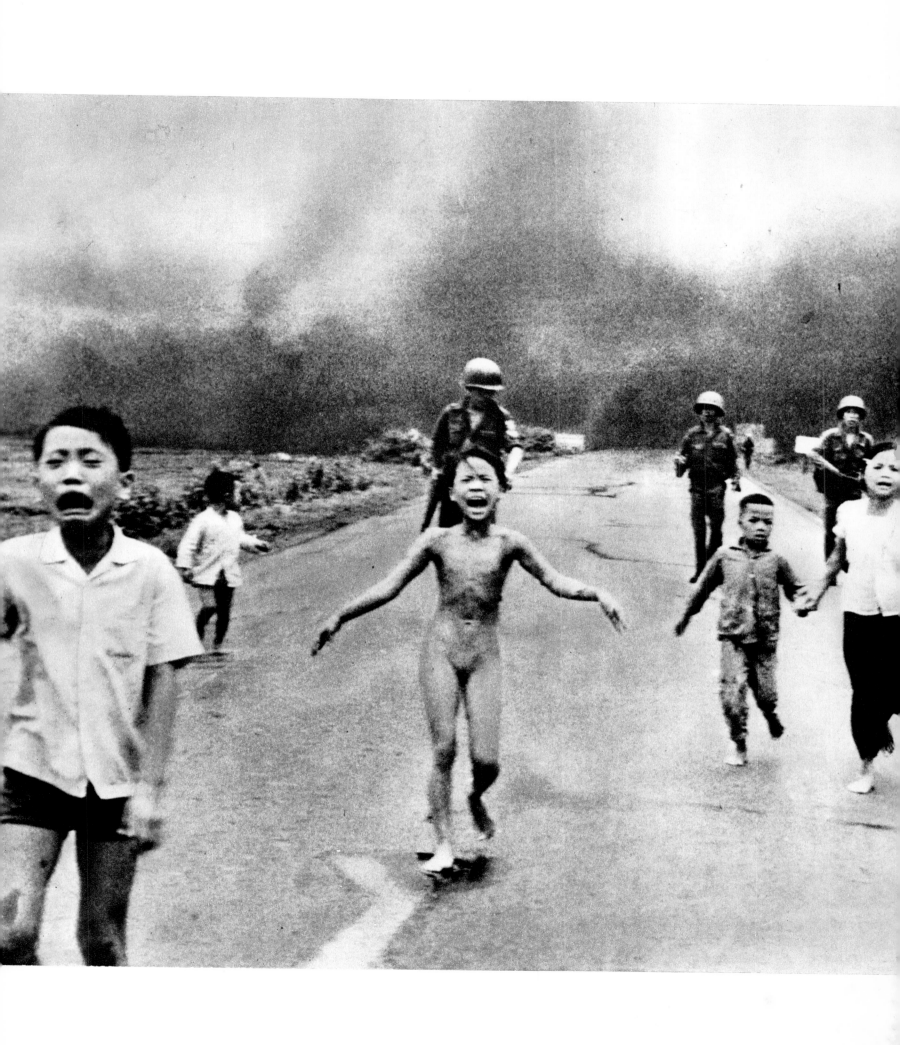

"DADDY!"

One at a time they came running in a sunburst of joy and motion: Lori, 15; Robert, 14; Cynthia, 11; wife, Loretta, and Roger, 12, last but pulling up fast on the field.

Lt. Col. Robert L. Stirm had been a prisoner of war in North Vietnam for more than five years, half of Cynthia's life.

And now the reunion, March 17, 1973, at Travis Air Force Base, California.

Stirm was one of 596 POWs sent home from North Vietnam in February and March as a result of the treaty signed in Paris Jan. 28, ending the longest war in American history. In the 12 years of that national agony and frustration, more than 55,000 Americans were killed, many more wounded.

The American pullout was completed on August 15, 1973, when U.S. warplanes ceased bombing throughout Indochina.

Neither the large nor the small story could be said to have a Hollywood ending. While Americans were no longer involved in combat, the war in Vietnam continued at a great cost in blood.

The Stirms?

They were divorced one year later, each to marry another.

––––––––––––––––

Pulitzer Prize photograph by Sal Veder of the Associated Press.

TANIA

Of all the traumas of the sixties and seventies, nothing appeared to unsettle and confound so many people as the sudden phenomenon loosely known as the generation gap.

Overnight, it seemed, our children became sullen strangers, burned colleges, fell into beds and drugs with complete abandon and denounced, from head to toe, those who had had the temerity to bring them into the world, raise, feed, clothe, educate and otherwise corrupt them.

By the early seventies, the tide of familial warfare seemed to have receded in most homes. Thus, the exceptions became more painfully dramatic.

Patty Hearst remained a painful symbol.

Patty Hearst, the young, pretty, rich daughter of a prominent publisher and granddaughter of one of the most rugged practitioners of American capitalism, was kidnapped from her Berkeley apartment Feb. 4, 1974.

More than a year later, she still remained a mystery hidden somewhere in the tangled underground of youth and radicalism.

In the months between, she managed to break her parents' hearts and, vicariously, middle-aged hearts everywhere.

She appeared to adopt the turgid, Marxist philosophy of her captors, the Symbionese Liberation Army. Captors and captive held up the Hearst family for $2,000,000 worth of food for the hungry, which, through inadvertence, became a chaotic, ineffective gesture.

Patty Hearst, now 20 and calling herself Tania, sent back from her world of the shadows tape recordings brutally denouncing her parents as "pigs" and the establishment in general.

After six of her underground comrades were killed in a Los Angeles shoot-out, she sent in another tape, June 7, vowing she would never return to her family.

That was the last heard from Patty Hearst, a profound mystery of time, place and circumstance.

———————————

On April 16, an unmanned automatic surveillance camera snapped the long-haired, kewpie-faced Tania in the act of holding up a San Francisco bank. Later, she was seen spraying bullets from an automatic weapon during a sporting goods store robbery.

INTO THE RECORD BOOKS

The swing.

The crack of the bat.

The fluid ballet: batter leaning and looking, catcher leaning and looking, umpire leaning and looking.

All of them looking, with millions of others, toward deep left center field.

At 9:07 on the cool and misty evening of April 8, 1974, Hank Aaron of the Atlanta Braves hit the 715th home run of his career, thus breaking a record held for 39 years by Babe Ruth.

In Babe Ruth's day, the closest a black man could get to major league baseball was cleaning up a locker room. Now, a black man held the sport's proudest record.

Like the picture, the feat rounded out a lovely symmetry. Four days before, Aaron hit his 714th homer with his first swing of the season in Cincinnati.

In the fourth inning of this game against the Los Angeles Dodgers in Atlanta, Al Downing's first pitch to Aaron was a changeup. It hit the dirt in front of the plate.

His second pitch was a fast ball that was supposed to fade. It didn't fade. Henry Aaron, 41 years old and 21 years in the majors, took his first swing of the night and for the next 10 minutes the ball game was stopped while the crowd roared.

Who won? Who cares?

Harry Harris of the Associated Press, who had also recorded Aaron's 714th on film, was stationed behind the centerfield fence in Atlanta with one mission.

He was to concentrate his long-lens camera on the batter at the plate. The Third World War might be starting at third base but Harry was to leave that to others. His job was Hank Aaron.

That meant pressing the button a fraction of a second after the ball left the pitcher's hand. That meant five useless pictures in Aaron's first appearance at the plate since he walked on five pitches. He pressed the button vainly again in the fourth inning for the first pitch into the dirt. And then came the big one.

Two and a half seconds after he snapped that, the historic ball landed in the bull pen 400 feet from home plate and seven feet from Harry Harris. Somebody else got the ball. Harris had the picture.

FRIDAY, AUGUST 9, 1974

In the broad, marble foyer, the Marine Orchestra was playing an incongruously gay medley of show tunes from Oklahoma, South Pacific and other old favorites.

It is through this foyer that one enters the White House, past the portraits of John Kennedy and Lyndon Johnson. Down the long, red-carpeted hall to the right is the elegant, crystal chandeliered State Dining Room, where a short prayer made by the First President to occupy the house remains carved in the fireplace mantel.

"I pray Heaven," said John Adams in 1800, "to bestow the best of blessings on this house and on all that shall hereafter inhabit it. May none but honest and wise men ever rule under this roof."

At the opposite end of the hall, past the portraits of Dwight Eisenhower and Harry Truman, past the grand staircase with its likenesses of Franklin Roosevelt and Woodrow Wilson, is the simple gold and white beauty of the East Room.

It was here that Union troops bivouacked in Abe Lincoln's time, here that Presidents danced with their ladies, entertained kings and prime ministers and here that they lay in state.

And here that Richard M. Nixon, the first President in history to resign and leave in dishonor, came to say farewell to his cabinet and staff. The long tortured road of lies and manipulation that began two years before in Watergate ended this day in the East Room.

With his wife and family behind him, between the portraits of George Washington and Dolley Madison, the 37th President of the United States talked in a disjointed way and slid into bathos.

He talked about his father and he talked about his mother and he came to tears. "Nobody'll ever write a book about my mother . . . My mother was a saint."

He talked about the destructive quality of hate, he pointed out that no member of his administration had profited at the public expense, he quoted Theodore Roosevelt on the death of his young wife. "And when my heart dearest died, the life went from my life forever."

Richard Nixon, who was fond of quoting that President, did not mention that the same Roosevelt said: "No man is above the law and no man is below it; nor do we ask any man's permission when we require him to obey it."

On the opposite wall of the East Room, among 100 other photographers struggling for space and the right angle, Charles (Chick) Harrity of The Associated Press was shooting and thinking:

. . . It's been a strange five years with King Richard, around the world, Russia, Poland, Mexico, San Clemente, Laguna Beach. Wonder where Ford will go? Does Grand Rapids have a beach?

. . . With all these sad faces, I wonder what everyone is really thinking. Why didn't he just slip away? He wanted to be big in the history books. Wow, is he going to be big . . .

Here he comes . . . The strain must be awful . . . The whole family looks pretty strong, considering . . . My God, the old thumbs up sign! Is he going to start chanting, "four more years"?

Come on, Pat, don't break down now. You and Julie are the ones I really like. Look at those faces. Is that a tear he's brushing away? For God's sake, don't cry, not here, not now. There he goes. He never admitted anything, like he never had anything to do with the whole thing . . .

He looked like an embarrassed old man. Did I get that expression?

One generation passeth away, and another generation cometh: but the earth abideth for ever.

The sun also ariseth, and the sun goeth down, and hasteth to his place where he arose.

The wind goeth toward the south, and turneth about unto the north; it whirleth about continually, and the wind returneth again according to his circuits.

All the rivers run into the sea; yet the sea is not full; unto the place from whence the rivers come, thither they return again.

<div align="right">—Ecclesiastes</div>

Photograph by Eddie Adams, Associated Press.